CYBORG BABIES

CYBORG BABIES

CYBORG BABIES

From Techno-Sex to Techno-Tots

edited by

Robbie Davis-Floyd

and

Joseph Dumit

Routledge
New York and London

Published in 1998 by
Routledge
29 West 35th Street
New York, NY 10001

Published in Great Britain by
Routledge
11 New Fetter Lane
London EC4P 4EE

The editors gratefully acknowledge permission to reprint previously
published material here.

Rayna Rapp's essay, "Refusing Prenatal Diagnosis," originally appeared in
Science, Technology and Human Values 23 (1): 45–70, Winter 1998.
Copyright © Science, Technology and Human Values. Reprinted by
permission of Sage Publications, Inc.

10 9 8 7 6 5 4 3 2 1

Library of Congress Cataloging-in-Publication Data

Cyborg babies : from techno-sex to techno-tots / edited by Robbie
Davis-Floyd and Joseph Dumit, with a foreword by Donna Haraway.
p. cm.
Includes bibliographical references and index.
ISBN 0-415-91603-8 (hc). — ISBN 0-415-91604-6 (pbk.)
1. Human reproductive technology—Social aspects. 2. Human
reproductive technology—Moral and ethical aspects. 3. Cyborgs.
I. Davis-Floyd, Robbie. II. Dumit, Joseph.
RG133.5.C9 1998
176—dc21 97-44516
 CIP

To our own cyborg babies—Peyton, Jason, and Andrew.

contents

Cyborg Babies

Children of the Third Millenium

Joseph Dumit and Robbie Davis-Floyd

Cyborgs are symbiotic fusions of organic life and technological systems. From the Six-Million-Dollar man to the Terminator, cyborgs have populated the American cold-war space-race imagination for decades, evolving in tandem with our cultural attachment to technological solutions to life problems. Increasingly, these visions of human-machine coevolution have focused on practices of sexual reproduction and childrearing—areas in which our *codependence* with the technologies we have developed is intensifying. We use this term advisedly; the more positive *interdependence* does not sufficiently connote the compelling, addictive quality of our relationship to cyborg technologies, from ultrasounds to evaluate fetal progress to teddy bears that imitate the sounds of the womb. We are immersed in cyborgs; they saturate our language, our media, our technology, and our ways of being, posing questions we cannot answer about the exact location of the fine line between "mutilating" a natural process in a negative and destructive way and "improving" or "enhancing" it. That line may be impossible to locate; so many of the technologies that cyborgify us in (what we perceive as) positive ways, from air "conditioning" to laundry detergents to cars, carry a high environmental price. Yet we continue on our cybercultural path.

The discipline of anthropology, out of which this book arises, has itself developed a new and intensive focus on the sociocultural aspects of science and technology. Ever since Donna Haraway noted that "we are all cyborgs now," it has been ever more seriously suggested that anthropology, the study of humans, should move outside the limited domain of humanity to encompass the apparently limitless domain of the cyborg. This "cyborg anthropology" is already the subject of two key collections, *The Cyborg Handbook* (Gray

1995) and *Cyborgs and Citadels* (Downey and Dumit 1997). Feminist anthropology and feminist cultural studies have also contributed to our knowledge and analysis of the new reproductive technologies. Recent related works include *Technologies of Procreation* (Edwards et al. 1993), *Conceiving the New World Order: The Global Politics of Reproduction* (Ginsburg and Rapp 1995); *Technologies of the Gendered Body: Reading Cyborg Women* (Balsamo 1996); and *Reproducing Reproduction* (Franklin and Ragoné 1997). *Cyborg Babies* adds to this literature a critical focus on the varieties of cyborg reproduction among the middle class(es) of North America.

The imagination of cyborgs haunts North American pregnancy narratives. Accounts in newspapers and magazines struggle, oscillating between how technology and science help a natural process complete itself and how the process of childbearing has become technoscientific[1] through and through. Contemporary mainstream reproductive practices are characterized by the value placed on the language of high-tech, the ideological force of progress, and the latest quick fix. Biomedicine is accepted as best because it is expert, technological, scientific, and new, as opposed to wise, intersubjective, traditional, and time-tested. Women who have access to this technomedicine choose it because they believe in its promise—or want to. Women with few options beyond government-funded clinics and the treatments for which Medicaid will pay (Lazarus 1988, 1990) often serve as experimental subjects for high-technology treatments or as practice material for residents who need to perform their quota of techniques. The poor are sometimes the beneficiaries, and sometimes the guinea pigs, of the cyborgification of American reproduction.

Another symbol that pervades and exceeds this volume is "choice." Choice is granted as the key right of American identity: we *want* the ability to choose. We are clearly not faced with a simple case of offering women more choices. The multiplicity of options spawned by cyborg technologies presents the appearance of choice, yet as Barbara Katz Rothman (1985:32) so cogently pointed out, the more technological options that exist, the less possible it is to choose options that do not involve technology. She cites the automobile: as soon as most people began to drive cars, roads were paved, parking meters replaced the hitching post, and the chance to "choose" the horse and buggy disappeared into meaninglessness. Analogously, as soon as multiple reproductive diagnostic choices become available, from alpha-feto-protein (AFP) testing to ultrasound to amniocentesis, the choice *not* to choose from among this plethora of options begins to disappear into the same cultural void. Why would anyone be so foolish as to risk giving birth to a defective baby when the technologies to prevent this disaster exist? Carole Browner and Nancy Press (1995, 1997) have shown that since California legislation made AFP testing[2] an "option" paid for by the state, pregnant women have come to perceive that test as an integral part of "the best medical care." They are heavily influenced

in its favor by their health care providers, who stress the reassuring information AFP testing can provide, usually neglecting to mention that a negative diagnosis can force a woman to a choice for or against abortion. To decide for or against the test then disappears as a choice, as refusal makes the woman appear selfish, unwilling to provide her baby with "the best care."

The same is true for ultrasound and for amniocentesis—to refuse to allow technicians to peer into the womb and to sample the fetal DNA is to appear to refuse "the best care" for selfish reasons. Both Rothman (1986) and Rayna Rapp (1984–1995; this volume) have investigated the difficulties faced by women who resist amniocentesis, especially when they do end up with a less than "perfect" child. Yet both technologies are invasive and carry risks: amniocentesis increases the risk of miscarriage, and routine ultrasound screening has been shown in major studies on three continents to carry increased risk of intrauterine growth retardation (IUGR) (Newnham et al. 1993) and to fail to improve pregnancy outcome while significantly increasing the cost of prenatal care (Ewigman et al. 1993). The technology has its effects, which can manifest in subtle changes in the cyborg child. This is a perfect example of the ambiguity of the cyborg: are these costs of ultrasound worth its many nonmedical benefits and side effects, such as bonding between parents and fast-forwarding the reality and gender of the fetus? What price is too small to count or too great to pay for our cultural re-creation as cyborgs?

■ THE REPRODUCTIVE BODY-MACHINE: AN ORIGIN STORY[3]

The Cartesian model of the body-as-machine operates to make the physician a technician, or mechanic. The body breaks down and needs repair; it can be repaired in the hospital as a car is in the shop; once fixed, a person can be returned to the community. The earliest models in medicine were largely mechanical; later models worked more with chemistry, and newer, more sophisticated medical writing describes computer-like programming, but the basic point remains the same. Problems in the body are technical problems requiring technical solutions, whether it is a mechanical repair, a chemical rebalancing, or a "debugging" of the system.

—Barbara Katz Rothman, *In Labor: Women and Power in the Birthplace* (1982:34)

In the seventeenth century, the practical utility of this metaphor of the body-as-machine lay in its conceptual divorce of body from soul, and in the subsequent removal of the body from the purview of religion so it could be opened up to scientific investigation. During this time period, the dominant Catholic belief system of Western Europe held that women were inferior to men— closer to nature, with less-developed minds and little or no spirituality (Ehrenreich and English 1973; Kramer and Sprenger 1972 [1486]). Consequently, the men who established the idea of the body-as-machine also firmly established the male body as the prototype of this machine. Insofar as it devi-

ated from the male standard, the female body was regarded as abnormal, inherently defective, and dangerously under the influence of nature, which because of its unpredictability and its occasional monstrosities, was itself regarded as inherently defective and in need of constant manipulation by man (Merchant 1983:2).

During pregnancy and birth, the unusual demands placed on the female body-machine render it constantly at risk of serious malfunction or total breakdown. The demise of the midwife and the rise of the male-attended, mechanically manipulated birth followed close on the heels of the wide cultural acceptance of the metaphor of the body-as-machine in the West and the accompanying acceptance of the metaphor of the female body as a defective machine—a metaphor that eventually formed the philosophical foundation of modern obstetrics. Obstetrics was thus enjoined by its own conceptual origins to develop tools and technologies for the manipulation and improvement of the inherently defective and therefore anomalous and dangerous process of birth:

> In order to acquire a more perfect idea of the art, [the male midwife]
> ought to perform with his own hands upon proper machines, contrived
> to convey a just notion of all the difficulties to be met with in every
> kind of labour; by which means he will learn how to use the forceps
> and crotchets with more dexterity, be accustomed to the turning of
> children, and consequently, be more capable of acquitting himself in
> troublesome cases. (Smellie 1756:44)

> It is a common experience among obstetrical practitioners that there is
> an increasing gestational pathology and a more frequent call for art, in
> supplementing inefficient forces of nature in her effort to accomplish
> normal delivery. (Ritter 1919:531)

The rising science of obstetrics ultimately accomplished this goal by adopting the model of the assembly-line production of goods—the template by which most of the technological wonders of modern society were being produced—as its base metaphor for hospital birth. In accordance with this metaphor, a woman's reproductive tract is treated like a birthing machine by skilled technicians working under semiflexible timetables to meet production and quality control demands:

> We shave 'em, we prep 'em, we hook 'em up to the IV and administer
> sedation. We deliver the baby, it goes to the nursery and the mother
> goes to her room. There's no room for niceties around here. We just
> move 'em right on through. It's hard not to see it like an assembly line.
> (fourth-year male resident, quoted in Davis-Floyd 1992:55)

The hospital itself is a highly sophisticated technological factory (the more technology the hospital has to offer, the better it is considered to be). As an institution it constitutes a more significant social unit than the individual or the family, so the birth process should conform more to institutional than personal needs. As one physician put it:

> There was a set, established routine for doing things, usually for the convenience of the doctors and nurses, and the laboring woman was someone you worked around, rather than with. (quoted in Davis-Floyd 1992:55)

This tenet of the technocratic model—that the institution is a more significant social unit than the individual—will not be found in obstetrical texts yet is taught by example after example of the interactional patterns of hospital births (Jordan 1993; Scully 1980; Shaw 1974). For example, Jordan describes how pitocin (a synthetic hormone used to speed labor) is often administered in the hospital when the delivery-room team shows up gowned and gloved and ready for action, yet the woman's labor slows down. The team members stand around awkwardly until someone finally says, "Let's get this show on the road!" (1993:44).

The most desirable end product of the birth process is the new social member, the baby; the new mother is a secondary by-product:

> It was what we all were trained to always go after—the perfect baby. That's what we were trained to produce. The quality of the mother's experience—we rarely thought about that. Everything we did was to get that perfect baby. (thirty-eight-year-old male obstetrician, quoted in Davis-Floyd 1992:57)

This focus on the production of the "perfect baby" is a fairly recent development, a direct result of the combination of the technocratic emphasis on the baby-as-product with the many technologies now available to assess fetal quality. Amniocentesis, ultrasonography, "antepartum fetal heart 'stress' and 'non-stress' tests . . . and intrapartum surveillance of fetal heart action, uterine contractions, and physiochemical properties of fetal blood" (Pritchard and MacDonald 1980:329) are but a few of these technologies. Eighteen years ago, these authors of *Williams Obstetrics*, the preeminent obstetrical text, wrote:

> The number of tools the obstetrician can employ to address the needs of the fetus increases each year. We are of the view that this is the most exciting of times to be an obstetrician. Who would have dreamed, even a few years ago, that we could serve the fetus as physician? (Pritchard and MacDonald 1980:vii)

The conceptual separation of mother and child basic to the technocratic model of birth parallels the Cartesian doctrine of mind-body separation. This separation is given tangible expression after birth as well when the baby is placed in a plastic bassinet in the nursery for four hours of "observation" before being returned to the mother; in this way, society demonstrates conceptual ownership of its product. The mother's womb is replaced not by her arms but by the plastic womb of culture. As Shaw points out, this separation of mother and child is intensified after birth by the assignment of a separate doctor, the pediatrician, to the child (1974:94). This idea of the baby as separate, as the product of a mechanical process, is a very important metaphor for women because it implies that men ultimately can become the producers of that product (as they already are the producers of most of Western society's technological wonders). And indeed, male production of the babies women carry has intensified in recent years with the development and proliferation of the new technologies of conception, such as in-vitro fertilization (IVF), that involve the removal and the technological manipulation of women's genetic material and its reinsertion.

Although most modern obstetrical texts do give lip service to pregnancy as a natural and intrinsically healthy process, this is usually done in a paragraph or two. For example, the eighteenth edition of *Williams Obstetrics* states:

> The expectant mother has been commonly treated as if she were seriously ill, even when she was quite healthy. All too often she has been forced to conform to a common pathway of care that stripped her of most of her individuality and much of her dignity. . . . Too often the expectant mother has felt that her fate and the fate of her baby were dependent not so much on skilled personnel but upon an electronic cabinet that appeared to possess some great power that prevailed above all others. (Cunningham, MacDonald, and Gant 1989:6)

Meanwhile, most of the next 900 pages are devoted to a detailed discussion of everything that could possibly go wrong and of how to use the "electronic cabinet" to solve these problems. This electronic cabinet serves as a prosthetic device that has become integral to the mutilation and prosthesis of birth—in other words, to its technocratic de- and reconstruction.

■ CHOOSING CYBORG CONCEPTIONS?

Although the cultural consensus around the dysfunctionality of childbirth has generated widespread acceptance, even embrace, of its thorough cyborgification, that consensus does not (yet) extend to conception. In other words, most people in the United States still regard natural conception through sexual intercourse as the norm and artificial conception as the anomaly. Thus the

same degree of cultural pressure to cyborgify their bodies and their pregnancies does not apply to the choice to use new contraceptive technologies such as IVF and donor insemination. In this area, women put the pressure on themselves. If a woman wants a child and the technological options are there to help increase her chances of having one, then she will have failed *her own* expectations if she does not take the techno-conceptive plunge. Faced with patently defective body-machines, infertile women turn quite "logically" to the technicians. Those who can afford it douse themselves with antibiotics, arrange their work schedules around clinic visits, undergo countless invasive, often painful, always emotionally charged procedures—all for the chance that they will be that one woman out of ten to be blessed with the news of a cyborg conception. Thus they take the technocratic imperative—*if it can be done, it must be tried*—and write their own variation: *if it can be tried, then I must try it.* In other words, the existence of new reproductive technologies (NRTs) opens up new potentials for reproduction; once they are open, because they exist, they cannot be ignored. At the same time, options that arise out of a more organic or holistic worldview (such as changes in diet and lifestyle that might improve overall health and thus fertility, a move to a non-polluted area, psychological counseling to identify and heal unconscious pain or trauma that may be blocking the woman's ability to conceive) are rendered invisible in the face of the dazzling potentials of the NRTs.

While the cyborg technologies of birth do support the technocratic hegemony, the new contraceptive technologies, from sperm banks to in-vitro fertilization, have subversive potential; they can be and often are used to support the diverse types of families springing up on the American cultural landscape, including lesbian and gay families (Hornstein 1984; Klein 1984; Lewin 1995; Weston 1991). Yet Edwards et al. (1993) show clearly that in practice, the subversive potential of these technologies is often itself subverted into the service of the dominant cultural mode: access to them is often denied to nonconformists such as mothers who are too old, men who are not married to women, and women who are not married to men. And it is important to remember that this drama of who has access to these technologies and who does not is often dependent on who has money and who does not. And so the manipulation of nature for reproductive ends is a cultural game that is played almost entirely within the boundaries of the wealthier classes, save for those surrogates they hire from the classes below. By starting with a collection organized around middle-class North American women, we seek to avoid a standard, disempowering refrain: "cultural differences" account for reproductive "choices." By juxtaposing a variety of reproductive struggles— resistant, smart, cautious, and tragic—we hope to further pursue the questions of stronger objectivity, situated knowledges, and thoughtful activism (see Haraway 1991b; Harding 1991; Harding and O'Barr 1987).

In line with that goal, some of the chapters in this book speak not the language of high-tech but the organicized language of embodiment. These chapters bring us closer to those who have resisted high-tech care and opted out of the system, making it clear that from their perspective there exists a grand choice between mainstream medicine and holistic healing (see, e.g., Davis-Floyd and St. John 1998; Gordon 1996). They raise the question: does resistance to technologized reproduction equal resistance to the cyborg itself? Given that cyborgs by definition involve human-manufactured technology and (in the most common use of the term) "high" technology, can one be holistic, be organic, be embodied, and still be a cyborg or embrace cyborg modes of living?

■ CYBORG PROMISES AND CYBORG THREATS: WRITING WITH CYBORGS

Cyborg is a tricky term, a wily subject. In the following sections, we try to distinguish four different uses of the concept of cyborg at work in this volume. They are (1) the cyborg as positive technoscientific progress; (2) the cyborg as mutilator of natural processes; (3) the cyborg as neutral analytic tool and metaphor for all human-technological relationships; and (4) the cyborg as signifier of contemporary, postmodern times in which human relations with technoscience have changed for better and for worse. The chapters in this book embody the tension between these different perspectives on cyborgs as they reflect the meaning of biomedicine and the nature of reproduction.

(1) The Cyborg as Positive Technoscientific Progress

In their article inaugurating the term "cyborg," Clynes and Kline take the notion of supplementing ourselves with technoscience as pure and natural progress. Their term for it is "participant evolution":

> In the past, evolution brought about the altering of bodily functions to suit different environments. Starting as of now it will be possible to achieve this to some degree without alteration of heredity by suitable biochemical, physiological, and electronic modification of man's existing modus vivendi. (1995 [1960]:29)

In this manner, the shift from understanding ourselves as complete and natural and whole to seeing ourselves as limited is one of scope of vision and dreams of possibility. As soon as we desire to live in cold climates or somewhere other than on land on earth, we see ourselves as lacking—lacking fur, lacking the ability to breathe in water or in space, lacking radiation protection, and so on. This simple shift of perspective requires technoscience in order to make us "naturally" able to live in our newly desired homes.

Translated into the language of reproduction, this perspective on cyborgs sees "normal reproduction" as a kind of traditional throwback—dangerous, risky, random. Envisioning the appealing possibility that every woman can be a perfect mother who bears perfect children with every conception requires seeing every aspect of traditional reproduction as lacking and in need of technoscientific surveillance and intervention. Cyborg conceptions (such as IVF), cyborg fetuses (gray blurs on the ultrasound screen), cyborg labors (the contractions both traced and mediated by the monitor, the baby's heartbeat a green line on a black screen), cyborg births (via forceps, vacuum extractors, or cesarean), and cyborg babies (physically transformed by vaccines, SIDS monitors, and intelligence-enhancing toys) become the desired end. Like the toys labeled "transformers," cyborg babies are malleable, fluid, available for socialization into the latest technomania. We have moved so far into the cyborg realm that only those technological transfusions we call "assisted reproduction"—safe, monitored, controlled—are considered "natural" in this postmodern world. It has become unnatural to give birth at home, without the body-altering safety net of high technology. Instead, our culture has naturalized technobirth. We think, *This is how babies should be made, with all the resources of science and technology, not left to the caprices of Mother Nature alone.* Because we so deeply trust technology, we cannot trust nature anymore. Natural reproduction, when successful, becomes a special category: lucky.

None of the chapters in this book takes such an unreflexive, gung-ho perspective. What each takes from this notion of the cyborg as the future is a sense of urgency to analyze how technologies have, perhaps permanently, altered the processes of reproduction.

(2) The Cyborg as Mutilator of Natural Processes

The second use of cyborg sees the technologization of reproduction as a regression—away from what is natural and important. This oppositional approach to technoscientific progress has been elaborated by many proponents of "alternative medicine." In this account, the cyborgification of reproduction has been for the worse. Natural reproduction, with all its juiciness, randomness, and risk, is seen as better and safer than technological intervention and surveillance, which, because they often generate more problems than they solve, are seen as not only unnatural but also dangerous. Peter C. Reynolds images this powerfully with his identification of the "One-Two Punch of Technocracy" (1991). Take a highly successful natural process, like salmon swimming upstream to spawn. Punch One: In the name of progress and improvement, render it dysfunctional with technology—dam the stream, preventing the salmon from reaching their spawning grounds. Punch Two: Fix the problem created by technology with more technology—take the

salmon out of the water with machines, make them spawn artificially and grow the eggs in trays, then release the baby salmon downstream near the ocean. This One-Two Punch—destroy a natural process, then rebuild it as a cultural process—is an integral result of technocratic society's supervaluation of science and technology over nature. Reynolds articulates this technoscientific de- and reconstruction of nature as a process of mutilation and prosthesis.

Davis-Floyd (1994) has suggested that the cultural management of American birth is a significant example of this One-Two Punch. For example, biomedicine mutilates the natural rhythms of birth by multiple interventions in every phase (withholding food and drink from laboring women, which weakens them; administering pain-relieving drugs that slow labor; making the woman lie flat on her back during labor and birth and thereby reducing the flow of blood and oxygen to the baby), then prosthetizes the skewed results (inserting IVs to administer the fluids the woman is not allowed to drink; injecting into the IV drugs to speed up labors slowed by drugs that relieve pain—which further inhibit blood and oxygen supply to the baby; electronic fetal monitoring of the baby's level of distress, which will rise as its blood and oxygen supply drops; delivery of the iatrogenically distressed baby by forceps or cesarean section). In the process of cyborgifying childbirth, and in the name of progress, women and fetuses are endangered and a primal, intrinsically embodied act that women themselves used to perform is turned into a series of technological procedures performed on them.[4]

The cyborg in these accounts functions as a villain or an omen of the dangers of technoscientific practices and reliance. These dangers are real and their resultant dysfunctions are multiple; they range from an epidemic of unnecessary cesareans to the overpopulation of the neonatal intensive care unit with babies born prematurely from labors that should never have been artificially induced. Yet women demand their own cyborgification and that of their unborn and newborn children (Sargent and Stark 1989; Davis-Floyd 1993, 1994). As one of the women Davis-Floyd (1994) interviewed said, "I don't have the need or the desire to be biological—I'd rather see the finished product than the manufacturing process." To such women the cyborg speaks compellingly of the controllability and predictability that contrast favorably with what they perceive as the chaos of "natural childbirth":

> I [asked] for an epidural at one point, but they said they didn't have time to do it. . . . I was awfully uncomfortable and I had remembered how wonderful it was [with my first birth] and that I had instantly felt terrific. . . . I was mad that I was in so much pain, and then they would tell me something like "we don't have time," you know—that just drove me wild. I didn't like that at all—I wanted to have it when I wanted to have it. (Kay Williams, quoted in Davis-Floyd 1994:1132)

The transcendent message of the cyborg birth, that technology is better than nature, aligns with such women's everyday experience of order imposed on chaos by, e.g., the dishwasher, the minivan, the cell-phone, and the computer. The transcendent message of the One-Two Punch is that Punch Two is the point: we truly and deeply believe that to re-create a natural process technologically is to make it better. Damming the river is better than letting it flood, even if those dams are causing the salinization of the downriver water; driving is better than riding a horse or walking, even if we grow fat and our muscles atrophy from lack of exercise; and hooking a woman up to an electronic fetal monitor is better than letting her labor on her own, even if that monitor is likely to give a false reading (as they often do) that leads to an unnecessary cesarean section. In other words, (a sense of) control is better than surrender; and because it gives us (the illusion of) control, technology is better than nature.

In the arena of childbith, mainstream, public cultural consensus thus crystallizes around (1) the cyborg as positive technoscientific progress, while the countercultural critique focuses on (2) the cyborg as mutilator, and the large body of scientific evidence that supports its claims. This heretical approach took shape on a large scale in the United States with the "natural childbirth" movement of the 1960s and 1970s; when that movement was co-opted by the "prepared childbirth" movement and the phenomenon of the "awake and aware" Lamaze-trained mother hooked up to the EFM and the epidural (Jordan 1993:142–145), its originally heretical critique was continued on in various forms by childbirth activists, midwives, mothers, and proponents of the homebirth movement.

(3) Midwives and Monsters: The Cyborg as Metaphor

Both the participant evolution use of cyborg and the rejection of technologically assisted reproduction share a notion of "natural reproduction," whether it is to be replaced by the future or preserved in spite of it. There are two other uses of the metaphor of cyborg which bear emphasizing. In these, the notion of the cyborg serves to diagnose the present and to disrupt the very idea of "natural reproduction" as a kind of no-longer-useful and perhaps dangerous assumption.

This third use of cyborg extends the cyborg metaphor to a general theory of cultural relations, using it to better understand how reproduction is always mediated by different kinds of technoscientific interventions. One could, for instance, elaborate Clifford Geertz's (1973) metaphor of cultural evolution in which humans as biological animals use culture as a prosthesis in order to begin participant evolution. Midwifery, seen as the introduction of a learned, technical craft to the "natural" process of a lone woman giving birth to a baby, is thus a form of cyborg reproduction. This kind of interpretive strategy often

depends upon the disruptive, disconcerting notion of cyborgs (the pleasure and unease alluded to at the beginning of this Introduction) to provide a better place for reflection on reproduction. Basically an agnostic position that tries not to be fixated on either the promises or the dangers, this approach advocates a better, more reflexive understanding of the power of metaphors in science, medicine, our imaginations, and daily life. To apply a notion advanced by Sandra Harding (1991), by attempting to clarify the work of images and metaphors, those who espouse this third approach are advocating a "stronger objectivity," one which starts with the findings of contemporary science and medicine and asks how they can be improved by attending to issues of gender, social position, race, and class.

(4) The Cyborg as Signifier of Postmodern Times

The fourth use of cyborg is to locate and diagnose the present. An excellent example of the cyborg as signifier of postmodern times can be found in Monica Casper's notion of the "technofetus." Using ethnography and history, Casper (1995, n. d.) traces how the construction of fetal surgery produced a particular meaning of the fetus as an unborn patient. By carefully attending to the ethical dilemmas surrounding the limits of fetal surgery and the relationship between the fetus as patient and the mother, who is simultaneously patient and incubator, Casper reveals the depth of both the technological and the personal effects biomedicine can have on women.

Rather than neutrally employing the metaphor and refusing both utopia and dystopia, employing the cyborg as signifier of the times accepts both premises—that there are wonders of technoscience *and* that there are horrible dangers and abuses caused by it. (Donna Haraway argues, for instance, that we are all already children of the nuclear bomb, the green revolution, the master gene, the database, and the microchip.) This approach to cyborgs uses the tactic of science fiction to narrate the present as an opportunity to imagine that the past doesn't determine the future—to imagine, or to force the reader to imagine, how things might be otherwise.

This book was put together in an attempt to locate the different and yet complementary values of these various strategic uses of cyborg imagery. We sought to provide detailed scenarios within which to consider how and why each kind of intervention and each kind of writing strategy become useful and perhaps necessary. How in some cases, for instance, does biomedicine provide hope and life to women who otherwise are at risk of losing both, and in other cases, does the same biomedicine serve to disempower, depress, and endanger women? When one starts from one perspective, one situation in which there is real danger to person and personhood, might it be necessary to

imagine, and perhaps to demonize, a homogenous "other side," whether as technocratic medicine or ignorant traditional medicine? What is gained or lost when one instead chooses a distant, third-person, neutral voice? For instance, does one then lose the ability to be angry at current practices and personal tragedy?

Cyborgs thus represent a paradox: they are potentially better than human, *and* they threaten the loss of our identity—if we become too much the cyborg, will we be no longer human? Serving as both enhancers and mutilators of what went before, cyborgs—and especially cyborg modes of reproduction—represent, in another of Haraway's potent phrases, a "promise of monsters."

■ CYBORG BABIES: AN OVERVIEW

The organizational scheme of the chapters in this book mirrors the chronology of the cyborg baby's techno-organic life cycle. We begin at the beginning, with "Cyborg Conceptions." As this Introduction has analyzed the cultural production of birth, so the chapters in Part I analyze the cultural production of technosemen (Schmidt and Moore), of kinship in an infertility clinic (Cussins), of one couple's cyborg baby (Mentor), and of "natural conception" in a futuristic society that mutilates and prosthetizes sexual intercourse the same way our society mutilates and prosthetizes birth (Ashford).

The chapters in Part II explore cultural and personal constructions and rejections of "The Techno-Fetus," beginning with baby's first picture, which Lisa Mitchell and Eugenia Georges analyze as a technocultural event generated by the pervasive use of ultrasound in pregnancy. Emily Martin investigates the cyborgian implications of the current dominant model of the immune system, which is perceived as "tolerating" the fetus—an immunologically foreign substance. Rayna Rapp and David Chamberlain tell stories of resistance. Rapp speaks for the women she has studied who resisted the high-tech, high-consequence procedure known as amniocentesis. Chamberlain speaks for fetuses themselves, refuting the medical myth that babies, in the womb or in the world, don't feel pain from the technological interventions they are increasingly forced to undergo.

In Part III, "Postmodern Pregnancy, Cyborg Birth," Elizabeth Roberts describes both cultural and individual representations of surrogacy. Joseph Dumit and Sylvia Sensiper show how established facts about dangerous problems (the drug DES) are dependent on the prosthetics of publishing (doctors' handbooks and popular pregnancy guides). Elizabeth Cartwright analyzes mother and monitor as the cyborgs of technobirth. And Robbie Davis-Floyd offers a retrospective on sixteen years of birth research, struggling with the

paradigmatic dilemmas posed by her personal engagements with cyborg anthropology and with the resistance to the cyborgification of birth embodied by the midwives and homebirthers with whom she is ideologically aligned.

The chapters in Part IV investigate the reproduction of culture in the raising of cyborg babies, through developmental narratives (Croissant), the playing and living out of computer games (Ito and Turkle), and the curious blend of the organic and the cyborgian that characterizes some elements of Pagan culture (Hill). Locating Athena as the first cyborg goddess within the Greek mythos, Anne Hill disarms the struggle between traditional and contemporary. She provocatively shows that for "technopagans," there never was a time before technoscience, only different kinds of it, each needing a holistic approach. Childrearing also involves community knowledge and responsibility. In the end, for Hill, cyborgs are merely a mundane, necessary fact of the world, one that we must get over being upset over or challenged by. The real challenges of birth and childrearing are ones of accepting the responsibility to make informed and holistic decisions that fully address the needs and the capacities of both parents and child.

Each of these chapters traces the often antagonistic themes of embrace and resistance that run through the lives of many men and women in America today. Each works with and against the four notions of cyborgs outlined above. For a postmodern anthropology, the cyborg and the "Earth Mother" alike are intrinsically and equally interesting. The Earth Mother seems a throwback to a romanticized "better than now" earlier age that never really was; the anthropologist analyzes her construction as "better than" against the backdrop of the over-technologization of life. The cyborg seems progressive, exciting, ambiguous—a future-oriented direction for our evolution that both scorns and transcends its earth-based past. And yet we must ask, can our civilization sustain its cyborgian evolution? Will the earth provide us with enough resources to stay this course? Or will we be forced to abandon our high-tech trajectory when we have finally depleted the planet beyond technological redemption? Will what one ecologist calls "the prosperous way down"[5] include the cyborg, or must we ultimately abandon cyborgs as a value in order to survive at all? What are the ethics, the moralities, and the environmental realities that will govern us as we continue to cyborgify ourselves and our world?

Acknowledgments

We wish to express our gratitude to our colleagues and friends who provided support and constructive criticism throughout the long process of getting this book into print, especially Chris Hables Gray, Sarah Franklin, and Sylvia Sensiper. Marlie Wasserman provided the initial burst of enthusiasm for this project at Routledge, and since then, Bill Germano and Alex Giardino have kept us on track, and Lai Moy has seen the work through to produc-

tion. Joe's work was supported in part by grants from the Smithsonian Institution, the National Museum of American History, the National Institute of Mental Health Postdoctoral Fellowship Program, and the Department of Social Medicine at Harvard Medical School. Robbie's work has been supported in part by the WennerGren Foundation for Anthropological Research.

Notes

1 Terms like technoscience, technoculture (Penley and Ross 1991), and biomedicine refer to the reconfiguration of science, technology, and medicine in the era of biotechnology and the new reproductive technologies, where the distinctions between basic and applied science, between scientific and technological medicine, and between academic and corporate science and medicine are all blurred and increasingly meaningless.

2 The alpha-feto-protein (AFP) blood test screens for neural tube defects and the possible presence of Down's syndrome. Although it cannot provide a definitive diagnosis, because it is safe, easy to administer, and inexpensive, it is increasingly regarded as a cost-effective and viable way to reduce a woman's risk of bearing a disabled child (Browner and Press 1995:309).

3 Portions of this section are excerpted from Davis-Floyd 1992:48–59 and Davis-Floyd 1994.

4 To be sure, birth carries its own set of risks. In societies in which women are malnourished and overworked, rates of both maternal and infant mortality are high. But when women are healthy, well nourished, and receive adequate social support, the percentage of complications in childbirth is very low—well under 10 percent. And the majority of complications that may occur can be screened for in advance. Even the most conservative obstetricians will agree that 90 percent of all pregnancies and births in healthy mothers will be normal and uncomplicated. The problem is that far too often, technomedical interventions are not reserved for the small percentage of births that actually need them; rather, they are performed on most laboring women. By interfering with the normal process of labor, such interventions often generate the very complications they are designed to prevent. (For more information, see Davis-Floyd 1992; Goer 1995; Wagner 1994; Rooks 1997).

5 Robert J. King, personal communication, Austin, Texas, 1995.

References

Balsamo, Ann. 1996. *Technologies of the Gendered Body: Reading Cyborg Women.* Durham: Duke University Press.

Browner, Carole, and Nancy Press. 1995. "The Normalization of Prenatal Diagnostic Testing." In *Conceiving the New World Order: The Global Politics of Reproduction*, edited by Faye Ginsburg and Rayna Rapp, 307–322. Berkeley and London: University of California Press.

———. 1997. "The Production of Authoritative Knowledge in American Prenatal Care." In *Childbirth and Authoritative Knowledge: Cross-Cultural Perspectives*, edited by Robbie Davis-Floyd and Carolyn Sargent. Berkeley: University of California Press.

Casper, Monica. 1995. "Fetal Cyborgs and Technomoms on the Reproductive Frontier: Which Way to the Carnival?" In *The Cyborg Handbook*, edited by Chris Hables Gray. New York: Routledge.

———. n.d. *The Making of the Unborn Patient: A Social Anatomy of Fetal Surgery.* New Brunswick, N. J.: Rutgers University Press, in press.

Clynes, Manfred E., and Nathan S. Kline. 1960. "Cyborgs and Space." *Astronautics.* Reprinted in 1995 in *The Cyborg Handbook*, edited by Chris Hables Gray, 29–33. New York: Routledge.

Corea, Gena. 1985. *The Mother Machine: Reproductive Technologies from Artificial Insemination to Artificial Wombs.* New York: Harper and Row.

―――. 1987. *Man-Made Women: How the New Reproductive Technologies Affect Women.* Bloomington: Indiana University Press.

Cunningham, F. Gary, Paul C. MacDonald, and Norman F. Gant. 1989. *Williams Obstetrics.* 18th ed. Norwalk, Conn.: Appleton and Lange.

Davis-Floyd, Robbie. 1992. *Birth as an American Rite of Passage.* Berkeley: University of California Press.

―――. 1993. "The Technocratic Model of Birth." In *Feminist Theory in the Study of Folklore,* edited by S. Hollis, L. Pershing, and M.J. Young, 297–326. Chicago: University of Illinois Press.

―――. 1994. "The Technocratic Body: American Childbirth as Cultural Expression." *Social Science and Medicine* 38 (8): 1125–1140.

Davis-Floyd, Robbie, and Gloria St. John. 1998. *From Doctor to Healer: The Transformative Journey.* New Brunswick, N.J.: Rutgers University Press.

Downey, Gary Lee and Joseph Dumit, eds. 1997. *Cyborgs and Citadels: Anthropological Interventions in Emerging Sciences and Technologies.* Santa Fe: School of American Research Press (distributed by University of Washington Press, Seattle).

Edwards, Jeannette, Sarah Franklin, Eric Hirsch, Frances Price, and Marilyn Strathern. 1993. *Technologies of Procreation: Kinship in the Age of Assisted Conception.* Manchester and New York: Manchester University Press.

Ehrenreich, Barbara, and Deirdre English. 1973. *Complaints and Disorders: The Sexual Politics of Sickness.* Old Westbury, N.Y.: The Feminist Press.

Ewigman, B. G., G. P. Crane, D. Frederic, F. Frigoletto. M. Lefevre, and the Radius Study Group. 1993. "Effects of Prenatal Ultrasound Screening on Perinatal Outcomes." *New England Journal of Medicine* 329 (12): 821–827.

Franklin, Sarah, and Helena Ragone, eds. 1997. *Reproducing Reproduction: Kinship, Power, and Technological Innovation.* Philadelphia: University of Pennsylvania Press.

Geertz, Clifford. 1973. "The Growth of Culture and the Evolution of Mind." In *The Interpretation of Cultures,* by Clifford Geertz. New York: Basic Books.

Ginsburg, Faye, and Rayna Rapp, eds. 1995. *Conceiving the New World Order: The Global Politics of Reproduction.* Berkeley: University of California Press.

Goer, Henci. 1995. *Obstetric Myths Versus Research Realities: A Guide to Medical Literature.* Westport, Conn.: Bergin & Garvey.

Gordon, James. 1996. *Manifesto for a New Medicine.* Reading, Mass.: Addison-Wesley.

Gray, Chris Hables, ed. with Heidi J. Figueroa-Sarriera and Steven Mentor. 1995. *The Cyborg Handbook.* New York: Routledge.

Haraway, Donna J. 1991a. "A Cyborg Manifesto: Science, Technology, and Socialist-Feminism in the Late Twentieth Century." In *Simians, Cyborgs, and Women: The Reinvention of Nature,* 149–182. New York: Routledge.

―――. 1991b. *Simians, Cyborgs, and Women: The Reinvention of Nature.* New York: Routledge.

Harding, Sandra G. 1986. *Science Question in Feminism.* Ithaca, N.Y.: Cornell University Press.

―――. 1991. *Whose Science? Whose Knowledge? Thinking from Women's Lives.* Ithaca, N.Y.: Cornell University Press.

Harding, Sandra G., and Jean F. O'Barr. 1987. *Sex and Scientific Inquiry.* Chicago: University of Chicago Press.

Hornstein, Francie. 1984. "Children by Donor Insemination: A New Choice for Lesbians." In *Test-Tube Women: What Future for Motherhood?* edited by Rita Arditti, Renate Duelli Klein, and Shelley Minden, 373–381. London: Pandora Press.

Jordan, Brigitte. 1993 [1978]. *Birth in Four Cultures: A Cross-Cultural Investigation of Childbirth*

in Yucatan, Holland, Sweden and the United States. 4th ed. Revised and updated by Robbie Davis-Floyd. Prospect Heights, Ill.: Waveland Press.

Klein, Renate Duelli. 1984. "Doing It Ourselves: Self-Insemination." In *Test-Tube Women: What Future for Motherhood?* edited by Rita Arditti, Renate Duelli Klein, and Shelley Minden, 382–390. London: Pandora Press.

Kramer, Heinrich, and Jacob Sprenger. 1972. "Excerpts from the *Malleus Maleficarum (The Hammer of Witches*, orig. pub. 1486)." In *Witchcraft in Europe 1100–1700: A Documentary History*, edited by Alan C. Kors and Edward Peters. Philadelphia: University of Pennsylvania Press.

Lazarus, Ellen. 1988. "Poor Women, Poor Outcomes: Social Class and Reproductive Health." In *Childbirth in America: Anthropological Perspectives*, edited by Karen Michaelson. South Hadley, Mass.: Bergin & Garvey.

———. 1990. "Falling through the Cracks: Contradictions and Barriers to Care in a Prenatal Clinic." *Medical Anthropology* 12 (3): 269–288.

Leavitt, Judith. 1986. *Brought to Bed: Childbearing in America 1750–1950*. New York: Oxford University Press.

Lewin, Ellen. 1995. "On the Outside Looking In: The Politics of Lesbian Motherhood." In *Conceiving the New World Order: The Global Politics of Reproduction*, edited by Faye Ginsburg and Rayna Rapp, 103–121. Berkeley: University of California Press.

Martin, Emily. 1987. *The Woman in the Body*. Boston: Beacon Press.

———. 1991a. "The Ideology of Reproduction: The Reproduction of Ideology." In *Uncertain Terms: Negotiating Gender in American Society*, edited by Faye Ginsburg and Anna Lowenhaupt Tsing, 300–314. Boston: Beacon Press.

———. 1991b. "The Egg and the Sperm." *Signs* 16 (3): 485–501.

Merchant, Carolyn. 1983. *The Death of Nature: Women, Ecology, and the Scientific Revolution*. San Francisco: Harper and Row.

Newnham, J., S. Evans, C. Michael, F. Stanley, and L. Landau. 1993. "Effects of Frequent Ultrasound during Pregnancy: A Randomized Controlled Trial." *Lancet* 342: 887–891.

Oakley, Ann. 1984. *The Captured Womb: A History of the Medical Care of Pregnant Women*. New York and Oxford: Basil Blackwell.

Penley, Constance, and Andrew Ross, eds. 1991. *Technoculture*. Minneapolis: University of Minnesota Press.

Pritchard, Jack A., and Paul C. MacDonald. 1980. *Williams Obstetrics*. 16th ed. by New York: Appleton-Century-Crofts.

Rapp, Rayna. 1984. "XYLO: A True Story." In *Test-Tube Women*, edited by R. Arditti, R. Klein, and S. Minden, 313–328. Boston: Pandora Press.

———. 1987. "Moral Pioneers: Women, Men, and Fetuses on a Frontier of Reproductive Technology." *Women and Health* 13 (1/2): 101–116. Reprinted in1991 in *Gender at the Crossroads of Knowledge: Feminist Anthropology in the Postmodern Era*, edited by Micaela di Leonardo. Berkeley: University of California Press.

———. 1988. "Chromosomes and Communication: The Discourse of Genetic Counseling." *Medical Anthropology Quarterly* 2 (2): 143–157.

———. 1994. "Women's Responses to Prenatal Diagnosis: A Sociocultural Perspective on Diversity." In *Women and Prenatal Testing: Facing the Challenges of Genetic Technology*, edited by Karen H. Rothenburg and Elizabeth J. Thompson, 219–233. Columbus: Ohio State University Press.

———. 1995. "Risky Business: Genetic Counseling in a Shifting World." In *Articulating Hidden Histories*, edited by Jane Schneider and Rayna Rapp, 75–189. Berkeley: University of California Press.

Reynolds, Peter C. 1991. *Stealing Fire: The Mythology of the Technocracy*. Palo Alto, Calif.: Iconic Anthropology Press.

Ritter, C. A. 1919. "Why Pre-Natal Care?" *American Journal of Gynecology* 70: 531.

Rooks, Judith P. 1997. *Midwifery and Childbirth in America*. Philadelphia: Temple University Press.

Rothman, Barbara Katz. 1982. *In Labor: Women and Power in the Birthplace*. New York: W. W. Norton. Reprinted in 1985 in paperback under the title *Giving Birth: Alternatives in Childbirth*. New York: Penguin Books.

———. 1985. "The Meanings of Choice in Reproductive Technology." In *Test-Tube Women*, edited by Rita Arditti, Renate Duelli Klein, and Shelley Minden. London: Pandora Press.

———. 1986. *Tentative Pregnancy: Prenatal Diagnosis and the Future of Motherhood*. New York: Viking.

———. 1987. "Reproductive Technology and the Commodification of Life." *Women and Health* 13(1/2): 95–100.

———. 1989. *Recreating Motherhood: Ideology and Technology in Patriarchal Society*. New York: W. W. Norton.

Salvesen, K., L. Vatten, et al. 1993. "Routine Ultasonography in Utero and Subsequent Handedness and Neurological Development." *British Medical Journal* 307: 159–164.

Sargent, Carolyn, and Nancy Stark. 1989. "Childbirth Education and Childbirth Models: Parental Perspectives on Control, Anesthesia, and Technological Intervention in the Birth Process." *Medical Anthropology Quarterly* 3 (1): 36–51.

Scully, Diana. 1980. *Men Who Control Women's Health: The Miseducation of Obstetrician-Gynecologists*. Boston: Houghton Mifflin.

Shaw, Nancy Stoller. 1974. *Forced Labor: Maternity Care in the United States*. New York: Pergamon Press.

Smellie, William. 1756. *A Treatise on the Theory and Practice of Midwifery*. 3d ed. London: D. Wilson and T. Durham.

Wagner, Marsden. 1994. *Pursuing the Birth Machine: The Search for Appropriate Perinatal Technology*. London and Sydney: ACE Graphics (U.S. distributor: ICEA Bookcenter, P.O. Box 20048, Minneapolis, Minn. 55420).

Wertz, Dorothy, and Richard Wertz. 1989. *Lying-In: A History of Childbirth in America*, 2d ed. New Haven: Yale University Press.

Weston, Kath. 1991. *Families We Choose: Lesbians, Gays, Kinship*. New York: Columbia University Press.

Cyborg Conceptions

Constructing a "Good Catch," Picking a Winner

The Development of Technosemen and the Deconstruction of the Monolithic Male

Matthew Schmidt and Lisa Jean Moore

Donor insemination (DI), the attempt to impregnate a woman with semen from a donor, can be a relatively simple procedure:[1]

> [Y]ou suck the semen into a needleless hypodermic syringe (some women use an eye dropper or a turkey baster), gently insert the syringe into your vagina while lying flat on your back with your rear up on a pillow, and empty the syringe into your vagina to deposit the semen as close to your cervix as possible. (Boston Women's Health Book Collective 1992:387; see also Federation of Feminist Women's Health Centers 1981)

Information on how women can inseminate themselves is easily accessible. The necessary technology is available in a kitchen. The ease, cost, and accessibility of this procedure create the potential for radical redefinitions of reproductive processes and the social relationships surrounding those processes. A traditional American homemaker's turkey baster can be transformed into a means of independence from patrilineal kinship relations, and new definitions of families can emerge.[2]

Despite the simplicity of this procedure, the semen banking industry has become enormously profitable over the past twenty years. Many semen banks have become subsidiaries of diversified medical services corporations. As fledgling members of the United States medical-industrial complex, semen banks are now diversifying to offer newer and more elaborate reproductive services and technologies. Industry expansion has largely been predicated upon the use of marketing strategies that influence the ways in which potential consumers perceive the processes of reproduction. These marketing

strategies shape emerging discourses over the meaning of reproduction in our society. They portray gender, technology, and the medical community in ways that advance the interests of capital accumulation and may have a substantial impact upon how we choose to procreate. In this chapter we examine the ways in which semen banks use discursive strategies in promotional materials and donor catalogues to construct the semen they sell as technologically superior to "natural" semen. These strategies reify differences among semen donors and contribute to the maintenance of hierarchies among men.

In our first section we briefly outline the emergence of semen banking. Second, we situate semen banking within the United States medical-industrial complex. Third, we discuss the importance of representation in reproductive discourses. Fourth, we explore the means by which semen banks inscribe cyborg identity to their products. Finally, we examine the ways in which such inscriptions portray masculinity and procreation.

■ SPAWNING NEW FRONTIERS: THE HISTORICAL DEVELOPMENT OF ARTIFICIAL INSEMINATION

In 1550, Bartholomeus Eustacius recommended that a husband guide his semen toward his wife's cervix with his finger after intercourse in order to improve the couple's chances of conception (Rohleder 1934). This was the first recorded suggestion in Western medical literature that humans could control their own reproductive capacities through the manipulation of semen. Throughout the sixteenth, seventeenth, and eighteenth centuries various strategies of artificial insemination for fish and livestock were developed with success. The first recorded incidence of mammalian artificial insemination (AI) was in 1742 by Abbe Lazarro Spallanzani. He "injected dog sperm into a female bitch, who sixty-two days later became the mother of 'three little vivacious puppies'" (Finegold 1976). Successful impregnation of women using AI soon followed. By the nineteenth century physicians across Europe and the United States were using this procedure for married couples of the upper and middle classes who were having difficulty reproducing.

The prevalence of donor insemination was low until the early 1960s. Several conditions were important in preventing earlier development of the industry. First, theologians, reproductive scientists, and women concerned with increasing self-control over reproduction were waging war over its morality. Second, demand for the procedure was relatively low. Finally, the technology which would allow for its full exploitation had not yet been developed (see Carter 1983; Finegold 1976). Advancements in cryopreservation techniques during the mid-twentieth century allowed for the indefinite preservation of semen. Commercial bovine semen banking developed rapidly after the introduction of glycerol as a cryopreservative in 1949. However, human

semen banking took a different route. Between 1954 and 1972 a number of human semen banks were established in the United States, all of which were university based and research oriented.

The first commercial human semen bank opened in 1972 (Sherman 1979). Since then, semen banking has become a $164-million-per-year industry in the United States.[3] The rise of semen banking has been predicated upon several important social conditions: (1) control by medical professionals; (2) advances in reproductive technologies; and (3) the expansion of the medical industrial complex (Moore and Schmidt 1998).

The growth of the semen industry is dialectically embedded within multiple contemporary situations. On the broadest level, the medical-industrial complex (Relman 1990; Estes, Harrington, and Davis 1992) has undergone a significant change in the last two decades involving industry growth in competition for patients (Relman 1992), increased investor ownership of medical services (McKinlay and Stoeckle 1990)—referred to as "corporatization" (Starr 1982)—and the exploding advances of biotechnology (Ginzburg 1990). Increasingly complex processes of medicalization have transformed this method of reproduction into an elaborate event, requiring the assistance of multiple actors in the medical industrial complex. Irving Zola (1990:401) locates the growth of medicalization in four processes:

> first, through the expansion of what in life is deemed relevant to the good practice of medicine; secondly, through the retention of absolute control over certain technical procedures; third, through the retention of absolute access to certain "taboo" areas; and finally, through the expansion of what in medicine is deemed relevant to good practice of life.

Semen banks participate in each of these medicalizing processes. The vast majority of semen banks are owned and/or operated by physicians. The expansion of control by physicians over access to the technical processes of donor insemination and the information relevant to its practice has become evident in that many banks refuse to send semen directly to buyers. They will send samples only to physicians—ostensibly so that the client will have the greatest chance at impregnation given the physician's superior knowledge and abilities. Finally, by selecting certain donors and rejecting others, semen banks judge the physical, social, and psychological attributes that will produce semen that will, in turn, increase the chances of impregnation and produce healthier babies.

These trends are situated within a broad economic context of supply and demand. Semen banks must address issues of demand for their products. One method is to expand their consumer base. Another is to increase the number of services and products sold to each customer. Semen banks attempt to do

both in the materials they normally send to prospective consumers. They address the demand of the market by presenting their products in ways familiar to consumers; shopping for donor semen is presented as being similar to shopping for clothing out of a catalogue. In order to increase sales to "hooked" customers, commercial semen banks develop peripheral services and products (semen accessories) and market them as necessary for reducing the risk of producing abnormal or sub-par children. Thus, semen banks attempt to influence consumer demand and increase sales.

Semen banks produce a great deal of written and visual material. These discursive materials are constructed at the intersection of many social worlds, including medicine, genetics, biology, law, ethics, and marketing. Semen bank promotional materials reveal the values and ideologies of those involved in their production. Linda Singer (1993:38) notes that:

> Advertising depends on marketing, which is the science of constructing, dividing, targeting, and mobilizing consumers. Marketing entails the transformation of an audience from one of potential to actual consumer. This is accomplished through a series of interrelated strategies, most saliently, market segmenting and establishing tactical specificity, which involves recognizing, producing, and proliferating differentiated needs in the services of profitability.

But not everyone approves of how semen banks transform browsers into consumers and semen banking into a highly profitable means of capital accumulation.

While many semen banks are being assimilated into corporate structures, others are maintaining their independent, noncorporate, non-university-based status. Some semen banks cater only to married women, others sell mail-order semen to single women and lesbians. Some banks offer a full line of reproductive services including IVF, GIFT, and genetic counseling; others simply sell semen. This diversity should not be overemphasized; all but one of the banks we sampled were for-profit ventures, 31 percent offered reproductive services in addition to semen, and more than 50 percent would send semen samples only to a physician.

A number of feminist researchers have made important critiques of semen banking practices as battlegrounds for social struggles between men and women (Wikler and Wikler 1991; Corea 1985). Little attention has been given to how these practices may affect relations of power among men. We argue that discursive practices used by semen banks to sell products construct differences and hierarchies among men and support the perpetuation of hegemonic forms of masculinity (on hegemonic masculinity, see Connell 1987).

Organizations specializing in reproductive products and services are often self-protective and suspicious of outsiders requesting access to information.[4] Tabloid accounts of the semen bank industry have further encouraged semen banks to step up their organizational gatekeeping. We have sidestepped the industry's resistance to scrutiny by analyzing preexisting, publicly available materials.

An accurate listing of the industry is impossible because semen banks are not highly regulated by any federal governmental agency.[5] The American Association of Tissue Banks (AATB) is currently the only accreditation agency that compiles a major listing of tissue banks; we selected our sample from its listing. But not all banks belong to the AATB.

Requests for promotional materials were mailed to all forty-six listed AATB agencies. Thirty-five of these semen banks responded (76 percent). We carefully reviewed each set of materials and analyzed them for common themes and variance. From these thirty-five, we chose a purposive sample of seven banks' materials for in-depth analysis using content analysis and grounded theory (Glaser and Strauss 1967; Strauss 1987; Strauss and Corbin 1990).

■ DOWNLOADING A DREAM DADDY: TECHNOSEMEN AND
 THE CONSTRUCTION OF MALE DIFFERENCES

In this section, we explore two aspects of the semen enterprise. First, semen banks represent their products as being of superior quality. We define this new, improved semen as *technosemen* and investigate its manufacture and representation. Second, we examine two important outcomes of representing technosemen for sale. These are (1) the deconstruction of a monolithic male and the ensuing production of hegemonic masculinities; and (2) the construction of donor semen as cyborg.

Technosemen

From a semen bank's promotional materials:

We believe that the quality and safety of the individual specimen must take precedence over all other considerations, therefore, this program is guided by the following principles:

SAFETY Systematic, mandatory testing aims to insure pathogen-free specimens;

CARE Patient-oriented communication meets the complex concerns of recipients and helps achieve satisfactory donor matching;

SUCCESS The selection process is specifically designed to include only those donors whose specimens exhibit a high likelihood of fertility through frozen/thawed techniques.

We define *technosemen* as the "new and improved" bodily product that semen banks advertise to clients through their informational pamphlets. Technosemen is the result of technologically based semen analysis and manipulation. Technological manipulation of semen is carefully presented to potential clients and described in great detail by each bank. For instance, semen analysis includes sperm counts, morphology, motility testing, functional testing (including the hamster penetration assay), and sperm washing ranging from the swim-up methods to percoll or the two-step simple wash. Sperm counts involve taking a small sample of semen from a donor and counting the number of viable sperm to determine the overall amount. Sperm counts may involve conducting morphology (shape assessment) and motility (movement assessment) tests as well. Computer assisted semen analysis (CASA)—which uses digital computer imaging devices connected to microscopes—is now available to conduct all of these tests. This technology has spurred the development of a new language for semen analysis; technicians can now measure the velocity, linearity, and wobble of sperm movements (Shanis, Check, and Bollendorf et al. 1991). Each of these new measures is represented as being highly correlated with semen fertility. Morphology testing may be done using electron microscopy; the resultant "spermprints" give fertility technicians another means of assessing sperm health.

In addition to these diagnostic tests, postcoital functionality tests are conducted to determine the fertility of semen samples. The hamster penetration assay uses hamster eggs to determine if semen is capable of penetrating an egg. Semen antibody testing is common. Often infertility is blamed upon immune reactions to semen from either seminal fluid or cervical mucous. Antibody testing is done to determine the reaction of sperm to these fluids.

Donors and semen samples routinely undergo disease and genetic testing. Semen is cultured for sexually transmitted diseases such as gonorrhea, chlamydia, and gardnerella. Microscopic analysis reveals any white or red blood cells in specimens. Donors are screened for genetic markers to Tay-Sachs disease and sickle-cell anemia. Donors are also screened for blood type, hepatitis, syphilis, HIV, CMV, and HTLV-1. Semen banks quarantine semen for six months so that donors can be retested for HIV infection.

Donor semen which passes these diagnostic and function tests is eligible for functionality enhancement by a variety of techniques. Sperm washing is sometimes recommended to consumers if physicians have determined that

they have "abnormal" or "hostile" cervical environments (semen bank publication). Each type of wash method is conducted in a laboratory. The "swim-up method" involves centrifuging the semen sample, removing the seminal fluid, and placing the remaining sperm pellet in an artificial insemination medium. After an hour, the most motile and active semen which "swim" to the top of the solution are retained. Percoll washing involves layering the semen with percoll (a solution to "clean" semen) and centrifuging for thirty minutes. In addition to increasing the motility of semen samples, percoll washing reduces the amount of seminal bacteria in each sample and may reduce the number of sperm with genetic defects. After washing, various performance-enhancing media can be added to sperm. Caffeine can be added to increase motility. A fluid marketed as Sperm Select™ is more viscous than cervical mucous and can allow sperm to swim more easily after insemination. Finally, many banks are now offering pre-sex selection services. A variation of the swim-up method of sperm washing can be used to increase the number of either X or Y chromosome-bearing sperm in each sample, thus, theoretically, increasing the chances that resulting children will be either female or male. The effectiveness of this procedure is a matter of great debate in the reproductive sciences (see Edwards and Brody 1995).

Semen analysis, disease testing, and manipulation together create and constitute technosemen. Marketing technosemen can increase demand in the semen market by convincing or, better yet, guaranteeing the general public that technosemen is fertile, uncontaminated, and genetically "engineered" for desirable traits. In this age of AIDS, geneticism, and environmental disasters, semen banks can capitalize on the promise these technological procedures offer, thus increasing their revenues. In so doing, semen banks reinforce and bolster public concern about these material threats to the future of the human race. The processes by which technosemen are produced and advertised to consumers are deeply connected with how the "contents" of the semen are represented in promotional materials.

In "The Materiality of Informatics," N. Katherine Hayles (1992) discusses how the body simultaneously produces and is produced by culture. Hayles posits that through a perception feedback loop characteristic of the late twentieth century, the body becomes "dematerialized." In other words, our means of perceiving the body and embodied experiences are dramatically changing through applications of technologies such as those employed in creating virtual reality or Internet chat rooms. Our experiences of familiar bodily responses (sensations and corporeality) become disengaged from our subjectivity. One method of bodily dematerialization is the attachment of discursive inscriptions to bodily products, like semen. This transformation of bodily fluids into discourses disciplines the ways in which people act and perceive bodies.

Automated laboratory machines turn semen into technosemen. These machines assist in what Hayles might call decreasing the friction of spermatic materiality. Semen becomes inscribed as malleable. Prior to the development of this technology the physiological character of semen was perceived as much less controllable. Once the genetic code was finally cracked, the manipulation of semen was largely viewed as the manipulation of genetic information. Now through the use of new reproductive technologies, semen can be tailored to fit consumer demand (Clarke 1995). Semen banks utilize promotional materials that articulate, both explicitly and implicitly, inscribed ideologies based on genetic, eugenic, medical, and other bioscientific discourses. These inscriptions portray malleable semen as highly desirable to consumers.

■ BODIES OF WRITING: GENDER, RACE, AND THE CONSTRUCTION OF CORPO(REALITY)

In her well-known essay "The Egg and the Sperm: How Science Has Constructed a Romance Based on Stereotypical Male-Female Roles," Emily Martin (1991) deconstructs reproductive stories about male and female gametes—cells—in scientific textbooks. She suggests they are tropes that reveal cultural beliefs and practices. Martin (1991:500) is concerned about "keeping alive some of the hoariest old stereotypes about weak damsels in distress and their strong male rescuers." Throughout her analysis, we learn how cells become performers acting out heterosexist fantasies/realities of patriarchal culture; for instance, she (1991:499) cites examples of sperm being personified as going on a "perilous journey" and being "survivors" where the egg is seen as "the prize." Martin's (1991:501) work implores us to investigate the sites of such gendered constructions of biological functions: "More crucial, then, than what kinds of personalities we are bestowing on cells is the very fact that we are doing it at all. This process could ultimately have the most disturbing social consequences." What happens in this process of giving personality to biological objects, according to Martin and others cited above, is that we naturalize socially, materially, and bodily experienced, but nonetheless constructed, gender inequities.

In Nancy Stepan's (1986) work, analogy and metaphor in science become naturalizing lenses through which social situations are brought into focus. In her words (Stepan 1986:274),

> because a metaphor or an analogy does not directly present a pre-existing nature but instead helps "construct" that nature, the metaphor generates data that conform to it, so that nature is seen via the metaphor and the metaphor becomes part of the logic of science itself.

Stepan implies that those who do science are culpable participants in processual obfuscation of material conditions through linguistic manipulation (see Latour and Woolgar 1987).

Both Martin's and Stepan's discussions attend to ways in which difference is constructed through reference to the body. Those who participate in the semen enterprise draw deeply on such cultural metaphors of the body to construct spermatic difference and to create the body and body fluids as incontestable (because of their material reality) sites of true difference.

Semen banks engage in a process of difference naturalization. Constructions of embodied differences among donors are inscribed in semen catalogues. Since catalogue listings refer to specific vials of semen, the semen itself is inscribed with these same differences. For example, there are many shades of skin and varied biographies of people we call "African American"; nevertheless the semen becomes "the African American man with a GPA of 3.2 with interests in sports and music." The commodification of race, through the advertisement practices and discursive constructions, reifies differences between men. In using the metaphor of "African American" or, more commonly, "black" to describe the donor, semen banks not only deny differences among variously colored men but also are constructing differences between these groups and other men. This metaphor reifies absolute differences between "the blacks" and "the whites." Within the semen banks' donor catalogue conventions, the metaphors are taken literally (as often occurs in everyday life), supporting Stepan's claim that "they (the metaphors) tend to lose their metaphorical nature and to be taken seriously" (1986:275).[6]

Discourse Templates

What are the consequences of semen bank promotional materials on corporeality? In one sense, semen banks dematerialize the body in the perception feedback loop. Body parts are turned into discursive statements, labels, and metaphors in the donor catalogue. For instance, one catalog reads:

Donor ID	Race/Ethnic Origin	Hair	Eyes	Ht./Wt.
OO1	Black/Creole	Dk Br	Br	6-1/180

Blood	Skin	Yrs. College	Occupation/Major	Special Interests
A+	Med	1	Theater Arts/Drama	Comedy, Boxing, Guitar

On one hand, the body of the donor becomes encoded into phenotypic, sociogenetic information. On the other hand, this dematerialization is not complete because semen is part of the body. The site of inscription is recast in the semen that represents a concentrated body, paralleling other liquids from concentrate. Semen banks market the chance to rematerialize, reconstitute, and reproduce the body of the donor. This chance to rematerialize is present-

ed to the client through discursive statements about the donor. Extending Hayles's argument, semen banks complexify the process of de/rematerialization of the body. Semen is simultaneously a part of the body, a potential body, and, as represented in a donor catalogue, a series of codes.

Semen banks inscribe semen using *discourse templates*. These are modes of representing information that have become routinized and appear in specific types of information presentations. Discourse templates organize novel or exotic information in ways that are highly familiar to an audience. Such templates may traditionally have been used to present other types of information. Templates allow for quick selections among many similar choices. Joel Best (1991) has observed that these templates may create hegemonic dominance over definitions of certain social phenomena.

Semen banks usually choose one or two common discourse templates that may be familiar to their clients, such as personal ads or charts. These templates create comfort zones and mitigate the strangeness of the new market. Consider the personal advertisement template. The conventions of personal ads include abbreviations and brief descriptive narratives like those used to meet people in the personals of newspapers. Donors are introduced in paragraphs, without names. Limited information is presented; more detailed information is available for additional cost. For example:

> He has wavy dark brown hair and eyes. He's 5' 10" tall and weighs 156 lbs. on a medium frame. His complexion is fair to medium. His ancestry is Eastern European. His blood type is A+. He is currently studying law with a GPA of 3.4. Other interests include music, classical and rock. He also enjoys tennis, cars, ice-skating and juggling.

> He has black hair, wavy, with dark brown eyes and a fair complexion. He's 5' 10" tall and weighs 145 lbs. on a small to medium frame. He is a student majoring in electrical engineering with a GPA of 3.0. His blood type is O positive. His ancestry is Chinese. His interests include racquetball and tennis. He also plays the piano, clarinet, French horn and percussion instruments.

The discourse template of personal ads thus encourages the client to think of semen purchasing as akin to a dating game; will they choose sperm number one, sperm number two, or lucky sperm number three? Compatibility and socially desirable properties such as evidence of upward mobility, intelligence, and social integration are portrayed as important in choosing the right semen. Efforts are clearly made to convince the woman that she is choosing a man rather than sticky, wriggly, little cells. Sperm may be disembodied, but they are vividly personified.

These templates provide a method of quick and easy rational comparison

among many different entries and products. The buyer has the opportunity to choose both attractive semen (which through comparison of phenotypic characteristics will produce an aesthetically pleasing child) and successful semen (which through comparison of social and psychological traits will produce a child who is a winner). The banks use donor catalogues as a means of creating reproductive dominance through the construction of male differences.

Three types of information are highlighted by semen banks; they serve as ways to easily segment the market, but they also do much more. Semen banks prioritize differences believed important to the client through the ordering of the characteristics of donors. These characteristics include (1) race/ethnic origin; (2) social characteristics; and (3) characteristics of social and physical power.

(1) Race/ethnic origin is always the first category presented; several personal ad-type lists are sectioned according to race. Race is thereby created as the primary choice. One bank even stores its semen in vials that are color-coded according to the race of the donor—white vials for Caucasian, black vials for African American, yellow vials for Asian American, and red vials for everyone else. Differences are thus visually reified and metaphorically stereotyped through these vials. Semen from donors with mixed racial and ethnic backgrounds is grouped as (the) Other and colored red (which suggests to us the mythic themes of the color red: revolutionaries, communists, Native Americans, redskins, enemies, emergencies). However, it is not clear that any racial group is presented as more desirable by semen banks. Most semen banks market semen from donors with a wide variety of racial and ethnic backgrounds. Anecdotal evidence suggests that most consumers prefer to buy semen from donors with similar racial characteristics to their own. Thus, presenting any one racial group or groups as more desirable than others could prove costly to the bottom line.

(2) Social characteristics are usually listed toward the end of each entry. Although they are not given as much significance as phenotypic characteristics, they are presented as consequentially creating differences in semen. These differences imply that semen may be qualitatively different because of the donor's personal history. For example, a donor who likes to run, swim, and read may culturally indicate healthier semen than a donor who smokes, rides a motorcycle, and juggles. The "scientifically disproven" Lamarckian assumption of the inheritance of acquired characteristics is both re-created and sustained in these catalogues.

(3) In addition, these categories of differences among men are fundamentally based on strata of both social and physical power. Categories of height, weight, body build, and favorite sport provide consumers with indicators of the donor's health and ability to be physically dominant. Categories of occupation, grade point average, and years of college provide indicators of social

survivability and social dominance. Donors who do not rate highly within these categories are not included in these catalogues, nor presumably is their semen stored in banks as sellable inventory.

Thus, these categories tend to reify power differences among and between men. A hegemonic masculinity is created and reinforced. Carrigan, Connell, and Lee (1985:92) have defined hegemonic masculinity as "a question of how particular groups of men inhabit positions of power and wealth, and how they legitimate and reproduce the social relationships that generate their dominance." Using this definition, Mike Donaldson (1993:655) has argued that "the view that hegemonic masculinity is hegemonic, in so far as it succeeds, in relation to women is true, but partial." Donaldson argues that within such a system of masculinity, one of the defining characteristics is control by a very few men over a great many men and women.

While the call has been made in masculinity studies to deconstruct the monolithic male, we have found that this deconstruction and the pursuant construction of differences among men may itself then involve the perpetuation of hegemonic masculinity rather than its demise. Connell (1987) has suggested that masculinity expresses itself in authoritarian ways through fatherhood. Owners and operators of semen banks are overwhelmingly men and take on the role of surrogate fathers in the reproductive process. In so doing, they have the power to determine who may be a donor and who may not, which social and genetic characteristics should be embodied within the semen they sell, and what the social relations of donors will be to the children produced with their donations. Our research suggests that semen banks are indeed wielding this power to prevent certain types of men from participating in semen donation. We are not suggesting that the semen banking industry is solely responsible for this situation. To a certain extent consumer demand limits the ability of banks to offer a wider selection of donors. Joanna Scheib (1994) has found that women purchasing semen in Australia tend to prefer donors with superior health and social skills. However, semen banks reinforce this desire, limit the categories across which women may choose donors, and construct hierarchies from categories previously unknown to consumers, e.g., sperm motility. While semen banks have the potential to radically open up control to women over their own bodies, to assist in the proliferation of heterogeneous family structures, and to provide men with alternative means for participating in the reproductive process, such promises are arguably being significantly compromised by relations of masculinity within the industry such as those described here.

The construction of technosemen has consequences for the understanding of semen ontology and how semen is inscribed as cyborg.

We have used our research to discover the political economy of semen banking. We have shown how the material as well as discursive construction of technosemen plays an important part in the political economy of the semen banking industry. Technosemen is not only a product that promises increased fertility to its consumers, it is the material that provides fecundity to a growing young industry. Out of technosemen a new semen ontology has emerged. At once inscribed with human characteristics provided by donors and superhuman characteristics provided by technological manipulation, semen becomes technosemen, bodily fluid becomes cyborg.[7]

Semen banks anthropomorphize the semen they sell across many different dimensions. Through discourse templates, semen is inscribed as embodied, socialized, racialized, and gendered. Some banks use other means to highlight the human characteristics of their semen. One bank prints a cartoon of sperm on the front of their informational pamphlet. Sperm in this image are shown with human facial characteristics, smiling, waving hello, and wrapped in scarfs to protect them from the chilling cold of liquid nitrogen. Here sperm are portrayed as emotional, friendly, communicative, and using tools. In one sense, the human body itself becomes a discourse template in an attempt to make the banking experience "user-friendly."

Semen banks simultaneously reinforce certain cyborg characteristics of semen. Semen is portrayed as encoded, disciplined by technology, and superior in potency to unprocessed semen. The construction of this cyborg ontology is an integral part of semen bank marketing. It allows banks to make claims about the potency of their products, while at the same time making claims as to the "naturalness" of new reproductive technologies. These constructions suggest that new reproductive technologies are not unnatural but rather an improvement upon the inherent unpredictability of natural procreation. As Hermann Rohleder, one of the first physicians to write extensively about reproductive technology, claimed, "[A]rtificial fecundation is not an unnatural method because it is scientifically founded . . ." (Rohleder 1934:142).

One consequence of this cyborgization is that semen banks are able to construct a discourse of reproductive risk, capitalizing upon consumers' concerns about the risks of producing defective children. "Natural" unprocessed semen is described as irrational, dirty, and unpredictable. For example, semen banks emphasize that unprocessed semen can produce genetic defects, cause STDs, and fail to get to the egg. What semen banks are selling is the ability to control risk and to harness the agency of semen in order to coerce it to act more rationally. This is more sellable to the consumer. As with

the technologies of childbirth (see Cartwright, this volume), creating and perpetuating a discourse of risk is a marketing strategy used to encourage the consumers to invest in technosemen. This discourse is beginning to proliferate among various medical and scientific worlds. For example, a recent article in the journal *Nature* reports the research of a zoologist from the University of British Columbia who claims that males are the weak link of our species. She finds that sperm are more likely to create genetic "disasters" than eggs. Her research suggests that it would be less perilous for women and their offspring to be able to reproduce without men or to seek out younger mates who produce fewer genetic deformities in their semen. Although semen banks have not (to our knowledge) capitalized on this particular research, claims such as these enhance the semen banks' ability to market their products and services. Semen banks construct technosemen as less risky to consumers, as being able to create better children, taller, smarter, and more musical, than those produced by "natural" semen.

The development of this discourse of reproductive risk means that technosemen is represented as less an option than an imperative. It becomes a necessary element in conception because it is the product of a process which weeds out unwanted semen (and donors) and creates a superfertile substance. Only some semen is good enough to be made cyborg; thus at its very essence technosemen is divisive. Only elite semen samples are allowed to undergo the disciplining processes of new reproductive technologies. Through the construction of semen as cyborg, hierarchies of potency are established across categories of men.

However, creating a new cyborg ontology establishes the potential for a new geometry of social relations that is non-dichotomous and non-hierarchical (Haraway 1989, 1995). By restructuring the ways in which technosemen is created, both discursively and technologically, the politics of the semen enterprise become potentially liberatory. Strategies that semen banks use to reduce the stigma and strangeness of semen banking, e.g., employing discourse templates for product presentation, could be used to open up a diversity of reproductive possibilities for both men and women. Instead of the ranking of semen and men according to characteristics that represent hegemonic forms of social and physical power, all men would be eligible to participate in semen donation. Rather than excluding the semen of men who do not rank highly across categories of power, new technologies would be used to empower the semen of all men, especially those with fertility problems. However, semen banking has not thus far lived up to this potential. Draper (1993) has explored how the construction of risk works to create a hegemony of corporate control, culturally privileges certain actors, and reinforces stratified social relations based upon inequities. Technosemen has had its cyborg ontology

constructed within a web of related interests that utilize a discourse of risk to enhance profits, bolster professional medical dominance over reproduction, and maintain hegemonic forms of masculinity.

■ IMPLICATIONS

We conclude by highlighting three significant issues raised by our analysis. First, semen banking is reconstructing the moral terrain of reproduction. If indeed it becomes the reproductive wave of the future, whose privilege or responsibility will it be to procure, use, and invest in such "healthy" semen? More specifically, what are the implications of this technology and the configuration of the industry for women, men, and couples? Since access to these technologies is still limited by its cost, will women, men, and couples who are unable to gain access to semen bank services come under increasing moral scrutiny for failing to reproduce appropriately?

Second, what was once a not-for-profit, informal, altruistic service largely available through medical school clinics has been transformed into a for-profit medical industry, largely outside of the new managed care medical-industrial complex. What are the implications for the social organization of reproduction? Is privatization of costs the new trend that will be sustained? Will children produced via such methods and their parents be further privileged in terms of access to insurance coverage because of assumed healthier outcomes?

Finally, feminists need to consider and explore other sites where the construction of male difference occurs. As we have demonstrated, even though men are often portrayed as benefiting as a group from the medicalization of reproduction, feminists must develop more sophisticated analyses of late capitalist technologies that diversify embodied genders. There is not one straw man in late capitalism, there are many. "[C]apital has fallen in love with difference" (Clarke 1995:146). In addition, men are differentiated across strata related to power and dominance by capitalist enterprises as a means of expanding markets and increasing profits. This process has a twofold effect, both contributing to the reproduction of existing gender discourses by advancing claims of superiority about men's phenotypical, biological, and social characteristics and altering the conditions of men's reproductive capacities. As semen banks begin to compete for customers, they may limit semen collection to men who rate more strongly across these types of categories. Thus, they may limit the abilities of large numbers of men to participate in these alternative modes of procreation. How semen banks broker their commodities is both shaped by how we think about men and, in turn, influences and is constitutive of our future understandings of men.

Notes

1 An earlier version of this paper was presented at the Society for the Social Studies of Science conference, New Orleans, October 1994. We greatly appreciate the feedback we received from conference participants. We would also like to thank the following individuals for their helpful comments: Monica Casper, Adele Clarke, Robbie Davis-Floyd, Joe Dumit, Paul Josephson, Virginia Olesen, Ariadne Sacharoff, Marise Phillips, and Barbara Raboy.

2 Leigh Star once attempted to discuss turkey basters during a talk in Europe and eventually had to draw the implement as turkeys there are rare and small, not requiring the technology Americans typically use (personal communication, 1994).

3 This is an Office of Technology Assessment statistic from 1992. The office discontinued research on the semen industry, and to date we know of no national organization currently collecting data on semen banking. The OTA itself has been discontinued.

4 See Hammersley and Atkinson 1983 for discussion on gatekeeping.

5 Representative sampling from such "hidden" populations is often time-consuming and costly, and generally yields insufficient results (Fowler 1983).

6 We argue in an upcoming paper (Moore and Schmidt, 1998) that investigating, analyzing, and understanding the construction of difference among men is a crucial yet ignored arena of feminist work. As Sandra Harding (1991:286) suggests,

> women cannot be the unique generators of feminist knowledge. Women cannot claim this ability to be uniquely theirs, and men must not be permitted to refuse to try to produce fully feminist analyses on the grounds that they are not women. Men too must contribute distinctive forms of specifically feminist knowledge from and about their particular social situation.

However, a number of industries are making a profit by constructing male diversity (Chapman and Rutherford 1988; Ash and Wilson 1992). Feminists need to consider how economic forces create new spaces for male hierarchical differences to emerge. These spaces become sites of knowledge production about men. Socially, in our everyday lives we experience men as different from one another. Instead of the perpetuating of the dematerialization of men's corporeality through the knowledge produced by researchers, the lived experience of embodied difference must be incorporated into their own theories. In so doing, we reveal the invisible Man about whom feminists have spoken for so many years and see that He is really plural, many "he's" (Brod and Kaufman 1994).

7 Chris Hables Gray, Steve Mentor, and Heidi Figueroa-Sarriera (1995) have noted that the definition of cyborg is not widely agreed upon. We define *cyborg* as they do: "Cyborg. Cybernetic-organism. The melding of the organic and the machine, or the engineering of a union between separate organic systems. . . ." These authors further explain that, "[c]yborg society also refers to the full range of intimate organic machine relations." We define technosemen as cyborg for two reasons: (1) to describe the intimate relations between semen and reproductive technology through which the physical properties of semen are altered; and (2) to describe new forms of social relations which may emerge when technosemen is made available to consumers.

References

Ash, Juliet, and Elizabeth Wilson, eds. 1992. *Chic Thrills: A Fashion Reader*. Berkeley: University of California Press.

Barratt, Christopher, Mayur Chauhan, and Ian Cooke. 1990. "Donor Insemination: A Look to the Future." *Fertility and Sterility* 54 (3): 375–387.

Best, Joel. 1991. "'Road Warriors' on 'Hair-Trigger Highways': Cultural Resources and the Media's Construction of the 1987 Freeway Shootings Problem." *Sociological Inquiry* 61 (3): 327–345.

Boston Women's Health Book Collective. 1992. *The New Our Bodies, Ourselves*. New York: Touchstone.

Brod, Harry, and Michael Kaufman. 1994. "Introduction." In *Theorizing Masculinities*, edited by Harry Brod and Michael Kaufman. Thousand Oaks, Calif.: Sage.

Carrigan, Tim, Bob Connell, and John Lee. 1985. "Toward a New Sociology of Masculinity." *Theory and Society* 14 (5): 551–604.

Carter, C. O. 1983. *Developments in Reproduction and their Eugenic and Ethical Implications*. London: Academic Press.

Chapman, Rowena, and Jonathan Rutherford. 1988. *Male Order: Unwrapping Masculinity*. London: Lawrence and Wishart.

Clarke, Adele. 1995. "Modernity, Postmodernity and Reproductive Processes 1890–Present, or 'Mommy, Where do Cyborgs Come From Anyway?'" In *The Cyborg Handbook*, edited by Chris Hables Gray. New York: Routledge.

Cockburn, Cynthia. 1993. "Feminism/Constructivism in Technology Studies: Notes on Genealogy and Recent Developments." In *European Theoretical Perspectives on New Technology: Feminism, Constructivism, and Utility*. Crict, England: Brunell University.

Connell, Robert W. 1987. *Gender and Power*. Stanford: Stanford University Press.

Corea, Gena. 1985. *The Mother Machine: Reproductive Technologies from Artificial Insemination to Artificial Wombs*. New York: Harper and Row.

Donaldson, Mike. 1993. "What Is Hegemonic Masculinity." *Theory and Society* 22: 643–657.

Draper, E. 1993. "Fetal Exclusion Policies and Gendered Constructions of Suitable Work." *Social Problems* 40 (1): 90–107.

Duster, Troy. 1990. *Backdoor to Eugenics*. New York: Routledge.

Edwards, Robert G., and Steven A. Brody. 1995. *Principles and Practices of Assisted Human Reproduction*. Philadelphia: W. B. Saunders.

Estes, Carroll, Charlene Harrington, and S. Davis. 1992. "Medical Industrial Complex." In *Encyclopedia of Sociology* vol. 3, edited by E. Borgatta, and M. Borgatta, 1243–1254. New York: MacMillan.

Federation of Feminist Women's Health Centers. 1981. *A New View of the Women's Body*. New York: Touchstone.

Finegold, Wilfred J. 1976. *Artificial Insemination*. 2d ed. Springfield, Ill.: Thomas.

Food and Drug Administration. 1992. *Federal Register* 57 (213): Nov. 3.

Fowler, Floyd J. 1983. *Survey Research Methods*. Beverly Hills, Calif.: Sage.

Ginzburg, E. 1990. "High Tech Medicine and Rising Health Care Costs." *Journal of the American Medical Association* 263: 20–22.

Glaser, Barney. 1978. *Theoretical Sensitivity*. Mill Valley, Calif.: Sociology Press.

Glaser, Barney, and Anselm Strauss. 1967. *The Discovery of Grounded Theory*. Chicago: Aldine.

Gray, Chris Hables, Steve Mentor, and Heidi J. Figueroa-Sarriera. 1995. "Cyborgology: Constructing the Knowledge of Cybernetic Organisms." In *The Cyborg Handbook* edited by Chris Hables Gray. New York: Routledge.

Hammersley, Martyn, and Paul Atkinson. 1983. *Ethnography: Principles in Practice*. New York: Routledge.

Haraway, Donna J. 1989. "A Cyborg Manifesto: Science, Technology, and Socialist Feminism in the Late Twentieth Century." In *Simians, Cyborgs, and Women: The Reinvention of Nature*. New York: Routledge.

———. 1995. "Cyborgs and Symbiants: Living Together in the New World Order." In *The Cyborg Handbook*, edited by Chris Hables Gray. New York: Routledge.

Harding, Sandra. 1991. *Whose Science? Whose Knowledge?* Ithaca, N.Y.: Cornell University Press.

Hayles, N. Katherine. 1992. "The Materiality of Informatics." *Configurations* 1 (1): 147–170.

Hochschild, Arlie. 1989. *The Second Shift*. New York: Avon.

Laqueur, Thomas. 1990. *Making Sex: Body and Gender from the Greeks to Freud*. Cambridge: Harvard University Press.

Latour, Bruno, and Steven Woolgar. 1987. *Laboratory Life: The Social Construction of Scientific Facts*. Princeton: Princeton University Press.

Martin, Emily. 1991. "The Egg and the Sperm: How Science Has Constructed a Romance Based on Stereotypical Male-Female Roles." *Signs* 16 (3): 485–501.

McKinlay, John, and John Stoeckle. 1990. "Corporatization and the Social Transformation of Doctoring." In *The Sociology of Health and Illness: Critical Perspectives*, edited by Peter Conrad and Rochelle Kern. New York: St. Martin's Press.

Moore, Lisa Jean, and Matthew Schmidt. 1998. "On the Construction of Male Differences: Marketing Variations in Technosemen." *Masculinities*, in press.

Olson, John. 1979. "Present Status of AIDS and Sperm Banks in the United States." In *Human Artificial Insemination and Semen Preservation*, edited by David George and Wendel Price. Paris: International Symposium on Artificial Insemination and Semen Preservation.

Oudshoorn, Nelly. 1994. *Beyond the Natural Body: An Archeology of Sex Hormones*. London: Routledge.

Oudshoorn, Nelly, and Marianne Van Den Wijngaard. 1991. "Dualism in Biology: The Case of Sex Hormones." *Women's Studies International Forum* 14 (5): 459–471.

Relman, Arnold. 1990. "The New Medical-Industrial Complex." In *The Sociology of Health and Illness: Critical Perspectives*. 3d ed. Edited by Peter Conrad and Rochelle Kern. New York: St. Martin's Press.

———. 1992. "What Market Values Are Doing to Medicine." *The Atlantic Monthly*, March: 99–106.

Rohleder, Hermann. 1934. *Test Tube Babies: A History of the Artificial Impregnation of Human Beings*. New York: Panurge Press.

Scheib, Joanna. 1994. "Sperm Donor Selection and the Psychology of Female Mate Choice." *Ethology and Sociobiology* 15 (3): 113–129.

Schiebinger, Londa. 1989. *The Mind Has No Sex? Women in the Origins of Modern Science*. Cambridge: Harvard University Press.

Shanis, B. S., J. H. Check, and A. Bollendorf, et al. 1991. "Basic and Computer-Assisted Semen Analysis: Methods and Pitfalls." In *Assisted Human Reproductive Technology*, edited by Elsayed Saad Eldin Hafez. New York: Hemisphere Publishing Corporation.

Sherman, Jerome K. 1979. "Historical Synopsis of Human Semen Preservation." In *Human Artificial Insemination and Semen Preservation*, edited by George David and Wendel Price. Paris: International Symposium on Artificial Insemination and Semen Preservation.

Singer, Linda. 1993. *Erotic Welfare: Sexual Theory and Politics in the Age of Epidemic*. New York: Routledge.

Starr, Paul. 1982. *The Social Transformation of American Medicine*. New York: Basic Books.

Stepan, Nancy. 1986. "Race and Gender: The Role of Analogy in Science." *Isis* 77: 261– 277.

Strauss, Anselm. 1987. *Qualitative Analysis for Social Scientists*. New York: Cambridge University Press.

Strauss, Anselm, and Juliet Corbin. 1990. *Basics of Qualitative Research*. Newbury Park, Calif.: Sage.

Terry, Jennifer. 1990. "Lesbians under the Medical Gaze: Scientists Search for Remarkable Differences." *The Journal of Sex Research* 27 (3): 317–339.

Tuana, Nancy. 1986. "The Weaker Seed: The Sexist Bias of Reproductive Theory." In *Feminism and Science*, edited by Nancy Tuana, 147–171. Bloomington: Indiana University Press.

Turner, Bryan S. 1984. *The Body in Society: Explorations in Social Theory*. Oxford: Basil Blackwell.

———. 1987. *Medical Power and Social Knowledge*. Beverly Hills, Calif.: Sage.

Wikler, D., and N. J. Wikler. 1991. "Turkey Baster Babies: The Demedicalization of Artificial Insemination." *Milbank Quarterly* 69 (1): 5–40.

Zola, Irving K. 1990. "Medicine as an Institution of Social Control." In *The Sociology of Health and Illness: Critical Perspectives*. 3d ed. Edited by Peter Conrad and Rochelle Kern. New York: St. Martin's Press.

"Quit Sniveling, Cryo-Baby. We'll Work Out Which One's Your Mama!"

Charis M. Cussins

■ EXPLORING FAULTS IN THE BEDROCK OF KINSHIP

In this chapter I recount a number of case histories from infertility clinics in the United States where I observed or worked over three and a half years, augmented with observations compiled from visits to infertility clinics and related sites in the United States and Europe over a decade. I discuss two technically identical procedures which lead to different kinds of kinship configurations— gestational surrogacy and in-vitro fertilization with ovum donation. Ovum donation and gestational surrogacy are compared in two different kinds of cases. In the first comparison the cases are non-commercial egg donation versus gestational surrogacy. In the second comparison, the cases also involve an intergenerational element.[1]

Using the different boundaries between what is natural/biological and what is social in conception, pregnancy, childbirth, and parenting of gestational surrogacy and donor egg IVF, I argue for two things. First, drawing on the different ways in which these two procedures distribute what is natural, I argue against a fixed or unique natural base for the relevant categories of kinship.[2] These cases open up a way of thinking about the grounds of kinship, and thereby offer a means to re-examine and even re-register the familiar. They show that high-tech interventions are not necessarily antithetical to affiliation and identity, as some groups (for example, official Catholicism[3]) have maintained. In the clinical setting the procedures are one means through which patients claim or disown bonds of ancestry and descent, blood and genes, nation and ethnicity.[4] This further suggests that the innovations offered by these technologies do not intrinsically provide only *new* ways of

drawing these fundamental distinctions, nor do they simply reinforce *old* ways of claiming identity (Farquhar 1996:1–11). The technologies contain both elements.

Second, the two procedures draw on blood and genes as natural resources for what makes parents and children, depending on who are designated as the parents-to-be, but they distribute the elements of identity and personhood differently. One can map out what is rendered relevant to kinship (what I call an "opaque" stage in the process of conceiving and bearing a child) and what irrelevant (what I call a "transparent"—perhaps "trans-parent" would be better—stage where kinship is not affected by a certain stage of the procedure). From this mapping exercise, one can suggest some things that underlie ways of using biology to configure kinship. The third section of this paper argues that in the technoscientific context of these infertility clinics, a person can be taken to be biologically related to another if the reproductive links between them are not transparent.

■ CASES FROM THE FIELD: WHOSE CHILDREN, WHICH PARENTS?

What happens to kinship in modern infertility clinics? Human reproduction is routinely "assisted" in infertility clinics, using many of the very techniques of modern biology that have enabled the successful mapping of predominant systems of Western kinship reckoning onto the science of genetics and the telos of evolutionary biology. One might expect to find the connections enhanced between relatedness as determined by biological techniques, and socially meaningful answers to questions about who is related to whom. The science would then serve to hone or perfect our flawed understanding of kinship, revealing the pared-down natural essence of such terms as *mother*, *father*, and *child*. This is a logic with which we are familiar, in contexts such as the determination of paternity using blood tests or DNA fingerprints. The biological techniques are taken to prove, within reasonable margins of technical error, that one person is the "real" father, and not another. That there is a fact of the matter is not questioned on this logic. Neither is it a possibility that the notion of "father" may be changed by applying it in such procedures, gaining for the concept new abilities to perform naturalistic and forensic work.

Tracking biomedical interventions in infertility medicine reveals something altogether different. Just where one might expect to discover the vanishing point at which the natural ground of our social categories would be revealed in its essence, one finds a number of subtle and not-so-subtle disruptions of the categories of relatedness (especially parent and child, but also sibling, aunt, uncle, and grandparent).

■ BLOOD AND GENES COME APART: DONOR EGG VERSUS
GESTATIONAL SURROGACY

Contemporary Westerners are used to thinking of there being just two biolog-
ical parents who both donate genetic material, a bilateral or cognatic kinship
pattern inscribed in our understanding of biogenetics. A baby is the product of
the fusion of the mother's and the father's genetic material. Kin are divided into
"blood relations" and non-blood relations, and it is usually assumed that blood
relations simply reflect genetic relationship. The three most familiar kinds of
disruption to this biogenetic understanding of what parents are all preserve the
genetic "natural" basis for Western kinship. In the case of commercial sperm
donation, this model is not disrupted but, if anything, is exaggerated and rein-
forced. The vast majority of sperm banks sort their donors by "genetic" traits so
that clients can pick a donor who is a phenotypic match for a husband, or pick
a Nobel laureate, on the basis of a theory of the genetic inheritance of these
traits.[5] The inseminated woman is taken to be related to the baby in the usual
way. In adoption, the "biological" parents or "birth" mother are distinguished
from the "social" parents, preserving the distinction between the two.[6] "Blend-
ed" families (where children from different marriages cohabit, or where chil-
dren live with stepparents or with a single parent after a divorce or separation)
muddy the waters of social parenting but leave intact the understanding of who
the biological parents of each child are.[7]

In donor egg in-vitro fertilization, however, the overlapping biological
idioms of blood and genes come apart. The maternal genetic material is con-
tributed by the egg, which is derived from the ovaries of a woman who is the
donor. Nonetheless, the embryo grows in and out of the substance of another
woman's body; the fetus is fed by and takes form from the gestational woman's
blood, oxygen, and placenta. This disrupts the coherence of the natural
ground for bilateral linear descent and creates a schism between the concepts
that seemed to map so perfectly onto one another. If "blood relation" does not
designate the same entities in all circumstances as "genetically related," then
the naturalistic reduction of blood to genes that validated both the science
and the bilateral system of kinship reckoning does not work in some settings.

Gestational surrogacy means that eggs from one woman are fertilized with
her partner's sperm in-vitro (occasionally donor eggs or donor sperm are used
in place of the gametes of one partner from the paying patient couple) and
then transferred to the uterus of a different woman who gestates the pregnan-
cy, known as a gestational surrogate. The woman from whom the eggs were
derived and her partner have custody of the child and are the parents (if
donor eggs from a third woman were used, the woman from the paying
couple is still the mother, and she adopts the baby at birth, as in conventional
surrogacy).

Gestational surrogacy is procedurally identical to donor egg in-vitro fertilization: eggs from one woman are fertilized and gestated in the uterus of another woman. Two things make donor egg in-vitro fertilization and gestational surrogacy different from one another. First, the sperm with which the eggs are fertilized comes from the gestational woman's partner (or a donor standing in for him and picked by that couple) in the case of donor egg IVF. The sperm comes from the partner of the provider of the eggs (or a donor standing in for him) in the case of gestational surrogacy. From a lab perspective there is no difference—sperm collected by masturbation is prepared and added to retrieved eggs, and the embryos are incubated and transferred identically in both cases. The sperm comes from the person standing in the right sociolegal relationship to whichever of the women is designated as the mother-to-be. Who is designated as the mother-to-be is the second difference between the two procedures. Whether the gestational woman or the egg provider woman is the mother-to-be depends on who came into the clinic for treatment for infertility, the various parties' reproductive history, and in the case of private clinics, who is paying. Where additional donors are used or where the egg donor or gestational surrogate is being contracted on a commercial basis, the importance of who is paying for the treatment in deciding who the designated parents are is reinforced.[8]

Gestational surrogacy also separates blood and genes, but whereas donor egg IVF traces motherhood through the blood half of this separation, gestational surrogacy traces it through the genetic half. Studying what happens in areas where the settled ontological hierarchy and distinctions break down should reveal possibilities for other ways of "doing" kinship that configure the mixture of nature and culture differently.

Cases 1 and 2 In-Vitro Fertilization with Donor Egg: Giovanna and Paula

One afternoon I was in an examination room getting ready for the next patient's ultrasound scan, which had been ordered to see whether her ovaries were clear of cysts after hormonal down regulation in preparation for a cycle of in-vitro fertilization (IVF).[9] The patient was already in the room, changed and ready for her scan, so we talked as we awaited the physician's arrival. The patient, Giovanna, described herself as an Italian American approaching forty. She explained that she had tried but "failed" IVF before, using her own eggs and her husband's sperm. Egg quantity and quality are negatively affected by maternal age over thirty-five, and rates of implantation of in-vitro embryos are said to be negatively affected by both the age of the woman from whose body the eggs are retrieved and the age of the woman in whose womb the embryos are attempting to implant (Flamigni et al. 1994). Her response to the superovulatory drugs and the doctor's recommendation had persuaded

Giovanna to try to get pregnant using eggs from another woman (donor eggs). Almost all clinics report better implantation rates in IVF using donor eggs, which are retrieved from women under thirty-five years old, than those obtained using the patient's eggs if the patient is over thirty-five.

In discussions with psychologists and nurse coordinators at IVF clinics I had learned that there is a typical trajectory for patients, such that treatments that are more expensive or more invasive or, especially, that involve donor sperm or eggs take a while to become acceptable. Frequently patients will start off being adamant that they will stop before a certain phase of treatment —say, before trying IVF or before moving to donor gametes. The passage of time and failure to get pregnant on other protocols often causes that boundary to shift. For women, accepting donor gametes is reportedly easier than for men, which correlates well with the lay belief that women find the idea of adoption easier to accept than their male partners. For women, conventional surrogacy is apparently harder to accept than donor egg or gestational surrogacy because the designated mother-to-be neither provides the eggs nor gestates the fetus. Donor egg IVF and gestational surrogacy are both easier to accept because the first involves gestating the fetus, whereas the last involves the development of an embryo formed from one of her eggs. By the time I was speaking with Giovanna she presented herself as committed about pursuing the option of an IVF pregnancy using donor eggs.[10]

Giovanna said that she had decided to use a donor who was a good friend, rather than an anonymous commercial donor.[11] She described her friend as excited and ready to help. Choosing a friend for a donor seemed to be an important part of reconfiguring the experience of pregnancy: if conception was not to occur inside her body or with her eggs, then it was preferable that she have emotional attachments of friendship to (and could make the corresponding demands on[12]) the woman who was to be her donor. She did not say anything about her husband's relationship to her friend or specifically address his feelings about expanding the pregnancy such that his sperm would fertilize eggs derived from her friend, but she did say that he was supportive of her pursuing this as a treatment option. Choosing a friend as her donor was also important in the ways in which Giovanna was articulating the kinship issues raised by this splitting of the biological basis of descent into a gestation component and a genetic component.

Giovanna explained to me that her friend was also Italian American. She described this shared ethnic classification as being "enough genetic similarity." Further, Giovanna accorded her gestational role a rich biological significance: she said that the baby would grow inside her, nourished by her blood and made out of the very stuff of her body all the way from a two-celled embryo to a fully formed baby. There are several contemporary arenas where the line between nature and nurture has been creeping further and further

back in pregnancy: fetal monitoring and fetal surgery, right-to-life political movements, the improved survival rates of significantly premature infants, and a predominantly child-based perspective for discussing the social and ethical dimensions of human reproduction. In these arenas gestation is increasingly assimilated to the care one provides to a child once it is born. Giovanna could have described her procedure as a further retraction of the boundary between nature and culture, bringing culture right back to everything that happens after fertilization. This would have preserved a unitary and grounding function for the natural component of kinship (reduced to genetics). Her use of donor gametes would then have fitted the general trend of de-privatizing pregnancy. Instead Giovanna cast her gestation in biological terms, appealing to blood and shared bodily substance.

Giovanna pried apart the *natural* basis for specifying mother/child relations into separable components. In addition, she complicated the natural status of the genetic component that would be derived from her friend by *socializing* genetics.[13] She said that what mattered to her in genetic inheritance was that the donor share a similar history to her own. She said that because her friend was also Italian American they both came from the same kind of home, and that as they both had Italian mothers, they had grown up with the same cultural influences. So genes were coding for ethnicity, which Giovanna was expressing as a national/natural category of Italian Americanness. This ethnic category itself coded for a sociocultural life history that I imagine Giovanna would say goes far beyond anything that is mandated by the natural destiny of having Italian American genes. Genes figure in Giovanna's kinship reckoning because there is a chain of transactions between the natural and the cultural that not only grounds the cultural in the natural but gives the natural its explanatory power by its links to culturally relevant categories.

When in scientistic mode, it is tempting to think that reductions of higher levels of organization or greater sociality to simpler or more natural or causal underlying factors work without remainder, and in one direction only. Applied here, the scientistic impulse is to assume that our biology underwrites our sociocultural potential and not the other way around, and that biology is sufficient to account for sociocultural reality. Even though there are infinite contingency and variability in the ways things actually turn out, for any actual state of human affairs, biology can give a full account of that state of affairs. Giovanna's separation of biology into shared bodily substance and genetics and her formulation of what matters to her about genetics in the context of her procedure resist both these assumptions. The reduction to genes is only meaningful because it codes back to sociocultural aspects of being Italian American (it is not unidirectional). Likewise, the ethnic category is not just a category that performs a transitional function between nature and culture, but is a category of elision, collecting disparate elements and linking

them without any assumption that every one of the sociocultural aspects of having an Italian American mother, for example, needs to map back onto biology.[14]

In a related case, an African American patient (Paula) whom I met at the clinic only once spontaneously offered commentary on the kinship implications of her upcoming procedure. Paula had undergone "premature ovarian failure" and entered menopause in her early thirties before she had had any children. She and her husband had decided to try donor egg IVF, and she was hoping to be able to carry a pregnancy. They had not yet chosen an egg donor, and Paula said that she would first ask her sister and a friend, to see if either of them would be willing to be her egg donor. Paula expressed a strong preference for using a donor from her community. She said, laughing, that using a donor was not as strange as it might at first seem. After all, "It's just like we've been doing all along!" When I asked her what she meant by that, she explained that in African American communities it was not unusual for women to "mother" or "second-mother" their sister's or daughter's or friend's children.[15]

This explanation has several interesting elements. First, it rejects the idea that these procedures are wrong because they are unnatural or because they are exploitative of the donor. If being a donor is just one more way of doing something that is already a prevalent social phenomenon—dividing different aspects of mothering across generations, between friends and between sisters—then it is not a radical departure from existing social practice. In presenting it like this, Paula is normalizing her reproductive options. Rather than being exploitative, using a donor is assimilated to other ways in which women help one another to lead livable lives. But just as much as normalizing her own reproductive plight, Paula's explanation suggests the possibility of legitimizing socially shared motherhood through the naturalization of shared motherhood. Legitimizing social "deviance" by pointing to its natural basis is a familiar strategy. In this case, however, the strategy mobilizes only newly available biological possibilities (pregnancy with one woman providing the egg and another providing the shared bodily substance) and reverses the usual form of the argument where naturalization is legitimizing because it is inevitable and because it precedes social forms.

Both Giovanna and Paula are pursuing new ontologies out of, but different from, their lived experiences of kinship. From the heart of biomedicine they are changing and extending the reference of the word *mother*. In this regard, they are practical metaphysicians.

Cases 3 and 4 *Gestational Surrogacy Within Families:*
Rachel/Kay/Michael, and Jane

I have observed the treatment cycles for a small number of pregnancies

involving gestational surrogacy. Michael and Kay had a history of long-term infertility, including two unsuccessful attempts to get pregnant with IVF. On Michael's and Kay's previous IVF protocol, fertilization and early embryo development had gone well both times, but the embryos had failed to implant. They decided to maximize their chances on one last attempt at IVF by using a gestational surrogate. Michael's sister, Rachel, agreed to be their surrogate. Rachel was referred to approvingly as an ideal surrogate by several staff members during the weeks of treatment. Her own family of three children was already complete (that surrogates already have children is a requirement of many clinics, both to show that the surrogate is of proven fecundity and to minimize the chances of contested custody at the birth of the child[ren]). She was actively compliant, making explicit references to how she would organize her life so as to do whatever was in the treatment's best interests. She was good-humored about the long waits during appointments at the clinic. Her husband's job was lucrative enough that she could assume the risks associated with taking a leave of absence from work, and Rachel said she was glad of a break from work and a chance to spend more time at home with her children.

Practitioners at this clinic generally viewed family member surrogacy favorably. They treated it as an easily negotiated subset of non-commercial surrogacy, and much preferred non-commercial surrogacy to commercial.[16] While this treatment cycle was in progress, however, another family member surrogacy treatment was ongoing. In this other case, the surrogate was married to the brother of a woman who, with her husband, was providing the gametes and hoping that they would be parents. This surrogate, Jane, was thus a family member but not a blood relation. Staff members compared Jane unfavorably with Rachel from the beginning, complaining that her heart was not in it and that she and her husband's sister (the mother-to-be) were "passive aggressive" toward each other. When Jane failed to get pregnant after two attempts, the clinic's psychologist told us at the weekly meeting that she wouldn't be surprised if Jane's unresolved feelings which had shown up on her psychological evaluation were getting in the way of implantation of the embryos.

I followed Rachel's treatment as a case study of gestational surrogacy, and my notes provide an account of the questions of kinship that occurred in the clinic during this time. It was necessary to rule out the wrong people as parents and to count in the right people; not getting these boundaries right risked having the procedure seen as incestuous. Despite this being a new kind of procedure, conventional strategies such as distinguishing between medium and information and between nature and nurture were used by the parties involved in the pregnancy. These discussions enabled them actively to rule out incest and to negotiate descent and heredity. As can be seen in the

excerpts below, the notes also reveal my surprise when my own presuppositions about kinship were dislodged.

Rachel comes in today for a scan; looks good. She has her toddler daughter with her. You can tell a non-commercial surrogate because they are the only people around here who bring kids in; the commercial surrogates don't because it would look unprofessional, the staff don't because it would be insensitive, and the patients mostly don't have children yet. There is some problem with Rachel's attorney, who wants to keep back one page of her surrogacy contract. The clinic will not proceed with the IVF and embryo transfer unless they get a copy of the missing page. The surrogacy agency woman arrives and eventually sorts it out; civility is restored.

The embryologist tells me that Kay's husband is Rachel's brother! I am still reeling from this information, wondering why no one seems to think it's incestuous, when Rachel turns to Kay and says that it is lucky that she had her tubes tied after her last child. Kay raises her eyebrows, seeming not to understand, and Rachel elaborates by saying that otherwise there might be a danger of one of her eggs being in her tubes or uterus and some spare sperm out of the petri dish from her brother fertilizing her egg. Kay understands now, and laughs and agrees. Again I marvel that this would be incest but gestating her brother's baby is obviously not—doesn't it matter that her brother's baby will grow inside her and out of her blood and tissue? Must be genetic essentialism. When the procedure is donor egg, the gestating woman is the mother; so then this same medical procedure would be incest, because Rachel would be the mother and her brother would be the father. You can make these paradoxes in the other direction too: if a donor egg procedure was done like this gestational surrogacy—the person who gives the egg is the mother and the one who gives the sperm is the father— then the husband and the donor would be the parents, which is adulterous. Seems that fidelity and avoiding incest still matters, but that fidelity is preserved and incest avoided according to who are supposed to be the parents and what they call the procedure.

Four days later. 8:00 a.m. Rachel and Kay and Michael are coming in for their embryo transfer later this morning. In the lab the embryologists are discussing the uncertainty about whether to use Rachel's or Kay's serum for the in-vitro fertilization and the embryo transfer. They got twelve eggs from Kay the day before yesterday and inseminated them with Michael's sperm; today they have five embryos that they want to transfer.

10:00 a.m. Kay and Rachel are in the operating room getting

prepped for the transfer. The doctor is trying to persuade them to let him try transferring three embryos into Rachel and two into Kay. He tells Kay that seeing as there are a fair number of grade 1 embryos, she could try one more time herself, without losing the chance of Rachel trying for her. Kay and Rachel exchange looks, but they have made up their minds that they want to maximize Rachel's chances of implantation and so want her to have all the embryos. The doc is being quite persuasive, reiterating, "Are you sure you don't want to split the embryos?" several times while I am in the room, but Kay and Rachel stand firm. In the staff room the doc tells me how disappointed he is that Kay and Rachel would not both have an embryo transfer. If they had both got pregnant, it would have been the first time that twins would have been born simultaneously from different mothers. He seems frustrated that he will not have this opportunity to "make history," as he calls it.

10:45 a.m. Rachel and Kay and Michael are in scrubs and waiting in the operating room adjoining the egg lab. The embryologist takes the petri dishes containing the embryos for transfer out of the incubator. There are television monitors attached to the microscope—one in the OR and one in the egg lab—so everyone, including all the parties to this conception, can see the magnified embryos and watch the embryologist loading them into the catheter. The doc narrates the process, counting the embryos as they are sucked up and commenting to the patients on how gently the embryologist is handling the embryos—"Look, they [the embryos] just *walked* up [into the catheter]!" The embryologist brings the catheter with the embryos in it into the OR, and she and the doc do the transfer.

Rachel's husband is not in the room for the embryo transfer and has been curiously absent throughout the whole treatment cycle. The staff describe him as an "awkward attorney." Everyone is calling his wife a saint for getting pregnant with someone else's baby, his brother-in-law's baby, and he is completely irrelevant to the whole process—fair grounds for awkwardness. I speculate about whether there have been hushed instructions about Rachel's and her husband's sex life during the pregnancy, and whether they would feel constrained or alienated from one another by the "in-law guest pregnancy." Kay's husband Michael (Rachel's brother) is in the room, though, as the father-to-be. Rachel's kinship transparence (it is as if Rachel is completely transparent to kinship—kin passes straight through her without involving her—she doesn't become the mother through gestating the baby, and she is not in the room as Michael's sister; she is a step in a procedure for Kay and Michael) is heightened during the embryo transfer by the pres-

ence of her brother while she is lying with her legs in stirrups. Brothers don't usually see their sisters like this.

In the operating room after the embryo transfer, Rachel has to remain in a prone position for two hours without getting up. Michael leaves soon after the embryo transfer, but Rachel and Kay are "in this together," as Kay says, and Kay stays by Rachel's side for the whole two hours. I stay in the room with Rachel and Kay for a while, during which time they discuss what the baby will look like if Rachel gets pregnant.

Again I am in for a surprise about the plasticity of kinship and heredity. Rachel flatters Kay, saying that if the baby looks like a combination of her brother Michael and Kay, it will be good-looking. This fits the normal genetic reckoning of half the characteristics coming from the egg (Kay's) and half from the sperm (Michael's). Kay responds, however, by saying that it might look more like Rachel, and that if it came out looking like her nephews and niece (Rachel's children), she would be happy. I am not sure if Kay is just returning the compliment; no doubt that is part of what is going on. But if the baby could look like Rachel, then Rachel is not as transparent or merely instrumental in this pregnancy as the logic of gestational surrogacy seems to need her to be so as not to be adulterous/incestuous. Rachel takes up the thread, asking rhetorically whether the baby could get anything of her from growing inside her. They joke a bit about dogs looking like their owners and identical twins having different birth weights depending on how they fared during pregnancy. This brief joking runs the gamut through classic cases of the effect of "nurture" on "nature," and it seems that they resolve the question by accepting that if Rachel has an effect on what the baby looks like, it will be because she is providing a certain environment for the baby to grow in, not because she is part of the baby's "nature." The pregnancy is re-instrumentalized, and Rachel becomes transparent again and the risk of incest is again avoided. I feel myself breathe a sigh of relief that the temporary metaphysical instability has been sorted out to leave the logic of the procedure and both compliments intact.

Ten days later. We come back across to the clinic after a long morning in surgery, and the head embryologist greets us with the news that Rachel's pregnancy test was positive—high levels of excitement all around and the embryologist exclaims, "We're good!" We stand around laughing and asking for the details, all surprised that the result is in already. The embryologist then tells us the story that she had just heard from Rachel: Rachel didn't phone Kay straight away but instead went out and bought a little teddy bear to which she attached a note saying,

"Your child(ren) are doing fine with Auntie Rachel—can't wait to meet you in eight and a half months." She took the teddy around to Kay's house and left it on the doorstep and rang the doorbell and hid herself. Apparently Kay opened the door, found the bear and burst into tears. As the embryologist repeats the story there is hardly a dry eye in the clinic—phew! high drama. So the kid(s) are with Auntie Rachel for a few months. Funny how normal that sounds.

About three weeks later. Rachel and Kay came in for Rachel's first pregnancy scan today. All looks good—there are two fetuses, each with a sac and decipherable heart flutter. Rachel and Kay and the doc are relieved that the pregnancy is not higher-order (not more than twins) and that they don't have to choose selectively to reduce the pregnancy (kill one or more fetuses).

Several weeks later. Rachel was in for a final scan. For the first time I hear Rachel's husband mentioned. Rachel tells the doctor that her husband is happy about the twins and wants to name them after the doctor, calling one by his first name and one by his last name. I am interested that Rachel's husband (the awkward attorney) has become visible and that he is getting in on the naming. His choice of boys' names and of the male doctor for eponymy seem poignant somehow. It's as if this—all the socially relevant agnatic valuations—are what he can contribute to the babies' lineage.

Cases 5 and 6 *Intergenerational Donor Egg In-Vitro Fertilization: Flora; and Intergenerational Gestational Surrogacy: Vanessa/Ute*

These two cases complicate the kinship situations described above by adding an intergenerational element. Case 5 (Flora) involves a case of egg donation where the egg donor is the daughter of the woman who is trying to get pregnant. Case 6 (Vanessa/Ute) describes a gestational surrogacy where the surrogate became pregnant with an embryo formed from the sperm of the husband of the couple trying to have a baby and a donated egg from a daughter from a previous marriage of the wife. In cases like these, the "mother" (as defined from the treatment perspective) is also the grandmother in the familiar way of accounting; the donor daughter is also the genetic mother. In case 6 the designated mother is neither the genetic nor the gestational mother, but by reversing the direction of linearity (the daughter passes on genetic material to her mother instead of the other way around), genetic relatedness is still mobilized (as in the case of Rachel/Kay/Michael) to override the shared bodily substance of the gestational surrogate and fetus. The daughters in cases 5 and 6 are both genetically related to the fetuses, but the genetic information

has been made available through them in a chain of relatedness that leads back to their mothers; the daughters are biological intermediaries. To avoid incest and intergenerational coercion, they are also made socially invisible. This social invisibility is achieved by the lack of duty toward any offspring conceived with their eggs, and will no doubt be enforced by the lived experience of relating to these children as siblings rather than sons or daughters.

A fifty-one-year-old woman, Flora, came in for treatment. She was perimenopausal, and had five grown children from a previous marriage. She did not fit the typical patient profile of the elite white postponed-childbearing woman. Flora was Mexican, and crossed the border from the affluent suburb of Tijuana where she lived to southern California for her treatment. With five children she already had what many couples would probably consider "too many" children. She had recently been remarried to a man many years her junior who had not yet had children. Flora was quite explicit about the gender, age, and financial relations between herself and her new younger husband, and her desire, as she put it, "to give him a child."

As mentioned in the discussion of Giovanna's case above, conception rates for women over forty are extremely low on assisted reproduction protocols but can be significantly improved by using donor eggs. It was therefore suggested that if Flora wanted any significant chance of getting pregnant, she should find an egg donor. The donor eggs would be inseminated by Flora's husband's sperm, and resulting embryos would either be transferred to Flora's uterus or frozen for use in subsequent cycles. Donor consent covers all eggs retrieved at the time from the donor, so any frozen embryos would also "belong" to Flora and her husband.

Flora read widely in the medical and popular literature and frequently made suggestions about or fine-tuned her own protocol. She also picked her own egg donor: one of her daughters in her early twenties, who herself already had children.[17] The mother's and daughter's cycles were synchronized, and the daughter was given superovulatory drugs to stimulate the simultaneous maturation of several preovulatory follicles. The daughter responded dramatically to the drugs and at the time of egg recovery the physician and embryologist removed sixty-five eggs from her ovaries (ten eggs +/- five is "normal"). The eggs were inseminated with Flora's husband's sperm, forty-five fertilized, and five fresh embryos were transferred to Flora's uterus that cycle. Twenty grade 1 embryos were frozen at the 2PN stage (when two pro nuclei are visible, indicating that fertilization has taken place, but before cell division has begun), and the remaining embryos were frozen at the 3 and 4 cell stage after the fresh embryo transfer. Flora did not get pregnant in the fresh cycle or in the first two frozen cycles, but did in the third.

Flora and her daughter did not seem overly perturbed by the intergenerational confusion of a mother giving birth to her own "grandchildren" and to

her daughter's "daughter/sister." Instead they discussed the mother's and daughter's genetic similarity. Like Paula (case 2 above) they also assimilated their case to existing social practice, in this case to the prevalence of generation-skipping parenting (where a grandparent parents a child socially and legally) in communities with which they were familiar. Nonetheless, Flora signaled some ambivalence on the part of the daughter. When I asked who her donor was, she replied, "My daughter." I then asked, "Is she excited?" and Flora replied, "Not exactly, but she doesn't mind doing it." The daughter herself told me when the mother was out of the room that she didn't mind helping them have a single baby, but that the huge number of embryos stored away was unsettling. After all, she said, her mother already had a family; "she doesn't need to start a whole new family—one baby is one thing but . . . !"

The daughter's reluctance to see her mother having "a whole new family" might have been due in part to a distrust or disapproval of her mother's relations to her new husband, or to a reluctance to have the grandmother (Flora) of her children back being a mother of babies again. The daughter's anxiety about the stock of embryos that were frozen, however, seemed to be at least partly an anxiety about the existence of unaccounted-for embryos using her eggs and her stepfather's sperm. Using one of her eggs to help initiate a pregnancy that was clearly tied into a trajectory on which it was Flora's and her husband's child placed Flora as an *opaque intermediary* (placed Flora as significant in the flow of kinship) between the daughter and the husband and protected the daughter from any direct connection to her stepfather. The embryos in the freezer, however, were in limbo. If they were not used to initiate a pregnancy in Flora, then they existed as the conjoined gametes of the daughter and the stepfather. The status of these embryos—even though technically owned by Flora and her husband—did seem to raise anxiety associated with inappropriate kinship.

Case 6 concerns Vanessa, who started up her own surrogacy agency shortly after being herself a commercial gestational surrogate and giving birth to a baby for another couple. I met Vanessa at a local fast-food restaurant which she had suggested as our rendezvous point. She explained over the phone to me that this was the neutral ground where she usually met with her surrogates and recipient couples before drawing up contracts or getting lawyers involved. Vanessa told me that she had seen a program on television in which she noticed the "joy in the mother's eyes" when the baby was handed over by the surrogate. Vanessa's family was in some financial difficulty at the time as their small-scale manufacturing operation had just closed. Since she had had "no trouble" during pregnancy or birth with her own four children, she thought that she would look into the possibility of being a surrogate herself. She expressed this decision in a religious idiom, as a chance offered by God simultaneously to do good and to make a fresh start. She contacted two agen-

cies and decided to work with the agency that was based closer to her home even though they paid their surrogates $1,500 less than the other program ($12, 000 as opposed to $13, 500).[18]

Vanessa was introduced to "her" couple in the middle of 1992. She described the couple as a "German woman of about forty" (Ute) and an "Asian man." It was agreed that they would try gestational surrogacy. Vanessa was given Lupron to shut down the production of estrogen and progesterone and thus put a halt to ovulation, so as to synchronize her cycle with Ute's cycle. On the first treatment cycle Ute ovulated before the physician took her to surgery for ovum pickup and they got only one egg at surgery.[19] The one egg was successfully fertilized with Ute's husband's sperm, incubated for two days, and transferred to Vanessa, but Vanessa did not get pregnant.

For the second treatment cycle, Ute and her husband decided to combine gestational surrogacy with donor egg IVF. Ute had an adult daughter from a previous marriage who agreed (as Flora's daughter above had) to be her mother's and stepfather's donor. I asked Vanessa whether the daughter or husband or Ute were worried about the genetic stepfather/daughter relationship. Vanessa said that the only things that were raised were that it was going to be kept secret and that using the daughter's egg was the next best thing to using Ute's eggs because of the genetic similarity. The daughter was made biologically transparent so that she was not the mother in the pregnancy by making the relevant fact be the genetic relation of her eggs to Ute. She was also rendered transparent socially by keeping her role secret. The logic of gestational surrogacy as explained above (essentializing the genetic aspect of biological kin, and making the blood and shared bodily substance of gestation instrumental rather than essential) was also maintained. Ute could be providing the essential genetic component, even if that genetic material had traveled a circuitous route from her down a generation and was being mobilized now through her daughter.

Vanessa did not get pregnant on the fresh IVF cycle using the daughter's eggs, but there had been sufficient embryos to freeze some for a subsequent attempt. On the frozen cycle, Ute's daughter's and husband's remaining embryos were thawed and transferred to Vanessa's uterus, and Vanessa became pregnant with a singleton. The pregnancy, unlike her four previous ones, was not easy for Vanessa. The difficulty of the last months and of the birth made her determined never to be a surrogate again and, as she described it, propelled her into the decision to start her own surrogacy agency. Under her surrogacy contract she was not allowed to make any of her own medical decisions while pregnant, and she had to consult with the recipient couple and the doctor before taking any medications or changing her agreed-upon routine in any way. The recipient couple and the physicians took over jurisdiction of her body for the twelve months of treatment and pregnancy.

Nonetheless, Vanessa described the pregnancy almost wistfully, explaining how exhilarating the intimacy with the couple was and how spoiled she felt. During the pregnancy Ute and her husband took her out, bought her fancy maternity clothes, and so on. Vanessa underlined the importance of the relationship between the surrogate and the recipient couple in all surrogacy arrangements by saying that they are "the couple you're going to be a relative with for a year and a half."

Despite her experience first as a surrogate and subsequently working with other surrogates and recipient couples, Vanessa seemed surprised by the severing of the ties of relationship between herself and the recipient couple after the baby was born and handed over. She said that the couple stopped contacting her and that when she called them to find out how they and the baby were, the couple made excuses and hung up quickly. Other gestational surrogates I have talked to have recounted similar experiences. It seems that Vanessa's relationship to the couple for the year and a half was enacted because she was prosthetically embodying their germ plasm and growing their child, but that, on the contrary, she was at no point related to the recipient couple or the baby in her own right. Designating Ute as the mother meant that Vanessa *had* to be transparent or irrelevant to the baby's kinship. Once the baby was born, Vanessa was in many ways just like any other instrumental intermediary in establishing the pregnancy, such as the embryologist or even the petri dish. The fact that she cared for and had good reasons for continuing to feel connected to the couple and the baby and so did things like make phone calls meant perhaps that she needed some postnatal management to be kept in the background. But the logic of disconnection was the same as for other intermediaries in the recipient couples" reproduction.

■ MAKING KINSHIP: OPACITY AND TRANSPARENCY

In the cases of Giovanna, Paula, and Jane described above, I do not know whether a pregnancy has been or will be established (cases 1, 2 , and 4). I try here hypothetically to isolate some of the strategies that were used in the clinical setting in each case for delineating who the mother was for each child. These strategies are not exhaustive and cannot be expected to be invariant in different arenas of the patients' lives either. For example, legal and familial constraints bring their own sources of plasticity and relative invariance which are very powerful in determining kin. But the clinic is one significant site of negotiation of kinship, and it is of particular interest because it articulates between the public and the private and because it illustrates flexibility in biological and scientific practice. I emphasize the mothers' and not the fathers' relatedness because in the cases I have chosen it is in motherhood that the procedures raise a challenge to biological essentialism. For each case I distinguish different sig-

nificant intermediaries in establishing the pregnancy. I then sort the interme-
diaries as to whether they are opaque or transparent in the determination of
who counts as the mother. I also ask where and under what conditions the ways
of designating the mother are liable to break down or be contested.

In recounting the cases above I referred to some of the women as "opaque"
in the establishment of a pregnancy. For analytical purposes, I call any stage
in the establishment of a pregnancy opaque if it gives rise to relatedness and
personhood. A stage does this kinship work if it brings two people into rela-
tionship. Here, I am interested in working out who the *mother* is, so an
opaque stage in this determination would be a stage that answers who the
mother is. As the cases showed, there are many resources for making a stage
opaque that are not necessarily well differentiated. Biology and nature are
resources; so are a wide range of socioeconomic factors, such as who is paying
for treatment, legal factors such as who owns gametes and embryos, and famil-
ial factors such as whose partner is providing the sperm and who is projected
to have future financial and "nuclear family" responsibility for the child. A
stage can be made securely opaque by separating but bringing into coordina-
tion the biological and social accounts of the relationship. Depending on the
kind of parenting in question, different kinds of coordination are appropriate.

By analogy, I call a stage *transparent* if it enables heredity or relatedness
but does not itself thereby get configured in the web of kinship relations. A
woman is transparent in conceiving and bearing a child as regards who the
mother is if she is an *intermediary* in the pregnancy and childbirth without by
her actions becoming the mother or contesting who the mother is. When
people—the paradigm opaque nodes of kinship webs—are biologically
involved in kinship transmission—the paradigm means of making kinship in
modern Western societies—but are transparent to the process, there is a
prima facie tension.[20] The cases described above exhibited different strategies
for achieving kinship transparence of some people and not others. Breakdown
(from the point of view of clinics or designated recipient couples), contesta-
tion, and prohibition usually occur when an attempt by at least some of the
actors to render one or more stage as transparent is contested or fails.

■ SIGNIFICANT INTERMEDIATE STAGES IN DESIGNATING
 MOTHERHOOD IN EACH PROCEDURE

In the first case, that of Giovanna, the Italian American woman who was plan-
ning to undergo a donor egg procedure with the eggs of an Italian American
friend of hers, the two potential candidates for motherhood were the donor
friend and Giovanna herself. The friend was made appropriately transparent
using three strategies. First, the friend's contribution of the eggs was biologi-
cally *minimized* by stressing the small percentage of the pregnancy that would

be spent at the gamete and embryo stage versus the length of time that the fetus would grow inside Giovanna. Second, genetics were *redeployed*, so that the friend's genes were figured as deriving from a common ethnic gene pool (Italian American) of which Giovanna was a member and so in which she was also represented. Third, the friend was secured as an intermediary in the pregnancy by stressing her other bonds to Giovanna of friendship and mutual obligation. She could be instrumental to the baby because she was very much not purely instrumental to Giovanna.

To further disambiguate who should be considered the mother, Giovanna put forward strategies through which she could assert her own opacity. Giovanna's opacity was to come from her gestation of the baby and provision of the bodily substance and bodily functioning out of which the baby would grow and be given life. Giovanna stressed the significance of the gestational component of reproduction and emphasized the importance of the experiential aspects of being pregnant and giving birth in designating motherhood. Further, Giovanna was married to, and would parent with, the provider of the sperm.

In Paula's case (the African American woman who was going to use an African American friend or one of her sisters as her donor), the strategies of making transparency and opacity were similar to those employed by Giovanna, but there were also interesting differences. The most striking difference was that Paula drew the line between opacity and transparency more tenuously, being content to leave more ambiguity in the designation of motherhood. This tolerance of ambiguity was part of her way of legitimating the procedure itself and simultaneously legitimating the social parenting practices with which she drew analogies.

Like Giovanna, Paula gave an ethnic or racial interpretation to the genes such that by getting genetic African Americanness from her donor the baby would share racial sameness with Paula. There was a difference in how they discussed this ethnic or racial commonalty, however. Whereas Giovanna routed her friend's genetics through cultural sameness and back to herself, Paula seemed not to trace a route from her donor back to herself; just coming from the same racial group and whatever its gene pool might be was enough. The trope that genes code for racial distinctions, inclusions and exclusions, and purity seemed to be more significant here than the equally prevalent trope that genes function as the thing that provides the definitive mark of individuality (the DNA fingerprint) which is passed down cognatically from a mother's and a father's individual contribution. In fact, Paula was the only one of the people whose cases are discussed in this chapter who did not bring genetics back to herself as an individual so as to have it function as a resource in designating her as the mother. Giovanna, Flora, and Ute all also mobilized the idea of genetic similarity with their donors, but unlike Paula they all start-

ed with the donor as an individual and ended up with the recipient as an individual. Thus, according to my definitions above, Paula's donor did not need to be transparent for race.

Similarly, the logic of transparency versus opacity was elided in Paula's analogy between her procedure and socially shared mothering. She took legitimacy for the procedure from the fact that shared parenting was commonplace among people she identified with racially, and she also commented on the natural confirmation of these social patterns that her upcoming procedure would provide. Socially and biologically her motherhood—including its ambiguity—would be recognizable and legitimate. She would be sufficiently opaque, and her donor sufficiently transparent without either needing to be wholly so.

Michael, Kay, and Rachel (the gestational surrogacy among a brother, his wife, and his sister, respectively) deployed yet other familiar resources for assuring the transparency of Rachel and the opacity of Kay. Because of the need to protect Michael and Rachel from incest, the negotiations over transparency and opacity were explicit and repeated at different phases of the treatment. Although the opportunities for ambiguity were legion, there was, as it were, a "zero-tolerance" standard for ambiguity in the designation of Kay as the mother. Kay provided the eggs containing the genetic information of heredity and was also married to and intending to parent with the provider of the sperm. These elements of her opacity were stabilized by emphasizing the genetic basis of heredity and the mirroring of biological kinship and heredity. When a threat arose to the uniqueness of this basis of heredity (when Kay said to Rachel that she wouldn't mind if the children looked like Rachel and the ensuing conversation), the threat was removed by assimilating that kind of acquisition of characteristics to environmental factors. The biological aspects of reproduction were made instrumental and environmental except for the provision of the genetic material.

The provision by Rachel of the bodily substance and site for fetal development was made transparent through two strategies. First, Rachel was assimilated at all points—by her active compliance and by the kinds of boundary discussions she initiated such as how lucky it was that her tubes were tied—to a model on which pregnancy and birth were merely instrumental phases of Kay's and Michael's reproduction with which she was helping. Second, Rachel's relatedness to Kay and Michael was used to make her intermediary assistance natural. These strategies simultaneously negated any relationship Rachel might have had as a mother to the babies and routed her relation to the babies through Kay and Michael, making her an aunt rather than a mother even while gestating the babies.

By comparison, the two strategies that seemed to work so efficiently at making Rachel transparent were both mentioned in the clinic as working

imperfectly in Jane's case (the other family gestational surrogacy case). Jane enacted fewer outward signs of being a transparent intermediary, not exhibiting the same compliance as Rachel and not engaging with her sister-in-law in the same kind of boundary-drawing conversations about kinship as Rachel and Kay. For Rachel the negation of her claim to motherhood of the babies was achieved in part by the dictates of her relation to her brother and his wife, and her instrumentality was framed as part of service to that relationship. For Jane, however, the recipient couple were only related to her through her husband and the relationship among the adults seemed to be less close and so to support fewer claims to service. Perhaps the strategy of drawing on demands of pre-existing kinship to render intermediary service is generally more tenuous when the connection is through marriage.

In Flora's case, where she was using her daughter as her egg donor, a significant strategy in making her daughter transparent was to see the genetic material not as deriving from the daughter and her eggs per se but as being passed on in the daughter's eggs, in a manner that could be retraced to Flora. The daughter was made an intermediary by making her gamete contribution a *detour* to her mother Flora's genetic material, which could no longer be accessed directly from Flora. Flora, perhaps more closely than any of the other donor egg patients whose cases are described here, attempted to recapture in her own claims to motherhood the genetic idiom of linear descent.

Flora's case was complicated by the intergenerational element, however, and her daughter's transparence was threatened from at least two sources. Flora and her daughter discussed the similarity of what they were doing to other intergenerational parenting in which a grandparent can be the social and legal parent. Drawing an analogy with prevalent social practices, as Paula had done, Flora strengthened the legitimacy of the procedure and so stabilized her claim to being the mother of the child. In making this analogy, however, the daughter's transparence was in danger of being compromised, because grandparenting often allows for the "real" parent to reclaim his or her parental jurisdiction. Unlike for Paula, this analogy to social practices did not loosen the designation of who was to count as mother but was meant to disambiguate it even beyond the norm for the social practices with which she was drawing the analogy. Both Flora and her daughter were adamant that there was to be no ambiguity in who was to be the mother—Flora. Flora's marriage to the provider of the sperm and the incestuous implications of reckoning it otherwise reinforced the disanalogy with social grandparent parenting.

The other threat to the daughter's transparence came from the unintended stockpiling of embryos formed from the daughter's eggs fertilized with her stepfather's sperm. The frozen embryos in the lab were only tenuously tied to Flora's reproduction, and their quasi-independence and potential to initiate other pregnancies were troubling to the daughter. The large numbers of

embryos owned by her mother but created from her eggs faced the daughter with a situation where she no longer had control over her instrumental role. This made it hard for her to be confident of the maintenance of her own transparence.

In Vanessa's pregnancy, there were three potential candidates for sufficient opacity to be designated as the mother. There was Vanessa herself, the commercial gestational surrogate; there was the intended mother who was the wife of the recipient couple; and there was the wife's daughter who was the egg donor. As for Rachel and Jane, Vanessa was made transparent by assimilating her role in gestating the fetus to the provision of a temporary caring environment. Unlike Rachel's and Jane's cases, however, Vanessa's intermediary role was not elicited by the obligations of a prior relationship to the recipient couple. Instead her services were contracted commercially, and Vanessa had no further claim on the child after the birth. This disconnection was underwritten by the assumption of contractual arrangements that both parties agree that recompense is satisfactory despite possible incommensurability of the things being exchanged. Furthermore, contracts assume that the transaction itself is limiting and does not set up any subsequent relationship or further obligation. Vanessa's transparence was threatened when she experienced the sudden severing of relations after the birth of the baby as baffling and troubling. The contractual relation assured the temporary intermediary relation of shared bodily substance with the recipient couple, but insofar as it was uncontested it sustained no further contact.

Ute's daughter, who was acting as the egg donor, was made transparent in two ways. First, the genetic contribution was described as being closely *similar* to her mother's genetic material. This is not quite the same argument as that made by Flora and her daughter, where the daughter became a vehicle or detour through which genetic material originally from Flora had passed; in this case the mother and daughter simply alluded to the similarity of the mother's and daughter's genes. The daughter was further rendered transparent by the recipient family's commitment to keeping her role a secret.

Ute, the recipient mother, was made opaque not by herself capturing either of the predominant biological idioms (genetics as represented by providing the egg, or blood and shared bodily substance as represented by gestation). Instead, the genetic component from the daughter was similar enough to stand in for her genetic contribution, and the blood component was made intermediary in the contracting out of the gestation. Neither natural base was sufficiently strong to overwhelm her claim to be the mother, which she asserted through being married to the person who provided the sperm, through her daughter's compliance with her desires, and through having the buying power to contract Vanessa.

The donor egg procedures seem to offer the potential somewhat to transform biological kinship in the directions indicated, for example, by Giovanna when she codes genetics back to socioeconomic factors and thereby de-essentializes genetics, and when she draws on the trope of blood relation and shared bodily substance without genetics. Developments in other contemporary sites in the United States over the same period as this fieldwork, such as decisions in legal custody disputes, have tended to favor genetic essentialism in determining motherhood, although this has not been universal (Jaeger 1996:123–125). If an overwhelming predominance of nonclinical cultural contexts come down on the side of genetic essentialism, donor egg procedures might well become assimilated to adoption or artificial insemination with donor sperm. The bid to make gestation in donor egg procedures opaque vis-à-vis biological kinship would have failed. A newer procedure, reports of which began to appear in journals and in the press in 1997, uses the eggs of older patients but "revivifies" them by injecting cytoplasmic material derived from the eggs of younger women into the older eggs before fertilization. This donor procedure preserves the genetic connection between the recipient mother and the fetus, and so brings the genetic and blood idioms back into line. It thereby tightens up again the flexible ontological space for designating biological motherhood that had been opened up by donor egg procedures.

Paula used a more mixed ontology for motherhood than Giovanna. For her it was satisfactory if there was no definitive answer to *which* one was the mother, and she was happy to accept that in some ways there was more than one mother. Likewise, because she raised the possibility of biologically enacting what she described as already prevalent social practices (shared mothering), there was less at stake in having gestation without genetics be biologically opaque. Shared mothering was not presented as necessarily involving a natural kinship rift; indeed it was presented as a practice which preserves racial identity and integrity. Conventional adoption, on the other hand, has historically gone in one direction: African American children being adopted into Caucasian families, disrupting racial identification without disrupting racism. For Paula, having her procedure assimilated to some kinds of social parenting would still entitle her to make appeal to notions of biological sameness.

The genetic essentialism of gestational surrogacy in procedures such as Rachel's and Jane's seems to be faring very well, slipping almost effortlessly into, and only slightly extending and reconfiguring, pre-existing ontologies. There have been gestational surrogates who have contested custody, but decisions have gone against them more often than for conventional surrogates who are genetically related to the child in question.

The likely stability of Flora's and Ute's kinship opacity and claims to motherhood is hard to gauge. Ute's opacity could have been challenged by Vanessa's desire for contact with the child after its birth, set against the purchasing power of the contracting couple. Flora is likely to encounter social censure, just as she did in the clinic, for her desire to bear a child "for" her younger husband. If either Ute or Flora confesses to using her daughter as a donor, she may be condemned for putting her daughter through medical interventions so as to regain her own youth. If either daughter contests the circumstances of her role at a later date, the settlement of who is the designated mother might break down. But it is also possible that parenting with donor eggs for perimenopausal and postmenopausal women will play a part in breaking down some of the more oppressive aspects for women of the "biological clock." If Flora and Ute can maintain their opacity with regard to their claims to motherhood, they will be cases to hold against the elision of women's identities, femininity, youth, and ovulation. If Flora is buying into the cult of youth to keep her husband, as she claims, she may yet be subverting the wider essentialist identification of women's identities with their youthful biologies, as she also maintains.

■ CONCLUSIONS ABOUT OPACITY AND TRANSPARENCY

In the above cases drawn from fieldwork in infertility clinics, human procreation was not unified enough to support a unique template for biological kinship. To track something as simple as how it is decided who the mother is in these procedures, I described a number of actual enactments of motherhood and the elements that went into enforcing one answer to the question "Which one is the mother?" over other possible answers or ambiguities. A wide range of strategies for demarcating motherhood was employed, each describing slightly different and potentially disruptive ontologies of relatedness. The connections between natural and social aspects of kinship were shown to be variable in this site. The examples also illustrated the possibility of different ways of configuring biological kinship offered by these technologies.

A number of recent high-profile breakdowns and contestations of transparency and opacity illustrate the stakes involved in disregarding the underdetermination of biological claims to parenthood. For example, in May 1995 a White Dutch couple had IVF twins, one Black and one White. It transpired that somehow in what should have been a conventional IVF using the husband's sperm and the wife's eggs, the twins were conceived with two different genetic fathers. The error was ascribed by practitioners at the clinic to reusing pipettes: they claimed that some sperm from a previous patient must have been left in the pipette and have made its way to the petri dish containing the

wife's eggs. The clinic's physicians moved immediately to counteract public
anxiety by appearing on television throughout Europe attesting to the fact
that they would use only disposable pipettes in the future. They also tested the
White twin to check that the husband was indeed his genetic father, and they
instigated efforts to track down the genetic father of the other baby; it turned
out that the genetic father was somewhere in the Caribbean by that point.
Luckily the couple wanted to keep both babies. An aspect of the story that got
less publicity was the conditions under which the couple had gone public
with their story. In their provincial neighborhood the wife had started to be
taunted for her assumed adultery or promiscuity by passersby as she wheeled
her different twins in their stroller.

This error constituted a breakdown in the permissible interventions—
interventions that can be rendered transparent. There was no call for a substi-
tution for the husband's sperm, and there was no acceptance of being an
intermediary on the part of the genetic father of the Black baby, who had nei-
ther donated nor sold his sperm to the clinic or to this couple. Likewise, there
was a lack of acceptance of the genetic father's transparence once the babies
were born, because the Blackness of one twin was taken to prove adultery or
promiscuity; it was assumed that the woman had become pregnant through
sexual relations with two different men. Similarly, a recent scandal at a promi-
nent California infertility clinic has involved allegations of egg and embryo
switching to improve the clinic's success rates. The mere fact of establishing a
pregnancy does not sort out the chains of kinship by itself. As the cases
recounted above illustrate, there is a complicated choreography necessary to
disambiguate transparent and opaque interventions. If the work is not done
(social, biological, economic, legal, familial) to sort out opaque and transpar-
ent links, there will be errors and breakdowns in determining who is related to
whom and how.

Notes

1 The importance of reproductive technologies to the revival of Western kinship studies has
been pointed out by Marilyn Strathern and her colleagues. See Strathern 1992; Strathern
and Franklin 1993; Edwards et al. 1993. See also Haraway 1997.
2 I take this not as antirealism but as attentiveness to the contingent realities of complex phe-
nomena.
3 See Catholic Church, Congregation for the Doctrine of the Faith 1987.
4 I am grateful to Bruno Latour (personal communication) for pointing out to me the impor-
tance of, as he expressed it, showing that "high-tech processes can be re-employed to provide
powerful fetishes—in the good sense of the word—to produce affiliation and identity."
5 Sperm banks have been important in the naturalizing wars about traits—such things as
socioeconomic class as reflected in careers or education, race, intelligence, and athleticism
are routinely listed as categories describing sperm donors in sperm bank catalogues, enact-
ing an elision in the direction of the naturalized, between the social and the natural. Other

things, such as linear, bilateral indications of a predisposition to mental and physical illness (a parent or grandparent having been afflicted with a hereditary—or supposedly hereditary—condition) are invoked as means to rule out potential donors (see also Schmidt and Moore, this volume).

6 In conversations with infertility patients who subsequently opted for adoption, I have been told about ways of drawing the distinction between reproduction and parenting. There seems not to be total agreement about how or where the distinction between adoptive parent and biological parent is drawn, but a sense of the validity of making the distinction somehow, and the consequent validity of each kind of parenting, seems to be widely shared.

7 Blended families in many Western countries are assumed to involve emotional and material conflicts of interest, in line with what are seen as the inevitably divergent claims of the different kinds of relatedness.

8 There are times when agreements break down, but the fact that usually there is a commonsense understanding of who is being helped to have a child, and thus who the parents are, shows that there is room for great flexibility in interpreting who will count as a parent (biologically, as well as socially).

9 In-vitro fertilization involves the fertilization of egg(s) with sperm outside the body, usually in a petri dish in the lab. The egg(s) are surgically removed from the ovaries of a woman who has (usually) taken hormones to induce the maturation of multiple follicles, and then the eggs are inseminated in-vitro with a partner's or a donor's sperm, and any embryos that result are transferred back to the same woman's or a different woman's uterus, or else they are frozen, donated, or discarded. *Down regulation* involves blocking the feedback loop that causes the production of hormones responsible for the development and ovulation of a dominant follicle each month and the building up of the uterine lining in anticipation of a possible pregnancy. Ovulation ceases and baseline levels of progesterone and estrogen are reached while a patient is on Lupron or a similar drug. It is thought that the response to the stimulation of the ovaries by exogenous gonadotropins (as happens in stimulated in-vitro fertilization cycles) is better following hormonal down regulation.

10 In all the cases recounted here, I describe strategies of making sense of treatment options based on what I was told or heard or saw in short periods of time usually in the clinical setting. It seems unlikely to me, however, that these strategies present themselves unambiguously to the patients, or that a way of disambiguating these questions in the clinic carries over into all contexts of the patients' lives.

11 The commercial dimension introduces a whole other series of kinship patterns based in particular on class, explored in depth in Helena Ragoné's (1994) book on commercial conventional surrogacy. When biological relationship is crosscut by class—and in the extreme, by notions of property in the person, as for slave owners and slaves—owning the child and thus the donor's or surrogate's reproduction can trump biology. In slavery, rape, and so on, ownership can be a means of the exact opposite: denying kinship.

12 An egg donor undergoes more invasive procedures than the gestational mother: she takes superovulatory drugs, has multiple ultrasounds and blood tests, and undergoes surgery for the ovum pickup. Unlike using donor sperm collected by masturbation, the woman who donates her eggs has herself to become a patient.

13 The ambivalence in feminist theory about the relative virtues of naturalism and social constructivism is entirely appropriate: sometimes important political work is done by socializing what has previously been taken to be natural and deterministic; sometimes the reverse is necessary. What cases like these drawn from infertility medicine show us is that it is not necessary for the theorist to champion one strategy rather than another. Modern medicine gives us many cases where the choreography between the natural and the social is managed flexi-

bly by ordinary people (the practitioners and patients using the technologies in question).

14 It would be inappropriate at this point to claim that Giovanna is simply wrong about what biology is. If she gets pregnant using the techniques about which she is talking, she will be renegotiating biology—the natural basis of life—and the kinship reckoning that coexists with it.

15 This woman was what I would call upper-middle-class and living in a predominantly White neighborhood (like most—but by no means all—infertility patients); I think the relevant notion of "community," given how she elaborated the notion in explaining to me the alternative kinds of mothering, was primarily one based on a shared African American identity.

16 Different cultural contexts for family member surrogacy are important: compare this to a prominent recent case in Rome, Italy. A man's sister gestated his and his deceased wife's embryos and bore a child. There was an uproar in the press, where the predominant opinion was that this was incestuous.

17 In the United Kingdom, daughters are not allowed to be donors for their own mothers because the relationship is seen as necessarily involving a coercive element. Price in Edwards et al. (1993:36–37), recounts the British test case at the end of 1986 that resulted in the Voluntary Licensing Authority's declaring mother-daughter egg donation out of bounds.

18 In the mid- to late-1990s, couples contracting for commercial surrogacy expect to pay about $30,000 in the State of California if the procedure is "traditional/conventional" surrogacy (the egg comes from the surrogate, and the procedure is artificial insemination), and about $50,000 if IVF is involved, as in gestational surrogacy. As well as the approximately $12,000, some couples also pay the surrogate's expenses and make up the difference between the amount the surrogate makes on disability and their previous salary to compensate for lost earnings. The surrogate gets $500 for each attempt and does not get the balance unless/until she becomes pregnant.

19 Ovum, or egg, pickup or retrieval is the surgical procedure whereby eggs are taken from a woman's ovaries for in-vitro fertilization—usually done using a double lumen needle attached to the side of a vaginal ultrasound probe which is passed transvaginally to the super-ovulated ovaries; the follicles are punctured and drained one by one, with the needle collecting the eggs from the follicles.

20 According to the Catholic Church no part of human reproduction can be made transparent. Every part of the process must be opaque, tracing a trajectory of ownership and presence at all points.

References

Catholic Church, Congregation for the Doctrine of the Faith. 1987. "Instruction on Respect for Human Life in Its Origin and on the Dignity of Procreation." In *Gift of Life: Catholic Scholars Respond to the Vatican Instruction*, edited by Edmund Pellegrino, John Collins Harvey, and John Langan, 1–41. Washington D.C.: Georgetown University Press.

Edwards, Jeanette, Sarah Franklin, Eric Hirsch, Frances Price, and Marilyn Strathern. 1993. *Technologies of Procreation: Kinship in the Age of Assisted Conception*. Manchester and New York: Manchester University Press.

Farquhar, Dion. 1996. *The Other Machine: Discourse and Reproductive Technologies*. London: Routledge.

Flamigni, Carlo, et al. 1994. "Oocyte Donation Programme: Implantation and Pregnancy Rates in Women of Different Ages Sharing Oocytes from a Single Donor." Paper presented at the American Fertility Society annual meeting, November.

Haraway, Donna J. 1997. "Universal Donors in a Vampire Culture: It's All in the Family. Biologi-

cal Kinship Categories in the Twentieth-Century United States." In *Reinventing Nature*, edited by William Cronon. New York: W. W. Norton.

Jaeger, Ami S. 1996. "Laws Surrounding Reproductive Technologies." In *Family Building Through Egg and Sperm Donation*, edited by M. Seibel and S. Crockin, 113–130. London: Jones and Bartlett.

Ragoné, Helena. 1992. *Reproducing the Future: Anthropology, Kinship and the New Reproductive Technologies*. Manchester: Manchester University Press.

— — —. 1994. *Surrogate Motherhood: Conception in the Heart*. Boulder, San Francisco, and Oxford: Westview Press.

Strathern, Marilyn. 1992. *Reproducing the Future: Essays on Anthropology, Kinship, and the New Reproductive Technologies*. New York: Routledge.

Strathern, Marilyn (project director), and Sarah Franklin (research coordinator). 1993. "Kinship and the New Genetic Technologies: An Assessment of Existing Anthropological Research." Report compiled for the Commission of the European Communities, Medical Research Division (Human Genome Analysis Programme). Submitted Jan. 1.

Witches, Nurses, Midwives, and Cyborgs

IVF, ART, and Complex Agency in the World of Technobirth

Steven Mentor

■ MY CHILD IS A CYBORG!

Late-twentieth-century technoscience lends itself to locutions out of the *National Enquirer* ("Woman Gives Self Cesarean") and the *Sun* ("Gorilla Has Human Baby"). My wife Margann and I have struggled with both infertility and its "cures" for many years, and our experience with in-vitro fertilization (IVF) could easily yield similar headlines: Doctor Suppresses Woman with Her Permission! Pornography Found in Andrology Lab! Miracle Process Harvests Eggs from Inside Woman's Body, Then Puts Them Back!

Regardless, here are the facts: female infertility leading to high-tech surgery, followed by "natural" conception and then "unnatural" ectopic pregnancy, followed by even more high-tech medicine, followed by "unnatural" conception and then natural pregnancy, all coming to a head (!) when our baby, Bailey, emerged from his mother at 4 A.M. on Summer Solstice, born at home with midwives attending.

His first view of life on earth was his father's face peering down at him, and the ceiling fan.

So our first narrative genre is a comedy: all's well that ends well, as you like it. I could show you pictures. And the pictures would do what all pictures do: make some things visible at the expense of making other things invisible. We don't have pictures of the daily needle injections or the laparoscopic view of Margann's ova follicles, though we do have the quintessential '90s baby artifact, Baby's First Ultrasound. These pictures side by side in the wallet would show the ghosts in the machinery of reproduction: behind the organic coherent body, an entire techno-journey through the interior of the uterus before conception, the endometrial lining as jungle/future cultivated land.

Or I could tell you stories. But is IVF a comedy or a tragedy? Romance of

miracle technology or farce of Frankenstein human reproductive and genetic engineering? Consider, if you will, a (not the) primal scene. Fall 1995. My wife is lying on a hospital bed, sedated with Versed. It is nine in the morning by the large clock. The room is square, white, and chrome. In the room are a nurse, an andrologist, a patient's advocate. Also in the room are a fine needle attached by Teflon tubing to a transvaginal ultrasound probe and a vacuum regulator and pump. We're waiting for the doctor to arrive and aspirate Margann's hyperstimulated egg follicles. The andrologist wheels in the humidi-crib—the thirty-seven-degree controlled environment box the eggs will end up in—containing a stereomicroscope and petri dishes. I chat with the nurse, with the andrologist; they chat with each other. In a back room the radio is on; it's playing classical music of some kind: loud but low-fi.

As the minutes pass I find myself split between two worlds and two paradigms for this reality. On the one hand, I am trying to stay present emotionally for my wife; this is a serious if not necessarily life-threatening procedure, and it will involve some degree of pain for her. So I hold her hand, stroke her forehead, worry, try to stay calm. At the same time, I'm drawn into the surgery room banter. Television remotes; the nurse tells a story about how men control them, always flipping between stations; the andrologist confirms this, telling a funny story about her husband; I defend channel surfing, so does the advocate, and there's a lot of laughing and teasing of the male doctor when he arrives. He starts to rib the andrologist. . . .

And all of a sudden I'm in the Twilight Zone. It's not a hospital, it's a . . . garage! And my wife is the car and these are the grease monkeys, down to the bad radio blaring and the power tools. I feel a surge of anger at this; how could they treat my wife's body as if it were a machine? Then I waver—no; it's just that they've done this so many times it is mechanical for them. It shows confidence, not disrespect. After all, I'm in their shop.

The entire time I flip back and forth between worlds. The body and/as the machine; machines and humans making humans by turning humans into machines; my wife's body as an organic, whole thing and as a car up on blocks. The heroic humanism of a symphony—Brahms First?—pathetically reduced, bravely escaping the tinny speakers of a little music machine; the amazing ultrasonic vision of human ova delicately enticed out along a tube, each journey ending with the terse "Got it" of the andrologist bent over her microscope. Each time we hear it, we as a group get that thrill, and I get the ghost of a chill.

This complex set of feelings, this hybrid of machinery and human bodies—this is a primal scene of IVF. Following Bratton (1995) I argue that our relationship to reproductive and most other technologies in the late twentieth century is fundamentally schizophrenic and ambivalent. Different voices tell me that IVF, for example, is simply science giving infertile women and men

more choices, or simply science making progress in knowledge and over igno-rance/s, or simply patriarchal eugenics or techno-apocalypse. Each voice, each text wants to keep its body pure, its boundaries intact, but just as women's bodies are dis- and reassembled in cyborg technologies of reproduction, so too linguistic bodies representing these technologies fragment, circulate in a larger linguistic economy, trade metaphors, and transform figures. It is this parallel linguistic economy that I wish to invoke/explore; within this economy, strategies of naturalization and legitimization are crucial, for they reveal the always/already constructed nature of birth as well as its cyborgian transformations well under way (Clarke 1995).

Late-twentieth-century humans—some privileged ones—are faced with staggering decisions: which transforming technologies to use, when, on whom and with whose permission, for whose benefit? Much of the ethical debate surrounding IVF ignores the politics of its language. Naturalizing strategies obscure the shadows of a technology; in turn, resistance strategies that rely on apocalypse narratives often miss the textual resonances and figural depth of naturalized technologies, and thus often fail to raise objections effectively (Killingworth and Palmer 1992; Cohn 1987). I want to suggest a notion of cyborg competencies: an ability to see the myriad ways humans are intimately connected with technologies (including textual and representational technologies), and to make decisions based on a more hybrid, intertextual notion of meaning/s making. Seeing, for example, both hospital and home birth as sites of technologies, many of them subjugated knowledges, may help us depathologize reproduction and birth, placing it along a continuum of technologies. The alternative is schizophrenic dual dystopias, where conception, gestation, and birth are routinely hospitalized, narrated, and surveilled by high-technology, de facto genetic engineering, and protocols of paranoia, while homebirth is further criminalized, its technologies driven more underground.

■ CYBORG RHETORICS

Off of/into the supposedly coherent body of IVF jut various textual prosthetics: medical realism mixing with science fiction, discourses of animal breeding, eugenics, progress, marketing, all violating each other's boundaries. The "object" is a collage whose figures become ground for other figures, a discourse that constantly disassembles and reassembles genres (Ulmer 1983).[1] The cyborg figure helps us see IVF as a hybrid of human and machine, of physical practices and textual practices. IVF combines old and new reproductive technologies, modern and postmodern economic constructions, multiple genres of representation and rhetoric (including "organic" narrative bodies and "systemic" scientific rhetoric that end up shading into each other). Cyborgs are

made, and help us see, retrospectively, the constructed nature of conception and birth, their narrative technologies and conflicting genres, and, prospectively, the processes of "naturalization" that alien biotechnologies (and their equally alien resistances) undergo. Successful technologies mobilize multiple narratives along networks that reveal economies of (asymmetrical) power. Any attempt to resist or modify IVF and reproductive technology will have to confront the network of legitimizing narratives and also take responsibility for its own technologies of birth, even those dubbed "natural."

Both journalistic and academic approaches to reproduction pretend to stay within generic bounds, ignore internal contradictions in favor of false closures, and fail to explore the situated knowledge of their production. Technology like IVF is overdetermined, a network or confluence of several types of narrative and discourse tied to larger cultural narratives (Davis-Floyd 1992). Therefore my writing wants to be a cyborg to simulate that confluence, to immerse us in different types of narratives and generic representation and its effects, as well as continually search for both political analytic and critical clarity (which technology, which control or choice or transformative ability is good for whom?) and move toward finding silences and suppressions and shadows of current biotechnological "advances." Rather than ex-plain (i.e., "flatten") contradictory voices and narratives, by choosing one voice or story to be master, I want to immerse you, gentle reader, in these contradictions, while also deploying, *bricoleur*-like, different tools of discourse analysis, to periodically pluck us out of the flood/network for a moment. The goal is not to hang, de-pend, on the purity of analysis, but to catch our breath for the inevitable reentry into the net of discourse, the schizophrenic stream of voices.

IVF and reproductive technology as a conceptual body are invaded by all sorts of prefiguring discourses, including the abortion debate (when does life begin? when is an embryo a person?), genetic engineering (with its implications of engineered life, controlling reproduction at the microscopic level), embryo research, eugenics, and animal husbandry. Just as technologies and techniques circulate now through the body of human reproduction, terms from these discourses circulate through the linguistic economy of IVF. This intertextuality mirrors the strategies of feminist and other resistances to the medical and pathological models of pregnancy: both are hybrids that borrow from widely differing genres and discourses.

This doesn't mean that IVF or genetic engineering or homebirth are "just" language. Discourse analyst Michael Shapiro (1988) argues that "social practices are always mediated by modes of thought which are themselves practices whose immediate expressions are linguistic." Because IVF is a relatively new body of knowledge, we can witness the construction of privileged representations, within scientific texts and crucially within science journalism and pop-

ularizations of IVF. Shapiro stresses looking at the "social depths" of certain forms of representation (in this essay, gambling and miracle metaphors). Potentially monstrous (because alien) languages are normalized and naturalized, partly by borrowing from other, uncontested "lending discourses" (Clarke 1995; Shapiro 1988). We need to ask *why* particular figures and metaphors are dominant, why others are subjugated. Linguistic productions/fictions are zones of contested meanings: is it "genetic engineering" or "biotechnology"? Is IVF therapeutic or experimental? Is it driven mainly by concerns for women or for fetuses? When IVF discourse borrows from "lending" discourses that everyone participates in (gambling, miracles), the contested nature of IVF falls away, leaving only naturalized forms of the "real" IVF (including what I call "medical realism").

So to understand IVF we must historicize the production and acceptance of prevailing representational practices; and we must understand the economies of those representational practices, ways they achieve their value effects. What lending discourses lend is precisely social depth, global currency, the effect of the "natural." This means that to contest dominant figures and narratives, one must produce alternative networks, themselves impure, constructed, cyborgian collages. We might ask, What competing ways of narrating IVF exist? One alternative to the metaphors of gambling, apocalypse, and pathologized birth I discuss below is the notion of cyborg competencies. How are different people able to tolerate contradictions in the discursive modes through which thinking about IVF is produced?

■ THE ART OF THE DEAL: MEDICAL REALISM AND CORPORATE CYBORG WRITING

When Margann and I leave the IVF clinic, we leave with a lot of reading, including one of the ubiquitous Serono pamphlets on infertility therapies. It is exactly the same size as *Witches, Midwives and Nurses* (Ehrenreich and English 1973), and so the two texts sit side by side on my bookshelf for the duration of the IVF cycle and subsequent pregnancy. I now think that the Serono pamphlet is one side of the Janus-faced medicine that Ehrenreich and English discuss: the sober, clinical, reasonable, careful prose of Science. It reflects a master Fiction: that science is beyond fiction, beyond the rhetoric of persuasion.

Alan Gross argues that scientific discovery (such as the discovery of infertility therapies) is properly described as invention, where invention "captures the historically contingent and radically uncertain character of all scientific claims, even the most successful" (Gross 1990). And implicit in all scientific texts is persuasion, because only through persuasion are importance and

meaning established in scientific inquiry. I want to ventriloquize the pamphlet as a technology, make it speak its unspoken strategies that lie behind its powerful reality effects.

The pamphlet is titled *ART: Assisted Reproductive Technologies*, by Serono USA Symposia. Serono is in a smaller font, as an author would be; but below this is a large logo SERONO, with a corporate motto ("The world leader in infertility therapy"). This same logo is repeated on the back, along with a graphic depicting (presumably) the nuclear family. The graphic deserves some comment. The heads of the two parents are schematic enough to be any race, even any sex; their mouths are separated from their faces by the outline of the child's head, creating a surreal image of infertile couples as expressionless and fertile couples as returned to language and expression. The child's head is in turn trisected by the jaw lines of its parents. Sitting in the clinic waiting room, I stare at it as if it were one of those images that defy one reading: the young woman and/or the old crone. Two faces or a goblet. But I kept seeing the picture of a child who has been assembled: brain section, face section, with a middle headband section that could also be a helmet. The whole square resolves into a jigsaw puzzle of fragmented humans, which ends up being a fairly accurate image of IVF technology in a cyborg world.

When you open the pamphlet, you see what looks like a preface by the author but is really a discussion of the authors (Drs. Asch and Marrs) by the authorizing institution. In case this isn't clear after reading, the authors' names are boxed in the left-hand corner of the inside cover. If the authors represent the human face of IVF therapies, they in turn are actually authorized (or in the terms of the preface, "produced")[2] by the economic bodies of corporate and academic biotechnology. The pamphlet's scientific prose, with its rhetoric of factuality, is always/already embedded in a deal: you are reading this in order to buy or not buy a therapy. Serono Laboratories is the sole purveyor of Pergonal (a widely used fertility drug) in the United States, though the pamphlet somehow fails to mention this. Doctors and drug laboratories underwrite each other, write under the authority of each other. Cyborg authorship allows a convenient confusion between doctor and corporation, therapy and sales.

This confusion is repeated with the acronym ART. The cover refers to *assisted* reproductive technologies, but everywhere else in the pamphlet ART means *advanced* reproductive technologies. This isn't accidental. *Assisted* is so much more user-friendly; its etymology is from the Latin *sist*, "to cause to stand" *ad*, or "toward"; hence, "to stand by someone." In this case ART is standing by (ready to be used, but never pushy) and will stand by women and men suffering from infertility. Amazingly, "assisted" is used only twice, once on the cover—this is the face of IVF—and once on page 14, in a discussion of women over forty, who presumably don't want to hear the word "advanced."

Everywhere else, this technology is "advanced"—where advanced means better than old reproductive technologies (including, of course, the human body) and also advanced in a progression of therapies: "after other surgical and hormonal methods have failed." Advanced is from *van*, "the front of an army," "avant garde"; with *ad*, Latin for "toward," one imagines the Serono corporate army marching behind a banner reading "the last and best hope" (Serono 1992:i). Or perhaps this is the late-twentieth-century avant garde of medicine, fulfilling the surrealist project of a marriage of ART and science! The scientists are ARTists, and they produce artworks (children) from materials at hand, even throwaways. In fact, read with only slightly squinted eyes (say, after a day of hospitals and injections), the book can simply be a surreal manifesto on art: "ART—Alternatives" involve IVF, GIFT, ZIFT, cryopreservation, and so on. The posthuman body here, as in so many cyberpunk novels, is canvas, assemblage zone. "To prepare the body for . . . ART, various hormonal medications are used alone or in combination" (Serono 1995:5). This can be read either as a prediction about twenty-first-century museums or as a forbidding surrealist character: ART as the corporate doctor, the virile high-tech Father.

More seriously, the pamphlet assumes a fairly high degree of education on the part of the reader—and this is borne out in many studies of IVF patients as "advanced" in their experience and medical knowledge (Crowe 1987; Modell 1989). The text discusses human fertilization, ART procedures, and reproductive technologies in detail, anticipating and constructing the doctor's own discussions with patients. The effect is one time-honored in medical language, what Alan Gross (1990:42–43) calls "overdescription"—defined as "the characterization of sense objects in detail far beyond a reader's ordinary expectations." It creates a "referential presence" which connects with literary realism in that it seems to present language unproblematically in relation to the real world. I call this *medical realism*. Medical realism thus produces the "effect of the real" (Barthes 1986) while hiding the persuasive elements of the text.

For example, the pages in the ART pamphlet are filled with the language of science textbooks and experiments, the language of denotation. Detailed, staged procedures fill the pages, and fill one's visual and mental field; the initial topic that brought readers to such a text, "infertility," is transformed into a series of techniques which we readers witness, techniques based on the real: the real way women's bodies produce eggs, the real technologies deployed to overcome infertility, all in the constrained, objective language of scientific description. But as Shapin and Schaffer show (1985), this description is strategic, generic, borrowed from juridical discourse, and deployed in a complex argument over the nature of science, rhetoric, political power, and Truth. Tracing this strategy back to the experimental writings of Robert Boyle, they argue that exhaustive overdescription in science writing attempts to reproduce the conditions of witnessing the event of the experiment for readers, to

persuade "virtual witnesses." This tradition of experiment rhetoric continues in the language of the Serono pamphlet, which begins with a detailed discussion of fertilization, then moves seamlessly to ovarian stimulation, monitoring, egg recovery. We witness (as if in a laboratory) first the microscopic rupture of egg follicles in natural fertilization, then the administering of hormone medications, the measuring of estradiol concentrations in the blood, the insertion of the aspiration needle. The agents in this continuum of description are not human, and the prose style seems to speak in "their language"—the language of follicles and needles alike, the technical language of the laboratory. The genre of medical realism is used to construct IVF on the same level as organic reproduction, that is, as "Nature." Overdescription appears exhaustive, and in this lies its ability to persuade us of the legitimacy of IVF procedures. The writing produces the effect of the unproblematically real, rather than the chosen or the experimental.

This "reality effect" has several effects on readers. Witnessing the several acts of the drama of conception, we accept this representation: we see how conception "really happens." When we turn to the descriptions of IVF, this ultra-high modality carries over; this is how technoconception really happens, not how technoconception has been experimentally constructed. Also, scale becomes important; the same powerful technologies that unveiled the mysteries of conception (microscopes, needles, machines for measuring) and rendered the invisible visible are involved in IVF procedures. Below the human-scale realities of in/fertility lie the sublime truths of the microscopic; this is the message of the ART pamphlet's modes of description. One can only petition those who have access to such truths.

Medical realism conflates scientific factuality with generic rules of the (scientifically) beautiful description; such texts are persuasive because they forsake the typical rhetorical techniques of persuasion. As Barthes puts it, "denotation is . . . the last of the connotations . . . the superior myth by which the text pretends to return . . . to language as nature" (Barthes 1974:9). The linguistic technology shows me the IVF procedure but also implants stories and arguments about IVF that are hidden to the eye: natural conception is really a technological process; IVF is a benign process much like natural conception; IVF is contained in the space we call human infertility and circulates in no other contexts; IVF is based simply on the "real" of reproduction. The genre is literally "in vitro," a rhetoric of glass: it promises complete visibility but in fact operates at a level invisible to most readers.

In addition to the effects of medical realism, discourse analysis shows us other implicit strategies used to disguise the persuasive elements of science writing. The Serono text assumes that the ideal reader is a patient-consumer who wants to choose between technologies; it puts possible risks in the least prominent places textually and downplays those risks. Locutions generally

erase women and instead focus on their parts: ovarian hyperstimulation syndrome (OHSS), for example, "causes enlargement of the ovaries accompanied by abdominal discomfort and/or pain. In severe cases additional symptoms may require hospitalization of the patient." Ovaries and symptoms first, patients last. The problems associated with ovarian stimulation are not given a separate heading but instead are buried in a long paragraph which sandwiches OHSS between shift of responsibility ("talk to your doctor") and reassurance of no increase in birth defects. Dangers to pregnancies and fetuses eclipse parallel dangers to the women who carry fetuses while pregnant; doctors and technologies have agency, while women are patients, implied or in the object position.

This may be another "real" meaning of assisted: women are bystanders, or, worse, they are made to "stand by" the technologies, to contribute to advances in medicine. In fact, the actual fertile field in the pamphlet is the proliferation of technologies: ZIFT, GIFT, MESA, PZD.[3] There are no pictures of women undergoing IVF or the related procedures, but we do see diagrams of laparoscopy and ultrasound aspiration. Potentially the field of IVF is narratable as invasive, Frankensteinian; thus, one of the burdens of IVF narratives is to normalize or naturalize its existence. After an overview of the new reproduction technologies, bristling with acronyms, the Serono pamphlet provides "a review of 'normal,' 'natural' fertilization, and the basic elements of the ART procedures. . . ." In this locution normal is marked, abnormal, while the procedures in the ART pamphlet are normalized and naturalized as "basic elements." In addition, the same style and modality of language—medical realism—is used to describe the process of fertilization whether assisted by technology or not, so that retrospectively the "normal" reads as technically as any technological procedure. As IVF is naturalized, women are technologized even in their "natural" reproductive state; as a result, all women in reproductive science are "cyborged."

Accompanying this process is an erotics of language. As Carol Cohn (1987) points out for nuclear discourse, even "resisters" must learn the complexities of the language, the acronyms and theories, in order to speak at the table. This seductiveness gives one the illusion of power and control—at the same time that it makes impossible certain questions one had before. The Serono booklet surrounds prospective IVF patients with the tools to appear knowledgeable, even completely so, before they enter the Final Phase of their search for fertility. I recall many discussions involving HCG levels, live pregnancy and take-home baby rates, even OHSS risks. One feels a strange pleasure in talking about the highest technologies; it combines the communality of computer worshippers with the desire for control over the technological body that is about to envelop and invade your own. This techno-pillowtalk is the erotic foreplay before the technological coitus.

While some of us experience IVF "from the inside" (by reading technical explanations such as the Serono pamphlet, having similar conversations with doctors, and ultimately subjecting ourselves to the procedures), most people know of IVF through magazines and television. Here we find the technical, apparently nonnarrative text of science wedded to the organic narratives of science journalism and the popular press. In these media the implicit persuasion of scientific prose is made visible, narrated, while remaining separable from (prosthetic to) the purer body of Science. Much of the early popular discussion of IVF, beginning with the "miracle baby" of Louise Brown in 1978, has been epideictic (concerned with praise), whereas professional science writing appears forensic (concerned with fact) in its bid for medical realism. And this praise is complex: doctors are doubly articulated as heroic and humble, miracle workers and careful men of science. This carefulness can be and indeed must be narrated as epic (overcoming all odds) and quest (the doctor's search for Truth merging with the infertile woman's search for fertility, translated as "our" society's quest for advanced medicine) in order to transmit the persuasion embedded in all science writing.

Popular accounts of IVF often praise the doctors and the technology at the expense of women's bodies and experience; this erasure of women persists when the inevitable happens, when the miracle technology fails as a secular miracle, when the inflated truths deflate. In this case journalism has other organic narrative bodies: the tragedy and its diminutive cousin, the farce. Dr. Ricardo Asch, one "author" of the Serono ART pamphlet and inventor of the GIFT technique, is now a protagonist in the UC Irvine fertility clinic scandal. He and two other doctors are charged with unapproved experiments on patients, falsified research, insurance fraud, and stealing human eggs (in this case, ART mirrors art: this is the farcical central plot of the film *Junior*). According to the university, Ash and his colleagues took donated eggs from fertile women and, without their knowledge or permission, used these eggs in other women.

News stories about this case, like Ellen Hale's "God's Work" (1995), focus on the men: "They were young, handsome, rich and respected throughout the world for helping thousands of childless couples have babies" (Hale 1995). Dr. Asch reportedly was often introduced by a colleague as "a man whose goal in life is to get every woman pregnant." The miracle stories of early IVF turn easily into stories of the Fall, of mere men-doctors who play God (the role they are cast in), usurping God's work. Playing God means ignoring the rules of these doctors' real authors, in this case the university which, like Serono, rakes in millions from the doctor-medical center arrangement. As I show later in my discussion of animal husbandry and IVF, generic "playing God" narratives like the Frankenstein or Faustian myths serve to hide the godlike roles played by hybrid, "cyborg" institutions.[4]

The article frames the scandal as both "high drama" and as a cautionary tale, the latter acknowledging that IVF in the United States lacks proper oversight. Hale quotes Dr. Stanley Krenmen, who suggests that the case is a "Greek Tragedy" complete with "little gods" and the breach of trust between doctor and patient. Perhaps Dr. Kremmen has in mind Oedipus (whose lands and people are infertile) or Hippolyta (in which the maddened women tear the male protagonist to pieces). But whether tragedy or quest, story of praise or story of blame, the organic narrative highlights individual error while maintaining the boundaries between medical realism and its prosthetic, changeable rhetorics of persuasion. Both the pamphlet and the subsequent scandal serve to naturalize IVF discourse, make it thinkable, give it the semblance of the human even as it dis- and reassembles the human.

■ LEAVING LAS VEGAS

Journal entry: September 1994. Today we spoke with our doctor about undergoing IVF. We are a little too bright, like nervous beginners at a high-stakes poker table, and we admit it. Our doctor talks about the psychology of "the last chance." Up till now nothing, not even the high-tech operations and infertility work, has been the last chance. Laparoscopy and laparotomy had been aimed at allowing "natural" conception, which unnaturally ended up in an emergency ectopic surgery. We have come down to three choices: in vitro, or risk another ectopic, or accept the limits of, the betrayal of, the body, and adopt. So the in vitro has a lot riding on it, and this is very emotionally trying. What did he say? I can't remember; all I remember is the gambling metaphors. The last chance; the last roll of the dice; betting it all emotionally. And this gambling is the highest stakes I'll ever play: after a certain point, you have to pay $8K to stay at the table, and to win you bet against a House that holds 70 percent odds (at least). This gambling metaphor tends to obscure others: your chance at winning the lottery renders invisible the emotional costs of buying all those psychic tickets every day. The emphasis is on blind luck, on all this technology coming down to just upping your chances from none to slim on the biological craps table. And you have to keep winning; it isn't a single throw, it is one throw (suppression) and another (hyperstimulation of ovary production) and another (successful harvest) and another (successful fertilization) and another (successful reintroduction of ova) and another (successful implantation on endometrium). And another (carrying the child to term without miscarriage). And another (successful birth). How do you handicap a miracle?

Gambling and miracles: both the popular press and participants in IVF use these discourses not only to make sense of potentially alien technologies but also to gain a kind of rhetorical control over the experience. Researching

media coverage of women over forty having babies via IVF ("miracle" babies by women betting against time), I came across a *Time* magazine article (Andersen 1994) proclaiming Las Vegas as the new all-American city: "America has become Las Vegasized." The Temple of gambling has gone family: Luxor and MGM Grand have built Disneyesque worlds around the gaming tables, and the article displays a toddler in backpack accompanying Dad into the blackjack parlor. A photo of hands and chips bears the caption "A nonstop flow of insane hunches and wishful superstitions."

Anyone who has dealt with infertility will read such an article with a strange sense of déjà vu. In vitro fertilization in the United States is figured, narrated, contained, and contested with gambling metaphors. I remember saying over and over, "Yeah, we just put down $8K on one roll of the dice" as a description of our IVF cycle. Kids and odds circulate in the same linguistic economy, days in the hospital merge with nights at Circus Circus. Standing in front of a slot machine, dropping coins in, and pulling: the illusion of doing something, but the ultimate passivity. At a certain point in the discussion of fertility odds the doctor casts the shadow of an oddsmaker, a blackjack dealer calmly stating the odds to the next player/mark.

So what *are* the odds? Worse than a scratch card for most: numbers vary, but the American Society for Reproductive Medicine puts the United States birthrate per IVF treatment cycle at 21.2 percent (Begley 1995).[5] Percentages go up with the number of embryos transferred, but so does the risk for multiple pregnancy, prematurity, and perinatal mortality. It doesn't help when IVF clinics advertise rates based on pregnancies rather than live births (Feldman 1988, Raymond 1990, Spallone 1987, Winston 1993); at least in Vegas, when your number comes up you win money every time. In fact, among the infertile there is a neverending search for the right game, the clinic where your odds are best, where your miracle has the best chances of defeating chance.

If you feel the preceding language has been flip, glib, cruel even, you are right. Anyone who has dealt with infertility would sense all that is missing from this description. In fact, the gap between the gambling metaphor and narratives of conception and reproduction defines some of the schizophrenia of IVF, a cyborg schizophrenia. In "Last Chance Babies," Judith Modell argues that the discussion of "odds" in IVF reflects differential rhetorical strategies of medical experts and patients (Modell 1989). On the one hand, IVF patients know an unusual amount about bodies, medical condition, and available treatments. They could count as particularly powerful patients. But the rhetoric of "odds" has different emotional valence for patients (our own child) and doctors (the success rate of our procedures).

Modell cites the odds language in ways that bear out my own experience: doctors frequently refer to Vegas, roulette wheels, IVF as a gamble with no sure outcome. When doctors use this language, they put risk primarily as los-

ing money "which [has] the unforeseen effect of downplaying the medical risks (e.g., of multiple births) outlined to patients before they entered the program" (Modell 1989:129). In "The IVF Roulette—Helping Your Patients Beat the Odds," Paul Feldman extends the metaphor to include women's emotional "stakes" (inconvenience and pain, the trauma of failure), but his trope leads him to argue mainly for the regulation of published IVF success rates (as in other forms of gambling) and against premature IVF diagnosis: "Does the one attempt at GIFT entice the patient to repeat attempts at GIFT just as the losing roulette player keeps putting down more and more $5 bills after each spin of the wheel?" (Feldman 1988:5).

Modell (1989:130) argues that patients, unlike doctors, don't "think of IVF as one gamble among several—and a better one than Las Vegas." Instead, the stakes seem to involve everything, including one's identity and dreams: IVF is the end of road, the last chance, when I play all my cards with nothing to lose. In this context, optimism is essential for continuing (I only need to win once), and while doctors see this as naive, it isn't hard to see how it is also the pull, the hook into the baby casino. Under these narrative circumstances, IVF looks like a particularly bizarre cyborg technology. The body has let me down; its "meat" must be transcended; it needs technology to even become meat again, an animal capable of reproducing. So I come to reproduction's Las Vegas and bet a wad on complex biotechnologies, which I constantly handicap with/against my own body in the "medical real" version of the racing sheet.

The rhetoric of gambling here merges with the rhetoric of medicine; IVF is a technique, an application of technology, but it is also an intense merging of technology and body narrated as a gamble. Notice that this is different from the narrative of risk: for example, the risk of OHSS, of multiple cycles of drug treatments, of using a technology in its infancy. As a gambler I retain a sense of agency, even if at a slot machine; I don't think of myself as a guinea pig or a victim.

Symbiotic with gambling and reproduction are magic and miracle. Vegas is the capital of stage magic in the United States; magic and gambling are rooms in the same temple. In *Tonight! Miracles, Live!* magician Penn Jillette (1994:49) suggests that magic is one of the few things that must happen in real time, that doesn't work on TV: "Miracles have to be seen live." Change the pronunciation of "live" and you have IVF: beyond the spectacle of miracle babies in the press, beyond the IVF magician sawing the body in half, if your gamble pays off you experience the magical: a child who lives, a living miracle, which then transforms your life utterly. Part religious rhetoric, part stage rhetoric: explicable via Serono pamphlets and yet miraculous: for me, a plastic strip turning colors replaces the body and blood as sign for the shock of the magically real.

In this case we can let the pregnancy test qua artifact speak. "Hope and Fear as Marketing Tools," an article from *Forbes* magazine (Koselka 1994), quotes the head of Quidel Corporation on why his company's Conceive pregnancy test (with a smiling baby on the package) costs more than his company's RapidVue, an identical product with plainer packaging: "'The market definitely divides between the women who want babies and those who don't,' explains Quidel Chief Executive Steven Frankel. The smiling baby sells for more than the plain-wrapper product because 'It's like what Charles Revson said about cosmetics: People buy hope. In our case, they pay more for hope than for possible relief'" (Koselka 1994:78).[6]

Gambling metaphors for IVF circulate in a larger linguistic economy that gives it "depth" in this culture. Attempts to pose ethical issues by purifying technofertility discourse into either cost-benefit-risk or religious language will fail to plumb these hybrid depths.

■ HUGH GRANT'S EPIPHANY AND MINE: ULTRASOUND NARRATIVES

I'm assuming Hugh has had more than one epiphany, actually: this one refers to the divine moment in the film *9 Months* when the heretofore-terrified child psychologist is won over to the True and Good (the reality of his responsibility to mother and child, and the sudden realization that he *wants* this new responsibility) by confronting the ghostlike vision of his developing child on the screen of an ultrasound machine. Everything in the film turns on this moment; it is his rite of passage into fatherhood and, in some ways, adulthood. Suddenly, the invisible becomes visible, the unreal real; the fetal deity appears to the unwilling Mage, and he becomes a wise man instead of just a wise guy.

Margann and I have undergone so much ultrasound imaging we could be poster children for the med tech community. I've traveled in amazement into my wife's body, first looking for signs of pregnancy, then signs of a heartbeat; then the screen showed, instead of a bouncing baby fetus, an ectopic pregnancy. The suddenness of the shock—a picture on a screen, the physician's face, and within minutes we are preparing for surgery. And all that was before IVF: ultrasonic trips into the uterine world, scanning for ova development; then watching ultrasound guide the harvesting tube into place, literally seeing the resistance as embedded egg follicles and aspiration vie for dominance.

Finally, my Hugh Grant moment: after technoconception, after the little plastic pregnancy tests passed us, we are in a room looking for a fetus, looking for normality, a heartbeat, the right shape. The tension is thick: my wife, myself, our midwife friend, the technician, and the doctor, all waiting for the electronic curtain to rise on either a comedy or a tragedy. The machine is turned on— and we see nothing; the technician moves the probe, and we see nothing, noth-

ing—and then, right off the pages of *Life* magazine, a living being—fetus, baby, nipper—the whole room erupts. Screams, yells, the whole decorum of Medicine broken, as if we were watching a baby being born, or the climax to a particularly suspenseful film. Like a computer switch, like a byte of drama, this was on/off, yes/no—and the answer is yes, alive, moving.

I want here to convey the awe-fullness (Romanyshyn 1989) of ultrasound technology. We were all amazed, in awe—in a world that values sight over sound and other senses (including the feeling, perhaps, of carrying a baby), seeing our baby alive was a kind of miracle of reassurance and existence. This was magic, the making visible of the invisible world, and perhaps as importantly, the "direct" representation of the invisible insides of female fertility (see Mitchell and Georges, this volume). The moment reframed the experience of the pregnancy for Margann, certainly: from a mark on a plastic stick, a set of readings, to a body image, in real time, and an affirmation of her hopes. The power of the surface image here is the power to tap depths—of fear, of hope, of the abyss of not knowing, fears of every parent. But I keep thinking back to Hugh and the male gaze of cinema: this was my first vision of my child, a vision "unmediated" by Margann's own reported experiences, or plastic sticks.

Let's look at this looking. First, Margann is lying on a table as the technician/doctor manipulates the transvaginal probe; as the screen flickers on, all of us, including Margann, are looking at it, away from the literal location of the fetus/child (i.e., in Margann's belly). The externalization of the image takes the "real" from inside her and reframes it as a medical movie, over here, subject to various manipulations (using point and click computer technology, the doctor measures, freezes frames, downloads the pictures). At that moment the screen is a virtual forceps, taking the baby out, but also taking the kinds of knowledge of the baby out of the mother and replacing them with technical knowledge. In this sense the ultrasound is simply a metonym for the technocratic medical model of reproduction and birth (Davis-Floyd 1992): as one form of bioknowledge ascends, another descends, to become Foucault's "subjugated knowledge." Ultrasound (even the name sounds '90s—etymological kin to ulterior, ultimate, and outrageous) not only externalizes images, it autonomizes them. It is no accident that the fanatic fetalism of the late twentieth century has used such images as this (my son!) to reassert patriarchal control over "life"—as one feminist puts it, everywhere you look there are fetuses but no women (Laborie 1987). The image on the screen vibrates inside an electronic virtual womb, kept alive not by the mother (over there) but by the on-switch, brought into view not by birth but by a turn of the probe, now appearing, now disappearing.

External, autonomous—and real. This is the third term of Hugh's epiphany—ultrasound combines the "realism" of photography with the real-

time experience of motion, in an age defined by televisual and screen environments (Hartouni 1992). These images take linguistic medical realism one step further: that "really" is the baby, the uterus, the umbilical cord. The depth of a mother's insides, both literal and experiential, are exploded, flattened into a surface image, the sublimity of deep ocean space caught on a fifteen-inch screen. But the very mimesis of the image is what twentieth-century theories of representation call into question: is this really the interior in which babies survive? The interior which women carry, define, sense, imagine? No—and yes.

The medical model as villain; patriarchal medicine using technology to wrest even reproduction from women's control—this is an old story. But the combination of realism (as a genre of representation) and externalization in ultrasound reflects a replacement of "insides"—depth now resides in the fetal image, reverberating down a new set of discursive networks (fetalism, medical interpretation, elaborate technical protocols), while eclipsing other possible insides (the imaginative moment of carrying a child, quickening maternal body-knowledge). This isn't simply because medicine overwhelms the patient—rather, the embedded realism of TV ultrasound deploys the dominant reality-engine of our time.

By putting women's wombs on the outside and by using photographic realism to render dependent developing babies independent, body-coherent, ultrasound reflects the trend in medicine to render fetuses as individuals and mothers as di-viduals (Mies 1988). Di-viduals are made up of (sellable) parts: wombs (for rent, synthesizable), embryonic tissue for research, eggs. Posthuman women's bodies are exploded, and then reassembled, starting with externalized eggs, for all the king's medicine can't make an egg. Harvested eggs, women as resources for increased embryo research, "scrambled" or cloned eggs; in some senses these eggs, too, gain a kind of autonomy, a commodity identity superior to that of the women who produce them.

Margann and I have pictures of our son at one egg, or rather a microsnapshot of the egg we think he developed from. We have a picture of him at two cells. Oddities to us, these images are not innocent—they have corporate and technical sponsors, they are mobilized in regimes of reactionary politics, they come out of women's bodies partly to threaten those bodies. And they mark the assembly zone not only of future designed children, but also of hybrid discourses for naturalizing genetic engineering and postmodern eugenics.

■ SMART BIRTH, OR "HONEY, CAN YOU CHANGE THE BABY?"

So let's renarrate the IVF story: in the late twentieth century the amazing ability to help infertile couples (almost always heterosexual, Northern, wealthy) and test for fetal genetic disease (amniocentesis, chorionic villus sampling)

overcomes social unease (from feminists of FINNRAGE, church groups, scientists) and results in mass and niche production of recombinant DNA technologies, further unrestricted experimentation on animals, and complex forms of state/corporate/academic body-suturing. Already we have sex identification and preselection, and genetic testing for Down's syndrome, other chromosomal abnormalities, and neural tube defects. These allow for a crude quality control (from ending a future Down's baby's life to modernizing the practice of female infanticide) and aim at "whole" natural babies. But gene manipulation of human embryos is on the horizon, as many have pointed out (Ewing 1988; Bradish 1987; Mies 1988; Winston and Handyside 1993).

Work on somatic cell and germ line manipulation, oncomouse and other transgenic animals, and microinjection of rat growth hormone into mice all suggests that genetic embryo work is the real fertility in fertility technology. Human fertility work itself remains pathetically infertile ground (Gibbs and Beardsley 1994; Spallone 1987). Many critics label this trajectory "eugenics"—and cite the Nazi experiments and the continuity of eugenic attitudes and laws from the late nineteenth century to the present (Kaupen-Haas 1988; Ewing 1988). The sexist, racist, classist elements of eugenics are alive and well as dangers in IVF and GE; but they will look different, be narrated differently (see Rapp, this volume). A parallel: those Nazis in the film *Indiana Jones* with their uniforms and leather and swastikas make a certain fascism visible but make another kind—a more contemporary version—invisible. Contemporary moves to eugenics will look less like *Brave New World*'s state control and more like niche marketing and consumer choice (Clarke 1995). Postmodern eugenics will involve boundary-shifting discourses that import breeding logic into medicine, cloaked in the language of technology that mediates and "humanizes" this logic. This will happen partly because current discourses on pregnancy and birth already include elements of eugenics and market language, so that "I want what's best for my baby" moves easily into a demand for medicalized versions of "the best."

It will also happen because of journalistic containment strategies, perhaps best seen in the "cloning" controversy. The *New York Times* reported, page 1, that George Washington University embryologists had made a breakthrough in cloning human beings (Kolata 1993). The breakthrough involved "splitting" a two-cell embryo by dissolving the surrounding zona pellucida and then using sodium alginate as an artificial zona for the two now-distinct cells. These cells then divide and presumably would become embryos. Subsequently, *Newsweek* ran a large three-part story called "Clone Hype" which argued that such experimentation represented neither a slippery slope of ethics nor a valid reason for public protest. Jeremy Rifkin, a vocal critic of genetic research, is marginalized ("gadfly"), and a militarized "left" opposition ("Rifkin's troops . . . parading outside") is joined to conservative fetalist

opposition as examples of "apocalyptic" overreactions. The obligatory Nazi eugenic fear is invoked and revoked: "A lock of Hitler's hair, even if scientists could extract its DNA, would only give rise to the world's most disgusting hair-ball" (Adler 1993:61). And by linking criticism of genetic work to fictional (*Jurassic Park*) and fraudulent (David Rorvik's "nonfiction" fiction about a cloned millionaire) "paranoias" about "nightmare scenarios," *Newsweek* reestablishes the linguistic and generic boundaries surrounding public discourse on embryo research. All critique equals paranoia.

The containment strategy revolves around—what else?—IVF and helping women, in this case by allowing embryologists to artificially reproduce embryos. And this legitimizing narrative is itself contained within abortion discourse (the embryos were nonviable). Yet the article simultaneously reflects that something momentous is, after all, going on: the huge header "Clone Hype" is wonderfully ambi-valent (this is one more hyping of cloning and embryo biotechnology, as well as its putative critique) and the graphics of identical babies in versions (1994a and b, 2007a, b, c, and d) legitimately reflect the possibilities of the technology. By deploying popular representations such as the film *Boys from Brazil* and then debunking these using embryology science as medical realism,[7] *Newsweek* embeds its own narratives (opposition to science is simply anti-progress; science is not political; the best source of rules for genetic engineering is not the government or a frightened and unscientific populace) seamlessly in the body of the text.

The same strategy attempts to build (or maintain) boundaries between therapeutic genetic testing and eugenic possibilities. Clone Hype's companion piece, "The View from the Womb" (implying not only the fetus' but the embryologist's point of view; mothers are again nowhere to be found), discusses BABI (blastomere analysis before implantation), which allows doctors to analyze the genetic code of in vitro embryos for hereditary diseases such as Tay-Sachs (Cowley et al. 1993). Obviously, the more diseases and behaviors that are "discovered" to be genetic, the more control such externalization of embryos allows. But the article moves directly to the most extreme case ("made-to-order" babies who are smarter or have particular personalities) and again mobilizes medical realism to debunk and contain. Such articles reflect the anxiety around human reproduction as a cyborg dis/assembly zone, as well as generic ways of resolving crises (celebrating the public airing of these issues while basing the reporting on the overreaction to and fear of science in the media).

BABI babies must be separated from the discourse of animal breeding, eugenics, and the industrialization of reproduction in order to naturalize externalization and assembly. The answer is Smart Birth. What is (or might be) Smart Birth? Cyborg augmentation: the move from lists of the qualities of sperm bank donors (Moore and Schmidt, this volume) to the same qualities

as genetically engineerable traits in one's own child. Sex choice is already off the shelf; growth hormone is a likely next step (since it is already common in animal husbandry); and as Ewing points out, a whole host of quasi-scientific narratives (sociobiology, among others) see the Human Genome Project as the map of behaviors to be technologically controlled, enhanced, or eliminated (Ewing 1988).

Smart Birth is the (narrative) end product of the desire for postmodern niche market quality control (Clarke 1995). If now IVF techniques are seen as extreme, only for the infertile, this is only to say that they have not yet been naturalized. Consider: genetic screening via amniocentesis, ultrasound imaging, and fetal scalp monitoring are all routine now: it is considered a lapse not to use them. And the only way to really know the genetic Truth about one's progeny is to externalize embryos, test them, and fix them before reimplantation. Smart Birth contains most of the contradictions and injustices found in the linguistic economy of the new "smartness"—"Smartness is intelligence that is cost efficient, planner responsible, user friendly, and unerringly obedient to its programmer's designs" (Ross 1994:331).

If infertility allows science to externalize and then test/repair, and if testing becomes natural, indicated, postmodern birth quality control, then the argument, unless contested by other (subjugated) knowledges, proceeds from the technology to the practice. The gen(i)e is out of the bottle. "Honey, can you change the baby?" will comprehend diapers and DNA, unless, of course, as proposed in the original Clynes and Kline (1960) cyborg article, we get rid of human elimination itself.

■ LABOR, THEORY, VALUE

> As Goethe said, theory is gray, but the golden tree of life is green.
>
> —Donald Barthelme, "City Life"

When Margann delivered our son at home, she labored at the site of two overlapping and constructed technologies. On the one hand, she rode out wave after wave of painful contractions in a constant negotiation of body knowledge and the techniques of midwifery, including not only ways of pushing or breathing but ways of conceiving such activity (see Davis-Floyd, this volume). Her labor was an intense ordeal within culturally specific modes of understanding these things, accompanied by herbs, tinctures, postures. On the other hand, the oxygen tank and the waiting car symbolized the powerful medical technologies virtually present at any home birth. The hospital, with its routine fetal scalp monitors and maze of medical protocols, is present as supplement.

Yet this supplement is Derridean: the hospital paradoxically both adds to

and fills a lack in home birth, just as technoconception with its genetic testing adds to and fills a lack in "natural" conception (which is itself ringed round with cultural-fictional practices and rules). Technoscience turns animals and humans into cyborgs, but its discursive practices naturalize these processes, turn them into Nature. This new linguistic economy parcels out value and valuelessness in parallel with the money economy, so that homebirth seems a bankrupt or indebted idea and genetic testing an unproblematic source of valuable information and therapy.

Changing economies is perhaps the hardest thing humans try to do. Yet instead of dualist models (do you want embryo science or preventative medicine?) and the rhetorics of consumer choice and free markets (which ask an absurd leap of faith concerning choice and freedom and reinforce the mythic individual in a time of cyborg institutions [see Raymond 1988, 1990; Mies 1988]) we need to open up the economies by which we represent reproductive reality. If the cyborg figure helps us see the always already constructed nature of medical and reproductive bodies, then perhaps it will allow us to assemble wider discursive networks, networks that include more voices (women's, in particular) in a wider discussion of bioethics and socially responsible science. Beyond traditional realisms (medical but also critical appeals) we need to learn to read collages of discourse and practice and to write the new cyborg institutions into the generic stories of science fiction and science journalism. Numerous governments have charged commissions with the task of analyzing IVF and proposing rules for its regulation; these commissions, often formed in response to media coverage of IVF, swing wildly in anxious attempts to protect now the vulnerable human body, now the needs of institutional scientific and technological bodies (Spallone 1987). Cyborg research, by joining these bodies in writing their histories and rhetorics, should strive to recast the kinds of questions we usually ask of biomedicine. Without looking at how IVF is narrated in public discourse, without a critique of the divide between medical realism and these public narratives, such commissions seem doomed to failure.

Currently, IVF as a cyborg technology produces autonomous fetuses and erases/disassembles women's bodies; it reflects the externalization of the organic, and the organicization of biotechnique. IVF and technobirth work to obscure subjugated knowledges, including midwifery networks and body-knowledge as technique (see Davis-Floyd, Hill, this volume). I don't want to romanticize the latter; I simply want to deploy them within the discursive space of late-twentieth-century conception and birth, as Margann and I have in our own lives. We have gambled on the IVF miracle road, conceived a child using oocyte aspiration and an avant garde of biotechnologies. The child, conceived from deep within the medical model, grew under a hybrid regime of herbs and HCG, ultrasound and the sound of a mother's voice (and

a father's) crossing the tight drum of skin. His body emerged on a June night in 1995, courtesy of rational bodies of knowledge, but only as these knowledges were embodied and enabled by Margann's own body, her blood, sweat, musculature, a hot and moist inscription. This story imagines a cyborg competence—never forgetting the machines and technologies, never losing the bodies, in a struggle that is also a dance.

Notes

1 The metaphors of writing (DNA transcription, RNA translation, nucleotide messages, genetic codes) and collage (cutting DNA with restriction enzymes, recombining DNA, manipulating, rearranging, cloning, reproducing) all imply editing. And as in postmodern writing, as in twentieth-century collage and its progeny (photomontage, the cut/paste operations on my keyboard), the traditional body (of art, of writing) is cut up, rearranged, the logic of prosthesis rather than synthesis.

2 "Serono Symposia, USA, a division of Serono Laboratories, Inc., produced this booklet" (inside cover). A cyborg notion of writing implies complexity of authority: labs as well as doctors produce texts which textualize products. In turn, the present analysis is "produced" by institutions and interests that go beyond my own "writing."

3 GIFT and ZIFT are variations on IVF. In Gamete Intra-Fallopian Transfer, a sperm-egg mixture is transferred to the fallopian tubes so that fertilization takes place inside the woman. Zygote IFT is a hybrid of GIFT/IVF that ensures fertilization before placing the zygote in a healthy fallopian tube. MESA (Microsurgical Epidydmal Sperm Aspiration) and PZD (Pellucida Zone Drilling) are procedures for male infertility factors, which find the best sperm (MESA) and help less healthy sperm enter and fertilize the oocyte, respectively.

4 By this I mean both institutions capable of producing cyborgs and institutional bodies which have added other institutions as prosthetics. Universities with for-profit IVF clinics that incidentally produce research, or animal breeding departments that merge with human IVF clinics, beg traditional questions of ethics and knowledge and call for a "cyborg ethics" that recognizes the boundary-breaking nature of these new hybrids.

5 This figure is for 1993 and is based on clinics reporting to the ASRM. These clinics started 41,209 assisted reproduction procedures, of which 8,741 resulted in live births.

6 I found this story, as well as many powerful narratives of loss, anger, and support, on the alt.infertility newsgroup.

7 The *Newsweek* article is a good example of the stylistic Great Divide between medical realism and its detachable narratives. Several critiques of embryological research are represented as hysterical; these paranoiac voices begin and end the article. In the middle is a technical description of the actual experiment, in language much like that of the ART article, likewise accompanied by a textbook-like illustration of the process of splitting an embryo into two cells. Both text and illustration include assertions that the experiment is ethical, but in a sense this point is redundant: the careful style and overdescription have signified it already.

References

Adler, Jerry, Mary Hagen, and Karen Springen. 1993. "Clone Hype." *Newsweek* (Nov. 8): 60–63.
Andersen, Kurt. 1994. "Las Vegas, USA." *Time* (Jan. 10): 42–52.
Animal Biotechnology Cambridge Limited. 1988. "Research into Profit: Aims and Practices of

the Animal Research Station." Cited in *Reproductive and Genetic Engineering* 2 (1): 295–296 (1989; undated pamphlet received 1988).

Barr, Maureen. 1988. "Blurred Generic Conventions: Pregnancy and Power in Feminist Science Fiction." *Reproductive and Genetic Engineering* 1 (2).

Barthes, Roland. 1974. *S/Z: An Essay*. Translated by Richard Miller. New York: Hill and Wang.

———. 1986. "The Reality Effect." In *The Rustle of Language*: 141–148. Translated by R. Howard. New York: Hill and Wang.

Begley, Sharon. 1995. "The Baby Myth." *Newsweek* (Sept. 4): 38–47.

Boerge, Valerie. 1988. "Views on Human Reproduction and Technology in Science Fiction." *Extrapolation* 29 (3): 197–215.

Bradish, Paula. 1987. "From Genetic Counseling and Genetic Analysis to Genetic Ideal and Genetic Fate?" In *Made to Order*, edited by Patricia Spallone and Deborah Lynn Steinberg, 94–101. Oxford: Pergamon Press.

Bratton, Benjamin. 1995. "Preface: Science and Enchantment." *Speed* 1 (1).

Bullard, Linda. 1987. "Killing Us Softly: Toward a Feminist Analysis of Genetic Engineering." In *Made to Order*, edited by Patricia Spallone and Deborah Lynn Steinberg, 110–119. Oxford: Pergamon Press.

Calves à la carte. 1987. *New Scientist* (Dec. 3): 23.

Carlson, Margaret. 1994. "Old Enough To Be Your Mother." *Time* (Jan. 10): 40.

Clarke, Adele. 1995. "Modernity, Postmodernity and Reproductive Processes, 1890–1990, or 'Where Do Cyborgs Come From Anyway?'" In *The Cyborg Handbook*, edited by Chris Hables Gray, with Heidi Figueroa-Sarriera and Steven Mentor, 139–155 New York: Routledge.

Clynes, Manfred E., and Nathan S. Kline. 1960. "Cyborgs and Space." *Astronautics* (Sept.) Reprinted in *The Cyborg Handbook*, edited by Chris Hables Gray, with Heidi Figueroa-Sarriera and Steven Mentor, 29–33 (1995). New York: Routledge.

Cohn, Carol. 1987. "Sex and Death in the Rational World of Defense Intellectuals." *Signs: Journal of Women in Culture and Society* 12 (4).

Cowley, Geoffrey, Mary Hager, and Joshua Cooper Ramo. 1993. "The View from the Womb." *Newsweek* (Nov. 8): 64.

Crowe, Christine. 1987. "'Women Want It': In Vitro Fertilization and Womens' Motivations for Participation." In *Made to Order*, edited by Patricia Spallone and Deborah Lynn Steinberg, 84–93. Oxford: Pergamon Press.

Davis-Floyd, Robbie. 1992. *Birth as an American Rite of Passage*. Berkeley: University of California Press.

———. 1996. "Intuition as Authoritative Knowledge in Midwifery and Home Birth." In *The Social Production of Authoritative Knowledge in Childbirth*, a special edition of the *Medical Anthropology Quarterly* 10 (2): 237–269, edited by Robbie Davis-Floyd and Carolyn Sargent.

Ehrenreich, Barbara, and Deirdre English. 1973. *Witches, Midwives and Nurses: A History of Women Healers*. Old Westbury, N.Y.: The Feminist Press.

Ewing, Christine M. 1988. "Tailored Genes: IVF, Genetic Engineering, and Eugenics." *Reproductive and Genetic Engineering* 1 (1).

Feldman, Paul. 1988. "The IVF Roulette: Helping Your Patients Beat the Odds." *OBGYN News* 23 (19).

Gibbs, W. Wayt, and Tim Beardsley. 1994. "Fertile Ground." *Scientific American* (Feb.): 26–29.

Glasgow, Liz. 1989. "Kit for Sexing Embryos Sets to Work Down on the Farm." *New Scientist* (Dec. 9).

Gray, Chris Hables, ed., with Heidi Figueroa-Sarriera, and Steven Mentor, 1995. *The Cyborg Handbook*. New York: Routledge.

Gross, Alan G. 1990. *The Rhetoric of Science*. Cambridge: Harvard University Press.

Hale, Ellen. 1995. "'God's Work': Tale Rife with Charges of Fraud, Stealing Human Eggs." *Tacoma News Tribune* (July 23): A1.

Hartouni, Val. 1992. "Fetal Exposures: Abortion Politics and the Optics of Allusion." *Camera Obscura, A Journal of Feminist and Film Theory* 29 (May): 131–146.

Jillette, Penn. 1994. "Tonight! Miracles! Live!" *Time* 143 (2) (Jan. 10): 48–49.

Kaupen-Haas, Heidrun. 1988. "Experimental Obstetrics and National Socialism: The Conceptual Basis of Reproductive Technology Today." *Reproductive and Genetic Engineering* 1 (2).

Kelley, Robert T. 1993. "Chaos out of Order: Discourse of Semi-Popular Scientific Texts. In *The Literature of Science: Perspectives on Popular Scientific Writing*, edited by Murdo William Mcrae. Athens: University of Georgia Press.

Killingsworth, M. Jimmie, and Jacqueline Palmer. 1992. *Ecospeak: Rhetoric and Environmental Politics in America*. Carbondale: Southern Illinois University Press.

Kolata, Gina. 1993. "A Genetic Experiment Ignites a Bioethical Debate." *New York Times* 143 (4) (Oct. 31).

Koselka, Rita. 1994. "Hope and Fear as Marketing Tools." *Forbes* 154 (5) (Aug. 29): 78–79.

Laborie, Francoise. 1987. "Looking for Mothers, You Only Find Fetuses." In *Made to Order*, edited by Patricia Spallone and Deborah Lynn Steinberg, 48–57. Oxford: Pergamon Press.

Lazarus, Ellen S. 1994. "What do Women Want? Issues of Choice, Control and Class in Pregnancy and Childbirth." *Medical Anthropology Quarterly* 8 (1).

Mies, Maria. 1988. "From the Individual to the Dividual: In The Supermarket of 'Reproductive Alternatives.'" *Reproductive and Genetic Engineering* 1 (3).

Miller, Calvin. 1988. "Scientists Set to Ripen Human Eggs in Millions." *The Herald* (June 29).

Modell, Judith. 1989. "Last Chance Babies: Interpretations of Parenthood in an In Vitro Fertilization Program." *Medical Anthropology Quarterly* 3 (2): 124–138.

Raymond, Janice. 1988. "At Issue: Of Eggs, Embryos and Altruism." *Reproductive and Genetic Engineering* 1 (3).

―――. 1990. "At Issue: The Marketing of the New Reproductive Technologies: Medicine, the Media, and the Idea of Progress." *Reproductive and Genetic Engineering* 3 (3).

Romanyshyn, Robert. 1989. *Technology as Symptom and Dream*. London: Routledge.

Ross, Andrew. 1994. "The New Smartness." In *Culture on the Brink: Ideologies of Technology*, edited by Gretchen Bender and Timothy Druckrey, 329–341. Seattle: Bay Press.

Serono Symposia, USA. 1992. ART: *Assisted Reproductive Technologies*. Norwell, Mass.: Serono Laboratories, Inc.

Shapin, Steven, and Simon Schaffer. 1985. *Leviathan and the Air Pump: Hobbes, Boyle, and the Experimental Life*. Princeton: Princeton University Press.

Shapiro, Michael. 1988. "Representing World Politics: The Sport/War Intertext." Working Paper no. 9, First Annual Conference on Discourse, Peace, Security and International Society. University of California Institute on Global Conflict and Cooperation, UC San Diego, La Jolla.

Spallone, Patricia. 1987. "Reproductive Technology and the State: The Warnock Report and Its Clones." In *Made to Order*, edited by Patricia Spallone and Deborah Lynn Steinberg, 163–183. Oxford: Pergamon Press.

Sterling, Bruce. 1994. "Our Neural Chernobyl." In *Globalhead*, 1–10. New York: Bantam Books.

―――. 1988. "Test Tube Kids Bred at Rye." *The Southern Peninsula Gazette* (Feb. 17). Quoted in *Reproductive and Genetic Engineering* 1 (1).

Ulmer, Gregory. 1983. "The Object of Post-Criticism." In *The Anti-Aesthetic: Essays on Postmodern Culture*, edited by Hal Foster, 83–110. Seattle: Bay Press.

Winston, Robert M. L., and Alan H. Handyside. 1993. "New Challenges in Human In Vitro Fertilizaton." *Science* 260 (May 14): 932–937.

Natural Love

Janet Isaacs Ashford

Kate and Sam took a six-week course in natural love during the last months of their engagement. They felt prepared for what would happen. Still they were nervous when their hospital appointment was confirmed. Their time had been set for the second week after their wedding, when Kate was expected to ovulate. They had requested a trial of conception.

Kate and Sam planned to use the "natural love room," which had been decorated to look more homelike. Here couples were allowed to have foreplay and intercourse in the same place, without having to transfer. They were allowed to wear their own gowns and bring a few items from home to make the room more personal—pictures or special things to eat. Alcohol was not allowed, as it might hamper their progress. But Sam and Kate had packed a variety of sparkling fruit juices.

When Kate's mother first had love, many years ago, everything was different. Women were stimulated to go through foreplay without their partners, who ejaculated artificially in a separate room. The semen was injected after the woman was under sedation and orgasm was chemically induced. Many couples left the hospital feeling they'd never had love at all.

Some people began having love at home, without medical supervision. They wanted to return to more traditional ways ("primitive," the doctors said). They believed that emotional issues were more important than safety. In fact, some of these people believed that hospital love itself was unsafe. They claimed that the hospital's handling of love caused more problems than it solved. Yet one had only to walk through a cemetery or glance at statistics to see how many people once died of heart attacks and other complications of unsupervised love.

Kate and Sam learned this from the nurse who taught their love preparation course. Nurse Linda was not married and had never had love herself, but she had been teaching the hospital's course for several months and knew a great deal.

"I'm telling you the history behind our 'natural love' program so that you'll understand our philosophy here at the hospital," Linda told the class. "It's true that hospitals were sometimes too rigid in the past. The home love movement offered a challenge and we responded. Over the years our love ward policies have become much more flexible. But please understand that home love is very risky and can never provide the kind of trained staff and access to lifesaving equipment which is available in a hospital. Why take a chance? We feel our 'natural love' room offers the best of both worlds."

Kate and Sam took a tour of the hospital before their love appointment. They saw the old-fashioned foreplay rooms—small, brightly lit cubicles without windows and with unyielding stainless steel furniture. The coitus room was even more formidable with its high, narrow table, straps, and racks of electronic equipment.

By contrast the natural love room was much nicer, though a bit disappointing. The room had a window, but it offered a view only of an opposing bank of windows. There was a special love bed wide enough to accommodate two people fairly comfortably. The sterile sheets, usually white, had been dyed a pinkish mauve. The racks of electronic equipment were discreetly hidden behind a flowered curtain. Yet the gray walls and high ceiling of the hospital structure remained. The floor was polished gray linoleum. There were so many fluids involved in love, it just wasn't practical to have carpeting.

Kate and Sam were instructed to call their doctor as soon as they felt sexual desire. But they were so nervous during the first day of their appointed week they felt nothing. Sunday night they went to bed feeling frustrated and a little incompetent. Maybe their bodies were not normal. On Monday they felt a little desire. They were sitting on the couch kissing each other, and both distinctly felt a movement of blood into their genital parts. "Should we call the doctor?" whispered Sam.

Both Kate and Sam were very accustomed to arousal. It was considered normal for human beings, indeed for all animals, to go through regular periods of sexual arousal. These were dealt with matter-of-factly by inducing release or by taking drugs. But arousal is different from love. And when you're waiting for sexual desire to begin, and you know it's going to lead to love, it's hard to know whether it's true desire or just a bout of false arousal.

"I'm going to call the doctor," said Sam, after another fifteen minutes of kissing. He went into the kitchen to call, leaving Kate rather uncomfortably

disheveled on the couch. "Yes," he said, in answer to the nurse's questions. "I have an erection and Kate says she feels hot and 'mushy.'"

Sam came back smiling. "She says to inspect your vulva. If your inner labia are red, we can come in."

Kate went to the bathroom to check. But with her hand mirror it was hard to tell whether her genitals were really "red." They certainly looked pink. But what color were they usually?

"I'm sort of a dark pinkish color," she reported.

"Well, are you red? We don't want to drive all the way to the hospital and then not be admitted."

"I don't know," said Kate. "It's hard to tell. I've never been through this before."

"I've lost my erection," said Sam. "I didn't think this was going to be so difficult."

It went on like that for two more days. On Thursday morning the doctor's secretary called to say that if they did not have desire by Saturday morning, they would have to come in to the hospital and be induced.

Fortunately, by Friday night, Kate and Sam went into spontaneous desire in their bedroom, lying next to each other in bed. They didn't bother to call the doctor's office this time, for the waves of feeling were so intense it was unmistakable. They gathered up their things and drove quickly to the hospital.

Kate and Sam had hoped to stay together during the registration process. They had filled out the preliminary forms ahead of time. But in their eagerness, they made the mistake of driving right up to the hospital entrance. A guard opened Kate's door and asked her to get out. "You park the car," she told Sam. "You can't leave it here." Kate was bundled into a wheelchair and taken inside alone.

Sam was annoyed. The inconvenience and the cold night air threatened to lessen his spontaneity. By the time he parked the car and got up the elevator with their bags Kate had already been processed and moved out of the prep room.

Sam was alone when the nurse came to shave him and give him an enema. Usually, the woman and man were able to hold hands while the nurse worked. This helped to maintain their desire. But love can be dangerous without proper sterile technique. Tiny microorganisms living in the pubic hair can pass into the woman's vagina during intercourse. These can damage the conceptus if they migrate into the uterus along with the sperm. To avoid this, lovers are routinely shaved and the contents of their bowels emptied.

Sam was asked to lie flat on his back on the narrow, hard table. The nurse, with a confident, practiced manner, carefully shaved the coarse hairs from his testicles, anus, and pubic area. He only nicked Sam once, near the joint of his

thigh, and quickly dabbed on a stinging astringent. "That wasn't as bad as I thought it would be," said Sam, anxiously, looking up for reassurance. But the nurse did not reply. He'd seen hundreds of lovers in his years in this hospital, and knew all about their fears.

The enema surprised Sam. It was hotter and more forceful than he'd expected. He barely made it off the table and onto the toilet in time. "Good," said the nurse, seeing what Sam produced.

Sam put on the special love gown he had brought from home and walked to the natural love room, where Kate was nervously waiting. She put on her love gown and they sat side by side on the bed, holding hands, waiting for their first assessment.

Kate and Sam had been assigned a special natural love nurse, who would remain with them throughout their foreplay and intercourse, no matter how long it took. This helped ensure continuity of care. Nurse Tom was a young man, very friendly and cheerful. Like their love teacher, Tom had never had love himself. But he had been trained at one of the more progressive nursing schools and had taken several unit hours of instruction in natural love techniques and rationales. Tom would be able to help them a great deal if their foreplay faltered.

Tom explained that they would be left on their own during most of their foreplay. He would come in from time to time to assess their progress and offer advice. If their progress was normal, they would be allowed to remain in the natural love room. If their foreplay was dysfunctional, they would have to be transferred for monitoring. They might have to be separated.

"You are low-risk," he assured them. "We don't expect any problems."

Kate set their tape recorder on the window sill and put on a tape. Sam put out some bread and fruit. He found a water pitcher in which to place the beautiful bouquet of fresh flowers they'd brought. Tentatively, but with great tenderness, they began to kiss each other. They wrapped their arms around each other and felt the warmth of each other's bodies through their thin gowns. Sam felt the soft pressure of Kate's breasts against his chest and ran his hands down her sides to feel her waist and hips. The feel of her body excited him and he felt his blood moving toward his penis. Kate ran her hands along Sam's back and kneaded the flesh of his buttocks with her fingers. Gradually they fell sideways onto the bed, till they were wrapped up together, side by side, their faces close. It seemed they were normal after all. Their hormones were working.

Sam began to rub Kate's breasts with his hands and she seemed to like it. Encouraged, he lifted up her gown, pulling it up awkwardly from her knees. Her bare breasts were very round. The nipples looked so appealing, he

couldn't help kissing them. Kate began to moan. She moved herself forward to press her breast closer and Sam felt the softness of it coming to rest on his cheek. His penis was very hard now. He reached down to feel Kate's vulva. It was wet! He touched the smooth, newly shaved surface, then slowly put his fingers into her vagina. It was incredibly hot and soft. Kate began to move her hips in an extraordinary way, which seemed almost involuntary. Sam imagined what it would be like to put his penis into Kate while she was moving like that.

"I don't care if the doctor's here yet or not," he whispered and pulled up his gown. Without thinking, Kate opened her legs. Sam brought the tip of his penis right up against her clitoris and gently slushed it around in the wetness there. They lost their common sense. They knew it was dangerous for intercourse to occur without proper monitoring and without the doctor in attendance. So many things could go wrong! Their blood pressure might go too high or their pulse become too rapid. Sam's semen hadn't been sampled yet and if conception occurred with unapproved sperm, they'd have to have a termination later.

But Sam and Kate were both moaning now and moving against each other. Without thinking about the consequences, Kate put her hand firmly around Sam's penis and guided it slowly into her. Sam felt the lovely hot wetness at the opening, felt himself sliding into her and . . .

The heavy door of their room suddenly swung open and Tom came in with two medical technicians. "Hi," he said cheerfully. "It's time for your first check. I see you're coming right along."

Sam looked up, startled, withdrew and pulled down his gown. He got off the bed and stood up, his penis poking against the loose gown like a tent pole.

"Nancy will take a semen smear from you now, Sam," said Tom, reassuringly. "We do this routinely in order to sample your sperm and make sure it's motile and normal. I'll examine Kate, okay?"

Tom placed Kate on her back in the bed. She was still breathing heavily. "Don't worry," Tom said, "This won't hurt." He put on a sterile glove, then carefully inserted two fingers into Kate's vagina. "When ovulation is near, your cervix becomes slightly softened and the os opens slightly," he said. "There's also a ballooning of the upper vagina which takes place with arousal." He pressed his fingers further into Kate and she moved back slightly on the bed. "Your cervix feels fine," said Tom, withdrawing his hand, which was now covered with her mucus discharge. Your chart shows you should be ovulating now. But your uterus has not yet swung up out of the way, as it should before intercourse can be safe. You're not yet fully aroused. You're making good progress though!"

Sam now took his place on the bed and the technician placed a fresh ster-

ile underpad beneath his bottom. His penis was still erect. Tom donned a fresh sterile glove and gently inserted one finger into Sam's rectum. "Now hold on, Sam, and don't let yourself ejaculate," cautioned Tom. I'm going to put my other hand on your abdomen and feel your internal organs now." Sam was quite uncomfortable. He'd never been examined like this before. He looked away toward the bouquet of flowers. He tried to breathe slowly and deliberately as they'd been taught. He counted slowly to himself, as Tom's exploring finger pressed hard against his prostate gland. "One, two. One, two. One, two." Finally the exam was over. He had not ejaculated, but his erection was somewhat diminished.

"You're both doing fine," reported Tom, as he recorded the results of his examinations on their charts. "You can resume foreplay now. I'll be back to check you again in an hour or so. I imagine we'll be calling the doctor to come fairly soon."

The music tape had ended. Sam started another. "Do you want something to eat?" asked Kate.

"Not really," said Sam. "I'll just have some juice." Kate poured some for both of them and they sat together on the stiff bed. It was a little hard to get back in the mood after being interrupted. Nurse Linda hadn't mentioned this. She had said that once desire is under way it takes on a life of its own. She had said they would hardly notice the exams.

"I don't feel very excited any more," said Kate.

"Me neither," said Sam, and they looked at each other and suddenly began to smile.

"Maybe we're not normal," they both said at once and burst out laughing. They were friends after all. They wouldn't let the hospital get them down.

"Hey, let's try it again, and this time let's put one of those chairs under the doorknob," said Kate.

"Come on, we can't do that!" cried Sam as he leaned forward and gently bit Kate's neck. Soon they were lying side by side on the bed again and it seemed that their desire built up even faster this time.

Though they were not supposed to, Kate and Sam took off their gowns completely. Sam played with Kate's vagina with his fingers and as he kissed her he began to feel that he would like to be kissing her there, where it was so hot and soft. He had never done this before, but somehow he couldn't help wanting to. He kissed his way down Kate's body, while she laughed and ran her fingers into his hair. He sniffed along the skin of her breasts and down her belly until he reached her vulva. Closing his eyes, he pressed his lips to her labia and found the little knob of her clitoris with his tongue. He began to lick it and push it around.

"Oh, do that!" sighed Kate and let her head sink back into the pillow. Sam

felt her clitoris getting stiffer and bigger. Their tape had stopped playing again, but neither of them noticed. The faint hum of the hospital's air conditioner wrapped them in a soothing haze of white noise. Kate felt herself reaching a place in which you know that the final pleasure is inevitable. Sam's tongue sometimes found the very center of her being and sometimes glanced away. She was waiting for one more direct hit. She felt her skin flush and her pelvis seemed to arch itself. She wiggled just a little to meet Sam's tongue. Just one more…

What are you doing!" cried Tom, coming through the door suddenly. "Don't you know you're not supposed to do that!"

Kate felt a deep, throbbing pain resound throughout her groin. Sam looked up dumbfounded. Neither could speak.

"Didn't your teacher tell you not to do this?" demanded Tom again. "It's extremely dangerous. Your mouths can never be made sterile and when all the bacteria in your mouth is transferred to your genitals, it's all ready to travel right up to Kate's uterus! Now you're going to have to be swabbed and disinfected before you can continue."

Tom called for a technician to help him. Because the bed was not designed for the treatment of two people at once, Sam had to go back to the prep room. He was given a mouth wash. Then his genitals were painted with a red-colored antiseptic. "But I didn't put my penis in her, so why does it have to be washed?" protested Sam.

"It's hospital routine," replied the technician, curtly, clearly not wanting to get into a discussion about it. The disinfectant wash was cold. It stained Sam's skin a deep orange.

When Sam got back to their room, Kate was lying on her back crying. A douche bag was hanging from a stand by the bed, and Tom was flushing out her vagina with the same red wash. "What's wrong?" said Sam, coming to Kate's side.

"Naturally she's upset over what happened," said Tom, looking right at Sam. "You should have known better than to do what you did. It was irresponsible. We are here to help you have safe love, but we certainly can't do our job if you don't cooperate."

"Tom examined me," said Kate, quietly. "He says my genital tissues are very engorged with blood and if I don't finish soon I'll have to be monitored. Also, my blood pressure is high."

If he hadn't interrupted us, we *would* be finished by now, Sam thought to himself. But he held his tongue. He had learned that it doesn't do any good to argue. If you make the staff mad at you, that just makes things worse.

"I'm going to call your doctor now," said Tom. "He may want to move you to a foreplay room."

"Oh, no," cried Kate.

"Well, we'll have to see," said Tom. "Your signs are not good."

Sam and Kate were left alone again, sitting on the bed. This time Sam didn't bother to put a new tape on the player.

"I liked what you were doing," whispered Kate. "I don't see why they get so upset about it."

Sam hugged Kate, grateful that she didn't blame him. For a long time they sat quietly, holding onto each other. Tom came back into the room, and Kate and Sam didn't look up or stir away from each other.

Their exams were conducted in silence. Tom informed them of the results, then wrote on their chart: "Patient, male—flaccid. Patient, female—pelvic congestion, no desire." Kate and Sam were transferred to a foreplay room.

A high table was set up in the center of the room. To one side stood a rack of electronic monitors. Kate and Sam were given clean gowns and were positioned, face to face, on their sides on the table. An intravenous needle was placed in the arm of each, on the inside of the elbow. These were connected to flexible tubing which led to bags of fluid hanging from metal stands. These lines would provide Sam and Kate with a glucose and water solution, so they would not become dehydrated or suffer low blood sugar. They were no longer allowed to eat or drink. It might cause problems later if they had to be placed under anesthesia.

Several electrodes were placed on their bodies to monitor their response to sexual activity. Two electrodes monitored brain activity, while one placed over the heart monitored pulse and output stress volume. A blood pressure cuff was wound around the arm which did not have the IV needle. It sampled their blood pressure automatically every ten minutes and the results were recorded. The device sounded a tone just before beginning to pump up its tightening pressure on their arms.

An electrode was attached to Sam's penis at its base, to monitor size and tumescence. Two devices were attached to Kate—one inside her vagina and one just to the side of her clitoris.

By this time Kate and Sam's doctor had arrived to supervise the final stages of love. "Before intromission we need to make sure that Sam's penis is not too big for you, Kate. You had a problem before with your uterus not swinging out of the way fully. Vagino-penile disproportion can be a serious problem for some couples. We don't want Kate's cervix to be battered in this process."

The doctor seemed quite cheerful. She assured Kate and Sam that they should not regard their transfer from the natural love room as a personal failure.

"Sometimes I get upset with these natural love teachers for giving their stu-

dents such high expectations," she said. "After all, the purpose of sex is to have a safe conception, not to have some kind of 'experience.'" Some couples are simply not able to get through love without help. This is nothing to be ashamed of. We are here to make sure that you go home with a healthy zygote."

Once all the electrodes and other devices were in place and their lead wires arranged, Sam and Kate were encouraged to continue foreplay. "But be careful not to move too much and please call for a nurse if, for any reason, you need to get up. Movement can upset the recording equipment and give us false data," said the doctor, before leaving.

"Doctor," said Sam, weakly. "We don't feel much like doing it anymore."

"Don't worry about that," smiled the doctor. I've ordered a hormone drip to be started in your IV and also a little something to take the edge off your anxiety."

"What is it, doctor?" asked Kate, "some kind of drug?"

"Just a little something to help you be calm," replied the doctor, heading for the door.

"But, I'm not supposed to take drugs," said Sam, alarmed. "It may hurt my sperm. We want to have a natural child."

"Don't worry about that," said the doctor, as the door was closing.

Sam and Kate lay still in each other's arms. A tear rolled silently down the side of Sam's face. He felt the soothing dullness of a mood drug spreading through his body. He no longer cared about his sperm or about much else. At the same time he felt a strange sensation. The device on his penis seemed to be stimulating him in some way. He felt his penis stiffen, but it seemed to be very far away from him.

"What's going to happen?" asked Kate.

"I don't know," said Sam, and they both seemed to drift off into something like sleep.

They were awakened by the sound of voices calling their names. "Come on, Sam, wake up," the voices called. "Come on, Kate, lift your leg. It's time for intromission now."

Someone had taken hold of his penis and was pushing it against the opening of Kate's vagina. "Push! Push!" cried several voices, and Sam tried as hard as he could to comply. He felt his penis slide into Kate. He sighed and sank back against the table. "Again, now! Sam! Pull it back and push again! Push!" The voices kept insisting. Sam wished they would go away. Kate was still half-dozing. Sam had to do all the work. "Push! Push!"

Suddenly one of the monitors sounded an alarm—a loud, insistent tone. A nurse checked the gauge. "It's vagino-penile disproportion," she announced. "His penis is hitting her cervix."

"I thought something like this would happen," said the doctor, who was now also in the room. "Get him out and let's get her into the other room."

Everyone began to move very quickly now. Kate and Sam were separated and rolled onto separate gurneys. Their wires were plugged into portable units which rolled with them down the hall. Kate was taken to a gleaming room and prepared for insemination. Sam was taken to a separate ejaculation room.

The dosage of drugs in Sam's IV was increased. He was placed on his side on a table and half-covered with a blanket. A new nurse came in with a device, which she attached to his penis. She turned it on and adjusted the stimulation until she could see on the monitor that Sam was responding. Sam didn't realize what was happening. He thought he was still in the natural love room, having love with Kate. He was inside of her warm vagina at last. He felt her moving back and forth around him. Then suddenly he ejaculated. He reached for Kate, but there was no one there. The nurse removed the device from his penis. She pulled the blanket up over him and whispered, "Go to sleep now," and Sam fell asleep.

Kate had been placed on her back on a high narrow table, her legs strapped into high stirrups. Her hands were bound at her sides, one arm still attached to the IV and the other to the blood pressure monitor. A metal speculum was inserted into her vagina and locked into place. The room was cold, and Kate was shivering. No one spoke to her. A group of medical students stood at the back of the room, observing the procedure. Sterile drapes were hung on Kate's belly and legs. She could not see what was happening at the other end of herself. She feared someone might touch her there without warning. Yet under the haze of drugs it was difficult to get very upset.

She felt a sudden warmth on her vulva. It was the bright light of an examination lamp. Then there was a splash of cold as the nurse doused her with antiseptic again. The doctor came in, followed by a nurse with a tray of instruments. On the tray was a small dish of semen, along with a device for inserting it. The insemination was performed by the doctor, who dilated Kate's cervix mechanically to make sure the sperm would be able to gain entrance. Kate winced at this sudden cramping pain.

The doctor rubbed Kate's clitoris with a gloved, lubricated finger. Kate felt herself responding, but as with Sam, the sensation seemed to be happening to someone else. "Increase her hormone drip," said the doctor, looking at Kate's response monitor. She continued for another few minutes until she saw the meter's needle give her the information she wanted. She turned on her stool to whisper something to the medical students—something about female orgasm, whether it was necessary or not.

"It's all over now, Kate," she said, satisfied. "You've had a perfectly normal orgasm and, we hope, you're on your way to a perfectly normal conception."

"Thank you, doctor," said Kate, weakly. "I'm sorry about our behavior before."

"Don't worry about it," said the doctor. "You did beautifully, especially for your first time."

Kate was given a dose of local anesthetic for her cramps. She was wheeled into a recovery room and given another dose of mood drugs. She soon fell deeply asleep.

When Sam woke up he wasn't sure where he was. At home? In the natural love room? A nurse came in to check him. "When am I going to have love?" Sam asked, confused.

The nurse laughed. "You've had love, don't you remember? You had a perfectly normal ejaculation. It's all on the monitor strip."

Sam reached down to feel his penis. It was soft. He felt all right, but woozy and uneasy.

"Where's Kate?" he asked, "I want to see her."

"You'll be able to see her in a little while," said the nurse. "She's recovering right now and we don't want to disturb her."

"Is she all right!?" asked Sam, alarmed. "Did she . . . did you inseminate her?"

"You'll have to ask the doctor. I'm sure she's all right. You rest now." Sam was given a sedative.

When Sam woke up again, he found Kate beside him on another small bed. They'd both been moved to a post-coital room, where they would stay until discharge. Kate was awake and smiling at him as Sam opened his eyes. He was so glad to see her! He reached out his hand for hers across the space between their two beds.

That morning the doctor stopped in to give them some unhappy news. They had both had normal orgasms, of course, and Kate's insemination appeared to have been successful. But, unfortunately, they hadn't been able to use Sam's sperm for the conception. His sperm was normal, but the sampling technician found it was not motile enough. A compatible donor sperm sample had been used instead.

Sam was upset at first. Why had the doctor given him drugs, when he knew that might hurt the sperm? Why hadn't they been given the choice of coming back for another love, to try again for a natural child? The doctor patiently explained the hospital's policies. Eventually Sam came to feel it had been for the best.

Kate and Sam were discharged from the hospital that afternoon. They were taken down the elevator in wheelchairs, as they had been brought up. But they had to carry their things back to the parking lot by themselves.

For the next two weeks Sam was depressed. Friends came to visit. He told them it was a good thing they had been in the hospital, because his blood pressure had gone up and had to be treated. He was deeply embarrassed that his sperm had been rejected. Yet he discovered that this had happened to many of his friends. In fact, the rate of sperm rejection was quite high—about 40 percent in the United States, though it was apparently much lower in Europe.

In his parents' day, sperm rejection could be very traumatic for a man. But since it had become so common, most men were not upset by it, though some did look with envy at their friends who had natural children. Some men were now requesting donor sperm right from the start. Why go through the trouble of a natural love, which could take hours, only to have your sperm rejected in the end?

Sam and Kate had been instructed to report any symptoms of conception to their doctor. Two weeks after their love day, Kate had a normal menstrual period. When the nurse called to check, Kate told her.

"I'm so sorry," said the nurse. "Would you like to schedule another love?"

"No," said Kate.

Two weeks later Kate began to feel sexual desire again. She had a dream about making love with Sam. But instead of being in the hospital, they were in their own bed at home. The dream was so vivid it awakened Kate and she found herself lying next to Sam, her vagina throbbing, just as it was becoming light. Kate kissed Sam's neck as she had done in the hospital. He sighed and turned to embrace her sleepily, then awoke more fully and looked into her eyes.

"What are you doing?" asked Sam.

"I'm not pregnant," said Kate. "I had a normal period two weeks ago. Do you want to try it again, the real way?"

Sam did. For the past month he'd been trying to convince himself that what happened in the hospital was normal. But it didn't feel right. He and Kate had not talked about it. Now he realized that she felt the same way he did. He felt such affection for her!

Kate and Sam made love in their own bed. They were nervous at first, but nothing went wrong. They seemed to be all right. At one crucial moment, when Sam was inside her, Kate didn't feel any pain at all in her cervix. And Sam was bigger and firmer than he had been in the hospital! So much for vagino-penile disproportion!

Two weeks later, Kate did not have a normal period. Neither did she have one a month after that. She and Sam began having home love often. They felt wonderful and never seemed to have any problems. They felt so good, in fact, that they had to hide their new happiness from their friends, who were able to have love only once or twice a year.

Kate decided not to apply for a gestation card. She did not register with the fetal surveillance program. One night she whispered to Sam, "When the baby is ready to be born, let's give birth to it at home."

"Yes," said Sam. "Yes!"

part two

The Techno-Fetus

The Techno-Fetus

Baby's First Picture

The Cyborg Fetus of Ultrasound Imaging

Lisa M. Mitchell and Eugenia Georges

One of the most common rituals of pregnancy in late-twentieth-century urban North America begins when a woman and her partner are ushered into a small darkened room by a white-coated person known as the "sonographer." Asking the woman to lie down on a table, the sonographer squirts her belly with a cool blue gel, moves a device over her abdomen, taps at a keyboard, and suddenly a grayish blur appears on a bright luminescent screen. It is customary during this ritual for the couple to smile, laugh, and point at the screen even though they frequently do not recognize anything in the blur. The sonographer taps at the keyboard again and peers intently at the gray-and-white blur. She measures parts of it, calculates its age, weight, and expected date of delivery. She looks closely at the couple to see if they like the blur and show signs of "bonding" with it. The couple also look closely at the sonographer, anxious in case she finds something wrong with the blur. Sometimes, when the sonographer pronounces the blur to be "really nice," she talks to it, strokes it, and congratulates the couple. After about fifteen minutes, the blur is turned off, the gel is wiped away, and the couple are given a copy of the grayish blur to take home. This copy is known as "Baby's First Picture," or as "Baby's First Video" if they get the full-length, moving version. It is often shown to other people who are also expected to smile at it.

In Greece, too, where pregnancy and birth have been thoroughly medicalized over the last one or two generations, pregnant women are routinely and universally monitored with ultrasound. The procedure is usually repeated several times over the course of a normal pregnancy. Surprisingly often, scans are performed in response to a woman's request to "put the baby on television," as the procedure is commonly described.

This chapter is about the cyborg fetus of ultrasound imaging. In the Introduction, Davis-Floyd and Dumit define cyborg babies as children reproduced "in symbiosis with pervasive technology." Here, we extend that definition to include the cyborg fetus—the cognitive and sensual apprehension of the fetus as electronically mediated by a variety of technologies. Ultrasound is not the only way to make a cyborg fetus (see Cussins, Rapp, Cartwright this volume), although arguably it is the most prominent and prevalent of these technologies. At least one or two ultrasounds have become an expected and routine part of pregnancy for millions of women in the United States, Canada, and Australia as well as in Greece and other parts of Europe. Ultrasound is widely regarded by physicians and sonographers as a necessary, passive, and neutral technology. For them, the blur is relatively unambiguous, described in one obstetrical text as "a window of unsurpassed clarity into the gravid uterus . . . capable of providing exquisite detail regarding the fetus and the intrauterine environment" (Pretorius and Mahoney 1990:1). The possibilities for seeing, we are told, are numerous: the state of fetal anatomy, growth, and development; numerous fetal pathologies; the sex of the fetus as early as eleven weeks; and fetal sleep, rest, and activity patterns.

Women undergoing ultrasound, along with friends, family, and anthropologists who are observing, may find other meanings in those echoes. Paradoxically, though many of us recognize little or nothing in the fetal blur, we nonetheless regard the image as persuasive evidence confirming far more than the pregnancy (Mitchell 1993; Villeneuve et al. 1988). In North American cultural discourses, ultrasound is firmly lodged as a "normal part of pregnancy," allowing us a sneak preview of our baby's sex, age, size, physical normality, and personality. So convincing is this cyborg fetus that millions of women in North America may experience a "technological quickening" several weeks before they sense fetal movement in their own bodies (Duden 1992). As our comparison with Greek women will show, such technological quickening is becoming an increasingly common cross-cultural experience as well.

Ultrasound's cyborg puts the social reality of the baby and mothering into "fast forward," as this effect was described by one woman (Rapp 1997). Drawing on our separate studies of routine fetal imaging, we put this process into slow motion in order to look more closely at how this cyborg fetus is culturally configured through practice and discourse. In keeping with the theme of this volume, this chapter focuses predominantly on North American women's experiences with ultrasound, on the basis of fieldwork carried out by one of us (LMM) in an ultrasound clinic at a Canadian hospital.[1] Despite differences in medical reimbursement models (state-administered versus privatized/ welfare), the ultrasound experiences of the Canadian women resonate broadly with those of women in the United States (e.g., Black 1992; Rapp 1997). Thus, in this chapter we refer to both Canada and North America. A study

carried out in a public hospital in Greece (by EG) revealed both commonalities and striking differences with the experiences of North American women. Both studies draw on observations of scans and on interviews with sonographers, pregnant women, and their partners.

We look at the cyborg fetus through a cross-cultural lens primarily to highlight that which is culturally and historically specific to North American understandings of the cyborg fetus (for a fuller discussion of ultrasound in Greece, see Georges 1997; Mitchell and Georges 1997). A cross-cultural perspective is also crucial for "getting at the complexities of the way power operates in society" (Hess 1995:14). In this case, our task is to explore how the couplings of body and machine, as mediated and translated by experts, are firmly embedded in culturally and historically specific scripts. We begin with an extensive discussion of ultrasound in the North American context, first showing how this coupling simultaneously dissolves women's bodily boundaries, undermines their experiential knowledge, and represents the fetus as an autonomous, conscious agent. We then illuminate how sonographers employ specifically North American cultural scripts about personhood, maternal altruism, and bonding to intervene in the physical and social relationships of pregnancy. Third, we discuss some of the ways in which North American women may use the "transgressed boundaries and potent fusions" (Haraway 1991:154) of ultrasound's cyborg fetus to reflect on and rework their experiences of pregnancy. We then turn to ultrasound practices in Greece to examine the culturally specific production of fetal and pregnant subjects there. In both contexts, the cyborg fetus of ultrasound imaging is often represented alone, as if removing it from the body and life of the woman improved our chances of understanding it. We try to resist this dis-location by re-membering the cyborg and critically examining its production in the embodied and social coupling of woman, machine, and sonographer. In the conclusion, we reflect on the implications of our cross-cultural perspective for emerging understandings of cyborgs and the processes of cyborgification.

■ SONOGRAPHIC PRACTICE:
 "SEEING" THE (NORTH AMERICAN) BABY

Like all cyborgs, the cyborg fetus arises through the coupling of human and machine. As part of the "mechanics" of this coupling, a transducer is pressed onto and rolled over the woman's belly. If the ultrasound is done during the first twelve weeks of pregnancy, the transducer, phallic-shaped and sheathed with a condom, may be inserted into her vagina. Guided by the sonographer's hand, high-energy sound waves are projected from the transducer into her womb, and the reflection of these waves produces an image of the uterus, placenta and moving fetus on a television-like screen.

Ultrasound examinations of pregnant women labeled "high risk" and those with a "suspected anomaly" are generally carried out by a physician, usually an obstetrician, radiologist, or gynecologist. The much larger number of "routine" scans done each year are more likely to be done by lower-paid female ultrasound technicians. During each fifteen-to-twenty minute routine scan, they search for a fetal heartbeat, note the position and number of fetuses, and assess fetal age, size, development, and the expected due date by measuring parts of the fetus. Using ultrasound to discover and know the cyborg fetus is, in Haraway's (1991:164) terms, a problem of translation; sonographers must translate not only the physics of echoes but also the clinical and social meaning of these different shades of gray.

The cyborg fetus is, however, often difficult to spot. Sonographers must be trained to see the grayish ultrasound echoes as distinctive uterine and fetal landmarks and structures which convey diagnostic information. Women and their partners, in turn, depend heavily on the sonographers' accounts of the image in order to see their little cyborg baby. As part of their role as gatekeepers, Canadian sonographers silently and quickly search for a fetal heartbeat and major anomalies. Once they believe that the fetus is alive and "normal" at this level, sonographers begin to do what they refer to as "showing her the baby." Describing the image for the woman includes some diagnostic information (usually fetal age, weight, and a statement that "everything looks okay"). As we elaborate below, talk about the cyborg fetus by sonographers to expectant parents also includes statements about its (1) physical body, appearance, and activity; (2) subjectivity; (3) potentiality; and (4) social connections to kin and to sonographers. These statements resonate with sonographers and many pregnant women as signs of both humanness and selfhood and, thus, are integral to how the ultrasound image is made culturally meaningful as a "baby."

Sonographers' descriptions of the physical parts of the fetus pass through a cultural sieve, as they select out those parts which they believe are most appealing and reassuring for women—the beating heart, the skull and brain, "baby's bladder," and the hands and feet, especially the fingers and toes. Sonographers consider the "weird" or "strange-looking" fetal face at sixteen to eighteen weeks to be alarming to women. Later in pregnancy, the rounded fetal nose, forehead, and cheeks often receive special comment and sonographers like to include the face in a woman's own copy of the image. During the ultrasound, parts of the fetal body are often not simply named but are described in terms of fetal behavior, their "babylike" appearance, and their resemblance to the anatomy of other family members. Fetal movement seen during ultrasound may be referred to as "the baby moving"; often it is described as a particular kind of movement—an activity. Thus, the fetus is described as "playing," "swimming," "dancing," "partying," and "waving."

While Canadian women sometimes refer to the photographic images of the early fetus in their guides to pregnancy as "alien" or "ET," what is called forth even during the earliest routine ultrasounds observed is the image of an idealized infant, rather than that of a fetus or embryo with its distinctive appearance, uncertain subjectivity, and contested personhood. Even the term *fetus* is generally restricted to diagnostic matters and to discussions among sonographers, although there is considerable variation among Canadian hospitals on this point. It is rare to hear expectant parents use the term *fetus* and some sonographers discourage women and men from using it. For example, during a scan one of us (LMM) observed, a man looked at the ultrasound photograph handed to him by the technician. "Great!" he said. "Now I can put this on my desk and say, 'This is my fetus.'" The technician replied: "Your *fetus*? Ugh! Don't say that! It's your *baby*."

The uncertainty about fetal subjectivity is also erased in the cyborg. Awareness of surroundings and of being distinct from other selves, intention, moods, and emotion on the part of the fetus are included frequently in the explanation of the image for parents. Fetal movement which impedes the process of conducting the examination is described as evidence that the fetus is "shy," "modest," or "doesn't like" something. As sonographers attempt to photograph the image, they may comment: "He moves away when I try to take the picture" or "He's shy. He doesn't want his picture taken." They may also refer to fetal shyness and modesty when visualizing the genitalia is difficult. Conversely, a clear, easily attained fetal image may be offered as evidence that the fetus is "being good" or "very cooperative."

The cyborg also demonstrates its potential, its ability to acquire elements of cultural competence such as language, a moral sense, or a role as a "productive" member of society. Just what kind of person the fetus will become (athletic, smart, wakeful, fast-moving, just like Dad) is revealed in the sonographer's explanation. Activity seen during the ultrasound may be described in terms of future behavior of the baby or young child: "Your baby is moving a lot. You're gonna be busy!" These kinds of statements are often gender-specific: "What a big baby. It must be a boy!" "With thighs like that it has to be a girl."

The compelling nature of this cyborg is especially evident when sonographers see an image which they particularly like. Their posture, facial expression, and voice change as they lean closer to the screen, often tilting their heads and smiling. Sonographers may even touch, stroke, and "tickle" the on-screen image, particularly the fetal feet, and create a voice so the fetus may "speak" to the expectant couple and communicate its "feelings." Expectant couples watch, delighted, as sonographers may wave to the image and speak to it, giving instructions and words of encouragement or reprimand, as in "Hold still, baby" and "Smile for the camera!" At these moments, sonogra-

phers and expectant couples closely resemble people admiring a baby in someone's arms.[2]

Personified in these ways, the cyborg fetus mesmerizes the viewer into forgetting that the main embodied, subjective, perceptive actor of ultrasound is the woman. The distinction between the fetus inside the woman and the collection of echoes on screen is blurred, creating what Sarah Franklin (1993:537) has called "bodily permeability," allowing the viewer to move "seamlessly from the outside to the inside of the woman's body" (see also Duden 1993). The loss of their bodily boundaries and bodily knowledge passes unnoticed or without comment by many women, as they are captivated by the fetal image or distracted by the discomfort of the full bladder which some hospitals still insist upon. This bodily permeability may also be desired by many women. Their excitement about the "chance to see," their conviction that "seeing is believing," and their fascination with the printout of the fetal image—the "baby's photo"—that they take home all underscore the cultural valorization of the visual.

A few women express a sense of sadness that their intimate privileged knowledge of the fetus is lost during ultrasound. Some are startled to see fetal movement on-screen, when they do not yet sense it. Seeing this movement prior to bodily quickening reinforces women's acceptance that ultrasound provides authoritative and distinctive information, but for some women it is unsettling.

> It was neat and all that, you know, to see the baby moving. But, I don't know, I guess I thought the mother was supposed to feel it. Like that's when you know it's there. (Tina, twenty-eight, social services worker)

> We could see it moving and I told her [the sonographer] I had felt it when I was taking the Metro. She said that wasn't it, that I couldn't feel it until a few more weeks. I thought for sure it was the baby moving, but I guess not. (Teresa, twenty-seven, business owner)

After listening to the sonographer lay claim to the fetus, some women, like Teresa in the previous quote, try to (re)assert the importance of their own bodily awareness in detecting fetal movement and knowing fetal age and gender. But contests over knowledge about the fetus are usually won by the cyborg, spoken for by the "expert" sonographer. For example, estimates of fetal age based upon ultrasound measurements nearly always take precedence in physicians' reports over the estimates given by women. Sidelined into what some physicians call an "unreliable source" or a "poor substitute" for the ultrasound-generated knowledge, women are left trying to relocate the fetus in their own bodies, looking back and forth between the image on screen and their own abdomens.

The fact that very few women express negative feelings or are critical of ultrasound while they are pregnant may also be due in part to their feelings of dependence upon the technology. For many of the Canadian women interviewed, the first few months of pregnancy bring about a heightened sense of the possibilities of their own body. They talk at length about subtle changes in its shape and appearance and worry openly about its normality and potential for failure. Anxious about miscarriage and fetal abnormalities, many women hesitate to tell friends and extended family about the pregnancy or to signal their changing status by wearing (more comfortable) maternity clothing, effectively putting the pregnancy "on hold" until after they "pass" the first ultrasound examination. Their dependence on ultrasound diminishes somewhat by the second routine scan during the seventh month of pregnancy. By that time, a woman's own bodily knowledge, based largely on fetal movements, also conveys the message that "everything is okay." By postpartum, however, the appeal and persuasiveness of the cyborg is eroded, as women express disappointment and frustration with ultrasound's failure to accurately predict fetal size, long and difficult labors, or cesarean deliveries.

Mum, Dad, and Cybaby

Through these conditions of "bodily permeability" and the dis-location of the fetus onto an external monitor, women are simultaneously marginalized and subjected to increased surveillance. As they carry out the scan, sonographers mediate not only the bodily and physical connections between woman and fetus but also their emotional attachment and social relationship. The cyborg fetus, as we discussed, emerges as a social being, a social actor with a distinctive identity—"the baby"—enmeshed in a social network where a pregnant woman and her partner are often referred to as "Mum" and "Dad" and family members who are present are encouraged, for example, to look at their "niece" or "grandchild" or "baby brother."

Linked to these identities and included in the sonographers' accounts of the fetal image are normative and culturally specific expectations about parental behavior. Implicit in these accounts is the idea that women who come for ultrasound, who avail themselves of the benefits of this technology, are doing what is best for their babies. The sonographers refer (among themselves) to certain women as "nice patients." These are women who, the sonographers believe, "care" about the fetus; that is, they show interest in the image and concern about fetal health, but not too much interest in fetal gender. These women tend to receive detailed and personalized accounts of the cyborg, as described above. In contrast, abbreviated accounts of the image may be given to women believed to be uninterested in the image or more concerned about fetal gender than fetal health.

The sonographers' accounts of the ultrasound image are infused with a

powerful cultural script on "natural" behavior for pregnant women and mothers. According to this script, women from certain groups—"different races," to use the sonographers' term—are assumed by some sonographers to be abnormal or "different" by nature: impassive, unemotional, or overly interested in the "wrong thing." Black women and First Nations women are sometimes said to be unexcited or unmoved by the prospect of having a baby and thus may receive relatively brief accounts of the fetal image. In the Canadian clinic, one of us (LMM) was told by several sonographers that "some women just want to know the sex." East Asian and South Asian women, in particular, are said to be "overly" interested in knowing the fetal sex, and it is assumed that they want only male babies.[3] Women who appear to be particularly interested in learning the fetal sex are often told: "Finding out the sex isn't important. The most important thing is that the baby is healthy." If sonographers are concerned that a woman will be disappointed by the sex of the fetus, especially if they think she may terminate the pregnancy, they may simply tell her that they are unable to see whether it is a boy or girl.

This discourse on motherhood is played out not only along lines of cultural or "racial" difference but also in terms of reproductive history, personal habits, and self-discipline. Women having their first child may be dissuaded from knowing the fetal sex with statements such as: "This is your first? You don't want to know, do you? You can always try again." Women in their teens, women in their forties, women with more than four or five children may be asked about their decision to have a baby at this point in their lives. Women over thirty-six may be asked to give reasons if they mention refusing amniocentesis. Similarly, if they admit to smoking during pregnancy, women may be shown the image of the placenta and told, incorrectly: "We can see the smoke in it." Obese women, told that "it's hard to see," are thereby reminded that their bodies are an obstacle to prenatal diagnosis. Women are constantly monitored during ultrasound, not only for fetal anomalies or physical conditions which may complicate labor and delivery but also for their own shortcomings—failure to monitor their bodies and behavior, failure to be compliant and selfless—in short, for failing to be "good mothers."

Central to this discourse on maternalism is the notion of "bonding" or emotional attachment to the fetus. The idea of using ultrasound to modify a woman's sentiments and behavior toward the fetus first appeared in clinical journals during the early 1980s. Once elevated to the status of "psychosocial benefit," bonding with the cyborg fetus during ultrasound quickly became a new area of ultrasound research (Garel and Franc 1980; Kemp and Page 1987; Kohn et al. 1980; Milne and Rich 1981; Sparling et al. 1988; Villeneuve et al. 1988). Detailed explanations of the fetal image were said to stimulate "positive feelings" toward the fetus (Reading et al. 1982), and the reaction of women to the image could then be re-presented as a gauge of their

emotional commitment to the fetus. The power of the cyborg fetus to stimulate a woman's "natural" mothering response is now also assumed to reduce her anxiety and improve her compliance with such things as medical advice, regular dental care, and avoiding cigarettes and alcohol (Reading et al. 1982). As we discussed above, the cyborg fetus also serves to identify those women whose "nature" is different. The disciplinary response or corrective action for being different varies from the "silent treatment" observed in the Canadian clinic to the more draconian efforts of some American lawmakers to legislate mandatory viewing of ultrasound fetal images as a way of dissuading pregnant women from having an abortion (Lippman 1986:442).

The use of ultrasound to promote bonding follows a path similar to the "One-Two Punch of the Technocracy" as described by Dumit and Davis-Floyd in the Introduction to this volume. That is, once having mediated and helped effect the conceptual separation of pregnant woman and fetus, ultrasound later comes to be regarded as integral to the process of re-membering the two, that is, to technologically "bonding" mother to fetus. Maternal attachment, formerly considered "natural," a ubiquitous "instinct," can no longer be left to nature and to women. In recent years, the sonographer's objective has expanded to encompass fathers as well, as a new clinical niche, "family-centered sonography," has been promoted as a means of enhancing both maternal and paternal attachment to the fetus (Craig 1991; Spitz 1991). In the Canadian clinic, during the routine ultrasounds, male partners are encouraged by sonographers to "move closer" to the screen and to talk about the image; women who come alone to the examination are asked, "Your husband didn't come?" (See Sandelowski 1994 for more on men's and women's differing responses to fetal ultrasound.)

■ BOUNDARIES, FUSIONS, POSSIBILITIES

What "dangerous possibilities" do the "transgressed boundaries [and] potent fusions" of ultrasound hold for women in North America?

At the time of the interviews, the forty-nine Canadian women were between the ages of twenty-two and thirty-three and living with a male partner. The women were awaiting the birth of their first child and had been labeled by their obstetricians as "low risk" for fetal anomalies or complications of pregnancy. Most of the women are Canadian-born, but they construct their identities along diverse cultural lines. They include, by their own terms, women who are "Lebanese," "Anglophone," "Italian-Canadian," "Québécoise," "Jewish," "WASPS" and "just Canadian," among others. They are also women from different religions, educations, and work worlds, but their lifestyles, homes, and incomes signal their middle-class status. Despite differences in their cultural and social locations, their narratives on the cyborg fetus are strikingly similar.

It is clear that many of these women feel reassured and empowered by the cyborgification of the fetus. Hearing the sonographer say "Everything is fine" and seeing the heartbeat or fetal movement is eagerly accepted by most women as evidence that they will give birth to "a normal baby" and can publicize the pregnancy. The sonographer's redescription of the fetus in sentimentalized and personalized terms also touches a chord with many women. They use what they saw and heard during ultrasound as both proof of the fetal presence (as opposed to merely "being pregnant") and a means of discovering their baby's gender and clues about its behavior, character, and family resemblance.

> The first thing I saw, it's crazy I know, but this kid has my husband's legs. Everything about it was like my husband. Just the way it looked, the build, the bones, the proportions. It was incredible. (Sylvie, twenty-five, florist)

> It's a girl! I'm sure it's a girl. They said it was too early to tell, but the baby was so tiny and delicate. I know it's a girl. (Suzanne, twenty-seven, office manager)

Universal and comprehensive health insurance throughout Canada includes at least one prenatal scan, and many women now expect this technologically mediated introduction to the fetus. Although the vocabulary, idioms, and metaphors among women's accounts of the cyborg fetus vary, there are few markedly different voices. At the research hospital, the sonographers make a special effort to personalize this introduction, and perhaps the similarities in the women's accounts of the cyborg fetus are due in part to the detailed accounts which they receive. Notably, for a small group of women, recent immigrants to Canada and unfamiliar with either ultrasound or the North American discourse of maternal-fetal bonding, ultrasound is viewed as a diagnostic test, rather than a means of elaborating the social identity of the fetus.

The cyborg created and apprehended in this ritualized, technological, and public quickening transforms the social reality of pregnancy for these Canadian women. The dis-location of the fetus from women's bodies and from their experiential knowledge opens up a space with multiple possibilities for monitoring, controlling, and altering women's behavior during pregnancy. For more than a decade, Anne Oakley (1984:185) and others have argued that ultrasound is one of "a long line of other well-used strategies for educating women to be good mothers." Women, however, are not passive recipients of ultrasound; they are attuned to the possibilities of using the cyborg fetus in the context of their own social relationships.

For some women, ultrasound holds the possibility of stimulating or engaging a partner's interest in the baby and testing his commitment to the relationship.

> I want him to know that this is a baby. It's not going to go away. He just can't get it yet. I guess it's a physical thing. Men don't have all the changes in their body. . . . The ultrasound changes that. It's like a slap in the face for him! Now he's got to get serious about us and this baby. (Vicky, twenty-five, medical receptionist)

> My husband hasn't said very much about this baby. He's older, he's got two other kids from his first marriage. So I guess I'd like him to show more interest. A friend told me her husband cried when he saw the ultrasound. I guess I'm kind of hoping that happens to Russ. (Gillian, thirty, management consultant)

Ultrasound also offers some women a means of rescripting or validating their position in a network of family and friends. For example, one woman gave an enlarged photocopy of the ultrasound image to her parents and in-laws.

> Our parents, especially his, they didn't really want us to get married. They said we were too young or not ready or something. I don't know. I mean, I think this baby shows them that, you know, we're really serious about each other. This isn't some boyfriend-girlfriend thing. We're a family now. (Erika, twenty-four, business owner)

Among one-quarter of the women, those who had once miscarried or are particularly anxious about miscarriage, ultrasound echoes are especially and poignantly meaningful as reassuring "proof" that they *will* have a baby. A few are even willing to use the ultrasound as evidence to counter the opinions of their own doctors.

> I took my picture in to my doctor the next week and said, "See, see. I told you this time it would be all right." She's very cautious, always saying, "Let's take it one step at a time." But I feel great. (Marie-Claude, twenty-seven, sales clerk)

It is clear that some Canadian heterosexual, middle-class women may embrace the cyborg fetus as a means of confirming, strengthening, or testing their relationships with partners, kin, and friends and a way of asserting the authority of their bodies and voices. At this point, however, we do not know much about the possibilities the cyborg fetus holds for North American women of different medical traditions and birth philosophies, or for disabled women, single parents, pregnant teenagers, or lesbian women.

The cyborg fetus is a cultural rather than a natural entity. Whereas the North American cyborg fetus may display emotions and consciousness, a distinctive or potentially distinctive self, and be immersed in social relationships, in Greece it is clear that other cultural scripts are at work. Ultrasound scans observed in the public hospital in a small Greek city reveal striking differences from, as well as some intriguing similarities to, the experiences of North American women. In Greece, as in Canada, fetal ultrasound is a routine procedure, with most women undergoing multiple scans over the course of a normal pregnancy. Scans in Greece are embedded in a paternalistic model of doctor-patient relations, and almost all obstetricians are male. While the authority and expertise of doctors may be challenged, the technical knowledge produced by machines, which symbolize a modernity avidly desired in health care, rarely is.

Scans, which are most commonly referred to by doctors and women alike as "putting the baby on television," are always performed by a woman's (male) obstetrician in nearly complete silence. The scanning session is brief, lasting on average about five minutes. Women crane their necks to look at the monitor, but usually, for most of the scan, their eyes are trained on the physician. Typically, the session's silence is punctuated at just three points by the physician's terse announcements of fetal sex (or a brief explanation of why sex cannot yet be determined), fetal "health" ("the baby is all right"), and fetal age, precisely given in weeks and days. If a woman speaks at all, it is usually to prompt the physician to pronounce on fetal health if he fails to do so.

Both Greek and North American women commonly refer to the ultrasound image as the "baby" or the "child." However, the Greek women do not attribute to it the qualities of a separate individual, with its own subjectivity and potentiality, as do so many North American women. Notably, the Greek women agreed that all ultrasound could reveal about the fetus was its physical attributes. They took the doctor's assurance that "the baby is all right" to mean that the fetus was *physically* integral or, to use the women's words, that the "baby had its hands and feet," "all its organs," and was "whole" or "able-bodied." What it could not reveal was how these organs, including the brain, functioned. In both Greece and Canada, evidence of fetal personhood was read through signs of physical normalcy and fetal gender. However, none of the Greek women felt that ultrasound could provide any information on fetal personality or other subjective characteristics (in fact, asking this question often provoked puzzled looks).

Although the Greek women do not think of the ultrasound as a opportunity to "meet their baby" as though it were a separate and distinct individual, like many Canadian women, they often interpreted the scan as readily recog-

nizable evidence of fetal "reality." That is, the fetus became more "real" after visualization. Both Greek and Canadian women appear to be actively interpreting the fetal blur according to the codes of objectivity and realism that underwrite modern visual technologies (most notably television, but also videos and photography) in general (see Duden 1993; Fiske 1987; Petchesky 1987; Rapp 1997; Sontag 1989).

■ FETAL CYBORGS AND PERSONS

Although the sonographers' descriptions of the ultrasound image are very different in Greece and in Canada, women in both countries regard the image as a powerful and objective glimpse at what is "really" happening inside their wombs. Ultrasound's persuasiveness is due in part to the circumstances of its production at the hands of authoritative white-coated medical professionals. The truthfulness and authority of the image are further reinforced through the dramatic ability of the camera-like apparatus to compensate for the deficiencies of the human eye—both the doctor's and the woman's (see Crary 1990). In this regard, Greek and Canadian women's use of metaphors of other visualizing machines (television, camera, microscope) to refer to the ultrasound apparatus is revealing. For both Greek and Canadian women, a common early exposure to television (nearly all of the Greek women interviewed were born after the introduction of television to Greece in 1966) may have socialized them to be "relatively flexible readers of images" (Condit 1990:85), and thus prepared them to metaphorize the shadows that appear on the screen into "my baby." The sense that what is seen on the screen is "really real" also derives from the codes and conventions of visual realism that ultrasound shares with other visualizing technologies. Thus, for instance, ultrasound's ability to reveal movement in "real time," like live television, imparts a feeling of "nowness" and immediate contact with the image on the screen. As the impact of the mass media has become increasingly global, so too has the visual realism that is one of its most characteristic genres. In the process, the boundaries of cultural difference may be blurred (Appadurai 1991:205).

While many Canadian and Greek women appear eager and willing to accept the cyborg as an improvement over their own understandings of the fetus, the ways in which they metaphorize the fetal blur indicate culturally different understandings of ultrasound technology, pregnancy, and fetal personhood.

According to the tenets of the Greek Orthodox Church, to which nearly all Greeks belong, the soul—and thus, it would seem, personhood—is acquired at conception. Yet the Greek women never spoke of the fetus as an autonomous in-utero subject. The striking absence of attributions of fetal subjectivity, agency, and potentiality is nonetheless consistent with the more rela-

tional everyday Greek understanding of the person: persons are constituted through their relations with others, particularly with family members, and not as autonomous and separate units. In contrast to a distinctively North American ethnopsychology premised on an abstract and quasi-sacred individual self, in Greek local understandings the self is constituted as "an integral part of the group" (Pollis 1987:590).

One particularly telling manifestation of the relational view of the person is anti-abortion discourse. Abortion is a much more common experience for Greek women than for North American women (see Georges 1996 for the reasons why). This is so despite the teachings of the Greek Orthodox Church, which equates abortion with the sin of murder. Its absolutist equations notwithstanding, Church opposition to abortion remains relatively muted and anti-abortion discourse in the public sphere is largely limited to the periodic lamentations of the press or of politicians decrying the falling birthrate. In public discussion, Greece's high abortion rate and low birthrate are primarily represented as threats to Greece's geopolitical security and to the continuity of the Greek nation, the *ethnos*, or "organic national whole," and of the Greek "race" and religion (Georges 1996; Halkias 1995). The Greek context is thus in sharp contrast to North America, where attention has been overwhelmingly focused on the fetal individual and its rights.

As Barbara Katz Rothman (1989:114, 59) points out, the view of the fetus, "not as part of its mother, but as separate, a little person lying in the womb," has deep historical roots in North American traditions of viewing individuals as "autonomous, atomistic, isolated beings." While they may talk about the fetus in terms of its relations and resemblance to family, many North American women do think of the fetus as a separate individual. During the last few decades, however, there has been a further significant rupture in the way the fetus is conceptualized, talked about, and acted upon. The fetus is no longer simply a separate entity; representations of the fetus in medical discourse have shifted from passive and parasite-like to active and independent (Franklin 1991:193; Hartouni 1991). The fetus as agent is powerfully naturalized through the discourses of science and maternalism and reinforced in popular culture and anti-abortion imagery and rhetoric. Thus the "fetoplacental unit" is said to issue hormonal commands to the mother who, if she wants to do the "best for her baby," must learn to read her moods and bodily symptoms as evidence of fetal signals for nutritious foods, rest, and regular medical care.

The North American fetus has become highly visible as a public figure, reflecting once again distinctive constructions of the person, as well as divergent historical and political contexts. Electronic and print media stories about fetal diagnosis and therapy, fetal rights, and the abortion issue appear frequently. Anti-abortion discourses are undeniably better organized, more vocal, and more politically powerful in the United States, but Canadian

women's understandings of pregnancy are infused with their personal reflections on the legal, ethical, and political controversy over fetal rights and abortion. For example, although only a few of the Canadian women interviewed describe themselves as "anti-abortion" or "pro-life," nearly all women avoided the term "fetus," saying it reminded them of the abortion issue. The North American fetus is also a source of cultural entertainment, appearing in Hollywood films, in advertisements for telephone companies and cars (Taylor 1992), and in comic strips. Through these diverse representations, North Americans have become accustomed to *seeing* the fetus and seeing the fetus as a *social actor*. In Greece, in contrast, there is no "public fetus." Images of the fetus in the media are not frequent, and only an occasional hospital poster exhorts women not to smoke during pregnancy.

Not only are the fetal subjects of ultrasound culturally constructed, so too are pregnant women. Actively consuming ultrasound technology is one way of constituting oneself as a modern pregnant subject in contemporary Greece. Medical technology (and technology in general) is a metonym for modernity, not only for mothers and fathers but also for physicians. This valorization of modernity is closely linked to what has been called Greeks' "perennial identity crisis" (part of the East/Orient or the West/Europe) which has been heightened in recent years as a result of its "full" (but nonetheless de facto marginal) membership in the European Union (Papagaroufali and Georges 1993). Although membership in the EU has been actively embraced by Greeks, to the more powerful states Greece is an unruly junior partner whose capability of applying Western values and institutions remains in doubt. In this ambiguous contemporary moment, consumption of technology is an important way of identifying oneself as modern and, implicitly, European. In contrast, a few of the Canadian women talked about ultrasound as an example of "medical progress" or "something our mothers didn't have," but most did not. Canadian women seem to regard ultrasound primarily as a means of "doing what's best for the baby" and relieving their own anxiety about anomalies and miscarriage. Rather than a metonymic connection to a modern identity, ultrasound in Canada is firmly embedded in an individualizing ideology of risk and maternal responsibility. Implicit in women's anxieties and actions is the belief that "good" mothers do not take risks and, therefore, "good" mothers avail themselves of ultrasound (see also Quéniart 1992).

Differences in Greek and North American constructions of the fetal and maternal persons are further highlighted when we compare popular cultural translations of expert knowledge about pregnancy. One such important channel for the diffusion of scientific images and knowledge about the fetus is pregnancy guides. All of the Canadian women read pregnancy guides, many of which contain Lennart Nilsson's famous photographs of the live fetus in utero. About half of the Greek women used pregnancy guides, and the major-

ity consulted the same book, called *Birth Is Love*. The only guide written by a Greek, *Birth Is Love* also includes reprints of Nilsson's images—in this case, the earlier (1965) photographs of autopsied fetuses. However, the Nilsson images in the guides read by Greek and Canadian women are embedded in sharply contrasting rhetorical constructions. Instead of the soft-focus, vulnerable, solitary, pink, thumb-sucking North American in utero "baby," the grainy black-and-white photos included in *Birth Is Love* are far from cuddly. Throughout the Greek text, attention is focused almost exclusively on the physical characteristics and development of the fetus. In distinct contrast, the guides read by the Canadian women interviewed portray the fetus, even during the early weeks of pregnancy, as a sentient, active, and socialized individual, often engaged in purposeful activities, and emphasize maternal-fetal bonding as a central and essential experience of pregnancy. This discourse of prenatal bonding is entirely absent in the Greek text. *Birth Is Love* does, however, contain a lot of advice to women on how to be a proper patient: it urges women to be prompt for appointments and precise and concrete in their reports to the doctor. In Greece, Nilsson's cyborg is recruited to encourage women to be both modern pregnant subjects and disciplined patients. North American pregnant women, already disciplined and medicalized, can now be "rewarded" with maternal-fetal communication.

Conceived and widely regarded as the means to revealing what is natural, true, and common to all fetuses and all pregnancies, fetal ultrasound imaging appears to lack culture, to be a universalizing technology. As we attempt to show in this chapter, rather than the rational unveiling of nature, the cyborg fetus emerging from this technology says as much about the cultural and historical conditions of its production as it does about "nature" (Haraway 1992:304). Specifically, our chapter illustrates that cyborgification simultaneously reproduces and reconfigures understandings of, and relationships with, the fetus. Although the ultrasound apparatus may dramatically expand the sensual and cognitive apprehension of the fetus, it always does so within the constraints of dominant discursive formations. One advantage of the cross-cultural perspective we have adopted here is the possibilities it opens up for exploring the complex ways in which these powerful discourses operate in society.

In Canada, ultrasound is about the separation and reconnection of individuals. Pregnant women expect that they will "meet their baby" on the ultrasound screen, and are encouraged by experts to see in the image digitalized evidence of a gendered, conscious, and sentient fetal actor communicating its demands and needs. Caught in a complex and very public ideology of fetal risk and maternal responsibility, Canadian women embrace ultrasound as a means of demonstrating that they are "good mothers."

In Greece, the production of fetal and pregnant subjects is markedly different. Ultrasound's evidence of fetal physical normalcy is read as evidence of fetal personhood. However, fetuses remain relational beings whose personhood is constituted primarily through networks of kin. As the Greek pregnant women eagerly demand and consume ultrasound technology, they actively constitute themselves as modern pregnant subjects and, by implication, symbolically affiliate themselves with Europe and the West.

Yet if the cyborg fetus collaborates in the reproduction of dominant discourses about personhood, motherhood, and modernity, it also helps reconfigure women's experiences of pregnancy. For the cyborg, "[t]he machine is us, our processes, an aspect of our embodiment" (Haraway 1991:180). As such, it expands and alters the bodily experience of pregnancy in significant ways. Through their intimate interaction with ultrasound, both Greek and Canadian women have emphatically redefined the experience of quickening as occurring when they first see the fetal image on the screen. "Seeing the baby" and "putting the baby on television" are what make the pregnancy feel "real." However, this reconfiguration is not a simple and automatic result of visualizing the sonographic blur. Rather, it is mediated by the codes and conventions of visual realism embedded in ultrasound. This genre of visual realism is now globally familiar, powerfully inculcated by the mass visual media. Through the ultrasound apparatus, these mass-mediated codes and conventions of visual realism have become part of the commonsense bodily experience of pregnancy for both North American and Greek women. In its reproduction and reconfiguration, the cyborg fetus is constituted by cultural understandings both local and global.

Notes

1 During fifteen months of fieldwork, primarily at one hospital ultrasound clinic with additional observations at other sites, LMM watched hundreds of ultrasounds and spoke with numerous sonographers—the obstetricians, technicians, nurses, radiologists, family physicians, residents, medical students, and others who perform ultrasound. Forty-nine women and the partners of some of these women were interviewed throughout pregnancy and postpartum. Funding for this research was provided by a Wenner-Gren Foundation Predoctoral Research Grant.

EG conducted six months of fieldwork in Greece, most of it in a public hospital, with additional observations in other sites, including a teaching hospital in Athens. Over eighty ultrasounds were observed, and obstetricians, residents, professors of obstetrics, and professional midwives were interviewed. In addition to dozens of informal interviews with women before and after ultrasounds, in-depth interviews were conducted with twenty-six postpartum women within one to three days of their giving birth. Funding was provided by the American Council of Learned Societies and a Landes RISM Award.

2 While ultrasound images in Canada may show consciousness, emotion, and intention as obvious and "natural" facts of the cyborg fetus, the varieties of ultrasound practices among Cana-

dian hospitals point to the continual shaping and filtering of these fetal images by institutional agendas, professional contests, and personal styles. At one Canadian hospital, obstetrician-sonographers compare their ultrasound practices with those of radiologists, claiming that radiologists can obtain technically superior images and more precise measurements, but lack certain communicating skills. "Knowing how to talk to patients" during ultrasound, taking the time, that is, to "show women the baby" and personalize the fetal image is believed by the obstetricians to be an essential part of good prenatal care. At a second hospital, one of the sonographers dismissed queries about why her clinic discusses only the diagnostic elements of the ultrasound and does not "show the baby." "We're not in the entertainment or warm fuzzies business," she said bluntly. "All that talk is just stuff to make women feel better. We're using it [ultrasound] to look for problems, make diagnoses, and then we send them home."

3 Sunera Thobani (1993) shows how the opening of a sex selection clinic in the United States directed at South Asian women in Western Canada reinforced racist and patriarchal assumptions about South Asian culture.

References

Appadurai, Arjun. 1991. "Global Ethnoscapes: Notes and Queries for a Transnational Anthropology." In *Recapturing Anthropology*, edited by R. Fox, 191–210. Sante Fe: School of American Research Press.

Black, Rita Beck. 1992. "Seeing the Baby: The Impact of Ultrasound Technology." *Journal of Genetic Counseling* 1 (1): 45–54.

Blue, Amy. 1993. "Greek Psychiatry's Transition from the Hospital to the Community." *Medical Anthropology Quarterly* 7 (3): 301–318.

Condit, Celeste M. 1990. *Decoding Abortion Rhetoric: Communicating Social Change*. Chicago: University of Illinois Press.

Cox, David, et al. 1987. "The Psychological Impact of Diagnostic Ultrasound." *Obstetrics and Gynecology* 70 (5): 673–676.

Craig, Marveen. 1991. "Controversies in Obstetric Gynecologic Ultrasound." In *Diagnostic Medical Sonography: A Guide to Clinical Practice*, vol. 1 *Obstetrics and Gynecology*, edited by Mimi Berman. Philadelphia: J. B. Lippincott.

Crary, Jonathan. 1990. *Techniques of the Observer: On Vision and Modernity in the Nineteenth Century*. Cambridge: MIT Press.

Duden, Barbara. 1992 "Quick. with Child: An Experience That Has Lost Its Status." *Technology in Society* 14: 335–344.

———. 1993. *Disembodying Women: Pespectives on Pregnancy and the Unborn*. Cambridge: Harvard University Press.

Eyers, Diane E. 1992. *Mother-Infant Bonding: A Scientific Fiction*. New Haven: Yale University Press.

Fiske, John. 1987. *Television Culture*. New York: Routledge.

Fletcher, John, and Mark Evans. 1983. "Maternal Bonding in Early Fetal Ultrasound Examinations." *New England Journal of Medicine* 308 (7): 392–393.

Franklin, Sarah. 1991. "Fetal Fascinations: New Dimensions to the Medical-Scientific Construction of Fetal Personhood." In *Off-Centre: Feminism and Cultural Studies*, edited by Sarah Franklin, Celia Lury, and Jackie Stacey, 190–205. New York: Routledge.

———. 1993. "Postmodern Procreation: Representing Reproductive Practice." *Science as Culture* 3 (part 4, no. 17): 522–561.

Garel, M., and M. Franc. 1980. "Réactions des Femmes à l'Ecographie Obstétricale." *Journal of Gynaecology, Obstetrics, Biology and Reproduction* 9: 347–354.

Georges, Eugenia. 1996. "Abortion Policy and Politics in Greece." *Social Science and Medicine* 42 (4): 509–519.

— — —. 1997. "Fetal Ultrasound Imaging and the Production of Authoritative Knowledge in Greece." In *Childbirth Across Cultures: The Social Production of Authoritative Knowledge,* edited by Robbie Davis-Floyd and Carolyn Sargent, 91–112. Berkeley: University of California Press.

Halkias, Alexandra. 1995. "When Talking about the Nation Means Talking about Babies: The Case of Greece's Demografiko and the Press' Portrayal of Abortion." Paper presented at the Modern Greek Studies Association Meetings, Cambridge, Mass., November.

Haraway, Donna. 1991. *Simians, Cyborgs, and Nature: The Reinvention of Nature.* New York: Routledge.

— — —. 1992. "The Promises of Monsters: A Regenerative Politics for Inappropriate/d Others." In *Cultural Studies,* edited by Larry Grossberg, Cary Nelson, and Paula Treichler, 295–337. New York: Routledge.

Hartouni, Valerie. 1991. "Containing Women: Reproductive Discourse in the 1980s." In *Technoculture,* edited by C. Penley and A. Ross. Minneapolis: University of Minnesota Press.

Hess, David. 1995. *Science and Technology in a Multicultural World.* New York: Columbia University Press.

Hyde, Beverley. 1986. "An Interview Study of Pregnant Women's Attitudes to Ultrasound Scanning." *Social Science and Medicine* 22 (5): 587–592.

Kemp, Virgina, and Cecilia Page. 1987. "Maternal Prenatal Attachment in Normal and High-Risk Pregnancies." *Journal of Obstetrics, Gynecology, and Neonatology in Nursing* (May/June): 179–183.

Kitzinger, Sheila. 1991. *The Complete Book of Pregnancy and Childbirth.* New York: Alfred A. Knopf.

Kohn, C. L. et al. 1980. "Gravidas' Responses to Realtime Ultrasound Fetal Image." *Journal of Obstetrics, Gynecology, and Neonatology in Nursing* 9: 77–80.

Lippman, Abby. 1986. "Access to Prenatal Screening Services: Who Decides?" *Canadian Journal of Women and the Law* 1 (2): 434–445.

Milne, L., and O. Rich. 1981. "Cognitive and Affective Aspects of the Responses of Pregnant Women to Sonography." *Maternal-Child Nursing Journal* 10: 15–39.

Mitchell, Lisa M. 1993. "'Showing Her the Baby': Clinical Interpretations of Ultrasound Fetal Images for Women." Unpublished ms.

Mitchell, Lisa, and Eugenia Georges. 1997. "Cross-Cultural Cyborgs: Greek and Canadian Women's Discourses on Fetal Ultrasound." *Feminist Studies* 23 (2): 373–401.

Morgan, Lynn. 1994. "Imagining the Unborn: Technoscience and Ethnoscience in the Ecuadorian Andes." Paper presented at the annual meeting of the Society for the Social Studies of Science, New Orleans.

Oakley, Anne. 1984. *The Captured Womb: A History of the Medical Care of Pregnant Women.* Oxford: Basil Blackwell.

Papagaroufali, Eleni, and Eugenia Georges. 1993. "Greek Women in the Europe of 1992: Brokers of European Cargos and the Logic of the West." In *Perilous States: Conversations on Culture, Race and Nation,* edited by George Marcus, 235–254. Chicago: University of Chicago Press.

Petchesky, Rosalind. 1987. "Foetal Images: The Power of Visual Culture in the Politics of Reproduction." In *Reproductive Technologies: Gender, Motherhood and Medicine,* edited by M. Stanworth, 57–80. Minneapolis: University of Minnesota Press.

— — —. 1990 *Abortion and Woman's Choice: The State, Sexuality, and Reproductive Freedom.* Rev. ed. Boston: Northeastern University Press.

Pollis, Adamantina. 1987. "The State, the Law and Human Rights in Modern Greece." *Human Rights Quarterly* 9: 587–614.

Pretorius, Jack Dolores, and Barry S. Mahoney. 1990. "The Role of Obstetrical Ultrasound." In *Diagnostic Ultrasound of Fetal Anomalies: Text and Atlas*, edited by David Nyberg et al., 1–20. Chicago: Year Book Medical Publishers.

Quéniart, Anne. 1992. "Risky Business: Medical Definitions of Pregnancy." In *The Anatomy of Gender*, edited by D. Currie and V. Raoul, 161–174. Ottawa: Carleton University Press.

Rapp, Rayna. 1990. "Constructing Amniocentesis: Maternal and Medical Discourses." In *Uncertain Terms: Negotiating Gender in American Culture*, edited by Faye Ginsburg and Anna Lowenhaupt Tsing, 28–42. Boston: Beacon Press.

———. 1997. "Real Time Fetus: The Role of the Sonogram in the Age of Monitored Reproduction." In *Cyborgs and Citadels: Anthropological Interventions in Emerging Sciences and Technologies*, edited by Gary Lee Downey and Joseph Dumit. Santa Fe: School of American Research Press.

Reading, Anthony, et al. 1982. "Health Beliefs and Health Care Behaviour in Pregnancy." *Psychological Medicine* 12: 379–383.

———. 1988. "A Controlled, Prospective Evaluation of the Acceptability of Ultrasound in Prenatal Care." *Journal of Psychosomatic Obstetrics and Gynecology* 8: 191–198.

Rothman, Barbara Katz. 1986. *The Tentative Pregnancy: Prenatal Diagnosis and the Future of Motherhood*. New York: Viking Penguin.

———. 1989. *Reinventing Motherhood: Ideology and Technology in a Patriarchial Society*. New York: W.W. Norton.

Sandelowski, Margaret. 1994. "Separate, But Less Unequal: Fetal Ultrasonography and the Transformation of Expectant Mother/Fatherhood." *Gender and Society* 8 (2): 230–245.

Sontag, Susan. 1989. *On Photography*. New York: Farrar, Straus and Giroux.

Sparling, Joyce, et al. 1988. "The Relationship of Obstetric Ultrasound to Parent and Infant Behaviour." *Obstetrics and Gynecology* 72 (December): 902–907.

Spitz, Jean Lea. 1991. "Sonographer Support of Maternal-Fetal Bonding." In *Diagnostic Medical Sonography: A Guide to Clinical Pratice*, vol.1, *Obstetrics and Gynecology*, edited by Mimi Berman. Philadelphia: J.B. Lippencott Company.

Taylor, Janelle. 1992. "The Public Fetus and the Family Car: From Abortion Politics to a Volvo Advertisement." *Public Culture* 4 (2): 67–80.

Thobani, Sunera. 1993. "From Reproduction to Mal[e] Production: Women and Sex Selection Technology." In *Misconceptions: The Social Construction of Choice and The New Reproductive and Genetic Technologies*, edited by G. Basen, M. Eichler, and A. Lippman, 138–153. Hull, Quebec: Voyageur Publishing.

Villeneuve, Claude, et al. 1988. "Psychological Aspects of Ultrasound Imaging during Pregnancy." *Canadian Journal of Psychiatry* 33: 530–535.

The Fetus as Intruder

Mother's Bodies and Medical Metaphors

Emily Martin

One of the "technologies" that profoundly affects the contemporary experience of reproduction is the very language of biological science. The imagery and metaphors that are the organizing features of scientific accounts are as real in their effects on the way doctors and patients act in the world as the effects of an antibiotic or a scalpel. For example, the science of reproductive biology includes in its inner core, its very language and concepts, deeply cultural assumptions about males and females. The standard medical accounts of a woman's body going through menstruation, birth, and menopause depict her as engaged in various forms of industrial production: when she menstruates instead of getting pregnant, it is interpreted as failed production. (Menstrual fluids, which one author of a standard text used in medical schools described as "the uterus crying for want of a baby," are seen negatively, as the result of breakdown, decay, necrosis, or death of tissue.) When a woman gives birth, it is regarded as successful production, but only if it adheres to a rather strict timetable reminiscent of assembly-line production. And when she reaches menopause, the central control apparatus of her body's bureaucratically organized production system is thought to undergo a devastating breakdown (Martin 1987). For another example, the standard medical account of fertilization (as well as accounts in popular science) see the egg metaphorically as a damsel in waiting, or a damsel in need of rescue, and the sperm as her seducer, rescuer, or violator, depending on whose account you read (Martin 1990).

These scientific cosmologies of the world and the person are some powerful ways we learn about gender and other cultural concepts, while thinking we are only learning facts about the "natural" world. While one might expect

reproductive biology to entail a lot of gendered imagery, what about biological sciences that focus on processes (unlike menstruation, birth, and menopause) that both men and women *share*? Immunology is such a science: only a woman has a uterus, but each of us has an immune system. In what follows I will describe some organizing metaphors that operate in immunology and how these metaphors, applied to both male and female bodies, contribute to the construction of women's bodies in pregnancy and labor as an immunological "problem." In this case, the problem is caused because the woman's body contains both "self" and the immunologically "other" fetus, instead of containing only the pure "self" privileged by the immunological model. Hence the pregnant woman becomes a kind of paradigm case of boundary transgression as well as the forbidden mixing of kinds. Here, the language of science acts like a stiff mold into which processes and beings must be made to fit even at the cost of distorting them. In Toni Morrison's words, this language is a "dead language." "It is unyielding language content to admire its own paralysis. . . . Unreceptive to its own interrogation, it cannot form or tolerate new ideas, shape other thoughts, tell another story, fill baffling silences" (1994:13–14). In this situation, the concept of a cyborg, positively glossing transgressions and mixing of kinds, can play a liberatory role, opening scientific models to different ways the body could be imagined.

■ THE IMMUNE SYSTEM AS THE CURRENCY OF HEALTH

The immune system has come to be a kind of "field" of health, in the sense that the underlying common regard for the immune system in the United States allows it to become a kind of currency in which health—degrees of it—can be measured and compared among different people and populations. Awareness and regard for the body's health as defined by the functioning of its immune system have come to be so general in the society that one cannot avoid them, wherever one turns.

In 1991 there was headline coverage of the fact that immune system dysfunctions had reached even the White House. Every member of the First Family resident in the White House—Barbara and George Bush with Graves' disease and their dog Millie with lupus—suffered from autoimmune disorders (Altman 1991). Somewhat later, major ad campaigns made direct use of the language, cells, and processes that belong to the immune system in order to promote new products. For example, Saab promoted its chassis as "The Antibody for the Auto Accident."[1]

These are just two moments in an extremely pervasive use of the immune system as a kind of "field" against which many phenomena have been given new interpretations and understandings. Over the course of the 1980s and

1990s, numerous long-existing conditions were redescribed as immune system dysfunctions: allergy, multiple sclerosis, cancer, heart disease, lupus, miscarriages, Addison's disease, myasthenia gravis, arteriosclerosis, aging, arthritis, and diabetes. Other more recently named conditions began to be understood medically as immune system dysfunctions and came under wide public discussion: chronic fatigue syndrome, AIDS, environmental immune response.

A great many factors in a person's environment that had long been thought to influence health came to be explicitly reinterpreted. Their effects, for good or ill, were now understood to be mediated through the immune system: sunlight, the seasons, smoking, silicone breast implants, electromagnetism, radiation, chemical toxins of all kinds, diet, malnutrition, exercise, pregnancy, fatigue, consumption of cocaine, opiates, alcohol, sleep, and even academic examinations.

A variety of specific social experiences were also related directly to immune functions, and discussed in the media. Positive effects on the immune system are claimed for: confessing one's troubles, volunteering to help others, caring for someone with Alzheimer's, attending a support group, getting sexually turned on. Negative effects on the immune system are claimed for: arguing with one's spouse, undergoing a divorce, bereavement. And of course there are a flood of new products focused on the immune system, such as "Immunergy," a vitamin supplement, and immune system–enhancing light masks.[2]

These reinterpretations amount to a change in our definition of what it means to be healthy. The immune system has moved to the very center of the culture's definition of health. Let me illustrate with an example of how people talk about the immune system:[3]

[Two men are talking, Bill Walters and Peter Herman]

Bill: I don't even think about the heart anymore, I think about the immune system as being the major thing that's keeping the heart going in the first place, and now that I think about it I would have to say yeah the immune system is really . . . important . . . and the immune system isn't even a vital organ, it's just an act, you know?

Peter: It's like a complete network . . . if one thing fails, I mean if [Bill interrupts:] if something goes wrong, the immune system fixes it, it's like a back up system. It's a perfect balance.

The immune system is the whole body, it's not just the lungs or the abdomen, it's, I mean if I cut myself, doesn't my immune system start to work right away to prevent infection? So it's in your finger, I mean it's everywhere. (Steven Baker)

How does the immune system work to keep us healthy? We will see that there is more than one answer. The portrait of the body conveyed most often and most vividly in the mass media shows the body as a defended nation-state, organized around a hierarchy of gender, race, and class.[4] In this picture, the boundary between the body ("self") and the external world ("nonself") is rigid and absolute: "At the heart of the immune system is the ability to distinguish between self and nonself. Virtually every body cell carries distinctive molecules that identify it as self" (Schindler 1988:1). One popular book calls these the individual's "trademark" (Dwyer 1988:37).

The notion that the immune system maintains a clear boundary between self and nonself is often accompanied by a conception of the nonself world as foreign and hostile. Our bodies are faced with masses of cells bent on our destruction: "to fend off the threatening horde, the body has devised astonishingly intricate defenses" (Schindler 1988:13). As a measure of the extent of this threat, popular publications depict the body as the scene of total war between ruthless invaders and determined defenders:[5] "Besieged by a vast array of invisible enemies, the human body enlists a remarkably complex corps of internal bodyguards to battle the invaders" (Jaret 1986:702).

In this total war, "Multitudes fall in battle, and together with their vanquished foes, they form the pus which collects in wounds" (Schindler 1988:24). "Killer cells," the technical scientific name of a type of T lymphocyte, are the "immune system's special combat units in the war against cancer." Killer cells "strike," "attack," and "assault" (Nilsson 1985:96, 98, 100). "The killer T cells are relentless. Docking with infected cells, they shoot lethal proteins at the cell membrane. Holes form where the protein molecules hit, and the cell, dying, leaks out its insides" (Jaroff 1988:59).

Not surprisingly, identities involving gender, race, and class are present in this war scene. Compare two categories of immune system cells, macrophages, which surround and digest foreign organisms, on the one hand, and T cells, which kill by transferring toxins to them, on the other. The macrophages are a lower form of cell; they are called a "primeval tank corps" (Michaud and Feinstein 1989:4) and "a nightmare lurching to life" (Page 1981:115). T cells are more advanced, evolutionarily, and have higher functions such as memory (Jaroff 1988:60). It is only these advanced cells which "attend the technical colleges of the immune system" (Nilsson 1985:26).

There is clearly a hierarchical division of labor here, one that evokes aspects of class, race, and gender distinctions in American culture. Macrophages are the cells that are the "housekeepers" (Jaret 1986) of the body, cleaning up the dirt and debris including the "dead bodies" of both self

and foreign cells. (One immunologist calls them "little drudges."[6]). As macro-phages feed, they may be described as "angry," in a "feeding fury," or "insa-tiable" (Page 1981:104), combining in one image uncontrolled emotions and an obliterating, engulfing presence, both common cultural ascriptions of females.[7]

Another kind of cell, the B cell, is sometimes feminized but ranks much higher in the hierarchy than the lowly macrophage.[8] This means that the B cell is sometimes imagined as a kind of upper-class female, a suitable part-ner for the top-ranked T cell. These two types of cells together have been termed "the mind of the immune system" (Galland 1988:10). In illustrations of these cells in *Peak Immunity*, each of them is depicted with a drawing of a human brain (DeSchepper 1989:16). Far below them in terms of class and race we would find the macrophage, angry and engulfing, or scavenging and cleaning up.

In this system, gendered distinctions are not limited to male and female, but also encompass the distinction between heterosexual and homosexual. T cells convey aspects of male potency, cast as heterosexual potency. They are the virile heroes of the immune system, highly trained commandos who are selected for and then educated in the technical college of the thymus gland. T cells are referred to as the "commander in chief of the immune system" (Jaret 1986:708) or "battle manager" (Jaroff 1988:58). Some T cells, killer cells, are masculine in the old-fashioned mold of a brawny, brutal he-man: in a mail advertisement for a book on the immune system, we are told, "You owe your life to this little guy, the Rambo of your body's immune system." A comic book for AIDS education depicts T cells as a squad of Mister Ts, muscular heroes from the television show *The A Team* (Cherry 1988:5).

In sum, for the most part, the media coverage of the immune system oper-ates largely in terms of the image of the body at war. Even when the problem is not an external enemy like a microbe but an internal part of "self," the mili-tary imagery is extended to notions of "mutiny," "self-destruction," and so on.[9] In one TV show, autoimmunity was described as "we have met the enemy and the enemy is us."[10] A book on AIDS written by a physiologist for a general audience repeatedly refers to autoimmunity as "the immunological equiva-lent of civil war" (Root-Bernstein 1993:87).[11]

■ OTHER VIEWS OF THE IMMUNE SYSTEM

The body as armed nation-state is also found in scientific immunological publications, often as vividly as in the media. But to some extent among sci-entists and to a greater extent among nonscientists, there is another compet-ing view of how the immune system should be understood. One (nonscien-

tist) woman we interviewed responded to an image of the immune system on the cover of *Time* magazine. A man's body was shown with a cutaway portion inside in which there was a boxing match between "the white cell wonder" (part of the immune system) and "the vicious virus." Vera Michaels objected to this drawing because it depicts "such violence going on in our bodies." She insisted that such violence is "not in there." She claimed her own representation would be "less dramatic":

> My visualization would be much more like a piece of almost tides or something . . . the forces, you know, the ebbs and flows.

> [Could you draw anything like that?]

> I could. I don't think anybody would perceive it as a portrayal of the battle within.

> [What is it that ebbs and flows?]

> The two forces, I mean, the forces . . . imbalance and balance.

As she spoke, she drew an accompanying illustration, labeling it "the waves."

A very senior immunologist who headed the department that included my fieldwork lab often talked to me about what came to be called "immunophilosophy." He thought that although most immunologists would take the self/nonself distinction as their starting point, this distinction sometimes gets them into trouble. "If you think just in terms of warfare, it is a little hard to explain autoimmunity, transplantation, why should you battle a leg from someone else, it would do you a lot of good!"

> [Microbes] are not just soldiers attacking us in the sense of attacking the United States. They are just living their lives because they happen to live their lives in us. Plenty of organisms live their lives happily with us. Warfare is a very nice way to explain it on a very superficial level, but a normal part of existence as microorganisms is *balance*.

And a subset of immunologists favor what they call a network theory of the immune system. Imagery of the dance replaces imagery of battle. The body positively reaches out into the world and takes it in:

> The dance of the immune system and the body is the key to the alternative view proposed here, since it is this dance that allows the body to have a changing and plastic identity throughout its life and its multiple encounters. Now the establishment of the system's identity is a *positive* task and not a reaction against antigens (foreign substances). (Varela and Coutinho 1991:251)

Even though the warfare/nation-state model is not uniform across either science or popular culture, it does seem to operate very actively when it comes to women's bodies specifically. In whatever way immune cells are marked by gender, sexuality, race, or class, all belong to "self" and have the primary function of defending the self against the nonself. When the nonself is a disease-causing microbe, the model works quite logically. But when the nonself is a fetus growing inside a woman's body, the model quickly runs into strange territory.

First we need to know a couple of definitions: according to one textbook, an *allograft* is a graft of tissue between genetically different members of the same species (Kimball 1986:433). A kidney I receive as a transplant from my brother is an allograft. On direct analogy with this, the fetus can be viewed as an allograft in the mother's body: it is genetically different but human tissue, transplanted into the mother's body. Given this model, this standard immunology text then wonders "Why . . . does the mother not mount an attack against the fetus as she would against any other allograft [such as a transplanted kidney]?" (p. 433). The text then goes on to suggest several answers: the placenta shields the maternal attacks; the mother's immune system is depressed during pregnancy; the baby's immune system may "play an active role in defending itself from its mother's immune system." All this debate takes place in the section of the text labeled "Tolerance of the Fetus."

One anthropological question is how immunology could come to picture the state of pregnancy as such an embattled one. What underlying models lead to such a picture? What would be the implications of a different underlying model? Scientific accounts often remain caught in puzzles produced by their models rather than examining the models themselves. As a headline in an article in *The Economist* put it, "Why Does the Body Allow Foetuses to Live?" (1985). The lack of the "expected immune attack" from the mother (Stites et al. 1987:619) is even more mysterious given that pregnant women have antibodies to certain antigens expressed by the fetus. This means that the women's immune system has recognized, *seen*, the fetus. The reduction in the woman's *normal* immune response, which would be to destroy the fetal "nonself," whatever the mechanism, is called *tolerance*. From an immunological point of view, the fetus is credibly described as a "tumor" which the woman's body should try furiously to attack (Dwyer 1988:60). But the mother's immune system "tolerates" her fetus; all of our immune systems "tolerate" our own tissues, unless we suffer from autoimmune disease.

Given the construction of the puzzle as "Why doesn't the mother 'kill' the fetus during pregnancy?" we might wonder about labor. Indeed it is suggested in the medical literature that immunologic factors may play an important role

in the initiation of normal labor (Rath 1994). In other words, it is suggested that labor is a result of the mother's immune system's finally expelling the fetus.

There are both drama and mystery in this situation. The drama lies in the "failure of most women to mount an immune response to inseminated spermatozoa" even though a woman "possesses an immune system that should be fully competent to recognize and react against them" (Billington 1992:417–418). The tension in the drama is that the survival of the species depends on the female's *not* destroying sperm and embryos when she is clearly capable of doing so: the woman seems to be pointing a fully loaded gun at the sperm/embryo, a gun she might fire at any time. As Billington notes,

> The immune system has evolved to provide a complex yet highly efficient mechanism for the recognition and elimination of foreign material entering into the body. It is therefore paradoxical that the survival of our species should depend upon a method of reproduction that involves the introduction into the female of genetically alien spermatozoal cells . . . that must not be allowed to activate immunological effector processes leading to their destruction. (1992:417)

The mystery in the situation is vividly brought home at the end of this article in a technical obstetrics-gynecology journal. The author actually ends his discussion of how little is understood about why two genetically disparate individuals (mother and fetus) can coexist harmoniously with a quote from a poem of Wordsworth:

> there is a dark
> Inscrutable workmanship that reconciles
> Discordant elements, makes them cling together
> In one society. ("The Prelude" 1850)

The specter of "Discordant elements" clinging "together/In one society" is such an appalling thought, given the starting assumptions operating here, that only a "dark/Inscrutable workmanship" could be responsible for reconciling them.

Work in feminist theory suggests there is a masculinist bias to views that divide the world into sharply opposed, hostile categories, such that the options are to conquer, be conquered, or magnanimously tolerate the other. The stance is one from which nature can be dominated, and a separation from the world maintained (Keller 1985:124).[12] Many mothers and fathers might find the notion of a baby in utero as a tumor the mother's body tries its best to destroy so counterintuitive as to warrant searching for a different set of organizing images altogether!

The idea of "tolerance" of self together with the imagery of aggressive

immuno-warfare against the foreign focuses on a body that is all of one kind, all purely self. This pure body is the "normal" body; hence, the "normal" woman would destroy her fetus to return to a "normal" state of internal purity. It is as if the body were a castle and its ramparts held stalwartly against anything foreign ever entering. As Donna Haraway puts it, "The perfection of the fully defended, 'victorious' self is a chilling fantasy" (Haraway 1992:320). She asks, "When is a self enough of a self that its boundaries become central to institutionalized discourses in biomedicine, war, and business?" (p. 320). Looking at the cover of a popular book about the immune system, *The Body Victorious,* by Lennert Nilsson (1985), gives us a very specific identification for this self, in terms of both race and gender. The cover shows a nude, muscular male figure, backlit so that the edges of his body are sharply outlined. Enough stray light escapes to show us that his facial features and hair type are Caucasian. Superimposed across his abdomen is a greatly enlarged color photograph of a macrophage, in the act of eating up bacteria. This is a body whose boundaries are defined extremely clearly. Inside is only self; outside is only nonself. Should any foreign matter enter, it will be swiftly dispatched by the roving armies of the man's immune system.

Compared with the internal purity of this self, women fall far short. When they are pregnant, they are truly hybrid, uneasily "tolerating" the foreign fetus. In addition to the "mixing" of self and other in pregnancy, they are said to be statistically more prone to autoimmune diseases. These diseases are said to be caused by the immune system's mistakenly attacking self. In one illustration of a woman with lupus, an autoimmune disease, she is shown lying inside the ramparts of a castle.[13] But the castle is not protecting her against threats to her health: instead the sharp spikes on top of the castle walls are turned inward. The castle of her body has literally turned against her. The depiction of a woman in this illustration is no accident: the American Auto-immune Related Disease Association estimates that there are fifty million Americans affected by eighty known autoimmune diseases, and most of them are women (Brody 1994).[14]

If *The Body Victorious* cover gives us a specific image of the Nordic, white, male defended-self, HIV/AIDS discourse gives us another side to the picture of how women deviate from the defended-self. Paula Treichler has pointed out how AIDS discourse describes the female body as more vulnerable than the male: in literature on sexually transmitted diseases in general, "The vagina is no longer so healthy and impervious to sordid pathogens; rather it is shot through with cracks and lesions, punctures and sores" (1992:27). Medical accounts see a woman's vulnerability in many places. In one account vulnerability occurs if there is sex during menstruation, under the influence of oral contraceptives, or during pregnancy: "The cellular lining of the uterine cervix, the narrow neck of the womb, may become fragile and crumble; blood

vessels, which are often opened during intercourse, provide a pathway of entry similar to that resulting from rectal intercourse" (quoted in Treichler 1992:28). In this quote, the linkage between the porous woman's body, shot with holes, and the gay male body, which allows "improper" use of body holes, is clear.

There are recent indications that an extreme version of the defended-self model is edging out the view of the mother "tolerating" or "allowing" the fetus to live. This view, which gives the fetus a defended-self, appeared around the mid-1980s. In this view, the fetus "is thought of . . . not as an inert passenger in pregnancy but, rather, as in command of it . . . the fetus is responsible for solving the immunological problems raised by its intimate contact with the mother (Findlay quoted in Franklin 1991:193). As Sarah Franklin puts it, "the emphasis is not only on fetal separateness and fetal independence, but on its ability to control the mother, rather than being controlled by her" (pp. 193–194). The fetus becomes a "little commander in the womb" and the mother an inert "host." (The phrases are from a medical text!) "The mother is required to accept and not reject the autoallogenic embryo" (Stern and Coulam 1993:252).

The mother's subordinate power relation to the fetus often involves technological devices. Electronic fetal monitoring, stress tests, or ultrasound can make the fetus' interests appear separately from the mother's: the mother may want to deliver vaginally, but the doctors say tests show this would endanger the baby; or the mother wants to get up and walk during labor but the nurses say the baby's safety depends on continuous monitoring (see Cartwright, Davis-Floyd, this volume). These models can have very real consequences in both the attitude of medical practitioners and the kinds of treatment they are most prone to administer.

The fetus in charge amounts to a shift from fearful "fetus-killing or eating" mother on the one side to mother as passive vessel on the other. In all of these scenarios I get the feeling that what is being dealt with is the defended, prototypically male self. Sarah Franklin argues that fetal independence from the mother is an aspect of "patriarchical individualism": "The powerful drive to constitute fetal personhood in terms of separateness, independence and individuality must also be located in relation to these characteristic psychic requirements of 'successful' masculine individuation and identity formation" (1991:202). The term *individual* itself, meaning "one who cannot be divided" seems to disqualify women from participating in becoming "one who cannot be divided," for "it is precisely the process of one individual becoming two which occurs through a woman's pregnancy. Pregnancy is precisely about one body becoming two, two bodies becoming one, the exact antithesis of individuality" (Franklin 1991:203). Donna Haraway (1991:253n) explains: "Why have women had so much trouble counting as individuals in modern

western discourses? Their personal, bounded individuality is compromised by their bodies' troubling talent for making other bodies, whose individuality can take precedence over their own." Speaking from the vantage point of female eroticism, the French theorist Luce Irigaray describes women as "this sex which is not one":

> Whence the mystery that woman represents in a culture claiming to
> count everything, to number everything by units, to inventory every-
> thing as individualities. *She is neither one nor two.* Rigorously speaking,
> she cannot be identified either as one person or as two. She resists all
> adequate definition. . . . And her sexual organ, which is not *one* organ, is
> counted as *none*. The negative, the underside, the reverse of the only
> visible and morphologically designatable organ . . . the penis. (1985:26)

I would add that not only the state of motherhood but also women's state of health in general, their failure in many ways to achieve the male norm of the self as a defended castle, leads to the same effect. Whether leaking fluids through ducts and membranes (which simultaneously allows penetration of the foreign into the body) or permitting the body to turn against itself, this porous, hybrid, leaky, disorderly female self is the antithesis of the sharp-edged man on Nilsson's cover.

It is possible that other models of the body that can be found on the fringes of immunology, the media, and in popular culture—the body as a complex system deeply embedded in other complex systems or the body as "waves" or as "a dance"—will avoid some of the masculinism of the defended-self model rather than merely incorporating it in other ways. Such a move might seem very appealing—the mother-fetus as a kind of complex ecosystem—but it would have tricky consequences. Barbara Duden tells us that in Germany, in 1990, a diverse group of churches issued a statement titled "God Is a Friend of Life." The declaration dealt with the challenges involved in the "protection of earth as a living space and in the protection of human life." This new "life" is "a complex ecosystem like a forest, the self-development and transmission of genetic information by a single organism, or the full development of a human being from the fertilized egg cell to the newborn and its further growth" (1993:1). Having become a public object, Duden argues, "life" seeks and gains the protection of science. Where does this leave the supporting ecosystem for this "life," namely the mother? Thinking about the answer to that question can almost make you nostalgic for the embattled fetus-as-tumor!

Of course, some advocates of homebirth and midwifery have developed ways of seeing the mother-fetus as a system that do not make the mother into an ecosystem housing the fetus (Davis-Floyd 1994:1133–1137). They see mother and baby as essentially one being, forming one "energy field." In this view, what feels right to the mother will also be best for the baby; for example,

the mother choosing to give birth in an environment in which she feels safe and relaxed will not only make her labor easier on herself but will also assure the safest birth for her baby.

■ CHANGING THE IMAGERY

Because medical descriptions of the body, the female body, or female physiological processes seem likely to be able to affect the self-images we internalize, not to mention medical practices, feminists have made energetic efforts to change the way textbooks and other materials are written. How difficult this is, and how discouragingly long it can take, is shown by the fact that the premier feminist manual of health care for women, *Our Bodies, Ourselves,* contained the failed production model of menstruation until the current edition, *The New Our Bodies, Ourselves,* published in 1992 (Boston Women's Health Book Collective). In Susan Bell's chapter on birth control, the old story of menstruation as the result of the woman's failure to get pregnant has been taken out and replaced with a new one. Bell (1994) describes menstruation for a woman who does not desire to be pregnant as a welcome sign of her body's having once again actively escaped fertilization at the hands of the sperm.

Another case in which the submerged cultural content of biological facts seems to be playing a role in scientific controversy is the recent flurry of new facts about menstruation claimed to have been discovered by a biologist, Margie Profet. The press has presented Profet as an iconoclast of sorts, who has never bothered to get a PhD because it wasn't worth the time but who won a MacArthur "genius" award. She is said to have an "uncanny knack" for explaining things other scientists have ignored, and she says she got her new idea about menstruation in a dream. The *New York Times* reports that "The idea that menstruation evolved as a protection against disease came to her several years ago in a vivid dream of black triangles stuck in deep red tissue."

In place of the standard medical view of menstruation, that menstruation is the waste product of a failed conception, composed of debris, dead tissue, scrap, of no use, Profet substitutes the argument, which she bases on comparative evolutionary data, that

> menstruation evolved as a mechanism for protecting a female's uterus and fallopian tubes against harmful microbes delivered by incoming sperm . . . according to [her argument] the uterus is extremely vulnerable to bacteria and viruses that may be hitching a ride on the sperm, and menstruation is an aggressive means of preventing infections that could lead to infertility, illness and even death. In menstruation . . .the body takes a two-pronged attack against potential interlopers: it sloughs off the outer lining of the uterus, where the pathogens are likely to be

lingering, and it bathes the area in blood, which carries immune cells to destroy the microbes. (Angier 1993)

I have no way of knowing in detail what lies behind the uproar in the scientific community over these claims: letters to the *New York Times* editor assert vehemently that Profet's ideas lack a "scientific or medical basis" and insist instead that menstruation is likely to *promote* infections (Grimes et al. 1993). But I would hazard a guess that the uproar has something to do with two powerful reversals Profet's account accomplishes. The first is that sperm, instead of being gallant and virile rescuers of the hapless egg, become unwitting "carriers of harmful pathogens and [germs]." The second is that women's menstrual flow becomes, instead of useless and disgusting debris, an important part of her *immune system*. Menstruation becomes "not a passive loss of unused uterine lining, but an aggressive way to prevent infection" brought in by sperm. Sperm carry germs; menstrual fluid washes them away. In Profet's reinterpretation, men's substances lose standing at the very same time that women's substances gain. As I argued earlier, whether you are concerned about nutrition, exercise, toxins, stress, cancer, or AIDS, the health arena is saturated with immune system talk. The immune system has begun to function culturally as the key guarantor of health and the key mark of differential survival for the twenty-first century. No wonder Profet's model of female menstruation as a major site for immune function where men have none has raised a few hackles!

It is this kind of activity—done in the heart of science but questioning deeply entrenched cultural assumptions about the body and its substances—that stands the best chance of realizing the powerful potential for change in science and medicine opened for us by bringing to life some of the dead and unyielding metaphors in scientific language. The field is wide open for cyborg imagery to do its work in immunology, for the task of imagining an account of fetal-maternal interaction in an immunological environment in which blurry self/nonself discrimination is assumed has barely begun to be done. There should be little doubt it *could* be done: after all, most babies are born from immunologically dissimilar mothers, tissue from another person can often be grafted, and many (foreign) bacteria live (to the benefit of our health) in our gut. An adequately revised notion of the pervasiveness (and benefits) of body processes that are mixed, hybrid, and boundary-blurring provides another way the female body could gain normality and lose its dangerous, problem-ridden position.

Research in transplant immunology is already pushing the boundaries of the "self" out beyond the individual body. Experiments have been done in which two calves who are made to share the same placental circulation in the uterus, but are otherwise unrelated, will later tolerate tissue grafts from each

other (Auchincloss and Sachs 1989:906). Rodents who receive a dose of bone marrow from an unrelated individual within several days of birth will tolerate transplants from that individual (ibid.). In these cases, a form of "twinning" is technologically induced so that an individual shares partial cellular identity with another. In other research, it has been discovered that kidney transplant patients tolerate transplants with cell antigens (identifiers) that their *mothers* possess but that they do not. Apparently, "during pregnancy maternal cells find their way into the bloodstream of the fetus, whose developing immune system 'learns' to tolerate the maternal cells' class 1 antigens as if they were its own. The immune system's 'memory' apparently lasts into adulthood" (T.M.B. 1988:31). In this case, the maternal "environment" becomes part of the fetal environment. In all this research, the boundary around the individual is being pushed out, to include others in the process of its self-definition.

Although some believe these technologies are unlikely to have clinical applications (Auchincloss and Sachs 1989:906), it is not hard to suggest future scenarios that would make the technological manipulation of transplant receptivity desirable. If the mother's body becomes part of our immune systems, for example, perhaps maternal tissue would come to have some direct use. Perhaps one day we will all keep our mother's placenta in a deep freeze against the day we need to make use of her tissue. If the fetus and newborn learn to tolerate substances they are exposed to, perhaps technological alterations of the uterine environment or the newborn's body will be possible, alterations that would facilitate skin transplantation, organ transplantation, cosmetic redesign, or other increasingly common cyborganic life-enhancing or life-lengthening procedures.

The point of bringing to life what was dead language is not to *remove* metaphors from scientific descriptions, sterilizing them to abstraction. Rather, it is the old, dead language that is already sterile, ossified, and unable to change.

> Oppressive language does more than represent violence; it is violence; does more than represent the limits of knowledge; it limits knowledge . . . the policing languages of mastery . . . cannot, do not, permit new knowledge or encourage the mutual exchange of ideas. (Morrison 1994:16–17)

The language of mastery can be recognized by "the tendency of its users to forgo its nuanced, complex, midwifery properties, replacing them with menace and subjugation" (pp. 15–16).

The cyborg, like the mother-fetus rethought, may push scientific medicine to tolerate ambiguity, admit subtle shading, and replace antagonistic opposition with mutual interest. By giving up the unthinking insistence on a winner

and a loser in the pervasive search for control, both families having babies and others who seek biomedical care may benefit. The trick will be to encourage this development, without at the same time falling into equally problematic traps, in particular: romanticizing the mother-fetus as an unproblematic form of wholeness and union; and succumbing to the enticements of systems thinking.

Overly romanticizing the wholeness of mother-fetus would encourage us to avoid thinking through problems that can arise from incompatibilities between mother and fetus. We need to think through the implications of premature labor, medical conditions of the mother that are worsened by pregnancy, the mother's desire for abortion, and so on, in order to have understandings of the various courses of action contemporary technology makes possible that are robust enough to help us in the complex situations mothers often meet today. Succumbing to the enticements of systems thinking would encourage us to use the model of the mother-fetus as a complex system without fully realizing its implications. One implication systems thinking frequently has is to elevate the importance of the system itself over the importance of any of the elements of the system. So thinking of the mother-fetus as a complex system has the potential of encouraging those who fight to protect an abstract concept of "life" at the expense of particular mothers in particular circumstances.

Cyborgs and other hybrid images can help open our minds to the complexities of thinking through the implications of a variety of models of giving birth and living in the world. If we had both scientific and nonscientific language with the kind of "midwifery properties" Toni Morrison envisioned, we would be better able to produce models of birth and life complex enough to contend with diverse contemporary concepts of the self.

Acknowledgments

This chapter has benefited from many perceptive comments I received on the occasion of lectures at Virginia Tech, the University of Delaware, and Princeton University. Thanks also to Robbie Davis-Floyd for her perceptive editorial suggestions.

Notes

1 *Time*, Apr. 6, 1992, vol. 139, no. 14, p. 21.
2 For detailed references on the above points, see Martin 1994.
3 For a description of the research design of this project, as well as how and where the over 200 interviews were done, see Martin 1994.
4 Haraway terms this the "hierarchical, localized organic body" (Haraway 1989:14). In her work Haraway eloquently stresses the displacement of the hierarchical, localized body by new parameters: "a highly mobile field of strategic differences . . . a semiotic system, a complex meaning-producing field" (1989:15). No one could improve on her characterization of these new elements; I would only add that there may be strategic reasons why a remnant of the old body is carried forward with the new.

5 These include mass media magazines such as *Time* and *Newsweek*, as well as *National Geographic*. They also include more expensive items such as Lennert Nilsson's popular coffee table book, *The Body Victorious*.

6 Overheard by Paula Treichler, personal communication.

7 Heard in an immunology department guest lecture during my fieldwork.

8 B cells are not always feminized: Michaud and Feinstein 1989:13 and 7 depicts them as admirals and supermen, respectively.

9 A Toronto newspaper reported that "Vancouver psychologist Andrew Feldmar offers an intriguing explanation for the adult onset of autoimmune disease: 'It strikes people who in their childhood were inhibited from differentiating who is their enemy, who is their friend'" (Maté 1993).

10 Reported to me by Ariane van der Straten.

11 David Napier explores the implications of using a metaphor of self-destruction to describe illness. He suggests that despite the disorientation that might be produced by telling someone who is suffering that his or her body is at war with itself, it can be a helpful thing to do: "People often do feel better when they can salvage a 'self' from a ravaged body; we learn to deal with illness by setting it up as something against which we can define (even through dissociation) a better condition of selfhood" (Napier 1992:187).

12 Keller (1992:116–117) illustrates how easily the language of evolutionary biology slips from descriptions of nature as neutrally indifferent to descriptions of nature as callous and hostile.

13 Cover of "To Your Health," *Baltimore Sun*, Oct. 3, 1989.

14 Ahmed et al. 1985 provide female/male ratios for various autoimmune diseases. For rheumatoid arthritis, it is 2–4:1; for type 1 diabetes, it is 5:1.

References

Ahmed, S. A., W. J. Penhale, and N. Talal. 1985. "Sex Hormones, Immune Responses, and Autoimmune Diseases." *American Journal of Pathology* 121: 531.

Altman, Lawrence K. 1991. "A White House Puzzle: Immunity Ailments: George and Barbara Bush Have Graves' Disease, Their Dog Millie Has Lupus—All Autoimmune Diseases." *New York Times* A (Part 2): 1.

Angier, Natalie. 1993. "Radical New View of Role of Menstruation." *New York Times* C (Part 3): 1, 5.

Auchincloss, Hugh, and David Sachs. 1989. "Transplantation and Graft Rejection." In *Fundamental Immunology*, edited by W. E. Paul, 889–922. New York: Raven Press.

Bell, Susan. 1994. "Translating Science to the People: Updating *The New Our Bodies, Ourselves*." *Women's Studies International Forum*.

Billington, W. D. 1992. "The Normal Fetomaternal Immune Relationship." *Baillière's Clinical Obstetrics and Gynaecology* 6 (3): 417–438.

Bordo, Susan. 1987. *Flight to Objectivity: Essays on Cartesianism and Culture*. New York: SUNY Press.

The Boston Women's Health Book Collective. 1992. *The New Our Bodies, Ourselves*. New York: Simon and Schuster.

Brody, Jane E. 1994. "'Hair of Dog' Tried as Cure for Autoimmune Disease." *New York Times*, Science Times (Part 1): C1.

Cherry, Dave. 1988. "AIDS Virus." In *Risky Business*, edited by S. A. Winterhalter, 3–10. San Francisco: San Francisco AIDS Foundation.

Davis-Floyd, Robbie. 1994. "The Technocratic Body—American Childbirth as Cultural Expression." *Social Science and Medicine* 38 (8): 1125–1140.

DeSchepper, Luc. 1989. *Peak Immunity: How to Fight Epstein-Barr Virus, Candida, Herpes Simplex and Other Immuno-Depressive Disorders and Win*. Santa Monica, Calif.: Luc DeSchepper.

Duden, Barbara. 1993. *Disembodying Women: Perspectives on Pregnancy and the Unborn*. Cambridge: Harvard University Press.

Dwyer, John M. 1988. *The Body at War: The Miracle of the Immune System*. New York: New American Library.

Franklin, Sarah. 1991. "Fetal Fascinations: New Dimensions to the Medical-Scientific Construction of Fetal Personhood." In *Off-Centre: Feminism and Cultural Studies*, edited by S. Franklin, C. Lury, and J. Stacey, 190–205. London: HarperCollins Academic.

Galland, Leo. 1988. *Superimmunity for Kids*. New York: Dell.

Grimes, David A., Nancy S. Padian, and A. Eugene Washington. 1993. "Infection Risk Rises during Menstruation." *New York Times*.

Haraway, Donna. 1991. "The Politics of Postmodern Bodies: Constitutions of Self in Immune System Discourse." In *Simians, Cyborgs, and Women*, 203–230. New York: Routledge.

———. 1989. *Primate Visions: Gender, Race, and Nature in the World of Modern Science*. New York: Routledge.

———. 1992. "The Promises of Monsters: A Regenerative Politics for Inappropriate/d Others." In *Cultural Studies*, edited by L. Grossberg, C. Nelson, and P. A. Treichler, 295–337. New York: Routledge.

Irigaray, Luce. 1985. *This Sex Which Is Not One*. Ithaca, N.Y.: Cornell University Press.

Jaret, Peter. 1986. "Our Immune System: The Wars Within." *National Geographic* 169: 702–735.

Jaroff, Leon. 1988. "Stop That Germ!" *Time* 131 (21): 56–64.

Keller, Evelyn Fox. 1985. *Reflections on Gender and Science*. New Haven: Yale University Press.

———. 1992. *Secrets of Life, Secrets of Death: Essays on Language, Gender and Science* New York: Routledge.

Kimball, John W. 1986. *Introduction to Immunology*. New York: Macmillan.

Martin, Emily. 1987. *The Woman in the Body: A Cultural Analysis of Reproduction*. Boston: Beacon Press.

———. 1990. "The Egg and the Sperm: How Science Has Constructed a Romance Based on Stereotypical Male-Female Roles." *Signs* 16 (3):485–501.

———. 1994. *Flexible Bodies: Tracking Immunity in America from the Days of Polio to the Age of AIDS*. Boston: Beacon Press.

Maté, Gabor. 1993. "Why Does the Body Sometimes Declare War on Itself?" *The Globe and Mail* (Toronto, Canada), A (Part 5): 16.

Michaud, Ellen, and Alice Feinstein. 1989. *Fighting Disease: the Complete Guide to Natural Immune Power*. Emmaus, Penn.: Rodale Press.

Morrison, Toni. 1994. *The Nobel Lecture in Literature, 1993*. New York: Alfred A. Knopf.

Napier, A. David. 1992. *Foreign Bodies: Performance, Art, and Symbolic Anthropology*. Berkeley: University of California Press.

Nilsson, Lennart. 1985. *The Body Victorious*. New York: Delacorte Press.

Page, Jake. 1981. *Blood: The River of Life*. Washington, D.C.: U.S. News Books.

Rath, W. 1994. "Prolonged Pregnancy—Prostaglandins as the Cause of Labor Onset." *Zeitschrift für Geburtshilfe und Perinatologie* 198 (5–6): 207–214.

Root-Bernstein, Robert S. 1993. *Rethinking AIDS: The Tragic Cost of Premature Consensus*. New York: The Free Press.

Schindler, Lydia Woods. 1988. *Understanding the Immune System*. Washington, D.C.: U.S. Department of Health and Human Services.

Stern, J. Jaroslav, and Carolyn B. Coulam. 1993. "Current Status of Immunologic Recurrent Pregnancy Loss." *Current Opinion in Obstetrics and Gynecology* 5: 252–259.

Stites, Daniel P., John D. Stobo, and J. Vivian Wells, eds. 1987. *Basic and Clinical Immunology,* 6th ed. Norwalk, Conn.: Appleton and Lange.

T.M.B. 1988. "Memories of Mother: Does the Immune System Allow Transplants That Seem Familiar?" *Scientific American* 259 (6): 30–31.

Treichler, Paula A. 1992. "Beyond Cosmo." *Camera Obscura* (28): 21–76.

Varela, Francisco J., and Antonio Coutinho. 1991. "Immunoknowledge: The Immune System as a Learning Process of Somatic Individuation." In *Doing Science: The Reality Club,* edited by J. Brockman. Upper Saddle River, N.J.: Prentice Hall.

No author. 1985. "Why Does the Body Allow Foetuses to Live?" *The Economist* 296: 89.

Refusing Prenatal Diagnosis

The Uneven Meanings of Bioscience in a Multicultural World[1]

Rayna Rapp

■ INTRODUCTION

This essay presents an anthropological analysis of prenatal diagnosis, a cluster of technologies used for assessing the chromosomal and genetic normalcy of fetuses in utero. An ever-expanding list of these technologies includes ultrasound imaging, amniocentesis, chorionic villus sampling, percutaneous-umbilical chord sampling, and other evolving experimental interventions, all backed up by abortion technology for those who receive bad news about the health of their fetuses and choose to end specific pregnancies.

As an anthropologist committed to studying the social impact and cultural meaning of prenatal diagnosis, I have benefited greatly from scholarship in the history and sociology of science and technology, learning about developments in medical genetics, cytogenetics, and biomedical visualization technologies which have made the routinizaton of these interventions into pregnancy possible (e.g., Cowan 1992, 1994; Judson 1992; Yoxen 1990). But as a fieldworking ethnographer, I am committed to breaching the boundaries often set up in those fields. My training orients me toward tracking what happens not only inside but also outside of laboratories and hospitals, as the technologies of prenatal diagnosis make themselves felt among their downstream users, audiences, or consumers: those whom Adele Clarke and Theresa Montini recently labeled "invisible and implicated actors" (1993). Like many others who work in science and technology studies, I long ago lost any belief in the potency of the inside/outside boundaries described by the science-speaking natives of the domains I study. While my research includes time spent in laboratories and observing genetic service providers, I am particularly interested in finding multiple ways to query how women of diverse racial-ethnic,

national, class, and religious backgrounds experience the offer of genetic testing in their pregnancies, what they do and don't want from technology, how they understand childhood disabilities, what a fetus is, and what might be worth an abortion. I understand this new biomedical technology to provide a context in which every pregnant woman is interpolated into the role of moral philosopher: one cannot confront the issue of the "quality control" of fetuses without wondering whose standards for entry into the human community will prevail and what the limits of voluntary parenthood might be.

When I began to investigate the social impact and cultural meaning of amniocentesis (and related prenatal diagnostic technologies) starting in 1983, the voices of experts in medicine, bioethics, health planning, and law dominated the published literature. The bodies from which these voices spoke were mostly male, overwhelmingly White, and highly professional. As a feminist researcher and health activist, as well as a woman trying to understand the complex consequences of having used amniocentesis in my own pregnancies, I thought I could help to wrest the discourse on new reproductive technologies from the hands of medical experts, turning it over to the women who used, might use, or might refuse to use them. My first pilot interviews were conducted with pregnant women who had received what is so antiseptically described in medicine as a "positive diagnosis," that is, the news that something was seriously wrong with their fetuses, forcing them to make a decision to end or continue the pregnancy. In those interviews, I was struck by the difficulties women had in working in a communicative system whose vocabulary was almost exclusively medical, whose grammar was technological, and whose syntax was as-yet-unnegotiated. Trying to discover a method to study a piece of reproductive technology, I attempted to identify and query as many layers or constituencies of people and processes with interests in amniocentesis as I could imagine. As an anthropologist, I was committed to using participant-observation to learn my way around this problem. It is, of course, a messy methodology because it encourages its practitioners to continually expand their work as far into a research topic as their own subjectivity and scholarly resources allow.

I began in the cytogenetics lab run by the Health Department of New York City, learning how diagnoses are constructed—laboratory life, to borrow a famous and felicitous phrase. I learned to spin samples, turn test tubes, and cut karyotypes. I also followed the lab's counselors through their peripatetic rounds at many hospitals in the city, observing hundreds of intake interviews where they explained prenatal testing to women of diverse race, class, ethnic, national, and religious backgrounds. I interviewed scores of women (and some men) across that diversity who had had the test, or who had refused it. And I hung out in a support group for parents whose children have Down's

syndrome, the most common condition picked up by the test, as well as in an early intervention program where infants and toddlers with other chromosomal and genetically caused disabilities were enrolled. I also became fascinated with genetics as a field which provides powerful and proliferating discourses on the state of being human, and spoke with geneticists and genetic counselors about how they saw the implications of their practical work. And I started to worry about the multiple intersections of popular media representations of all the related issues (genetics, prenatal testing, abortion, childhood disability, and disability rights) on which my study touched.

In constructing a kind of Venn diagram of these intersecting layers, I saw that pregnancy and the modern technologies which intervene to regulate it are not vested simply within the world of biomedicine and reproductive technology. (Indeed, when I went to interview women and their supporters about a new pregnancy technology, we often ended up spending much of our time discussing religion, but that's another story.[2]) Pregnancy and its technologies *both* occupy multiple and convergent spaces in the social life of individual women and their supporters; in the lives of diverse medical, educational, religious, and activist constituencies; in modern globally proliferating media technologies; and, of course, in the politics of representation.

Like historians, anthropologists are obsessed with following all the scraps and edges of their problems, often preferring to view a central issue from multiple and oblique angles. Here, I take the women who refuse to use amniocentesis as a pivot around which to view a cascade of problems concerning the impact of a new scientific technology. Rather like a negative whose transparencies are inscribed with images that work to develop positive representations, the stories that refusers narrate support an interpretation of the positive, productive powers of this technology and suggest the multiple locations from which pregnant women and their supporters contextualize the choices they must make.

Like many other feminist analysts of science and technology, I begin my work from a location which does not assume the unproblematic sovereignty of methodological individualism, nor that science in action begins or ends with the actions of scientists (e.g., McNeil 1987; Morgall 1993; Wajcman 1991). Rather, consumers (or, in this case, nonconsumers) of a routinizing biomedical technology can be taken as experts in embedding an analysis of its burdens and benefits, casting a different light on contests for meaning and rationality. By working through the narratives of pregnant women who opt not to use a technology increasingly described as "safe" and "rational" throughout the world of prenatal care in contemporary America, I hope to show what insights may be gained when a highly diverse group of women are taken as knowledgeable commentators on the social dimensions of science.

I wanted to take the test, but then he said no. At the hospital, I was all gung-ho, but on the way home, he expressed his feelings. That whole night, he expressed his feelings. We went back and forth. The next day, I called up so many people. I have this religious aunt, she's the one that made me see, Down's syndrome, no need to take the test for Down's syndrome. It's not necessary. Everything my husband said, she said, too. So I went, "OK, I won't take it." And I didn't take it.

—Catherine Judd, [3] African American legal secretary, thirty-six

When I first met Catherine Judd and her husband at a counseling session at Middle Hospital, I was sure from her reactions and questions that she intended to use the test. But a few weeks later, when I called to see how she was feeling after an amniocentesis and to schedule an interview appointment, she told me that she had changed her mind. We met for lunch that week, and, tape recorder in hand, I learned that Catherine's decision not to use amniocentesis was made in the context of opposition from her close kin. It therefore at first appeared to be an entirely personal one, mediated by the strength of her kinship community. But later in the same interview she also said,

My husband didn't say much there (at the hospital) but he sure read those forms carefully. He didn't much like the parts about experimentation.

At first, I intervened to say,

You mean the consent form for the laboratory? What they mean by experimentation doesn't have anything to do with you, or your husband or your baby's body. It's about using the left-over amniotic fluid to check for other chromosome patterns, to compare it with other fluid, instead of just looking at it for a diagnosis for you. That's the way they find out about general patterns, by comparing lots of left-over fluid. . . . And you can say "no" to the experimental use, and still have the test for your own use, if you want that.

But as we talked, I realized the narrow, science-focused preoccupations of my own interpretation. Her husband was expressing strong feelings about experiments in a much wider context: his perception of the role of Black people and medicine. And Catherine herself went on to say,

Because I read something . . . I don't remember what magazine I read it out of, but I remember reading that the reason why we have AIDS was to kill off the Blacks and the gays . . . I don't know how true it is, but supposedly over in Africa what they did was they shot the children. They shot something into the immunization shots, into the people over in Africa, and that's how it started.

The green monkey experimental theory of AIDS in Africa purports to explain how a malevolent experiment ran amuck and spread a killer disease first throughout that continent, and then to the New World. In the late '80s and early '90s, it was much discussed in certain Black-focused tabloids and talk shows. While scientists have denounced such theories as "disinformation" or even as "paranoia," their staying power needs to be evaluated in light of a long history of indifferent or even menacing experimental medical interventions for which Black communities *have* historically served as guinea pigs: the infamous Tuskeegee syphilis experiment, on the one hand, and the chaotic conditions attending early sickle-cell anemia carrier trait screening, on the other, have both been widely reported in Black-focused media. African-American consciousness of biomedical experimentation may thus be filtered through realistic if incompletely remembered and sometimes media-orchestrated views of prior medical interventions. It is not then so surprising that Catherine's husband read the informed consent form for laboratory work on the amniotic fluid sample with a cynical eye. Might we interpret this suspicion as a response to a structural position which Black communities have historically occupied vis-à-vis medical experimentation in the United States?

Catherine Judd's change of heart thus raises an important theoretical issue for me: it seems to be at once the product of individual choice contextualized by kin and community pressure and a response to racially differentiated histories and sentiments concerning medical intervention and experimentation. Indeed, the imbrication of social history and individual volition, collective position and personal choice, in short, the intertwined and negotiated workings of structure and agency, continually perplexed me as I attempted to find out how people came to accept or to refuse prenatal testing.

As amniocentesis has rapidly diffused and become part of routine prenatal care for some sectors of the population, there are those who choose not to accept its complicated benefits and burdens. Their narratives may enable us to understand why a routinizing technology does not always stay en route. Are some groups more likely to opt against the technology than others? Do some reject it categorically, while others accept parts of the bundle of assumptions, values, and practices to which it comes attached? A woman may step off the conveyor belt of a routinizing technology at many points in its trajectory; but not all exits are used equally, nor are those who exit at specific points a random group. These patterns provoked my interest in refusers. Initially I wondered if I might code refusers as "resisters," that is, as people who consciously opposed routinization. Or might their refusal be based on a lack of access to information and discomfort with biomedical discourse, thus also reproducing prior hierarchies between patients and providers? But my search for resistance and reproduction was, of course, too simple: the reasons for refusing to use amniocentesis are diverse and complex.

In prior essays, I have tried to indicate that the communicative practices on the basis of which women accept prenatal testing are themselves highly structured: comfort with the etiquette, protocol, and procedures of biomedicine surely varies with educational and occupational location (Rapp 1988, 1993, 1994, 1995, 1998). And there is a range of reasons some women give at counseling sessions for their decisions not to use amniocentesis. These include fear of miscarriage, disbelief in the accuracy of statistics and testing, discomfort with unbalancing the imagined forces sustaining a pregnancy, and religious beliefs. A refusal may also be based on a report of male opposition, a subject to which I return below. Yet each individual refusal exhibits a complex interplay between personal intention and social forces — after all, male dominance or scientific literacy or religious observance or prior reproductive history all express both individual and social characteristics. Moreover, the timing of an acceptance or a refusal may be structural as well.

■ THE INFLUENCE OF CLASS BACKGROUND AND ETHNICITY ON REFUSAL

Among the structural reasons for rejecting prenatal testing, class-associated differences loom large. It is an axiom of genetic counseling that middle-class patients (disproportionately White) usually accept the test while poorer women (disproportionately from ethnic-racial minorities) are more likely to refuse it. But that generalization needs interrogation. Private patients (i.e., middle-class ones) usually don't come for genetic counseling (to learn about amniocentesis) unless they are already determined to have the test. They are likely to have prior knowledge about it gleaned from books, friends, and private physicians, whom they inform about their lack of interest in or opposition to the test. They never schedule an appointment with a genetic counselor; thus, refusers in this class rarely get counted. This was surely true for a well-known economist I interviewed who opted against prenatal diagnosis when pregnant for a third time in her late thirties. She felt entirely confident about refusing amniocentesis on the basis of her own reading of health statistics. In perusing the medical literature, she discovered that cytogenetic tests in midtrimester amniotic samples produced a detection rate for Down's syndrome fetuses which was 25 percent higher than the liveborn rate for children with the same condition. Reasoning that the test was inaccurate, she opted out. What her reading failed to disclose, however, was the reason for the differences of rates given within biomedicine: fetuses with atypical chromosomes remain highly vulnerable to miscarriage throughout the pregnancy, and stillbirth and death in the neonatal period, so the difference is not one of laboratory error but reflects life-threatening physiological circumstances. Likewise, an educational consultant who had suffered through several years of infertility before

her first successful pregnancy at thirty-four rejected amniocentesis during her second pregnancy, at age thirty-seven. She was more frightened of the miscarriage rate than she was of the rate of detection of fetal chromosome problems. It should be stressed that both these cases involve scientifically confident middle-class women who felt empowered to make a decision "against the grain" of their immediate peer group to forego amniocentesis, while situating themselves comfortably within statistical, scientific thinking.

Some middle-class women and their partners also reject the test based on philosophical, ethical, or religious reasoning. For example, a nurse married to an epidemiologist in the New York City Health Department decided against amniocentesis after she and her husband had investigated the potential adoption of a "special needs" (disabled) child. Their Protestant church had directed them toward an agency which specialized in hard-to-adopt children when they had trouble getting pregnant again after the birth of their first child. By the time a second, successful pregnancy was established, they felt quite open to the possibility of raising a child with a disability, and decided not to use prenatal testing. Another male physician whom I met through the Health Department wistfully described himself as a virtual conscript to my study: his wife, raised a devout Catholic, would not consider amniocentesis, despite his own professional interests in the test. But these stories—which mirror class-refracted versions of concerns also offered by clinic patients who reject amniocentesis as well—came to me through personal networks of friendship and work; they were never entered into the medical ledger, for the rejections occurred in the context of private medicine.

But among clinic patients, an appointment with the genetic counselor may be the first opportunity they have to ponder the significance, risks, and benefits of prenatal testing. In all hospitals, registers are kept detailing pregnant women's appointments and their outcomes; in some hospitals, those who refuse amniocentesis are also asked to sign an "informed consent" document attesting to their decision. They then make up their minds in a context in which their choices become part of hospital statistics.

Moreover, many women from working-class and working-poor backgrounds, including African American and Hispanic women, do accept the test; their hospital-accounted rates of acceptance and refusal vary dramatically from from facility to facility. At one clinic which serves a majority Spanish-speaking, low-income population, for example, acceptance rates are high: 70–80 percent. At another clinic with an Afro-Caribbean and Spanish-speaking population, acceptance rates are low: 30–40 percent (Hsu 1989). We could go fishing for a cultural explanation about pregnancy beliefs, medical attitudes, etc. But a simpler observation is this: the first prenatal clinic is a stable and welcoming environment in which women tend to be very comfortable and to trust the nurses. Relative to many other hospitals, it has a lower

rate of nurse turnover; clinic patients therefore have the opportunity to develop an ongoing relationship with a health care provider whom they are likely to see through the course of one or more pregnancies. By the time they arrive for an appointment with a genetics counselor, pregnant women have usually talked with a favorite nurse, often in Spanish, and feel competent to accept or reject the test.

The prenatal clinic with a low rate of acceptance, by contrast, has been a site of struggle over services for many years, and it is a difficult environment in which to receive health care. Women (and often their young children) feel imprisoned in uncomfortable waiting rooms where they routinely spend two to three hours before being seen. By that time, the level of anger and frustration, as well as the lack of professional-patient communication, makes it much more likely that a woman will break a counseling appointment or sit through it in a state of distrust. Far more than simply "ethnic differences" are at stake in the microsociology of access to respectful medical services, which then condition acceptance rates. The stability of residential neighborhoods, city, state, and federal health care funding and politics, hospital labor contract negotiations, and issues of community control all enter into the ecology of prenatal clinics.

More complicated to evaluate structurally are the number of women who arrive too late in their pregnancies to be offered the test. In some city hospitals, a woman's tardy entry into the prenatal care system is based on her prior experiences with pregnancy. Very experienced mothers from some pronatalist, highly fertile ethnic communities do not seek much prenatal medical care. Hasidic women, for example, often do not register for maternity beds until the sixth month of their pregnancies, knowing full well that this is a hospital requirement. Prior to that point, many feel entirely competent to monitor their own progress, contacting doctors or nurses only if the present pregnancy feels different from their many prior ones. They are thus unlikely to visit a prenatal clinic in time to be offered an amniocentesis. Moreover, genetic screening in their communities is somewhat demedicalized and linked to marriage arrangements rather than to prenatal care. Among Hasids and traditional Orthodox Jews, a grassroots genetic screening program for those diseases which run at elevated rates in Ashkenazi-derived communities (initially, Tay-Sacks disease; now, increasingly, other conditions like Gaucher's disease for which prenatal screens have become available) works directly in the community, screening potential spouses before they meet one another, rather than relying on the screening of already established pregnancies. Marriages among those deemed "incompatible" by the screening program are then avoided as families plan for their adolescents' futures. So members of the Hasidic community are not likely to use the same entry point to genetic screening, nor to include it in prenatal care, except under emergency conditions.[4]

But in a city where over 20,000 women give birth annually without ever having received any prenatal care at all, there are other problems endemic to the health care system which condition the likelihood that a woman will enter too late to be offered an amniocentesis. Non-English speakers, especially if they are recent immigrants, may not know their entitlements: Medicaid will cover prenatal care, including prenatal diagnosis, but the paperwork necessary to get into the system is intimidating. A crowded, busy clinic may have a discouraging effect on women attempting to make an appointment, even though in principle, OB nurses are prepared to help anyone identified as of "advanced maternal age" or as having had a serious problem in a previous pregnancy to jump the line and receive prompt attention. But unless they have the confidence and ability to speak with the intake nurses, such women may well be dismayed by long waits for service and complex paperwork.

In some city hospital clinics serving the working poor, up to one-third of all the genetic counseling interviews I observed involved women who had arrived at the end of their second trimester of pregnancy, too late for prenatal testing. Some were quite willing to sit through the counseling sessions in order to learn about chromosomes, birth defects, and amniocentesis "for the next pregnancy," or to "spread the word" to friends and kin. Others were disconsolate to discover that they were no longer candidates for what they considered to be an important test of which they had no previous knowledge. Observing low-income women frequently entering prenatal care too late for amniocentesis made me wonder in each case if the woman would have used or rejected the test. My problem is moot: despite the best efforts of many individual health care providers, the health care system had already structurally rejected her through its inability to make prenatal clinics adequately accessible.

In addition to late entry into the prenatal health care system, there are other ways to exit the conveyor belt of amniocentesis. Some women, especially in city hospitals, refused the test indirectly, by missing one or more counseling appointments. "No-shows" are a highly variable lot: among private patients, the rate of those referred for counseling who do not keep their appointments is low, under 10 percent. But their numbers run toward one-third of all clinic patients referred for counseling in some city hospitals; in others, good communication between nurses and patients means that a pregnant woman can refuse the test directly, and no appointment will be made for her, in respect of her wishes. Episodically, I would attempt to follow up no-shows with a phone call. The reasons women gave for missing appointments were diverse. Sometimes, they would explain that the stresses of daily life— cancellation of baby-sitters, broken plumbing, bad weather without adequate coats—had kept them from an appointment. Sometimes, a woman had had a miscarriage before she was scheduled for counseling. But often, fear of the test was reason enough to skip an appointment, even to talk about it.

Most refusals, however, happen during or directly after a counseling session, and were therefore accessible to me. In such cases, I was observing women making a decision based on the information at hand, to which they responded with the resources of their personal and cultural backgrounds. The most common reason that women from many social sectors and cultural traditions gave for refusing amniocentesis was fear of miscarriage. For them, any risk of causing the loss of the pregnancy, no matter how small, was unacceptable. While concern about miscarriage rates was the single most common issue raised in counseling, this fear was especially prevalent among women who had suffered prior miscarriages or bouts of infertility.

Reproductive history entered strongly into most, perhaps all, of women's decision making. This is undoubtedly as true for women who accepted the test as for those who rejected it. Moreover, reproductive history was strongly intertwined with sources of knowledge which might be medical, or more broadly social. For example, one mother of a child with Down's syndrome refused amniocentesis in a subsequent pregnancy because she had learned too much: "Down's is only the tip of the iceberg," she told me. "There's hundreds of birth defects, this test can only pick up a few, what's the point in getting false assurances?" Her fear of "lightning striking twice" could not be allayed by the incomplete information testing offered. Another mother whose second child had died of hydrocephalus wanted no part of testing: "Doesn't matter, I can't go home empty-handed again!" she exclaimed. As all genetic counselors know, individual reproductive history figures large in the decisions women and their supporters make about using or refusing testing.

And reproductive histories are not simply individual; they are woven into family and community life. For example, Mercy Aguilar, an advertising executive, was sent for genetic counseling because of prior miscarriages and because, at thirty-four, she was "borderline A.M.A." [advanced maternal age] as well. Mercy had also been exposed to medical uterine radiation in the early weeks of this pregnancy, before she realized she was pregnant. She entered group counseling with a bias against amniocentesis: as a member of a large, close-knit, and practicing Catholic Filipina family, she had participated in raising a brother with Down's syndrome.

> We are eight in my family, and we all know the joy he [the brother with
> Down's syndrome] brought to us. When my mother gave birth to him,
> she blamed herself, but gradually, we learned you don't cause this. It's
> just part of nature. Now, my mother is only concerned with the danger
> to me of all this testing. She isn't concerned if I have a normal child.

Of course, we all want a normal child. But if the child is retarded, well, my whole family will be behind me. They will help me; it's different than for most people in America.

Mercy went on to speak eloquently about the solidarity of large families, even when separated by migration. She also said that the prior miscarriages had made her even more determined to carry the present pregnancy to term. And she added, almost as an afterthought, a liberal response when I asked about her Catholic background:

I would never have an abortion, it's OK for people who believe in it, but I don't believe. My husband agrees, we want this child, we don't want to endanger it. If there is something wrong, we accept that.

Here, "reproductive history" is family history, as well: the stability of a large family which raised a disabled child successfully and familial and religious acceptance of Down's syndrome all condition the meanings of prior miscarriages and form a context within which a decision not to use prenatal testing was made.

Sometimes, reproductive history refers back to a community or culture from which immigrants have come, encompassing a fund of social information which is at odds with medical practices in their new host country. Katya Janos, a Hungarian painter, refused amniocentesis at thirty-four, insisting with confidence that her family had no genetic problems and that testing wasn't offered before the age of forty in her native country. If she wouldn't do it there, then why do it here, she reasoned. Wilhemina Jordan, forty, told me she briefly considered having an amniocentesis when we met at City Hospital. But nothing in her Liberian background supported the test:

My sister, she hollered at me, "we never did this back home," and she got a healthy boy when she was thirty-six. She hollered, and she hollered and she hollered. She made me remember about her births, and our family's births. Here, everything is different: the babies get born here in the early morning, I never heard of such a birth at home. Perhaps they need the testing here, but not there. [At the hospital] they want me to come back to discuss it. I know they mean to help me, but I was brought up one way, and not another. I'm afraid of complications, I've been through a lot of pain to have my children, that is how we do it at home. I never did this, we never did this, what do I need this for now?

Other immigrants say,

I don't want to know about the future. That's not how we think in my country. (Rose Clarion, thirty-nine, Haitian garment worker)

And miscommunication between science speakers and the multiple Englishes of clinical life is always a possibility. When I interviewed Marcya Milton, age forty-four, after she refused prenatal testing at City, she spoke eloquently at length about her belief that a female deity had given her a healthy baby girl the year before and would protect her present pregnancy. As we were about to part, she added, almost as an afterthought,

Oh, and another thing. Now, before you go, there's one thing I really must tell you. When I went to counseling last year, it was a nice lady that counselled me, and the figure was one half. On the desk, she wrote that figure. It's a fifty-fifty chance the test will harm my baby (RR: she must have misunderstood your question: it's less than a *point* fifty percent chance of causing a miscarriage: fifty-fifty is a very big number, and I'm sure she intended a very small one). I didn't ask any questions, I just sat and listened and then I discussed it with my husband and what with the chances so high, well, we were against it. Now, this time, she said that the chances of having a baby that's retarded was nine hundred. Do you know what I mean, when I say nine hundred? (RR: do you mean one in nine hundred? At forty-five, the counselors usually say, the risk of having a baby with a chromosome problem is one in nineteen). Yes, it was only nine hundred, so you know what I mean now. We couldn't take a fifty-fifty chance of harming that baby. (Marcya Milton, forty-four, Jamaican home health attendant)

This refusal of testing intertwines a doubled discourse. At the beginning of our conversation, Marcya expressed a strong personal faith as the reason for her confidence in a healthy outcome: this was experientially the most significant reason she gave for choosing not to have the test. But at the end of our conversation, she also revealed a profound misunderstanding of both miscarriage rates and the risk of carrying a chromosomally atypical fetus. The numbers given were not the numbers received; this problem haunts medical decisions based on statistical thinking, especially when multiple and intersecting probabilities are being explained to someone without a privileged scientific education.

Many women without a high degree of scientific literacy have developed a practical sense of community epidemiology. Enfolding their own reproductive health into that of kin and friends, they say,

I don't smoke, I don't drink, I don't do drugs. My mother had my sister when she was forty, my sisters, they all had late babies, healthy babies.

My friends, they're all fine. I'm healthy, I don't need this test. (Veronica Landry, thirty-six, Trinidad-born factory worker)

To which a geneticist at City Hospital replied,

It doesn't depend on how you feel, on how you live. The only way to know for sure if your fetus has these problems is to have the test.

But Veronica had made up her mind, and she had the last word: "I like surprises," she said.

Sometimes, pregnant women and their partners refuse amniocentesis because the test cannot pick up the problems about which they are concerned, and they do not find the conditions it can detect sufficiently disturbing to merit testing. Women frequently sought counseling because of exposure to pharmaceuticals, street drugs, or other potentially toxic substances early in pregnancy only to learn that damage caused by such agents wouldn't show up in amniocentesis. The discourse of genetic counseling speaks of added and diminished risks, offering a test "for reassurance," which did not cover the conditions about which they were concerned. They opted against it, since it couldn't allay their anxieties.

Some people also express a disbelief in the accuracy of testing. Statements like "I don't believe they can *really* know all that stuff" or "Isn't that just baby's pee they're lookin' at?" or "No wonder they say it's '99 percent accurate.' That's for when they make their mistakes. Then you can't hold them to it" are most likely to come from those without privileged educational backgrounds. But occasionally, highly educated professionals express similar skepticism or misgivings. A close social science colleague who was attempting to get pregnant once told me she didn't believe in chromosomes: she thought that modern genetics had taken a wrong tack and was insufficiently focused on the interaction of environment and organism. While sympathetic toward her abstract philosophical position, I pushed hard to find out what she thought chromosomes might be (or not be):

That squiggly stuff in the microscope? It's cellular material, I'm sure, but I don't believe it does half of what they think it does. I wouldn't trust what they say is in it all that much.

Misunderstandings or disbeliefs concerning scientific discourse and findings account for some decisions to forego testing, especially but not exclusively among those women without advanced scientific education. But the incorrect "numbers crunching" of the White professional economist mentioned earlier in this essay should remind us that this interpretive tendency is not owned exclusively by those who come from working-class or working-poor backgrounds.

And not all rejection of amniocentesis comes from skepticism about scientifically based information. Religious beliefs provide another set of powerful resources from which a refusal may be drawn. Some women, like Marcya Milton, hold a personal or denominational faith in the health of their fetuses. Others, like Mercy Aguilar, meld religion and family history into their acceptance of Down's syndrome as a possibility with which they could comfortably live. And some use religion as a way to make a clear, if difficult, decision. Pat Carlson, for example, was raised as a Mormon in the Southwest. Living in New York and working as the head of a secretarial department in one of the city's largest and most high-powered law firms, she hadn't attended temple in decades. At age thirty-seven, with one grown child and one divorce behind her, Pat found herself pregnant after a casual liaison. She was extremely pleased, despite the complex conditions involved in undertaking late, single motherhood. She accepted an amniocentesis at the suggestion of her obstetrician without much concern. But when her fetus was diagnosed as having Down's, she was shocked. At that point, Pat beat a beeline to her Mormon roots:

> Maybe if I was married, maybe if I had another shot at it. But this was it: take it or leave it. So I took it. I called the Mormons back. Oh, I hadn't been to temple for years. But I knew in my heart of hearts they'd convince me not to have an abortion. And they did. One man, he just came and prayed with me, he still comes. Stevie (her son with Down's syndrome) gets a lot of colds, I can't always make it to temple. But when we don't make it, he comes over and prays with us.

In this case, the Mormons have consistently provided personally tailored shut-in prayer service and tremendous social support for a woman who left their fold to swim against the current but returned when she needed their help.

Religious beliefs and practices, and the concrete social resources churches provide, are thus central to many pregnant women's orientation. And while many denominations are, in principle, accepting of genetic testing and even abortion, others are vociferously opposed. In either case, the women with whom I have spoken rarely "toed the line" of any particular church; they were much more likely to describe the complex accommodations through which they tested and negotiated their faith. Religious orientation is a complex matter when viewed from a pregnant woman's point of view: she is both the reproducer of a child and guardian of its future moral education, and a bearer of a religious tradition which wields cosmological power over her own actions and intentions. The liminality of pregnancy sets these multiple and intersecting responsibilities into high relief. In their conversations with me, women did

not so much reflect theological or doctrinal positions as exhibit the working out of an experiential trajectory through which profound existential dilemmas could best be understood and internalized. This is no less true for the mainline Protestant medical professionals who decided not to use amniocentesis after exploring the possibility of adopting a "special needs" child with the help of their church, than it is for the factory-working Adventist clinic patients who thought that they would be rewarded for their faith and clean living with healthy pregnancies.

■ AMBIVALENCE

Sometimes, a woman who initially signs on for an amniocentesis changes her mind in the period between genetic counseling and the appointment for the tap. Many factors may influence a change of heart, as Catherine Judd's dilemma, which opens this essay, makes clear. In the "first yes, then no" stories that I collected, two processes stand out with particular clarity. One has to do with the lateness of the test; the other, with the role of men. Both strongly influence the ambivalence that women exhibit when they refuse prenatal testing after first accepting the idea of the test.

Because amniocentesis is conventionally offered between the sixteenth and twentieth week of gestation, it comes at a time in which a commitment to a pregnancy has already been made. As feminist sociologist Barbara Katz Rothman pointed out with both anger and poignancy a decade ago, the timing of this test forces women into a *Tentative Pregnancy* (Rothman 1986). Technologies for earlier intervention are under continuous development and testing, but that's another chapter of the story I am telling. They are not yet widely and safely available, nor are they likely to become so in the near future. For some women, the tardiness of the test looms larger and larger as they confront their scheduled appointments:

> I signed the forms, and then I said to myself, "let me think about it." I decided not to have it, I didn't want to know now, no way, it's too late. In the beginning, I almost had an abortion, but then I decided to keep it. Once I decided, that's it. If anything's wrong, it makes no difference now, I'm not going through no abortion at this stage. I just have to deal with it, whatever happens. I discussed it with my fiance, he said it was up to me, but I don't want no abortion this late. The lady showed it to me (on sonogram), I seen it, it's really a baby there. It's hard to know what will happen, but I'm not having no test, not now. If it had been earlier, well, yes, especially when I was making up my mind [i.e., to keep or end the pregnancy]. But not now, it's too late. (Charlene Gray, thirty-eight, African American bookkeeper)

A second reason for converting a "yes" into a "no" is also structural but is not connected directly to the technology itself. I have come to think of this reason as "The Man Question": it was particularly difficult to interview men directly about their responses to the offer of an amniocentesis for their pregnant mate during my fieldwork. I was only able to complete fifteen home interviews with men, and learned much of what I know about their responses as filtered through the interpretations of the women who were their partners. But I came to believe that men strongly influenced women's choices, despite their often apparent absence from the parts of the process that were visible to me. They did so in many ways, in part according to the gendered roles appropriate to their class and cultural backgrounds: by forbidding the use of the test, or pushing it; by picturing pregnancy as an exclusively female realm in which they had no decision-making interests; and sometimes, by "boundary-keeping" conversations between their partners, health care providers, and nosy anthropologists. In these gendered scripts, confrontation, manipulation, and resistance might flow in either direction. What was revealed was not so much a single pattern of male dominance and female subordination, or male insistence on female difference, but the disruption of not-quite-conscious gendered assumptions which the offer of a new, morally fraught technology brought to the surface. Nonetheless, it was striking to me how often women said, "My husband won't let me," in response to the query, "Why did you decide not to have this test?"

Lucile Edwards offered one classic version of this narrative, a few weeks after our meeting at City Hospital at a genetic counseling group. Although she said she was initially very interested in having an amniocentesis, she had eventually decided against it, and went on to elaborate:

> I was thinkin' of doin' it as my husband has diabetes in his family, and what with genetic problems, you never know. But then, he don't approve. . . . I don't quite know why. When they explained it at the hospital, it was so interesting to me. But he insist. My husband, he has seen people older than us havin' kids and nothin' happen. I explain to him, most of the times, it's all right, it all works out. But then sometimes, just sometimes, it don't. In England, I know this lady, she had twins, one came out fine, the other came out a mongol. Because of her age. I don't know what I'd do, how I'd raise it. But my husband, he don't believe in it, no abortions, he don't believe in that, either. . . . I have a friend, she asks me, "What do you think about all this, about your husband and you?" I say, "My ideas are not similar to his ideas. But we have to live together, to raise our children." We've got three kids, it's time to plan for their futures, to sacrifice for their futures. I need to get back to work, not havin' any more babies, and certainly, no

sick babies. But he won't permit it. (Lucile Edwards, thirty-seven, Afro-Caribbean cook)

Contained in this story is a personal history of male privileged decision making and female peacekeeping across gendered values. Likewise, Catherine Judd, whose story opens this chapter, was persuaded, but not commanded, to forego an amniocentesis by her husband's racial-historical and religious concerns. These cases, and many others, suggest that women's refusal is deeply responsive to their partners' opinion.

Thus ambivalence about the test—whether due to its looming lateness or to objections raised by partners—may be manifest in a change-of-heart. When a pregnant woman finds herself caught between a desire for scientific knowledge and control and attentiveness to timetables and agendas of intimate bonds with a growing fetus or a partner, she may choose not to choose the technological option. In these cases, social and psychological rhythms come to dominate over the powerful technoscientific choreography mandated by prenatal testing.

■ AGAINST THE TECHNOLOGICAL GRAIN

It has been my argument to date that the imbrication of class and ethnic backgrounds, religious influences, and intra- and interpersonal agendas all organize the possibilities which women evaluate as they decide to use or not to use amniocentesis. Those who refuse the test, no less than those who accept it, are therefore responding to a complex, highly structured social nexus within which they negotiate and exercise personal choice. There is another group of refusers whose structured choices also bear analysis: women who accept an amniocentesis and, learning of "bad" or "positive" results, decide to continue their pregnancies. It is to the decision-making processes of such women who employ the technology but do not pursue the consequences for which it was initially developed that I now turn.

But first, two caveats are in order. No records are kept either federally or by state on the outcomes of amniocentesis. According to epidemiologists, biostatisticians, and genetic counselors with whom I have spoken, the decision to keep a pregnancy after receiving the diagnosis of a serious condition is relatively rare. But it is not really possible to evaluate precisely how rare (Drugan et al. 1990; Meaney et al. 1993; Palmer et al. 1992). A second and related point is this: the decision rests in large measure on the diagnosed condition. Most people hold firm opinions about Down's syndrome long before they encounter amniocentesis; they thus feel entirely competent to make a decision to continue or end a pregnancy in which this condition has been diagnosed. When Down's syndrome is diagnosed, abortion rates run high—90 to

95 percent. But most of the other conditions for which the test can provide diagnoses—other chromosome problems ranging from the severe and deadly, like trisomy 13, to the ambiguous, like the sex chromosome anomalies, Turner's or Klinefelter's syndrome—are usually unknown before a pregnant woman and her supporters receive the news that their fetus "has something seriously wrong." Response to disability news, couched at first in entirely biomedical discourse, is thus a complicated affair, engaging a lot of hard work toward understanding and evaluation on the part of both genetic counselors and their pregnant patients. Pat Carlson, who returned to her Mormon roots when she wanted to keep a pregnancy after a positive diagnosis of Down's, is unusual. But she was *not* exceptional in the way in which both prior reproductive history and religious resources entered into her decision-making process. Before coming to resolution, Pat did a lot of work. Her obstetrician suggested an abortion as he delivered the bad news, but Pat stalled for time. She visited a neighborhood home for retarded adults, and said,

> You know, it was kind of nice. They looked pretty happy, they had jobs, they went bowling. It really made me think about it. Maybe if I was married, maybe if I had another shot at it. But this was it: take it or leave it. So I took it. And I called the Mormons back.

An unmarried divorcée with a grown child, Pat had survived two miscarriages and the death of a premature baby who lived only three days; her reproductive history made her value this pregnancy as a "miracle." She used the Mormon Church to sustain her decision to keep the pregnancy in the face of her obstetrician's objections.

Migdalia Torres-Ramirez's story also contains elements which are both usual and unusual. Sent for genetic counseling and an amniocentesis at the tender and unusual age of nineteen, Migdalia was a devout Puerto Rican Catholic who considered abortion to be "killing." But she was also the older sister of a girl with spina bifida whose disabilities had made a profound impression on Migdalia and her mother. As Migdalia described it,

> My sister, she can't walk, she can't see, they left her blind at City Hospital, my mother is still in a lawsuit. When I got pregnant the first time, I was very young, fifteen, sixteen when I had my baby. I talked with my mother, she really wanted me to have the tests, I wanted it too, she had such a cross to bear. God gave it to her, but it's a lot of work. . . . I was only concerned if my own baby couldn't walk or talk. . . . I just didn't want my baby to be like my sister. I don't know what I would have done if it had been like my sister, I think I would have had an abortion. My

mother and me, we're against abortion, so maybe I would have carried that cross, like my mother did. But then again, it's a case where I think I would have had an abortion.

Migdalia's fetus didn't have spina bifida, for which she had requested prenatal diagnosis. It did, however, have Klinefelter's syndrome, one of the sex chromosome anomalies involving growth problems, sterility, and possibly learning disabilities and mild mental retardation. Migdalia's reaction to the news is instructive:

> I wasn't too concerned when they said he'd be normal. Just that he might be slow-minded, but he'd look normal in appearance. I have faith in God, I'll be there for my son. And I have my mother helping me all the way. He's gonna be normal, he'll see and walk. That's all I care about. As long as he looked normal, acted normal, I'll be there for him. And I didn't mind if he maybe was a bit slow. And as it turns out, he isn't, he's quick to pick up everything. Back then, I talked it over with my mother, she thought so too, what's the use of killing it if he'll be normal, he'll walk.

Like many other women for whom religion provided orienting metaphors and beacons, Migdalia's narrative is richly embroidered with her Catholicism; it also highlights her close relationship with her mother. In deciding to keep her pregnancy after Klinefelter's syndrome had been diagnosed in her fetus, Migdalia was somewhat unusual; counselors estimate that more than 65 percent of women receiving this diagnosis choose terminations. But her unusual decision has a very strong context: intimate knowledge of one disabling and worrisome physical condition in her sister could be contrasted with a disability that "didn't show." It was the relative invisibility of the consequences of her son's atypical chromosomes that made them normal in her estimation. For Migdalia, both spina bifida (her sister's condition) and Klinefelter's syndrome (her son's condition) have concrete, specific meanings.

In one case, I was present as a positive diagnosis was produced. I observed a technician as he found something ambiguous on the #9 chromosomes of the sample he was scoping. The head geneticist agreed: there was additional chromosomal material on the top, short arm of the #9s. She called it "9P+", 9 for the pair of chromosomes on which it was located, P to designate the short arm, and plus to indicate additional chromosomal material. First, she scanned the literature for an interpretation, assimilating it to some rare clinical reports on "trisomy 9," the closest known condition. In all those cases, babies born with trisomy 9 had physical anomalies and were mentally retard-

ed. Armed with a provisional diagnosis, the geneticist met with the genetic counselor, who then counseled the mother. The mother was firm in her decision to keep the pregnancy.

A month after the baby's birth, the mother visited the genetics laboratory for a consultation. The "trisomy 9" turned out to be a six-week-old Haitian boy named Etienne St-Croix. His mother, Veronique, spoke reasonable English and good French. His grandmother, Marie-Lucie, who carried the child, spoke Creole and some French. The two geneticists spoke English, Polish, Hebrew, and Chinese between them. I translated into French, ostensibly for the grandmother and mother. Here is what happened:

The geneticist was gracious with Veronique but after a moment's chit-chat, asked to examine the baby. She and a second geneticist, both trained in pediatrics, handled the newborn with confidence and interest. The counselor took notes as the geneticists measured and discussed the baby. "Note the oblique palpebral fissure and micrognathia," one called out. "Yes," answered Veronique in perfect time to the conversation, "he has the nose of my Uncle Hervé and the ears of Aunt Mathilde." As the geneticists pathologized, the mother genealogized, the genetic counselor remained silent, furiously taking notes, and the anthropologist tried to keep score. When the examination was over, the geneticists apologized to the baby for any discomfort they had caused him and asked the mother one direct question. "I notice you haven't circumcised your baby. Are you planning to?" "Yes," Veronique replied, "we'll do it in about another week." "May we have the foreskin?" the geneticist queried. "With the foreskin, we can keep growing trisomy 9 cells for research, and study the tissue as your baby develops." Veronique gave her a firm and determined "yes," and the consultation was over.

Later, I asked Veronique and Marie-Lucie what they had thought about the amniocentesis, the diagnosis, and the genetic consultation. The mother replied,

> At first, I was very frightened. I am thirty-seven. I wanted a baby, it is my
> husband's second marriage, my mother-in-law is for me, not the first
> wife, she wanted me to have a baby, too. If it had been Down's, maybe,
> just maybe I would have had an abortion. Once I had an abortion, but
> now I am a Seventh Day Adventist, and I don't believe in abortion any-
> more. Maybe for Down's, just maybe. But when they told me this, who
> knows? I was so scared, but the more they talked, the less they said.
> They do not know what this is. And I do not know, either. So now, it's
> my baby. We'll just have to wait and see what happens. And so will they.

Here, marital and kinship relations clearly influence the decision to continue a pregnancy after positive diagnosis; so does religious conversion. But at the center of this narrative lies another important theme: diagnostic ambiguity.

Biomedical scientists work from precedent, matching new findings with old. When presented with an atypical case, they build a diagnosis in the same fashion, comparing the present case to the closest available prior knowledge in clinical archives.[5] While the geneticists are confident that this child will share the developmental pattern reported in the literature for other children with very similar chromosomal patterns, the mother was quite aware of the idiosyncratic nature of the case, its lack of clear-cut label and known syndrome. She therefore decided that the contest for meaning was still an open one. This is a dramatic instance of interpretive standoff between representatives of biomedical discourse and representatives of family life.

But in some sense, all positive diagnoses appear ambiguous to pregnant women.[6] An extra chromosome spells out the diagnosis of Down's syndrome, but it does not distinguish mildly from severely retarded children, nor does it indicate whether this particular fetus will need open heart surgery. A missing X chromosome indicates a Turner's syndrome female but cannot speak to the meaning of fertility in the particular family into which she may be born. Homozygous status for the sickle-cell gene cannot predict the severity of anemia a particular child will develop. All such diagnoses are interpreted in light of prior reproductive histories, community values, and aspirations that particular women and their families hold for the pregnancy being examined.

This problem of ambiguity—inside of biomedicine and inside of family life—is one encountered by genetic counselors with a fair degree of frequency. Virtually all counselors I interviewed mentioned mosaic conditions when I asked about difficult cases. In mosaic diagnoses, cells are both normal and atypical in varying proportions. Roughly speaking, the greater the density of atypical cells, the greater the likelihood of disabling conditions which are known to geneticists and can be described to potential parents. But some conditions—for example, trisomy 22—exhibit mosaicism at the cellular level, without profound clinical expression at the level of the whole organism, that is, the child later born from a diagnosed fetus. And sometimes, a known condition—for example, Down's syndrome—may be present in mosaic patterns on the cellular level, producing a child who is "slow" but still coded by the relevant caretakers in her life as "normal." Mosaic diagnoses are thus hard to explain, and harder to interpret. Their inherent ambiguity leads many women to continue pregnancies in which they have been diagnosed, especially if the number of atypical cells is relatively small, or the genetic counselor can say of a particular condition with some degree of confidence, "It rarely has profound clinical significance." Women receiving mosaic diagnoses are among the most likely to stop the technological conveyor belt, preserving their pregnancy and preparing for the birth of a child whose cellular "fortune" has been read but whose clinical future they understand to be truly unpredictable.

Existentially speaking, of course, we all live with truly unpredictable clinical futures; the existence of prenatal diagnosis has simply added a new twist to that impasse in the human condition. Now, it is possible, indeed, necessary, for those who would have the chromosomes of their fetuses "read" to know something about possible problems and limits a coming child may face in vitro, without having encountered those problems and limits as they unfold in vivo. The difference between a biologically described organism and a socially integrated child is of course enormous. And it is within this gap—between laboratory-generated descriptions of disabilities and potential disabilities, and their consequences for family life as a child develops—that some women receiving positive diagnoses choose to operate. Those who opt to continue a pregnancy after any positive diagnosis must consciously face what the rest of us only confront episodically: the hard work of redescribing and reinscribing a powerful biomedical definition into the more complex and variegated aspects of personhood, childhood dependency, and family life. In this situation, the structure of chromosomes initially looms large as a defining characteristic of what a child's future may bring. Women who continue pregnancies after positive diagnoses thus expend considerable agency reducing the significance of chromosomes in order to welcome a child on other grounds than biomedical normalcy.

■ BY WAY OF CONCLUSION

As I have tried to show throughout this essay, women with potent religious affiliations, strong kinship or other communitarian social support, or powerful reasons anchored in their reproductive histories are most likely to decide against the biomedical information amniocentesis brings as a basis for accepting or rejecting a particular pregnancy. These patterns hold true across differences of income, lifestyle, and job description, which provide rough measures of class. But other patterns of amniocentesis use and rejection are highly class-structured: access to information and respectful health care surely condition how prenatal testing is perceived and valued. And with better access, middle-class women are also less able to achieve any distance from the biomedical discourse within which their own rationality is forged. Those without much privileged scientific education are most likely to reject testing altogether, although many women from working-class and working-poor backgrounds also choose to be tested. And the problem of male privilege, or even male dominance, in decision making also intersects these patterns of use. Such socially structured heterogeneous processes thus do not reduce to a reflexive response to any particular diagnosis; in other words, they hold no automatic or predictable intersection with the biomedical diagnoses available through prenatal testing.

The "invisible and implicated actors" whose social subjectivity guards the passage points into and exits from this technology surely have much to teach us about its social construction. Operating at the intersection of reproductive technology, genetic discourses, and gender relations as they refract and enact other forms of social hierarchy, pregnant women in America have increasingly become "moral pioneers," recruited as judges of which standards for entry into the human community will prevail. Women in all their social and cultural diversity have long been exquisitely and differentially consigned to matters of the body and domesticity in North American culture. Their symbolic association with "private life" now offers material vantage points illuminating some of the implications of contemporary biomedical discourses and practices. Scientific practices seep unevenly through the crossroads and chasms where biotechnology and family life conjoin. When we begin with the amniocentesis stories of diverse women, we gain an important commentary on the difference between a scientific message of obligatory universality and the concrete, local contradictory particularities of applied technology as an aspect of a lived dilemma. That dilemma encompasses the social inscription in pregnant bodies of realms as seemingly distant as shifts from academic to commercial genetics. It includes papal politics at UN conferences on women and population. And it is deeply influenced by municipal, state, and federal struggles over health care budgets and clinic hours. Pregnant women are thus positioned as ethical gatekeepers vis-à-vis this technology. They are at once moral pioneers and cultural conscripts in a social drama played out upon an uneven and shifting terrain on which reproductive technologies are routinized in a multicultural, class- and gender-stratified world. The confident dominion of biomedicine here encounters a refusal through which some of the fault lines of science in social context may be mapped and investigated. Along these fault lines range the multiple and overlapping meanings of the ambiguous technologies that offer the options these women choose to refuse.

Acknowledgments

The research on which this essay builds was conducted in New York City over the course of the decade 1984–1993. At various times, my research has been funded by the National Science Foundation, the National Endowment for the Humanities, the Rockefeller Foundation's "Changing Gender Roles" Program, the Institute for Advanced Study, the Spencer Foundation, and a sabbatical leave from the New School for Social Research. I thank them all for their support, and absolve them from any responsibility for what I have made of it.

Above all, I thank the hundreds of pregnant women, and mothers of young children, and their supporters, as well as the medical service providers, who believed in the importance of this work and participated in it. All names have been changed for reasons of confidentiality. A first draft of this essay benefited from the insightful comments of Faye Ginsburg, to whom I owe my usual debt of gratitude for her extraordinary generosity as a friend and colleague. Three anonymous reviewers and Linda Layne, guest editor for *Science, Technology, and*

Human Values, also provided comments which were very valuable in the revision of this essay.

Notes

1 *Editors' Note:* This chapter is reprinted from *Science, Technology, and Human Values,* v. 23, no. 1, 1998. Although Rapp does not use "cyborg" vocabulary, we have included it here because we find her work both relevant to cyborg anthropology and critical of it. In our terms, Rapp studies the cyborgic incorporation of reproductive technologies into the everyday life of women and their decision making, but she is not distracted by their power. Rather, using the tools of ethnography, she carefully explores how women assess and often refuse the use of these technologies, for cultural, structural, and profoundly intimate reasons. In many ways, Rapp's careful attendance to the cyborgification of reproduction in the context of its embeddedness in political economies, ethnicities, and the personal lives of women represents important future directions for cyborg anthropology.

2 *Moral Pioneers: Fetuses, Families, and Amniocentesis,* forthcoming from Routledge (1998), takes up these religious and philosophical narratives.

3 Throughout this essay, all names are pseudonyms.

4 Satmar Hasids, in particular, are extremely sophisticated about medical technology and services. During the period of my second pregnancy in 1991–1992, my obstetrician also served members of the Hasidic community; intrigued by my neverending research questions, he told me many stories as a "provider informant" about their prenatal care practices. Although known carriers try not to become pregnant after having lost children to Tay-Sacks disease, Halasik law can be interpreted to permit testing and even abortion under certain circumstances. But both must be accomplished before the pregnancy is forty days old, the last moment at which the life of a male fetus may be ended. U.S. medical protocols offered chorionic villus sampling at nine to eleven weeks, too late in the pregnancy to accommodate religious teachings. The obstetrician thus told of sending Hasidic "accidental" pregnancies to England, where a cutting-edge experimental program was using CVS for prenatal diagnosis far earlier than it was available here. When I retold this story to a representative from *Dor Yeshurim* in 1994, he laughed and said, "That was yesterday's news. Today, we send them to Philadelphia, where there's a terrific doctor who will do it for us even earlier." In his estimation, the newest of reproductive technologies could be successfully used to sustain religious practice. To accomplish this goal, his organization was highly networked into the interstices of medical experimentation.

5 This problem of stabilizing diagnoses is not dissimilar to other problems of uncertainty in the development of diverse technologies described in the essays included in Clarke and Fujimara (1992).

6 The point is made throughout Rothman (1986). It was also pointed out to me separately by Shirley Lindenbaum and Emily Martin.

References

Clarke, Adele, and Joan Fujimara, eds. 1992. *The Right Tools for the Job: Materials, Instruments, Techniques and Work Organization in 20th Century Life Sciences.* Princeton: Princeton University Press.

Clarke, Adele, and Teresa Montini. 1993. "The Many Faces of RU486: Tales of Situated Knowledges and Technological Contestations." *Science, Technology, and Human Values* 18 (1): 42–78.

Cowan, Ruth Schwartz. 1992. "Genetic Technology and Reproductive Choice: An Ethics for

Autonomy." In *The Code of Codes: Scientific and Social Issues in the Human Genome Project*, edited by Daniel J. Kevles and Leroy Hood, 244–263. Cambridge: Harvard University Press.

———. 1994. "Women's Roles in the History of Amniocentesis and Chorionic Villi Sampling." In *Women and Prenatal Testing: Facing the Challenges of Genetic Technology*, edited by Karen H. Rothenberg and Elizabeth J. Thomson, 35–48. Columbus: Ohio State University Press.

Drugan, Arie, et al. 1990. "Determinants of Parental Decisions to Abort for Chromosome Abnormalities." *Prenatal Diagnosis* 10: 483–490.

Hsu, Lillian. 1989. "The Prenatal Diagnosis Laboratory of the City of New York: A Tenth Anniversary Assessment." Talk delivered at NYU Medical School, June 10.

Judson, Horace Freeland. 1992. "A History of the Science and Technology behind Gene Mapping and Sequencing." In *The Code of Codes: Scientific and Social Issues in the Human Genome Project*, edited by Daniel J. Kevles and Leroy Hood, 37–80. Cambridge: Harvard University Press.

McNeil, Maureen. 1987. "Being Reasonable Feminists." In *Gender and Expertise*, edited by Maureen McNeil, 13–61. London: Free Association Books.

Meaney, F. John, et al. 1993. "Providers and Consumers of Prenatal Genetic Testing Services: What Do the National Data Tell Us?" *Fetal Diagnosis and Therapy* 8 (suppl. 1): 18–27.

Morgall, Janine Marie. 1993. *Technology Assessment: A Feminist Perspective*. Philadelphia: Temple University Press.

Palmer, Shane, et al. 1993. "Follow-up Survey of Pregnancies with Diagnoses of Chromosomal Abnormality." *Journal of Genetic Counseling* 2: 139–152.

Rapp, Rayna. 1988. "Chromosomes and Communication: The Discourse of Genetic Counseling." *Medical Anthropology Quarterly* 2: 143–157.

———. 1993. "Constructing Amniocentesis." In *Knowledge, Power and Practice: The Anthropology of Medicine and Everyday Life*, edited by Shirley Lindenbaum and Margaret Lock, 54–76. Berkeley: University of California Press.

———. 1994. "Women's Responses to Prenatal Diagnosis: A Sociocultural Perspective on Diversity." In *Women and Prenatal Testing: Facing the Challenges of Genetic Technology*, edited by Karen H. Rothenberg and Elizabeth J. Thomson, 219–233. Columbus: Ohio State University Press.

———. 1995. "Heredity or Revising the Facts of Life." In *Naturalizing Power: Essays in Feminist Cultural Analysis*, edited by Carol Delaney and Sylvia Yanagisako, 69–86. New York: Routledge.

———. 1998. *Moral Pioneers: Fetuses, Families, and Amniocentesis*. New York: Routledge.

Rothman, Barbara Katz. 1986. *The Tentative Pregnancy: Prenatal Diagnosis and the Future of Motherhood*. New York: W. W. Norton.

Wajcman, Judy. 1991. *Feminism Confronts Technology*. University Park, Penn.: Pennsylvania State University Press.

Yoxen, Edward. 1990. "Seeing with Sound: A Study of the Development of Medical Images." In *The Social Construction of Technological Systems*, edited by Wiebe E. Bijker, Thomas P. Hughes, and Trevor Pinch, 281–309. Cambridge, Mass.: M.I.T. Press.

Babies Don't Feel Pain

A Century of Denial in Medicine

David B. Chamberlain

■ INTRODUCTION

For centuries, babies have had a difficult time getting adults to accept them as real people with real feelings having real experiences—a situation which their twentieth century cyborgification has only enhanced. Deep prejudices have shadowed them for centuries: babies were thought of as subhuman, pre-human, or, as sixteenth-century authority Luis deGranada put it, "a lower animal in human form." This loss of humanity was further elaborated in the Age of Science. In the last hundred years, scientific authorities have robbed babies of their cries by calling them "echoes" or "random sound"; robbed them of their smiles by calling them "gas"; robbed them of their memories by calling them "fantasies"; and robbed them of their pain by calling it a "reflex." In short, as anthropologists (Shaw 1974; Davis-Floyd 1992) have shown, in most American hospitals since the early part of this century, babies have been treated as the nonsentient products of the obstetrical manufacturing process called birth (see Introduction, this volume).

Before this century, newborns found themselves in the hands of women: mothers, grandmothers, aunts, and midwives, but in the twentieth century, infants collided head-on with physicians, typically male physicians. In this collision, infant senses, emotions, and cognitions were usually ignored. Doctors eventually gave serious attention to the pain of mothers but not to the pain of infants. Pediatricians and obstetricians created painful technoscientific routines which continue today. The effects of this particular kind of cyborgification on the unborn and newborn child are multiple and have been largely ignored in the popular, the scientific, and even the anthropological literature about birth and the new reproductive technologies—an imbalance this chapter seeks to begin to redress.

Against a background of scientific ignorance of infant behavior, experiments were undertaken as early as 1917 at Johns Hopkins University (Blanton 1917) to observe newborn tears, smiles, reactions to having blood drawn, infections lanced, and reactions to a series of pinpricks on the wrist during sleep. In these experiments, the first of many, infants reacted defensively. When blood was taken from the big toe, the opposite foot would come up at once with a pushing motion against the other ankle. Lancing produced exaggerated crying, and pinpricks during sleep roused half the babies to move the hand and forearm. Rough cleaning of the back and head to remove vernix provoked vigorous battling movements of the hands, frantic efforts to crawl away, and angry crying. Psychologist Mary Blanton concluded: "The reflex and instinctive equipment of the child at birth is more complex and advanced than has hitherto been thought."

Although these results were unequivocal, this line of experimentation continued at Northwestern University and Chicago's Lying-In Hospital (Sherman and Sherman 1925; Sherman 1927; Sherman et al. 1936), where newborns were stuck with needles on the cheeks, thighs, and calves. Virtually all infants reacted during the first hours and first day after birth, but the trend, researchers noted, was toward more reaction to less stimulation from day 1 through day 12. This finding suggested that at birth, newborns were not very sensitive but gradually became more sensitive. What the Shermans failed to tell us was that *all* mothers in the study had received anesthetic drugs during labor and delivery. They took no account of the effect of these drugs on the babies. (For the missing information, we are indebted to psychologist Daphne Maurer [Maurer and Maurer 1988: 40].)

The Shermans discovered that infants would cry in reaction to hunger, to being dropped two-to-three feet and caught, to having their heads restrained with firm pressure, or to someone pressing on their chins for thirty seconds. Babies tried to escape and made defensive movements of the arms and legs, including striking at objects to push them away. Today, we would interpret these behaviors as "self-management" or "kinesthetic intelligence," but in those days experts argued about whether the head end or the tail end of a human baby was more sensitive (Sherman et al. 1936:33).

Subsequent studies to learn how infants would react were directed at the big toe (Lipsitt and Levy 1959), calf (Kaye and Lipsitt 1964), head, trunk, and upper and lower extremities. Especially influential was an ambitious study by Myrtle McGraw (1941) at Columbia University and The Babies' Hospital, New York, using pinpricks to reveal the "progressive maturation of nerves." Seventy-five infants were stimulated with a blunt sterile safety pin at intervals from birth to four years of age, and their responses duly recorded. Half were

recorded on the new medium of motion picture film. *Ten* pricks in *each* area (head, trunk, upper and lower extremities) ensured that reactions were sufficiently "intense." Again, the influence of anesthesia on infant pain perception was overlooked.

After 2,000 observations, McGraw reported that some infants a few hours or days old showed no response to pinprick. The usual response, she said, "consists of diffuse bodily movements accompanied by crying, and possibly a local reflex." In spite of the fact that these babies cried and tried to withdraw their limbs, McGraw concluded that there was only limited sensitivity to pain and labeled the first week to ten days after birth as a period of "hypesthesia" (abnormally weak sense of pain, heat, cold, or touch). Her reference to a "local reflex" reflected the common medical view that reactions were mechanical and had no mental or emotional component. She asserted that the neonate could in no way localize or identify the source of painful stimulation because the cerebral cortex was not sufficiently developed to permit it.

To physicians, McGraw's work seemed so thoroughly scientific that it justified the continuance of painful practices with infants. The belief that newborns were somehow not yet sensitive to pain was a prejudiced interpretation which fit comfortably into the medical view expressed in journals reaching back into the nineteenth century (Bigelow 1893; Pierson 1852) and into the standardized format being developed for hospital birth. More recent research shows that newborns and older babies pinched on the arm react instantly to pain (Thoden and Koivisto 1980), with no sign of "hypesthesia."

But there were more pinprick experiments. In 1974, apparently ignorant of the experiments already performed, Rich et al. tested 124 full-term newborns to determine the "normal response" to a succession of pinpricks around the knee. The doctors concluded that "the normal response is movement of the upper and lower limbs usually accompanied by grimace and/or cry." All infants demonstrated the "complete" response after six or fewer pinpricks.

A different method for studying infant pain was to run water of different temperatures through cylinders attached to the baby's abdomen, leg, or forehead while observing reactions as the water was made hotter or colder. This line of research began in Europe in 1873 and was taken up in America by Pratt, Nelson, and Sun at Ohio State University (1930) and by Crudden at the University of Michigan Hospital in 1937. Babies reacted violently, especially to cold water. Crudden found that *any* deviation from normal body temperature provoked immediate respiratory and circulation changes in all subjects. (No sign of "hypesthesia" here either.)

Do babies feel pain? Of course they do. There are many objective signs—*if* you believe what you observe.

Crying

It seems perfectly obvious now, but for a long time experts were informing the public that infant cries were only "random" sounds or "reflexes," not genuine communications (e.g., Illingworth 1980). It took a quarter century of cry research to prove otherwise (Lester and Boukydis 1985). Cries are meaningful signals: they increase in intensity with degrees of pain. Spectrographs, which reduce sound to an elaborate visual portrait, reveal how varied and complex cry language is (Lind 1965). Acoustic studies show that changes in pitch, temporal patterning, and harmonic structure also reflect degrees of pain and urgency. For example, in a thorough study of cries during circumcision, acoustic features precisely reflected the degree of invasiveness of the surgery (Porter et al. 1986).

Parents who have been present at circumcision (a rarity) have recalled how their babies cried. One father, present in the delivery room, told me of his great surprise when the obstetrician circumcised his boy at delivery. The newborn, having been quiet during the entire birth, wailed loudly throughout the circumcision. A Jewish father, reflecting on his son's circumcision on the eighth day after birth, said it was the saddest occurrence of his babyhood: the boy cried more that afternoon, he said, than any time in his whole first year.

Facial Expressions

The pains babies feel are clearly expressed on their faces (Grunau and Craig 1987). Brows bulge, crease, and furrow. Eyes squeeze shut, and bulging of the fatty pads about the eyes is pronounced. There is a nasolabial furrow that runs down and outward from the corners of the lip. The lips purse, the mouth opens wide, the tongue is taut, and the chin quivers. This look on a human face of *any age* communicates pain.

Body Movement

Body language in its large motor dimensions is also a language babies share with older humans. In response to pain, babies jerk, pull back, try to escape, swing their arms, use their hands to push away, and frantically scrape one leg against the other to dislodge an offending stimulus in that area. Babies strike out with their upper extremities and kick with their lower extremities. Fitzgerald and Millard (1988) made close observations of babies receiving routine heel lancing—a deep wound made in the heel to obtain blood sam-

ples. Using calibrated hairs, they gently stroked the corresponding areas in the injured and noninjured heel. All infants, including premature infants, showed the same well-defined hypersensitivity to tissue injury found in adults. Various studies have shown that lancing is always painful (Owens and Todt 1984; Grunau and Craig 1987; Fitzgerald and Millard 1988).

Vital Signs

Pain is revealed by changes in respiration and circulation. Pain causes increased respiration. Babies may hold their breath momentarily, then release it in piercing cries. Researchers have observed that infant heart rates increase 50 beats per minute, peaking above 180 beats per minute in response to pain (Williamson and Williamson 1983; Owens and Todt 1984; Holve et al. 1984). In a study to compare behavioral states of the newborn with those of the fetus, Pillai and James (1990) discovered that the heart rate during newborn crying was unlike anything they had found in prenatal life. This racing heartbeat was unstable, often reaching peaks in excess of 200 beats per minute in spite of the fact that baseline heart rates after birth are generally 20–30 bpm *lower* than they are in utero. These extremely elevated heart rates signal serious disturbance.

Hormonal Changes

Objective measurements of blood and body fluids clearly reflect adjustments to pain and stress. Serum cortisol is such a measurement. In painful conditions, adrenals may release cortisol three to four times the baseline rate (Talbert et al. 1975; Gunnar et al. 1981, 1985; Stang et al. 1988). Cortisol levels clearly differentiated between three different surgical techniques of circumcision (Gunnar et al. 1984). Under painful conditions, tissue and blood oxygen levels drop (Rawlings et al. 1980). Dramatic shifts of beta-endorphin production also accompany invasive medical procedures or environmental upset.

Neurobehavioral Assessments

Further consequences of infant pain can be seen in neurobehavioral measurements. Babies who have been subjected to pain have difficulty quieting themselves. Following circumcision, the normal progression of sleep cycles is reversed, reflected by an immediate and prolonged plunge into non-REM sleep (Emde et al. 1971). After circumcision, babies withdraw, change their social interactions with their mothers, and modify their motor behavior (Dixon et al. 1984) just as they do with any serious injury or shock. Als, Lester, and Tronick (1982) developed an instrument for systematically observing early behavior (Assessment of Preterm Infants' Behavior), including those indicative of stress and defense. Some of these are: seizuring, tremoring, spit-

ting up, trunk arching, finger-splaying, fisting, squirming, refusing consolation, and becoming unable to rest.

Memories

Finally, we know that newborns feel pain because of their reports of painful experiences after they have acquired the ability to speak. A two-and-a-half-year-old, who had been bruised by forceps at delivery, told her mother that it hurt to be born, "like a headache." A spontaneous revelation from the back seat of a car came from three-and-a-half-year-old Jason, who told his mother that he remembered being born. It was "tight," he felt "wet," something hurt his head, and he remembered that his face had been "scratched up." Jason's mother, who said she had never talked to him about his birth, confirmed that he was monitored via an electrode stuck into his scalp and was pulled out by forceps. The photo taken by the hospital shows scratches on his face.

Many other spontaneous memories of painful experiences surrounding birth are documented in my book *The Mind of Your Newborn Baby* (1998). Both children and adults have these spontaneous memories of birth trauma. Three men have told me they have always remembered being circumcised as newborns. Keith, of Dallas, Texas, remembers being born with an open abdomen. He says he has always remembered this surgery and the emotions he felt at the time. We may not like to think babies remember pain, but they do.

■ THE SELLING OF CIRCUMCISION

In North America, male circumcision is still commonly performed without benefit of anesthesia—a glaring example of the continuing denial of infant pain. In a 1993 survey of family doctors in Ontario, Canada, 43 percent were conducting circumcisions but only one out of four were using anesthetic. Half still held the belief that anesthetics were unsafe, and 35 percent believed babies did not remember circumcision (Wellington and Rieder 1993).

Circumcision originated at least 6,000 years ago as a tribal and religious identity symbol in Semitic cultures. The ballooning of the practice in twentieth-century America was the work of pediatricians and obstetricians who gave it new status as a "medical" procedure. Circumcision also received a big lift from a wealthy layman, John Harvey Kellogg, founder of the cereal company, who was obsessed with the evils of masturbation and advocated circumcision as the solution. Kellogg's book *Plain Facts for Old and Young* urged parents to have their boys circumcised *without* anesthesia—because the pain would have a "salutary effect upon the mind"—and was as common in American homes at the time as his cornflakes.

Taking a sharply opposing view, psychohistorian Lloyd DeMause (1991)

finds in circumcision one of the numerous acts of genital mutilation and violence perpetrated on infants and children in virtually every culture since the earliest times. Other modern critics have labeled it a "betrayal of the innocent" and a "breech of trust" (Grimes 1978; Janov 1983). Anesthesiologist John Scanlon (1985) simply calls it "barbarism." Nevertheless, a century ago, the medical view held sway and circumcision swept through the male population, becoming a uniquely American phenomenon. About 80 percent of the world's population never adopted the practice: This includes most of Europe, and populous countries like Japan, China, and Russia. Researcher Edward Wallerstein (1985) refers to circumcision as an American medical "enigma." Urologist James Snyder estimates that 90 percent of American males currently living were initiated into life in this violent way. Circumcision is where sex and violence first meet. Swiss psychoanalyst Alice Miller (1983) sees in this kind of cruelty the roots of social violence. In spite of increasing public awareness of its risks, the current national average for the surgery is still about 60 percent; that is, over one million baby boys each year are subject to this kind of genital mutilation.

Leading the crusade for circumcision over a century ago, the physician P. C. Remondino (1891) called the prepuce "a malign influence causing all manner of ills, unfitting a man for marriage or business and likely to land him in jail or a lunatic asylum." According to him, "circumcision is like a substantial and well-secured life annuity; every year of life you draw the benefit. . . . Parents cannot make a better investment for their little boys, as it assures them better health, greater capacity for labor, longer life, less nervousness, sickness, loss of time, and less doctor bills" (cited in Speert 1953:165). Dr. Remondino claimed that circumcision would cure about a hundred ailments, among them asthma, alcoholism, enuresis, and rheumatism (Wallerstein 1985). Another physician of the day (Clifford 1893) enumerated the alleged dangers of the intact foreskin. These included penile irritation, interference with urination, nocturnal incontinence, hernia or prolapse of the rectum (from a tight foreskin!), syphilis, cancer, hysteria, epilepsy, chorea, erotic stimulation, and masturbation. This was the flimsy basis for selling circumcision to America—and none of it turned out to be true. In modern times, dire warnings are still dressed in medical language pointing to the normal foreskin as the source of sexual diseases, cancer, urinary infections, and even AIDS. Yet circumcision neither causes nor cures any of these conditions. The medical compulsion to perform the operation—usually without anesthesia—continues this long legacy of pain as many physicians are still turning a deaf ear to rational arguments from within their own profession (e.g., Grimes 1978; Wallerstein 1985; Winberg et al. 1989; and Ritter 1992). The American record is unique.

Meanwhile, as the trade flourishes, a humane trend is clearly visible in

journal publications. Numerous articles have reported empirical measures of stress during circumcision, and compare procedures and anesthetics for pain (e.g., Kirya and Werthmann 1978; Yeoman, Cooke, and Hain, 1983; Pelosi and Apuzzio 1985; Masciello 1990). In this professional literature, one can see a growing empathy for infants, full acceptance of their pain, serious doubts about performing circumcisions, and strong recommendations for anesthetics which effectively reduce pain (Williamson and Williamson 1983; Holve et al. 1984; Dixon et al. 1984; Stang et al. 1988; Rabinowitz and Hulbert 1995). Perhaps this is a harbinger of what is to come and a sign that the century of denial may be ending.

A mix of cultural forces blur the future. In exploring the extent of physician influence on parental choice for circumcision, one study showed that when the doctor was *opposed* to circumcision, the rate fell to 20 percent, but when he was in *favor*, the rate was 100 percent (Patel 1966). In contrast, when four pediatricians in Baltimore did an educational experiment with pregnant mothers (Herrera et al. 1982), they were surprised at the results. While half had been taught the medical "risks and benefits" of circumcision and half received no information, virtually *all* the mothers opted for circumcision. The doctors concluded that deep cultural and traditional issues were working against a change in attitude in their group.

Surveys examining parental motives for requesting circumcision have revealed these forces at work. Parents care about appearances, yield to pressure from relatives, and misunderstand the medical "benefits." They hold a variety of false notions that circumcision is mandated by hospitals or by public health law, or is required for admission into the armed forces (Patel 1966; Grimes 1978). Parents are not warned that their infants will endure severe pain and will be losing a highly functional part of their sexual anatomy (see Davis-Floyd, this volume).

■ BIRTH HAS BECOME MORE PAINFUL FOR BABIES

Ironically, in the hands of twentieth-century physicians, birth has become more painful for babies. Generally, doctors have not been concerned about babies' pain. They have been concerned about heart rate fluctuations signaling fetal distress (see Cartwright, this volume) but not about neonatal pain.

Increased Pain of Birth in Hospitals

In the last half century, the standardization of hospital birth has touched the vast majority of babies born in the United States. Whatever might be the pain of birth itself for infants (some are completely calm and quiet, while others smile, cry, or scream), doctor-caused pain is a cruel gauntlet: scalp wounds to install fetal heart electrodes; scalp blood samples during labor; use of for-

ceps or vacuum extractions for delivery (made more frequent by the choice of epidural anesthetics); abrupt spacial disorientations like being rushed through space or being held upside down by the heels; spinal strain in meeting flat surfaces; contact with frigid scales and metal utensils in a room thirty degrees colder than the womb; assault by bright lights, noises, needle injections, and heel lancings, application of stringent eye medications; painful wiping and washing of the skin, capped off by sudden separation from their mothers and banishment to nurseries full of crying babies—all distinctly painful and distressing to the newborn.

There are alternatives to much of this suffering: witness the generally superior safety of midwife-attended births, in which painful techniques are very rarely employed (Rooks 1997). In places where vitamin K has long been administered orally, the outcome statistics show no reason to change to painful injections. There is no excuse at all for the continued use of silver nitrate in baby's eyes after birth: a prophylactic ointment that does not cause the painful swelling and temporary visual impairment that are the side effects of silver nitrate solution can easily be substituted. Use of painful scalp electrodes for fetal heart monitoring has not saved lives as doctors had promised. Use of a baby's cord blood (blood previously thrown away) has become a gold mine of stem cells and should provide information equal to heel blood. Babies can be weighed in soft cloth slings instead of on cold metal scales. In short, most pain-inducing routine obstetrical procedures can safely either be eliminated entirely or made to be baby-friendly.

Yet obstetricians defend their practices as necessary and as "the best of care." At play in this obstetrical rationale is the first conceptualization of the cyborg outlined by the editors in the Introduction to this volume: the cyborg as positive technoscientific progress. Their uncritical acceptance of this notion has caused hospital practitioners to cyborgify almost every American baby, in spite of the mounting evidence that a great deal of harm results from this type of cyborgification. Thus my analysis necessarily invokes the editors' second conceptualization: the cyborg as mutilation and prosthesis. There are many ways to become cyborg; why must we apply the worst excesses of that process to our most helpless social members?

Pain in the Womb

Even prior to birth, conditions exist which can provoke crying. Whenever air is available to the fetal larynx, it is possible to hear a fetus cry. Vagitus uterinus (literally, "squalling in the womb"), a rare phenomenon which is well documented over many years, is a dramatic signal of fetal anguish (e.g., Graham 1919; Ryder 1943; Russell 1957; Thiery et al. 1973). Virtually all modern cases of fetal crying are subsequent to obstetrical manipulation such as tests, versions, deliberate rupture of the amniotic sac, attachment of scalp

electrodes, or taking scalp blood samples—all while a baby is still in the womb or the birth canal. The fact that in one study (Ryder 1943), 20 percent of these squalling babies died is testimony to the urgency of their cries and to the high price they paid for their cyborgification.

Recent research featuring precise monitoring of body fluids during fetal surgery has confirmed that pain perception is already present in utero. Giannakoulopoulos and colleagues (1994) studied forty fetuses during intrauterine transfusions, finding beta-endorphin increases of 590 percent and cortisol increases of 183 percent during the invasive procedure. Even the youngest babies, who were twenty-three weeks gestational age, showed similarly large rises in these stress-response hormones.

Parents whom we know told us about their little Clair at sixteen weeks of gestation. She reacted strongly to amniocentesis and showed extraordinary anticipation of danger. As her parents, the doctor, and the ultrasound technician watched the needle enter the womb, Clair's hand came up and batted the side of the needle! When the needle entered the womb a second time, her hand again batted it away. It took an hour to get the sample of fluid, leaving both men in a nervous sweat and the mother saying, "I'm not sure we should have done that." In this context, it is worthy of note that in the preceding chapter by Rapp, none of the women who resisted amniocentesis cited the consciousness of the child as a reason for refusing the test. Evidently, the concept of the baby as a conscious, active agent simply does not exist in the larger society.[1]

Pain of Neonatal Intensive Care

Premature and dangerously ill newborns face pain and peril trying to complete gestation in a neonatal intensive care unit (Kellman 1980; Perlman and Volpe 1983; Marshall 1989). In the NICU, the pain of cyborgification is a way of life for babies who are tied or immobilized while breathing tubes, suction tubes, and feeding tubes are pushed down their throats (Marshall 1989) and needles and wires are stuck into them. Their delicate skin is easily burned with alcohol prior to venipuncture or accidentally pulled off when adhesive monitor pads are removed (Harrison 1990; Peabody and Lewis 1985). The overwhelming need for gentle and maternal interactions with these premature babies is only partly met in some hospitals by therapeutic touch (Rice 1977; Whitelaw 1990; Ludington-Hoe and Golant 1993). (For a comprehensive review of the multiple stresses babies face in this man-made womb, see Gottfried and Gaiter 1985.)

Psychological strategies and principles of care, urgently needed in this intensely technological environment, are slow in making an appearance (e.g., Sexon et al. 1986; Field 1990, 1992; Als et al. 1994). Life in the NICU has been described as a "mixed blessing" (Guillemin and Holmstrom 1986) and

presents agonizing problems of public health policy and medical ethics (Gustaitis and Young 1986). The demonstrated benefits of kangaroo care (in which mothers keep their premature babies in close skin-to-skin contact instead of in an incubator) have been influential in other countries but have been largely ignored in the United States in favor of the high-tech interventionist model of care (Wagner 1994).

Pain of Surgery without Anesthesia

Hospitalized newborns, from preemies of twenty-six weeks upward, have routinely faced surgery without benefit of pain-killing anesthetics. Although surgery without anesthetic was standard practice for a century, this fact was unknown to the general public until 1985 when a few parents discovered that their seriously ill premature babies had suffered through major surgery unanesthetized (Lawson 1986a, 1986b, 1988a, 1988b; Harrison 1986, 1987). Instead of anesthetic, the babies had typically been given a form of curare to paralyze their muscles, making it impossible for them to lift a finger or make a sound in protest. Surgeons were afraid that anesthesia might kill infants but they had no such fear that surgery without anesthetics might kill them just as well.

Jill Lawson reported that her premature baby, Jeffrey, had holes cut in both sides of his neck, another in his right chest, an incision made from his breastbone around to his backbone, his ribs pried apart, and an extra artery near his heart tied off. Another hole was cut in his left side for a chest tube—all of this while he was awake, paralyzed, and feeling intense pain and terror. The anesthesiologist who assisted explained, "It has never been shown that premature babies have pain" (Lawson 1986b). The operation Mrs. Lawson was describing is the most common surgery done on premature babies, thoracotomy for ligation of patent ductus arteriosus (PDA). Experts taught that this surgery could be "safely accomplished with oxygen and pancuronium as the sole agents" (Wesson 1982). After the parents told their story to the television, radio, and print media, the ethics of these century-old practices were seriously discussed for the first time (Harrison 1987; McGrath and Unruh 1987; Cunningham-Butler 1989; Cunningham 1990; Lawson 1990). Resisting change, some doctors continued to argue that "following major operations, most babies sleep," and "all we need to do is feed them" (e.g., Campbell 1989: 203–204).

Surveys taken of policies and practices of infant surgery in the United Kingdom and in the United States reveal the historic ambivalence about whether infants really needed anesthesia or would be endangered by it (Purcell-Jones et al. 1988; Tohill and McMorrow 1990). Although some hospitals reported twenty years of successful use of anesthesia with infants (e.g., Berry and Gregory 1987), surveys of common practice showed infrequent use of anesthesia and a lack of policies and protocols on the subject in hospitals

(Franke et al. 1986; Bauchner and Coates 1992). Key medical objections to infant anesthesia, namely, that it was unnecessary and dangerous, were finally put to rest by a series of studies by Kanwal Anand and colleagues at Oxford University from 1985 to 1987. Making precise and comprehensive measurements of infant reactions to surgery, they proved that babies do perceive pain, and need and tolerate anesthesia well—and had probably been dying of metabolic and endocrine shock following unanesthetized operations (Anand and Aynsley-Green 1985; Anand 1986; Anand and Hickey 1987). When these findings arrived in the midst of the parent rebellion against unanesthetized infant surgery, medical resistance crumbled and official bodies of physicians began to acknowledge the need for change. They eventually promised to give neonates the same consideration in surgery as they gave to other patients (e.g., see Poland et al. 1987)—ending over 100 years of discrimination against babies. This was a milestone for medicine, but not a guarantee. Historically, announcement of a new policy by a guild has not always affected the practice of individual members (Patel 1982).

Nevertheless, it is a hopeful sign. Babies who must have surgery will still be rendered cyborg, but much more humanistically so, allowing me to invoke the third and fourth conceptualizations of the cyborg from the Introduction to this volume: (3) the cyborg as neutral analytic tool and metaphor for all human-technological relationships; and (4) the cyborg as signifier of contemporary, postmodern times in which human relations with technoscience have changed for better and for worse. This change for the better entails a recognition on the part of medical practitioners that babies are not the unconscious products of a mechanistic process but rather sentient beings who can be severely traumatized by pain. It is to be hoped that this perception will eventually result in massive reduction of the use of standardized obstetrical procedures that cause babies pain.

■ WHY SUCH INDIFFERENCE TO INFANT PAIN?

The literature on infant pain is both hopeful and discouraging. An analysis of the ten most commonly used textbooks in pediatrics by Rana (1987) turned up only three-and-one-half pages devoted to pain in 15,000 pages of text. Among the popular books about obstetrics, Frederick Leboyer's bestseller, *Birth Without Violence* (1975), stands virtually alone in its concern for the pain babies feel at birth.[2] Meanwhile, medical research in the area of infant pain has been rising sharply in volume. In my own collection of important journal articles, I can count only about forty studies of infant pain in the entire 100 years prior to 1979. But a surge of interest in the 1980s produced 100 papers in a single decade. In retrospect, we must wonder why infant pain perception was ignored for the greater part of a century.

Was It Because They Were Men?

Historically, men have been the surgeons and circumcisers of babies. In society at large, men have been notoriously violent, constituting at least 90 percent of all persons arrested for homicide. Until recently,[3] medicine was a male fraternity where aggressiveness and denial of feelings were honored. Now that women are entering the profession in large numbers—trained by men and often obliged to accept male beliefs and protocols—gender lines are blurring. Female nurses are often on the scene in supporting and approving roles. Nurse anesthetists have provided the curare for operations. In the high-profile death of Jeffrey Lawson, the anesthesiologist was a woman who didn't believe pain was a factor in his surgery.

Jill Lawson, who led the campaign to shield infants from surgical pain, questioned why the doctors had not reacted as individuals to the manifestations of infant pain. Writing in the *New England Journal of Medicine* (May 26, 1988:1398), she says, "I cannot help but wonder how such a situation came to develop. . . . If I had been told by a physician, no matter how senior, that infants don't feel pain, I would never have believed it. What constitutes the difference between my reaction and that of the thousands of physicians who did believe it?"

Were They Just Trying To Be "Scientific"?

Were the men and women of medicine just trying to remain objective and not give in to subjective feelings? Objectivity is a scientific ideal, but when it censors feelings and filters out observations, it can lead to monstrous behavior. There is a price for blunting feelings and denying unpleasant realities.

Ironically, in spite of pride in objectivity, these doctors were unable to accept the objective evidence for infant suffering presented by their colleagues. Why was it so hard for them? Why should doctors have to go to a library to find out if infants experience pain when they have seen it with their own eyes and heard it with their own ears? Conformity within the guild? Today, with a hundred articles in the medical literature discussing infant pain and what to do about it, what explains the host of physicians who continue to cause unnecessary pain to babies?

Was It Tradition?

In the guild of surgeons, tradition and loyalty to one another have been a powerful force. Following tradition is the only way to enter a guild, and breaking with tradition is a sure way to get expelled. Tradition and loyalty can overpower rational judgment. These forces are sharply revealed in guild reactions to the discovery of anesthesia a century and a half ago.

After the anesthetic properties of ether were demonstrated in 1846 in

Boston, doctors in Baltimore and Johns Hopkins Medical School refused to use it. They held out for seven years. Ether (and Boston medical schools) was outside the boundaries of their guild. After the acceptance of ether, surgeons developed an elaborate calculus to decide who "needed" anesthesia and who did not (Pernick 1985). Because of this reasoning, as many as a third of amputations were still done without anesthetic! The process of selection was deeply prejudicial. Among those who did not receive anesthetic were "Blacks," "Redskins," "Chinamen," immigrant Germans and Irish, many soldiers and sailors, "hardened" urban poor, and "tough" country women. Those who did receive it were the well off, the well educated, and the "artistic" urban woman.

Were They Held Captive by Their Beliefs?

When it came to babies, surgeons were never sure if they were among those who needed anesthesia or did not. The majority view was penned by Henry Bigelow (1893), who wrote in one of the first publications of the new American Medical Association that babies had "neither the anticipation nor remembrance of suffering, however severe," making anesthesia unnecessary for them. Like most of his colleagues then and since, Bigelow believed the ability to experience pain was related to intelligence, memory, and rationality. Like lower animals, the very young lacked the mental capacity to suffer.

A view with strong similarities—that babies don't feel pain as *we* do—was recently asserted by a developmental psychologist (Maurer and Maurer 1988: 33–36, 218). Although this matches earlier opinions that savages, Jews, or Blacks don't suffer "as we do," the statement was not challenged by either physicians or psychologists.

Were They Just Operating as Materialists?

The fundamental dogma that kept doctors from recognizing infant pain sprang directly from anatomy: the infant brain—they could plainly see—was incomplete and therefore unprepared for true emotion, memory, learning, and meaning. Students of anatomy were convinced that the "early" brain was primitive: only the "late" brain (cerebral cortex) was capable of complex human activity, and this cerebral cortex was not "complete" at birth. This interpretation opened the door to painful activities like surgery without anesthesia and became a false foundation for obstetrics and the perilous trademark of neonatology. You could inflict pain on the fetus and the newborn because it would not register on them.

In retrospect, the error of this medical thinking (which psychologists copied) was to reduce the definition of a human being to brain matter alone. Matter is who you were, and especially brain matter: if you didn't have the requisite brain matter, *you* did not matter. Without fully developed brain matter, you could not be a self, could not have feelings, experiences, knowledge,

or personality—all the things which babies were not supposed to have but which have now been documented about babies by modern research (for reviews, see Chamberlain 1992, 1997a). Along with research on adult states of consciousness, research with babies is pushing us toward a larger paradigm to describe who we are.

By thinking too narrowly about babies, professionals missed discovering them as persons with a range of innate capacities associated with human consciousness (e.g., Flavell 1977; Kagen 1981). Because babies could not "think," the mortification of the flesh was acceptable, and even opportune. Treating infants as decorticate nonpersons without the possibility of keen awareness, a directing intelligence, and a sense of self led doctors into unintentional abuse. In this kind of thinking, doctors were full participants in what Davis-Floyd (1992) has described as the technocratic model of birth—a model that defines the baby as the end product of the hospital's production of the baby (see Introduction). This kind of cyborg thinking focuses only on the mechanistic aspects of the cyborg and denies its sentience.

Was Denial the Easy Way Out?

The reductionist philosophies of materialism and mechanicity led not only to violations of dignity and needless suffering but also to clinical judgments which were superficial. Doctors failed to appreciate the complex, whole babies confronting them. When assessing the impact of surgery without anesthesia, physicians saw babies fall asleep after surgery and concluded they were all right. If a pale baby regained color or if blood pressure returned to normal twenty-four hours after surgery, surgeons felt justified in what they had done. This was actually wishful thinking, as Anand (1986) was able to demonstrate. Overly simple criteria were used to evaluate the effect of powerful anesthetics given to mothers on their babies. Doctors contended that the babies were unaffected, or soon back to normal. The truth of what was happening to the babies took years to determine (see Brackbill et al. 1985 and Mirmiran and Swaab 1993).

The pediatrician chairing the Task Force on Circumcision of the American Academy of Pediatrics said of circumcision that "responses are short-lived, lasting only minutes to hours, and there is no evidence of long-term sequelae" (Schoen et al. 1989:389). In fact, the circumcision wound could not possibly heal in a few hours, and the foreskin would be lost for life—a truly long-term "sequelae." Six years later, Taddio and colleagues (1995) reported significantly different reactions of circumcised and intact boys to vaccinations four to six months after birth. Circumcision was positively associated with post-vaccination behavior pain scores, net pain scores, and duration of crying. The authors concluded that "pain from circumcision may have long-lasting effects on pain response and/or perception."

Obstetricians and pediatricians were likewise naive about the suffering of infants and mothers they routinely separated, often for many hours, sometimes days, after hospital delivery. They could see neither the biological wisdom nor the psychological importance of mother and baby staying together after birth, and delayed full acceptance of bonding and its long-term advantages (Sugarman 1977; Klaus et al. 1976, 1995). Psychobiology has further illuminated the long-term sequelae of early mother-infant separation. Bessel van der Kolk (1987) wrote of the serious changes induced by separation in hypothalamic serotonin, adrenal gland catecholamines, synthesizing enzymes, plasma cortisol, heart rate, body temperature, and sleep. "These changes are not transient or mild, and their persistence suggests that long-term neurobiological alterations underlie the psychological effects of early separation" (1987:43). According to this expert, disruptions of attachment during infancy help pave the way toward mental illnesses featuring a biphasic protest/despair behavior and erratic activity of neurotransmitters. Such early trauma leads into panic attacks and cyclical depressions, which reflect a loss of faith in the order and continuity of life and loss of a safe place from which to deal with frightening emotions. The ultimate legacy of prenatal and perinatal trauma is angry, rebellious behavior, which is all too common today, and feelings of fear, anxiety, and depression— the burgeoning illnesses of our time. These represent the hidden costs of repeated pain and suffering during infancy.

■ IN CONCLUSION

Pain is a universal language that can be readily understood by its vocal sounds, facial expressions, body movement, respiration, and even color. Babies speak this language as well as anyone. Pain can also be confirmed by metabolic and hormonal measurements, which are as real for babies as for adults: age confers no immunity. If anything, early trauma is probably more serious than later trauma because it establishes basic patterns and hormonal set points for later experiences. The myth that prenates and neonates have insufficient brain development to experience, remember, and learn from trauma is ancient, insidious, and harmful.

The pain-inflicting technological protocols of routine obstetrics, pediatrics, and neonatology should all be reassessed with the goal of eliminating them wherever possible. Circumcision should not be routinely performed. And although it means a sharp break with a century of medical tradition, no surgeries, including circumcision, should ever be performed on babies without anesthetic.

At the end of the twentieth century, increasing public awareness that babies are sentient beings suggests that the century of denial of infant pain

may be ending. If these promising trends continue, we may hope that for future generations, the infliction of pain on unborn and newborn babies, cyborg or not, will be an exception rather than the rule.

Notes

1 The concept of the fetus as sentient, while apparently nonexistent in the wider culture, is prevalent among homebirthers, who often experience psychic connections with their unborn children (Davis-Floyd 1994; Westra 1996). It is possible that one of the reasons why the concept of the baby as a conscious, active agent has not permeated more deeply into American society, in spite of the many other trends toward humanizing childbirth, has to do with concern that any attention to the unborn as conscious will give further fuel to the fire of the right-to-life movement. Most childbirth organizations that promote this view of the baby as sentient, such as the Association for Pre- and Perinatal Psychology and Health (APPPAH), are thus careful to stress that viewing the child as conscious does not mean that the baby's interests take precedence over those of the mother. APPPAH, like other organizations of its kind, stresses the importance of the woman's right to choose.

2 This book has been criticized for its exclusive focus on the baby and negative attitude toward the mother. The challenge is not to privilege one at the expense of the other but to honor the feelings and needs of both. Since the United States is still a patriarchal society with a tendency to privilege the fetus at the expense of the mother, it is critical in most cases that this tendency be counterbalanced by giving primacy to the woman and the choices she makes.

3 See *From Doctor to Healer: The Transformative Journey* (Davis-Floyd and St. John 1998) for a detailed discussion of the "paradigm shift" in medicine that some doctors are choosing to undergo.

References

Als, Heidelise, Barry M. Lester, and Edward Z. Tronick. 1982. "Manual for the Assessment of Preterm Infants' Behavior." In *Theory and Research in Behavioral Pediatrics*, edited by Hiram E. Fitzgerald, Barry M. Lester, and M. W. Yogman, 65–132. New York: Plenum.

Als, H., G. Lawhon, F. H. Duffy, G. B. McAnulty, R. Gibes-Grossman, and J. G. Blickman. 1994. "Individualized Developmental Care for the Very Low Birthweight Preterm Infant: Medical and Neurofunctional Effects." *Journal of the American Medical Association* 272 (11): 853–858.

Anand, K. J. S. 1986. "Hormonal and Metabolic Functions of Neonates and Infants Undergoing Surgery." *Current Opinion in Cardiology* 1: 681–689.

Anand, K. J. S., and A. Aynsley-Green. 1985. "Metabolic and Endocrine Effects of Surgical Ligation of Patent Ductus Arteriosus in the Preterm Neonate: Are There Implications for Further Improvement in Postoperative Outcome?" *Modern Problems in Paediatrics* 23: 143–157.

Anand, K. J. S., and P. R. Hickey. 1987. "Pain and Its Effects in the Human Neonate and Fetus." *New England Journal of Medicine* 317 (21): 1321–1329.

Bauchner, H., A. May, and E. Coates. 1992. "Use of Analgesic Agents for Invasive Medical Procedures in Pediatric and Neonatal Intensive Care Units." *Journal of Pediatrics* 121 (4): 647–649.

Berry, Frederic A., and George A. Gregory. 1987. "Do Premature Infants Require Anesthesia for Surgery?" *Anesthesiology* 67 (3): 291–293.

Bigelow, Henry J. 1893. *Transactions of the American Medical Association* 1: 211. Cited by Pernick (1985).

Bigelow, Jim. 1992. *The Joy of Uncircumcising!* Aptos, Calif.: Hourglass Publishers.

Blanton, Mary G. 1917. "The Behavior of the Human Infant in the First 30 Days of Life. *Psychological Review* 24 (6): 456–483.

Boyd, Billy Ray. 1990. *Circumcision: What It Does*. San Francisco: Taterhill Press.

Brackbill, Yvonne, Karen McManus, and Lynn Woodward. 1985. *Medication in Maternity: Infant Exposure and Maternal Information*. Ann Arbor: University of Michigan Press.

Campbell, N. 1989. "Infants, Pain, and What Health Care Professionals Want To Know—A Response To Cunningham-Butler. *Bioethics* 3 (3): 200–210.

Chamberlain, David B. 1992. "Babies Are Not What We Thought: Call For A New Paradigm." *International Journal of Prenatal and Perinatal Psychology and Medicine* 4 (3/4): 161–177.

— — —. 1997. "Prenatal Body Language: A New Perspective On Ourselves." *Primal Renaissance: The Journal of Primal Psychology* (in press).

Clifford, M. 1893. *Circumcision: Its Advantages and How to Perform It*. London: Churchill.

Crudden, Charles H. 1937. "Reactions of Newborn Infants to Thermal Stimuli under Constant Tactual Conditions." *Journal of Experimental Psychology* 20: 350–370.

Cunningham, Nance. 1990. "Ethical Perspectives on the Perception and Treatment of Neonatal Pain." *Journal of Perinatal and Neonatal Nursing* 4 (1): 75–83.

Cunningham-Butler, Nance. 1989. "Infants, Pain, and What Health Professionals Should Want to Know: An Issue In Epistemology and Ethics." *Bioethics* 3 (3): 181–209.

Davis-Floyd, Robbie. 1992. *Birth as an American Rite of Passage*. Berkeley: University of California Press.

— — —. 1994. "The Technocratic Body: American Childbirth as Cultural Expression." *Social Science and Medicine* 38: 2.

Davis-Floyd, Robbie, and Gloria St. John. 1998. *From Doctor to Healer: The Transformative Journey*. New Brunswick, N.J.: Rutgers University Press.

DeMause, Lloyd. 1991. "The Universality of Incest." *Journal of Psychohistory* 9 (2): 123–164.

Dixon, Suzanne, Joel Snyder, Richard Holve, and Patricia Bromberger. 1984. "Behavioral Effects of Circumcision With and Without Anesthesia." *Developmental and Behavioral Pediatrics* 5 (5): 246–250.

Emde, Robert N., Robert J. Harmon, David Metcalf, Kenneth Koenig, and Samuel Wagonfeld. 1971. "Stress and Neonatal Sleep." *Psychosomatic Medicine* 33: 491–497.

Field, Tiffany. 1990. "Alleviating Stress in Newborn Infants in the Intensive Care Unit." *Clinics in Perinatology* 17 (1):1–9.

— — —. 1992. "Interventions in Early Infancy." *Infant Mental Health Journal* 13 (4): 329–336.

Fitzgerald, Maria, and Catherine Millard. 1988. "Hyperalgesia in Premature Infants." (Letters). *The Lancet* (Feb. 6): 292.

Flavell, John H. 1977. *Cognitive Development*. Upper Saddle River, N. J.: Prentice Hall.

Franke, Linda, C. Lund, and A. Fanaroff. 1986. "A National Survey of the Assessment and Treatment of Pain in the Newborn Intensive Care Unit." *Pediatric Research* 20: 347A, no. 1123.

Gairdner, Douglas. 1949. "The Fate of the Foreskin." *British Medical Journal* 2: 1433–1437.

Giannakoulopoulos, X., W. Sepulveda, P. Kourtis, V. Glover, and N. M. Fisk. 1994. "Fetal Plasma Cortisol and B-Endorphin Response to Intrauterine Needling." *The Lancet* 344: 77–81.

Gottfried, Allen W., and J. L. Gaiter, eds. 1985. *Infant Stress under Intensive Care: Environmental Neonatology*. Baltimore: University Park Press.

Graham, D. A. 1919. "Intrauterine Crying." *British Medical Journal* 1 (May 31): 675.

Grimes, David A. 1978. "Routine Circumcision of the Newborn Infant: A Reappraisal." *American Journal of Obstetrics and Gynecology* 130: 125–129.

Grunau, R. V. E., and K. D. Craig. 1987. "Pain Expression in Neonates: Facial Action and Cry." *Pain* 28: 395–410.

Guillemin, Jeanne H., and Lynda L. Holmstrom. 1986. *Mixed Blessisngs: Intensive Care for Newborns*. New York: Oxford University Press.

Gunnar, Megan R., Robert O. Fisch, S. Korsvik, and J. M. Donhowe. 1981. "The Effects of Circumcision on Serum Cortisol and Behavior." *Psychoneuroendocrinology* 6 (3): 269–275.

Gunnar, Megan R., Robert O. Fisch, and Steve Malone. 1984. "The Effect of a Pacifying Stimulus on Behavioral and Adrenocortical Responses to Circumcision." *Journal of American Academy of Child Psychiatry* 23 (1): 34–38.

Gunnar, Megan R., Steve Malone, G. Vance, and Robert O. Fisch. 1985. "Quiet Sleep and Levels of Plasma Cortisol during Recovery from Circumcisions in Newborns." *Child Development* 56: 824–834.

Gustaitis, R., and E. W. D. Young. 1986. *A Time to Be Born, A Time to Die: Conflicts and Ethics in an Intensive Care Unit*. Reading, Mass.: Addison-Wesley.

Harrison, Helen. 1986. Letter. *Birth* 13 (2): 36–41.

———. 1987. "Pain Relief for Premature Infants." *Twins* (July/August): 10ff.

———. 1990. Television interview. "The Dark Side of a Miracle." ABC's *20/20* (Feb. 2).

Herrera, Alfredo J., A. S. Hsu, U. T. Salcedo, and M. P. Ruiz. 1982. "The Role of Parental Information on the Incidence of Circumcision." *Pediatrics* 70: 597–598.

Holve, Richard, Patricia Bromberger, Howard Groveman, M. Klauber, S. Dixon, and J. Snyder. 1984. "Regional Anesthesia during Newborn Circumcision." *Clinical Pediatrics* 22: 813–818.

Illingworth, Ronald S. 1980. "The Development of Communication in the First Year and Factors Which Affect It." In *Infant Communication*, edited by T. Murray and J. Murray, 4–19. Houston: College Hill Press.

Janov, Arthur. 1983. *Imprints: The Life-Long Effects of the Birth Experience*. New York: Coward-McCann.

Kagen, Jerome. 1981. *The Second Year: The Emergence of Self-Awareness*. Cambridge: Harvard University Press.

Kaye, Herbert, and Lewis Lipsitt. 1964. "Relation of Electrostatic Threshold to Basal Skin Conductance." *Child Development* 35: 1307–1312.

Kellman, Neil. 1980. "Risks in the Design of the Modern Neonatal Intensive Care Unit." *Birth* 7 (4): 243–248.

Kirya, Christopher, and Milton W. Werthmann. 1978 "Neonatal Circumcision and Penile Dorsal Nerve Block: A Painless Procedure." *Journal of Pediatrics* 92 (6): 998–1000.

Klaus, Marshal H., and John H. Kennell. 1976. *Maternal-Infant Bonding: The Impact of Early Separation or Loss on Family Development*. St. Louis: C. V. Mosby.

Klaus, Marshal H., John H. Kennell, and Phyllis Klaus. 1995. *Bonding: Building the Foundation for Secure Attachment and Independence*. Reading, Mass.: Addison-Wesley.

Lawson, Jill. 1986a. Letter. *Birth* 13(2): 125.

———. 1986b. Letter. *Perinatal Press* 9: 141–142.

———. 1988a. Letter. *New England Journal of Medicine* (May 26): 1198.

———. 1988b. Letter. *Birth* 15 (1): 36.

———. 1990. "The Politics of Newborn Pain." *Mothering* (Fall): 41–47.

Leboyer, Frederick. 1975. *Birth Without Violence*. New York: Alfred A. Knopf.

Lester, Barry M., and C. F. Zachariah Boukydis, eds. 1985. *Infant Crying: Theoretical and Research Perspectives*. New York: Plenum.

Lind, John, ed. 1965. "Newborn Infant Cry." *Acta Paediactrica Scandinavica* Supplement 163.

Lipsitt, Lewis P., and N. Levy. 1959. "Electrostatic Threshold in the Neonate." *Child Development* 30: 547–554.

Ludington-Hoe, Susan and Susan K. Golant. 1993. *Kangaroo Care: The Best You Can Do to Help Your Preterm Infant*. New York: Bantam.

Marshall, Richard E. 1989. "Neonatal Pain Associated with Caregiving Procedures." *Pediatric Clinics of North America* 36 (4): 885–903.

Masciello, Anthony L. 1990. "Anesthesia for Neonatal Circumcision: Local Anesthesia is Better than Dorsal Penile Nerve Block." *Obstetrics and Gynecology* 75 (5): 834–838.

Maurer, Daphne, and Charles Maurer. 1988. *The World of the Newborn.* New York: Basic Books.

McGrath, Patrick J., and A. M. Unruh. 1987. *Pain in Children and Adolescents.* New York: Elsevier.

McGraw, Myrtle. 1941. "Neural Maturation as Exemplified in the Changing Reactions of the Infant to Pin Prick." *Child Development* 12 (1): 31–42.

Miller, Alice. 1983. *For Your Own Good: Hidden Cruelty in Childrearing and the Roots of Violence.* Translated by Hildegarde and Hunter Hannum. New York: Farrar, Straus and Giroux.

Mirmiran, M. and D. F. Swaab. 1993. "Effects of Perinatal Medication on the Developing Brain." In *Fetal Behavior,* edited by Jan G. Nijuis, 112–125. London and New York: Oxford University Press.

Owens, Mark E., and Ellen H. Todt. 1984. "Pain in Infancy: Neonatal Reaction to a Heel Lance." *Pain* 20 (1): 77–86.

Patel, D. A. 1982. "Factors Effecting the Practice of Circumcision." *American Journal of the Diseases of Children* 136 (7): 634.

Patel, H. 1966. "The Problem of Routine Circumcision." *Canadian Medical Association* 95: 576.

Peabody, J. L., and K. Lewis. 1985. "Consequences of Newborn Intensive Care." In *Infant Stress Under Intensive Care: Environmental Neonatology,* edited by A. W. Gottfried and J. L. Gaiter , 199–226. Baltimore: University Park Press.

Pelosi, Marco A., and Joseph A. Apuzzio. 1985. "Making Circumcision a Painless Event." *Contemporary Pediatrics* 85–88.

Perlman, Jeffrey M., and Joseph Volpe. 1983. "Suctioning in the Preterm Infant: Effects On Cerebral Blood Flow Velocity, Intracranial Pressure, and Arterial Blood Pressure." *Pediatrics* 72 (3): 329–334.

Pernick, Martin S. 1985. *A Calculus of Suffering: Pain, Professionalism and Anesthesia in 19th Century America.* New York: Columbia University Press.

Pierson, A. 1852. In *American Journal Medical Science* 24: 576. Cited in Pernick (1985).

Pillai, Mary, and David James. 1990. "Are the Behavioral States of the Newborn Comparable to Those of the Fetus?" *Early Human Development* 22 (1): 39–49.

Poland, Ronald L. 1990. "The Question of Routine Neonatal Circumcision." *New England Journal of Medicine* 322 (18): 1312–315.

Poland, Ronald L., R. J. Roberts, J. F. Gutierrez-Mazorra, and E. W. Fonkalsrud. 1987. "Neonatal Anesthesia." *Pediatrics* 80 (3): 446.

Porter, Fran L., Richard H. Miller, and Richard E. Marshall. 1986. "Neonatal Pain Cries: Effect of Circumcision on Acoustic Features and Perceived Urgency." *Child Development* 57: 790–802.

Pratt, K. C., A. K. Nelson, and K. H. Sun. 1930. "The Behavior of the Newborn Infant." *Ohio State University Student Contributions to Psychology* 10.

Purcell-Jones, Gari, Frances Dormon, and Edward Sumner. 1988. "Pediatric Anesthetists' Perception of Neonatal and Infant Pain." *Pain* 33 (2): 181–187.

Rabinowitz, Ronald, and William C. Hulbert. 1995. "Newborn Circumcision Should Not Be Performed Without Anesthesia." *Birth* 22 (1): 45–46.

Rana, Sohail R. 1987. "Pain: A Subject Ignored." *Pediatrics* 79: 309–310.

Rawlings, D. J., P. A. Miller, and R. R. Engle. 1980. "The Effect of Circumcision on Transcutaneous pO2 in Term Infants." *American Journal of Diseases of Children* 134: 676–678.

Remondino, P. C. 1891. *History of Circumcision.* Philadelphia and London: F. A. Davis.

Rice, Ruth D. 1977. "Neurophysiological Development in Premature Infants Following Stimulation." *Developmental Psychology* 13 (1): 69–76.

Rich, Eugene C., Richard E. Marshall, and Joseph J. Volpe. 1974. "The Normal Neonatal Response to Pinprick." *Developmental Medicine and Child Neurology* 16: 432–434.

Ritter, Thomas. 1992. *Say No to Circumcision! Forty Compelling Reasons Why You Should Leave Your Son Whole*. Aptos, Calif.: Hourglass Publishing.

Rooks, Judith. 1997. *Childbirth and Midwifery in America*. Philadephia: Temple University Press.

Russell, P. M. G. 1957. "Vagitus Uterinus: Crying in Utero." *The Lancet* 1: 137–138.

Ryder, George H. 1943. "Vagitus Uterinus." *American Journal of Obstetrics and Gynecology* 46: 867–872.

Scanlon, John W. 1985. "Barbarism." *Perinatal Press* 9: 103–104.

Schoen, Edgar J. 1990. "The Status of Circumcision of Newborns." (Sounding Board) *New England Journal of Medicine* 322 (18): 1308–1312.

Schoen, Edgar J., and Committee. 1989. "Report of the Task Force on Circumcision." *Pediatrics* 84 (2): 388–391.

Sexon, William R., Pam Schneider, J. L. Chamberlin, M. K. Hicks, and Sandra B. Sexon. 1986 "Auditory Conditioning in the Critically Ill Neonate to Enhance Interpersonal Relationships." *Journal of Perinatology* 6: 20–23.

Shaw, Nancy Stoller. 1974. *Forced Labor: Maternity Care in the United States*. New York: Pergamon Press.

Sherman, Mandel. 1927. "The Differentiation of Emotional Responses in Infants. I. Judgements of Emotional Responses from Motion Picture Views and from Actual Observations." *Journal of Comparative Psychology* 7 (4): 265–284.

Sherman, Mandel, and Irene C. Sherman. 1925. "Sensori-Motor Responses in Infants." *Journal of Comparative Psychology* 5: 53–68.

Sherman, Mandel, Irene Sherman, and C. Flory. 1936. "Infant Behavior." *Comparative Psychology Monographs* 12 (4): 1–107.

Speert, Harold. 1953. "Circumcision of the Newborn: An Appraisal of Its Present Status." *Obstetrics and Gynecology* 2: 164–172.

Stang, Howard J., Megan R. Gunnar, Leonard Snellman, and Roberta Kostenbaum. 1988. "Local Anesthesia for Neonatal Circumcision: Effects on Distress and Cortisol Response." *Journal American Medical Association* 259 (10): 1507–1511.

Sugarman, Muriel. 1977. "Paranatal Influences on Maternal-Infant Attachment." *American Journal of Orthopsychiatry* 47 (3): 407–421.

Taddio, Anna, Morton Goldbach, Moshe Ipp, Bonnie Stevens, and Gideon Koren. 1995. "Effect of Neonatal Circumcision on Pain Responses during Vaccination of Boys." *The Lancet* 345 (Feb. 4): 291–292.

Talbert, Luther M., Ernest N. Kraybill, and H. D. Potter. 1975. "Adrenal Cortical Response to Circumcision in the Neonate." *Obstetrics and Gynecology* 48: 208–210.

Thiery, M., A. Ye Lo Sian, M. Vrijens, and D. Janssens. 1973. "Vagitus Uterinus." *Journal of Obstetrics and Gynecology of the British Commonwealth* 80: 183–185.

Thoden, Carl Johan, and Maila Koivisto. 1980. "Acoustic Analysis of the Normal Pain Cry." In *Infant Communication: Cry and Early Speech*, edited by T. Murray and J. Murray, 124–151. Houston: College Hill Press.

Tohill, Jane, and Olive McMorrow. 1990. "Pain Relief in Neonatal Intensive Care." *The Lancet* 336: 569.

Van der Kolk, Bessel T. 1987. *Psychological Trauma*. Washington, D.C.: American Psychiatric Press.

Wagner, Marsden. 1994. *Pursuing the Birth Machine*. Australia: ACE Graphics

Wallerstein, Edward. 1985. "Circumcision: The Uniquely American Medical Enigma." *Urologic Clinics of North America* 12 (1): 123–132.

Wellington, Nancy, and Michael J. Rieder. 1993. "Attitudes and Practices Regarding Analgesia for Newborn Circumcision." *Pediatrics* 92 (4): 541–543.

Wesson, Sara C. 1982. "Ligation of the Ductus Arteriosus: Anesthesia Management of the Tiny Premature Infant." *Journal of the American Association of Nurse Anesthetists* 50: 579–582.

Westra, Teri Ellen. 1996. "An Exploration of the Transpersonal Dimensions of Pregnancy." Ph.D. dissertation, Department of Transpersonal Psychology, Institute of Transpersonal Psychology, Palo Alto, Calif.

Whitelaw, Andrew. 1990. "Kangaroo Baby Care: Just a Nice Experience or an Important Advance for Preterm Infants?" *Pediatrics* 85 (4): 604–605.

Williamson, Paul, and Marvel Williamson. 1983. "Physiologic Stress Reduction by a Local Anesthetic during Newborn Circumcision." *Pediatrics* 71 (1): 36–40.

Winberg, Jan, Ingela Bollgren, Leif Gothefors, Maria Herthelius, and Kjell Tullus. 1989. "The Prepuce: A Mistake of Nature?" *The Lancet* (March 18): 598–589.

Yeoman, P. M., R. Cooke, and W. R. Hain. 1983. "Penile Block for Circumcision: A Comparison with Caudal Blockade." *Anesthesia* 38 (9): 862–866.

Machines and Mothers:
Postmodern Pregnancy,
Cyborg Birth

"Native" Narratives of Connectedness

Surrogate Motherhood and Technology

Elizabeth F. S. Roberts

In the winter of 1995, James Austin beat his infant son, Jonathan, to death. Jonathan was borne of a surrogate mother, Phyllis Huddleston, who had met James Austin only once.[1] The unusual circumstances surrounding this murder merited a sensationalistic front page article in the *Philadelphia Inquirer*: "Two strangers—James Alan Austin and Phyllis Ann Huddleston—were united in the most coldly intimate way to create a baby by technology, and are now bound up in a uniquely modern family tragedy" ("The 2 Who Created Life That Was Taken," Jan. 22, 1995:1). The article insinuates that technology has interfered with the way families should properly be formed; it seems that the blame for this child's death should rest with the practice of surrogacy and not with the man who committed the murder.[2] Unsurprisingly, those directly involved with surrogacy have a significantly different understanding of the role of technology in this practice than the one put forth by the *Philadelphia Inquirer*.

This chapter draws on my fieldwork at a California surrogacy agency, and on interviews conducted with surrogate mothers, the infertile couples who commission them, and the agency personnel who arrange surrogacy contracts.[3] Through the narratives of my informants I will demonstrate that, for the most part, they view technology in the context of surrogacy as beneficial and as a source of pleasure. My informants characterize surrogates as techno-vessels, (e.g., "baby-machines"), which could be construed as alienating and cold. However, I will explore how these cyborgian metaphors and technological procedures establish the bond between commissioning parents and child as fundamental, while redefining our received knowledge about the relationship between mother and fetus. This remaking of motherhood has the poten-

tial to alter the stories we tell about the identities of women and the parameters of family.

■ THE PRACTICE OF SURROGACY: AN OVERVIEW

Surrogacy is one of several options available to infertile couples seeking to have a child.[4] Most couples will consider surrogacy only after attempting to "cure" their infertility with other methods, such as fertility drugs, surgery, in-vitro fertilization, sperm and egg donation, and even adoption.[5] Surrogacy is less desirable to many because the cost is often prohibitively high, the outcome uncertain, and the process logistically complicated. It invariably involves a large array of individuals, including doctors, surrogate agency personnel, and the surrogate and her family. Perhaps the underlying reasons for surrogacy's relative unpopularity are cultural beliefs that make us uncomfortable with the ramifications of surrogate motherhood. One such belief is that the technology of surrogacy interferes with a process that should be "naturally biological."

Surrogacy can be practiced in three different ways. In each case, a couple commissions a surrogate mother to be impregnated and bear a child for them. The most common method today (known, ironically, as "traditional" surrogacy) is one in which the commissioning father's sperm is used to inseminate the surrogate. This method is neither new nor complicated; all that is required is a syringe to insert the sperm into the surrogate's vagina. Slang references to "turkey baster babies" indicate how technologically simple the procedure can be. The second type, in-vitro fertilization, IVF, or gestational surrogacy, first successfully attempted in 1986 (Colt 1987), is increasingly popular, predominantly because both commissioning parents are genetic parents as well: an egg is taken from the commissioning mother and fertilized by the commissioning father's sperm in a petri dish. The resulting embryo is surgically implanted in the surrogate mother's uterus to be carried to term. This method requires the commissioning mother to have an intact ovary or viable frozen egg. If her eggs are not viable, the couple may pursue a third method, in which still another woman (a relative or paid egg donor) provides eggs which are "harvested" and mixed with the commissioning father's sperm. Following fertilization, the embryo is implanted in the womb of a surrogate mother.[6]

In her anthropological study of surrogacy, Helena Ragoné (1994:54) found that surrogates "are predominantly white working class, of Protestant or Catholic background; approximately 30 percent are full-time homemakers, married with an average of three children, high school graduates, with an average age of twenty-seven years." Surrogate mothers are paid between $10,000 to $15,000 for their services, with the arbitrating agencies receiving a

similar amount. In a typical contract the surrogate mother agrees not to smoke, drink, or use drugs during the pregnancy. More importantly, all contracts state that the surrogate gives up her maternal rights to the child at birth; and some contracts bind the surrogate to medical procedures such as amniocentesis or even abortion if the fetus is found to have a birth defect. As of 1993 there had been approximately 8,000 surrogate births in the United States.[7] Of these only a few have ended in litigation. Critics of surrogacy have relied upon these few well-publicized cases, such as the notorious Baby M trial, to buttress negative portrayals of the practice.[8] Until the publication of Ragone's *Surrogate Motherhood: Conception in the Heart* (1994), there had been little examination of the "successful" majority of surrogacy arrangements.

There are divergent viewpoints regarding surrogacy, all of which stem from sometimes conflicting American core cultural values. Proponents of surrogacy marshal several reasons to support the practice. For some, surrogacy is to be lauded simply as an opportunity for infertile couples to have a child (Andrews 1989:235). For others, as is reflected in a number of articles in *Life* magazine and other popular press venues, surrogacy is an exciting example of modern technological miracles (e.g., "Science and Surrogacy: Searching for a Biological Child on the High-Tech Frontier" [Colt 1987] and "Miraculous Babies" [Dowling 1993]). The practice has also been defended by those who advocate an individual's right to act as she or he chooses, regardless of the situation (Robertson 1983). Those who are critical of surrogacy, on the other hand, often depict the practice as an unnatural one, claiming that it destroys the bonds that should form automatically between mother and child. These critics tend to be socially and politically conservative. One such author, Scott Rae, a professor of Christian Ethics and Biblical Studies at Biola University, goes so far as to suggest that surrogacy rewards women who can give up their children for monetary gain, thus "turning a vice into a virtue" (Rae 1994:21–22).

Not all critics are traditionally conservative; some feminists are also vocal opponents of surrogacy. In this case, the practice is usually condemned for its exploitation of women. (e.g., Blakely 1983; Oliver 1989; Singer 1993).[9] Gena Corea, one of the more vociferous opponents of reproductive technology, including surrogacy, views reproductive technology as a continuation of male hegemony and domination (Corea 1985:4).[10] But there are other interpretations of surrogacy represented in feminist thought. Some feminists consider the use of artificial insemination in the practice of "traditional" surrogacy, with its relative lack of "technology," to be a wonderful, unregulated birth alternative (Zipper and Sevenhuijsen 1987:136). And others believe that it is crucial for women to be able to choose to be surrogates, especially in a society where women's ability to make rational decisions is called into question (Andrews 1989:256).

Jana Sawicki and Donna Haraway both advocate a more complex reading of these technologies than is offered by any position within the surrogacy debate mentioned above. Sawicki contrasts the approach of what she terms "radical feminism" (here she directly addresses Corea) with that of feminists who draw on Foucauldian theory. While both types of feminism regard new reproductive technologies as "potentially insidious forms of social control" (Sawicki 1991:70), "radical feminists," she posits, draw on a repressive model of power to portray the women involved with reproductive technology as suffering from false consciousness. By taking part in these technologies, women unwittingly aid the Patriarchy in gaining more control over women's bodies. For Sawicki, radical feminists ignore the resistance already emerging within this area. Instead, Sawicki advocates that feminists use the work of Michel Foucault to understand the practices and discourses surrounding these techniques as the "outcome of a myriad of micropractices, struggles, tactics, and counter-tactics" by its participants (1991:81). Sawicki proposes an analysis of reproductive technologies which has the ability to untangle why women "regard them as beneficial" (1991:70). Donna Haraway also suggests that we complicate our theories of experience; she calls for a shift away from dualistic, oppositional thinking which posits technology as solely destructive and fragmentary. Instead she proposes we examine how feminists can contest for "meaning, as well as other forms of power and pleasure in technologically mediated societies" (Haraway 1991:154). While it is true that technology can be and has been used as a negative force against women, to write it off as unredeemably patriarchal limits feminist thinking when more nuanced perspectives are needed.

I, like Sawicki and Haraway, am unwilling to accept the negative view of technology; I am also unwilling to embrace the alternative view of these technologies and processes as merely exciting signs of progress, benefiting those who wish to have a child and those who wish to help them (doctors, brokers, surrogates). It is imperative to examine the context in which these wishes arise and to reveal circumstances in which women are coerced into surrogacy (e.g., Munoz 1986, and "Test-Tube Mother: It's Not Just a Job," *Los Angeles Times*, July 30, 1987:1). But it is also imperative to examine how those directly involved with surrogacy shape their experiences with alternative reproduction and technology. This study of surrogacy has focused on these problems. Toward the end of each interview I asked my informants how they felt about the common image of surrogacy as an artifact of technoscience, which distances us from nature and damages social relations.[11] At this point commissioning couples and surrogates would invariably deny that surrogacy was technological at all, and instead "naturalize" it by comparing it to biblical stories or by explaining that it was common in the past and in "primitive" cultures perceived as being closer to nature.[12] In order to deflect criticism of surrogacy

as "coldly" technological, they emphasized the connections formed with others involved, thereby "warming up" the practice. What this chapter seeks to demonstrate, though, is that for my informants (when simply discussing their experiences), it is often technology itself which "warms up" the practice of surrogacy.

Initially, none of the commissioning couples I interviewed found the idea of surrogacy appealing. They had previously been just as influenced as anyone else by the dominant cultural view of the practice as odd, or even abhorrent. Coming to surrogacy as a last resort forced the commissioning couples to accept a radically different understanding of pregnancy. Indeed the commissioning mothers I spoke with often lamented their structurally male relationship to, and distance from, the pregnancy that "naturally" should have been taking place in their bodies. The bonds formed between commissioning couples, especially the commissioning mother, and surrogates helped to minimize the distance between couple, surrogate, and the experience of pregnancy, as well as allowing the couples to be more directly involved in the "baby making."

The intensity of these bonds was a central theme in my informants' narratives. One surrogate described the "sympathy pains" she felt for the commissioning mother:

> She was reading all she could about pregnancy. You can read how to operate a vehicle, but until you park your butt in that car you don't know what you're doing. So we [the surrogate and her husband] had sympathy pains for her. And the father too, but fathers don't go through the pregnancy like the woman does. She didn't have any sisters. She didn't even know any pregnant people. And it's terrible for her, because she has no physical hands-on preparation and yet she's gonna have a baby.

For this surrogate, physical experience is what is necessary to prepare for a baby. She uses the term "sympathy pains" to explain the anguish she has for the woman who will never experience the pain of labor because of her infertility.

Most of the couples and surrogates continually emphasized to me how close they felt to the other party. One commissioning mother described the moment when the surrogate gave her the baby: "That kind of a moment is really the best of the human spirit. You know, women really helping women." Commissioning mothers often described their relationship to the surrogate as that of a sister or, when the age difference was larger, as that of mother to the younger surrogate mother. The surrogates in turn explained that they acted to help a couple become a family. One surrogate described to me how her husband was moved by the birth of her surrogate child: "My husband, he didn't

cry when our son was born, but he cried this time. And I asked why, and he said because to see how happy the couple was, was a really great experience." Still another surrogate spoke of the "sacred trust" that a surrogate mother was given in being commissioned to carry a baby for a couple.

> You get what you pay for. You can't enter into it on the spur of the moment. Making a baby is a beautiful and sacred thing. You pick somebody off the street who needs cash, they're not going to honor the baby or you. If someone says, "I'm going to carry this baby for you," it's as sacred of a trust as you can make.

According to these commissioning couples and surrogates, this trust is necessary when another person is going to carry "your" child. This closeness may develop in a range of ways, but here I will focus on how the technological procedures utilized in surrogate pregnancies and labors create and foster connection.

■ CONNECTIONS FORGED BY TECHNOLOGY

Although the most common method of achieving surrogate conception may not be "high-tech," surrogate births and pregnancies are perhaps even more filled with the trappings of American technobirth than standard births (see Davis-Floyd 1992). All of my informants, including those involved with "traditional surrogacy," spoke of surrogate pregnancies crowded with ultrasounds, amniocentesis, chorionic villus sampling (CVS), labor inductions, and cesareans. This is not to say that, had pregnancy been possible, the commissioning mothers would not have undergone some or many of these procedures, but rather that the perception of surrogate pregnancies as more "technological" may influence the degree of intervention.[13] The surrogates I interviewed were comfortable with these procedures. They were in fact pleased with the technologies used throughout their pregnancy and labor. Needless to say, the commissioning couples were grateful for technology, from in-vitro fertilization to labor induction and cesareans.

If the commissioning couples' own initial attempts at in-vitro fertilization had been successful, their relationship to technology might have been different. Judith Modell found that the "patients" of an IVF clinic, trying to have a baby for themselves, understood the technology of IVF as a "bypass to nature." Because the outcome of the labors of women who have undergone IVF are no different from the outcome of women who did not have IVF to conceive, the appearance of "nature" is upheld (Modell 1991:134). With surrogacy, technology cannot "bypass" nature. When the surrogate is pregnant, the commissioning parents can hardly pretend that they are experiencing the pregnancy in a "natural" way. The technological interventions used through-

out a surrogate's pregnancy are a constant reminder of the abnormal means of conception; and technology is often portrayed as a mechanism that alienates people from one another and from their bodily experiences. But according to the commissioning couples, it was "natural" infertility that distanced them from pregnancy, and technology which enabled connection. While my informants denied the importance of technoscience when asked about it directly, technology played a pivotal role in their narratives; in fact it was a crucial agent in the creation of connectedness. As we shall see below, one technology merged the commissioning mother's body and the surrogate's body into one (IVF), another enabled the commissioning couples to connect with the image of the fetus (ultrasound), and yet others permitted the couples to be physically closer to the pregnancy and birth (labor induction). For the surrogates, these technological procedures furthered the sense of family and shared experience with the commissioning couples.

One aspect of surrogate IVF treatment served to strengthen ties between the commissioning mother and the surrogate mother by allowing commissioning mothers to approximate pregnancy. During the process of IVF, both the commissioning mother and the surrogate are given hormones to make their cycles match temporally. When this happens the commissioning mothers' eggs are retrieved. They are fertilized, then placed in the surrogate. While describing the kinds of tests she had undergone, one surrogate exclaimed: "And the doctor said that in doing our blood tests and our hormone levels and everything, we were so close in numbers that it was like working with one body. He said he'd never had it that close before!" A commissioning mother had a similar sentiment: "Once I got my cycle, then they boosted her again to sync with me so we're like one body. The doctor checked and it turns out our cycles correspond perfectly. Which was just another amazing thing!" Here it is the technoscientific intervention of drugs and boosted hormone levels during the IVF procedure that merges these women, temporarily making them closer than kin. They are "one body." The commissioning mother can, in some couvadelike way, alleviate the disembodied experience of the pregnancy which will result in her child. The surrogate mother is pleased as well to participate in a procedure which diminishes the "space" between the commissioning mother and herself. For a moment, while their bodies are "in sync," they can share the pregnancy.

Commissioning couples used other technologies to become closer to their child. To minimize the distance between themselves and the gestation of their child, couples often attended the surrogates' prenatal appointments and childbirth education classes. Both surrogates and commissioning couples agreed that it was crucial for the couple, or at least the commissioning mother, to be there for the birth. The surrogates I spoke with felt that this was another way to make up for the fact that the commissioning mothers could

not experience birth themselves. A surrogate expressed this wish: "They had to be at the birth, 'cause this is their baby. The whole time, that was one thing I was worried about: What if they didn't make it in time? There's so much they're missing out on already." This being the case, it is not surprising that technological interventions were frequently used to ensure that the couple would be there. A commissioning mother explains:

> She lived about an hour and a half from here. And we wanted to make sure that we would be there for the labor. She wasn't overdue, she was due. They know by the hour when the baby was implanted. So they know how many days a baby needs to be in the womb. And the doctor decided to put her in the hospital and scrape her membranes to see if that instigated anything. And it did. We were able to drive to the hospital in time.

While scraping membranes is hardly "high-tech," the fact that IVF allows physicians to know the exact moment of conception enabled this intervention. It is not uncommon for women who bear their own children to be induced even when they are not past due. The difference here, though, is that the procedure is used solely to ensure that the commissioning parents will be present for the birth of their child.

Another commissioning couple convinced their gestational surrogate to leave her rural town several weeks before the due date of the baby to come stay in the metropolitan area where they lived. This couple wanted to be at the birth of their child; they also found the condition of the hospital in the surrogate's town to be technologically crude in case of an emergency. The surrogate did end up having a surprise emergency cesarean. The commissioning mother described it in these terms:

> It was truly an amazing birth. It's so close to our hearts 'cause it was so close. It makes you so grateful for the technology. We have it on videotape and it still makes everybody cry. God forbid, if we had been in her home town it would have been a disaster.

In this case, the technology to be grateful for is the technology that allows gestational surrogacy, the technology permitting air travel and telephone communication, the technology on hand for the birth of baby, the technology that alerted them that the baby was in distress, the technology that permitted a cesarean, and also the technology that allowed them to videotape the birth, which made everybody cry. For this commissioning mother, the frighteningly precarious labor, abetted by technology, made the whole situation closer to her heart.[14]

The ultrasounds undergone by surrogates throughout their pregnancies also fostered bonds between the surrogate and commissioning couple and

prompted the couples to "attach" with the image of the fetus (see Mitchell and Georges, this volume). This enhanced bond, it has been theorized, might influence women considering abortion to continue their pregnancy. Anti-abortion groups seized upon this theory, and based the film *The Silent Scream* on this notion of "bonding" and "attachment."[15] Many feminist authors have criticized the use of ultrasound as unnecessary, and as one more technological intervention which designates the fetus as first patient and further determines the mother as mere vessel (e.g., Rothman 1988; Stabile 1994). But the practice of surrogacy and surrogates themselves create (inadvertently) a more complicated and transgressive reading of ultrasound technology (see Strathern 1992:50; Taylor 1997). All of the surrogates I interviewed included the ultrasounds as among the most thrilling moments of the pregnancy. They found it gratifying to watch the couple see the image of the fetus. Ultrasound technology did not influence them to bond with their babies; on the contrary, it helped them bond with the commissioning couple by enabling them to see themselves as conduits for that couple's fetus. As I describe below, neither they nor the couples consider this to be a derogatory image.

In each of the surrogacy arrangements described to me, the commissioning couple had gone to at least one ultrasound appointment with the surrogate. This visit was remembered fondly as a time when the child became "real" for the commissioning couple and when the surrogate and the commissioning couple could share their excitement. Many of the surrogates I interviewed were involved with commissioning couples who lived far away. One such surrogate described the importance of ultrasound in this context: "We talked on the phone just about every week at least. They came out in July and they got to see an ultrasound, which was really nice. That, I think, made it real for them. And, actually, it was kind of like family." One surrogate used the ultrasound as a way to reassure the commissioning couple, who lived in Europe, that the baby existed. The sonogram was the only (albeit mediocre) way to allay their fears: "I sent them the pictures of the baby. Well, seeing it on the screen is much better than seeing it on that itty-bitty piece of paper. You don't have the doctors to say, 'This is the head, this is the foot.' By the time they got to them they probably didn't look like much. And I think they still didn't believe it." The commissioning mother ultimately did make one visit before the birth and saw an ultrasound, which in this surrogate's view was preferable since the doctor could interpret the image more satisfactorily.

Another surrogate with a long-distance commissioning couple had a similar experience. When the couple came to visit, the doctor performed an ultrasound and chorionic villus sampling, which is similar to an amniocentesis but can be performed earlier. "The next time I got to see her [the fetus] she was in the tenth week, when we did a CVS. This was the first time her mom and dad got to see her. I finally got to share this with someone who was as excited as

me." The surrogate described the CVS procedure as a time for the couple to feel excitement at the sight of their child on the screen, as well as something she was able to share with the commissioning couple. But, significantly, she does not describe it as a moment to bond with the fetus growing inside her.

The surrogates I interviewed did not perceive ultrasound as a way to create a bond between the fetus and themselves but rather between the commissioning couples and themselves, and the commissioning couples and the fetus. This fact problematizes the notion that ultrasound creates a bond between mother and child. It is not the surrogate's place to bond with the fetus, and ultrasound does not encourage her to do so. The way that these surrogates interact with ultrasound technology could potentially be incorporated into the theoretical work of feminist authors, who have critiqued the use of ultrasound along with *The Silent Scream* and the notion of mother bonding itself.[16] The surrogates locate themselves in an altogether different position, which contradicts both feminist and conservative ideologies. They are thrilled to undergo ultrasound and see the fetus, but despite the elation, they are still able to give the child away. The cyborg technology of ultrasound becomes a means of transcending the bodily boundaries separating the surrogates and the commissioning mom.

In the case of "traditional" surrogacy, where the commissioning mother is not genetically related to the child, the commissioning mother can feel at an even greater distance from her child-to-be and the pregnancy than those involved in gestational surrogacy. In this situation she cannot merge with the surrogate through the IVF procedure by becoming "one body." One such commissioning mother, Fran, used the technology of ultrasound as a means to establish connection with her daughter-to-be (Tara), the surrogate (Nora), and the pregnancy itself. Fran visualized her daughter's face during one of the ultrasounds. She had this to say about the ultrasound:

> Nora's not a pretty woman, but she's not unpretty. Her features are a
> nice blend with my husband's. So when Nora was pregnant with Tara,
> I decided I had to fall in love with Nora's face because it could be on
> my child. And, in the ultrasound Tara is a dead ringer for Nora. In the
> outline of her profile, it's Nora! So, I had about four months to try on
> having this child that looked just like Nora.

The ultrasound allowed Fran to "fall in love" with her child's face, and thus with her child. Equating Tara's face with Nora's at this early stage of ultrasound allowed Fran time to become comfortable with the idea that Tara is genetically Nora's child and not hers. If Fran herself had been pregnant, she would most likely have had an ultrasound; but would she have needed to see a likeness on her fetus's technologically enhanced features? Fran also explained that a psychic had told her that Tara was really her child but had needed someone else

as an entrance into this world. This pleased Fran greatly and confirmed her feeling that Tara looks like Fran's family. But, as she said:

> Regardless of the psychic, from the moment Tara was born, I knew she wasn't part of me genetically. I viewed her as a very individual person. And I try to respect that if she doesn't like carrots who cares? And I don't think I would be that aware of it, if she had actually come from me. I would be more, "We do it this way, and you're one of us." But, instead, I have to remind myself all the time, that Tara may be unlike any of us. I think, as a result of it, she's a more spirited child. And I notice that other surrogate children are as well.

In Fran's narrative, the ultrasound produced a person related to Nora, while the psychic produced a person related to Fran. Tara's odd beginnings, unrelated to her mother-to-be and unattached to the woman who carried her, produced "a very individual" child, in some ways related to no one. If Tara is her own person, then Fran has just as much claim to her as anyone. My point in juxtaposing these quotes is to demonstrate Fran's keen awareness that she is not related to Tara, in our privileged genetic sense. She is conscious of individuating Tara because of her lack of genetic relationship, while at the same time she uses the technology of ultrasound just as fluidly as she uses a psychic, to bond with her child.

While technology constrains and makes surrogate familial relations abnormal in the popular media, it plays a more convoluted and subtle part in the minds of those actually involved. Commissioning couples and surrogates constructed surrogacy to be a connective experience. This "native" interpretation of surrogacy and technology might not be suspected from facile observation of the practice, especially in light of common ideas about the harmful aspects of technology and its prevalent linkage to surrogacy. One could posit that in order to establish themselves as the *parents* of the child gestating in the surrogate, the commissioning couples use the technologies common to surrogacy to merge with (hormone synchronization), regulate (labor induction), or peer through (ultrasound) the surrogate's body, thus ignoring her personhood. But to vilify these technologies as weighted toward the interests of the commissioning couple, although perhaps partially true, is simplistic. This view does not take into account the surrogate's own enthusiasm to share her pregnancy, and does not explain both parties' description of the other as "like family." Surrogates' and commissioning couples' perceptions of this assemblage of technological procedures explicate how and why they take pleasure in these technologies. In their interaction with technoscience, the surrogate's narratives resist a pigeonholing of motherhood as one type of experience. They delight in undergoing ultrasound, even as they give their children away, and as I analyze in the next section, they use technological metaphors like "baby-

machine" to characterize themselves. These understandings accommodate an expansion of the imaginable identities for women. Helena Ragoné encountered similar findings in her in-depth ethnographic analysis of surrogate motherhood. Although Ragoné does not specifically comment on technology, she argues that surrogates are usually women who hold traditional beliefs about motherhood, sex roles, and reproduction. The woman who agrees to be a surrogate has a chance to have a "cathartic" experience which will allow her to break out of her primary role while staying within the boundary of the traditional female domain. "Thus without threatening the structure that constrains her, she creates a small window onto other possible ways of being" (Ragoné 1994:85–86).

■ EMBRACING CYBORG BODIES

Technological procedures provide connective mechanisms that enhance the parent-child bond. The technological metaphors used in the language of these commissioning couples and surrogates play a similar role by severing ties between the surrogate and baby. The use of these metaphors reappraises the relationship of the surrogate to the fetus inside, undermining some of our most basic notions of what a mother is. During 1987 congressional hearings concerning a federal bill proposing a ban on surrogacy, critical witnesses found surrogacy's effect on these basic notions to be quite disturbing. Surrogacy was vilified and surrogates were called "interchangeable parts in the birth machinery, breeder stock, manufacturing plants, reproductive technology laboratories, and human incubators" (Andrews 1989:234). My informants knew of these cyborgian epithets. They used similar metaphors in their discussions of surrogacy, yet without negative connotation. The idea of woman as vessel is nothing new, but the idea that surrogacy makes women into *technological* and other "unnatural" vessels compounds the notion that surrogacy is artificial. Underlying the fears of "woman as technological vessel" (a specter invoked repeatedly in feminist arguments against surrogacy) are basic beliefs about the proper use of the female body.

Some feminists worry that, with surrogacy, women are being conflated with their reproductive capacities, and thus reduced to non-personhood. Christine Overall, for example, argues that:

Surrogate mothering is at the extreme end of the spectrum of alienated labor. . . . [A surrogate] surrenders her individuality . . . [by] receiving a fee not for labor that is the unique expression of one's personal abilities and talents, but only for the exercise of one's reproductive capacities. As one applicant for surrogate motherhood aptly expressed it: "I'm only an incubator." . . . Although her body and its capacities are hers to dis-

pose of, the practice of surrogacy negates her as a person. (1987:126–127)

For Overall, surrogates surrender their individuality because they will be seen only through the lens of reproduction. In effect, surrogates become mere uteruses, mother-machines. Those involved with surrogacy are keenly aware of this criticism of exploitation. A letter published in an Organization of Parents Through Surrogacy newsletter proclaims: "Contrary to opposition opinion, we do not . . . regard our Surrogate Mothers as breeders, human incubators or vessels. We hold our birth mother in the highest regard, feeling only deep appreciation and love for her" (Zager 1991:6). In the more informal interviews I conducted I received a similar impression, but some of my informants did characterize surrogates in mechanistic terms. One commissioning mother admiringly described her surrogate in these terms: "She was like my guardian angel. To this day we're very good friends. She's a real baby machine. A wonderful, wonderful, fabulous person." Each of these two statements identifies a surrogate as an individual for whom the commissioning couples feel deep appreciation, not as someone whose personhood is negated, even if she is a "baby machine."

Surrogates portrayed themselves as vessels as well. One surrogate stated: "My whole family was supportive. They understood that I'd be carrying the baby around like a little incubator" (Colt 1987:38). Another surrogate whom I interviewed said: "The baby wasn't mine. I was only the baby incubator." The surrogates I spoke with also used other vessel imagery to highlight their non-maternal relationship to the baby. One surrogate explained: "I was his surrogate mother. I was his garden." Another surrogate said: "Once the baby's conceived, part of it is somebody else's. I'm just a baby-sitter." The same surrogate discussed the possibility that the commissioning couple would want her to get a "therapeutic" abortion:

I am personally opposed to abortion, but I wouldn't want to deny it to the couple, in the case that I'm carrying it. It's not mine. I do not have any responsibility to make that decision for them. They're terminating their own pregnancy. Just because it's in my body it doesn't have anything to do with me.

According to this surrogate, because she serves as a mere "host" body, the baby is not her responsibility. Neither the abortion nor the baby has anything to do with her.

The surrogates I spoke with embraced metaphors of themselves as receptacles for the children they gestated, which may stem from a contrarian delight in turning criticism on its head. But other messages lie in their avowals of

mechanistic gestation. These women have a radically different view of their identity than is allowed or approved of by most critics of surrogacy. It is essential to recall one critique of surrogacy: surrogates are often represented by nonfeminists as unfeminine, unnatural women, women who are able to break the bonds of motherhood. Surrogates subvert this picture with their emphasis on vesselhood, a traditionally feminine trait. And contrary to Overall's portrayal of surrogates as losing their individuality, in the words of my informants, they maintain it, while abdicating control of part of their body, their womb. But by hiring out this hyperfeminine space, they garner the power accorded to those who can make their way in a capitalist society. They turn both criticisms—feminist and nonfeminist—on their heads.

This use of vessel imagery serves yet another function. Surrogacy raises a number of problems within our culture's assumptions about motherhood: (1) a woman becomes pregnant with no intention of keeping the baby; (2) she gives it to a couple who pay her; (3) the baby does not gestate in the womb of its mother-to-be; (4) the mother-to-be is not pregnant with the baby-to-be; and (5) the baby-to-be gestates in another woman's body, the "wrong" body. These "unnatural" quandaries are partly diminished when a surrogate and commissioning couple imagine the surrogate's body as a machine. In effect, to make the commissioning couple's experience of having a child more natural, those involved with surrogacy envision the surrogate as unnatural. Although a "sacred" trust forms between herself and the commissioning couple, by asserting that she is just an "incubator," "baby-sitter," "baby-machine," "garden," a surrogate locates the child inside her body (the wrong body) while at the same time identifying herself as a mere machine. And a machine is not something (at this point in time) with which we can form relationships. When surrogates described their relationship to the child after she or he was born, they usually spoke of themselves as "aunt," "godmother," "extended family," but never as "mother." The only time they could be "mother" is while the child is in utero, but even then they are only a mother-vessel. The technological procedures of IVF and ultrasound further relationships between couple and baby, mimicking "natural" conception, while metaphors of technological vessels sever the problematic connection between surrogate and fetus.

Within a surrogate's conceptualization of self is a woman who, by calling her uterus a "machine" and by partially denying her right to bodily determination, could be seen as both separating her identity from, and conflating it with, her reproductive capacities. This is a dangerous position for women, but it is also bursting with potential to undermine essentialist tales of womanhood told by individuals of many ideological persuasions. In one rhetorical maneuver, a surrogate becomes technological in such a way as to alter her relationship to the fetus, thus subverting prevalent scripts of motherhood, but also

becomes a feminine vessel, hence reifying herself as woman. The underpin-nings of surrogacy and the microtactics of those involved may ultimately aid in rewriting "women's experience" and identity.

■ CONCLUSION: REPRODUCTIVE HYBRIDS

The explosion of writing about surrogacy in the past decade is hardly surpris-ing. With its not-so-embedded oppositions of nature and culture, biology and technology, surrogacy impels us to make the implicit explicit (Strathern 1992:5). The practice of surrogate motherhood is hybrid, as it is viewed as both containing and corroding the borders of these oppositions. The surro-gate mother has become in her hybridity the "personification of anxieties about unpredictable technological and social developments" (Zipper and Svenhuijsen 1987:15) and just one more expression of our very public dismay surrounding the perceived fragmentation of inviolate wholes.

Anthropological discourses about surrogacy could gain from a more nuanced understanding of the dynamic of surrogating by attempting more "effective theories of experience" (Haraway 1991:173). What lies at the bot-tom of a surrogate's motivation may be problematic to many; certainly the charge of false consciousness cannot be ignored. But criticism limited to pat formulas about techno-patriarchal exploitation or false consciousness fails to consider the attitudes of the majority of surrogates. A reading of surrogate positions must be predicated upon an exploration of surrogate experience and an admission that such subjectivity is valid. To ignore this subjectivity is to ignore these "natives" whose experience of surrogacy may bear little relation-ship to that assumed by detractors of the practice and who direct their affirma-tions of the practice toward critical "outsiders." So far there has been no attempt by critics to account for why those involved in surrogacy have not been swayed by popular, academic, or legal disapproval, and have instead—partially through their encounters with technology—developed alternative understandings of their actions.

Are those who practice surrogacy extensions of patriarchal technocracy? Or are there ways in which they imagine surrogacy that could redefine our received knowledge about reproduction? The commissioning couples I inter-viewed had no intention of engaging in transgressive practices; many hold beliefs untenable to many feminists, including myself. Yet the practice of sur-rogacy presents a potential site for contesting our culture's interpretation of family and pregnancy. For Judith Modell's informants, IVF did nothing to question the ideal of the "biological model of parenthood" since it can be "hidden": "the petri dish leads to natural childbirth" (Modell 1991:135). But surrogacy, made explicit in the form of the surrogate's pregnant body, forces a

discussion of the proper use of all female bodies. It cannot be hidden. The potential for new imaginings exists.

Even at this point there are infractions on the edges of the practice. Surrogacy in most respects is no different from the society in which it occurs, although it could become part of a reproductive challenge to the political tyranny of the ideal of the heterosexual, nuclear family. For the most part, surrogacy shores up this venerated family. But within the "nuclear" families surrogacy helps create, a new family member is added—the surrogate herself. Officially, among most surrogacy agencies in the United States, only married heterosexual couples are considered to be appropriate recipients of a baby born through surrogacy. However, heterosexual single men are sometimes allowed, such as James Austin; and several of my informants said they had heard of surrogacy agencies brokering contracts between surrogates and single gay men or gay male couples.[17] Many of the surrogates I spoke with said they would be willing to help a gay couple in this way, and one had already done so. Agencies do not publicize these arrangements because they are reluctant to draw negative attention to this already controversial practice. And although monetary gain may be the primary motivation for the agencies secretly willing to allow gay men in their programs, some of the surrogates I interviewed (who were already aware of their flagrant disregard of the normative view of motherhood) seemed to take great delight in the thought of helping a gay couple.

The technological processes of surrogacy spawn affinities between families from different class backgrounds, across privileged genetics, and beyond disembodied experiences, while incubatory metaphors sever the once insoluble dyad of mother and fetus. A surrogate's body does not contain a machine (although it is frequently examined by machines). But she is widely perceived as a cyborg, a mother-machine. Indeed she views herself as vessel for a sacred trust, an oxymoronic sacred machine of reproduction. Whether or not these affinities produce revolutionary couplings remains to be seen, but the practice of surrogacy and the surrogates themselves reside as hybrids on the overlit social borders of the late twentieth century.

Acknowledgments

Many thanks to Robbie Davis-Floyd and Joe Dumit for the impetus to develop this chapter and for their editorial suggestions. I am indebted as well to Nancy Scheper-Hughes, Tom Laqueur, and Katie Lederer, who have all given me invaluable critical commentary and support over the last few years in relation to my research on surrogate motherhood. Naomi Leite was especially helpful in the editing and clarification of this particular chapter, for which I remain deeply grateful. And a special thank-you to Joe Eisenberg, Sophie Spindel, and Lynne Wander for moral support and inspiration and to all of my informants for sharing with me their lives and stories.

Notes

1 James Austin was unmarried. This made his surrogacy arrangement atypical since most surrogacy agencies will not allow single men to participate in their programs. I will elaborate on this issue at the end of the chapter.

2 One must wonder what makes this tragedy "uniquely modern." It cannot be the technology alone, since Phyllis Huddleston was inseminated by James Austin's sperm, using a "technology" which has been available since the eighteenth century (Moghissi 1989:117). And, sadly, there is nothing "modern" about a father killing his child. What is "modern" must lie in the practice of surrogacy itself, although the reader is led to believe that it is the "coldly intimate" technology that is new.

3 In addition to participant observation at the agency, I solicited formal interviews, twenty of which serve as the basis for this discussion. One informant was Hispanic; the rest were Euro-American. Most were economically middle-class, with the exception of one commissioning mother who was wealthy. In general, the surrogates had fewer economic resources than the commissioning parents. The majority of surrogate mothers I interviewed did not work outside their homes, while all of the commissioning mothers did. Because commissioning fathers were less willing to be interviewed, this analysis draws primarily from my interviews with surrogates and commissioning mothers. None of my informants participated in anonymous surrogacy contracts: they had all interacted extensively with the other party, surrogate or commissioning couple. Of the commissioning parents I interviewed, one commissioning mother was Jewish and another commissioning mother had a Jewish husband. The rest of the commissioning couples as well as the surrogates and their husbands had been raised Christian, although none of these informants expressed that they were especially devout. The quotes used here are excerpted and edited for clarity. All personal details have been changed.

4 The "official" definition of infertility is the inability to conceive after one year of failed attempts. The actual incidence of infertility in the United States today is debatable. In 1991 an article in *Time* magazine declared, "America today is in the midst of an infertility epidemic," and estimated that one in twelve couples is infertile. For couples in their thirties the rate is more like one in seven (Elmer-DeWitt 1991:56). In contrast, Valerie Hartouni (Hartouni 1991:47) has suggested that, "as for the 'epidemic' itself, the actual rate of infertility in the United States has remained relatively constant over the past two decades. What has changed is the expansion of possibilities for treatment, at least so far as women are concerned."

5 Adoption has an odd position on this list because of the desire of commissioning couples to have a child genetically related to them. Some of the couples I interviewed had pursued adoption, but after finding it difficult or impossible switched to surrogacy. Other couples had never looked into it.

6 The introduction of a third party, the egg donor, in the already complicated transaction may also be meant to prevent the surrogate mother from developing an emotional connection with the child, because she is thus in no way genetically related to it. This arrangement is still quite rare.

7 Outside of the United States and Israel, there are virtually no countries that allow commercial surrogacy, and many foreign couples come here to use private surrogacy agencies. The legal status of surrogacy varies from state to state, and as yet there has not been a federal legal decision regarding the legitimacy of surrogacy contracts. See Blank 1990.

8 Surrogacy is a pressing social problem more on a symbolic level given the relatively small number of births which have resulted from this practice.

9 The feminist critique of surrogacy has received far more publicity than feminist support of the practice. Consequently it is often presented by the media as *the* feminist position on the subject.

10 For further discussion of feminist "techno-phobia" see Stabile 1994.

11 There is some obfuscation when we link surrogacy to technology. Technological procedures are indeed a substantial component of most surrogate pregnancies and births, yet the media represent "traditional surrogacy" as being highly technoscientific even though it involves very little technology.

12 One surrogate interviewed in a northern California paper said "I've confirmed it with my pastor. It was like artificial insemination for God" (*Contra Costa Times*, Aug. 31, 1992:1).

13 It could be argued that surrogates undergo more technological procedures because the commissioning couple does not have to experience these procedures in their own bodies. They feel they can demand that the surrogate be examined in this way especially since they are paying her. The problem with this reasoning, though, is that most commissioning couples have themselves already undergone many technoscientific procedures in their attempts to have a child.

14 See Taylor 1997 for a discussion of communications technologies in relation to reproductive technologies.

15 *The Silent Scream* is an anti-abortion film which purports to show an abortion from the fetus's point of view and to give a face to the fetus a woman could not previously see.

16 E.g., Stabile 1994; Hartouni 1991; Scheper-Hughes 1992.

17 James Austin is not a "good" example of alternative family, but the murder of his son made headlines while other situations where atypical family arrangements were "successful" have not been publicized.

References

Andrews, Lori. 1989. *Between Strangers*. New York: Harper and Row.

Blakely, Mary Kay. 1983. "Surrogate Mothers: For Whom Are They Working?" *Ms.* (March): 18–20.

Blank, Robert. 1990. *Regulating Reproduction*. New York: Columbia University Press.

Colt, George Howe. 1987. "Science and Surrogacy: Searching for a Biological Child on the High-Tech Frontier." *Life* 10 (6): 36–42.

Corea, Gena. 1985. *The Mother Machine*. New York: Harper and Row,

Davis-Floyd, Robbie. 1992. *Birth as an American Rite of Passage*. Berkeley: University of California Press.

Dowling, Claudia Glenn. 1993. "Miraculous Babies" *Life* (Dec.): 75.

Elmer-DeWitt, Philip. 1991. "Making Babies." *Time* 138(13) (Sept. 30): 56–63.

Haraway, Donna. 1991. *Simians, Cyborgs and Women*. New York: Routledge.

Hartouni, Valerie. 1991. "Containing Women: Reproductive Discourses in the 1980s." In *Technoculture*, edited by Constance Penley and Andrew Ross. Minneapolis: University of Minnesota Press,

Modell, Judith. 1991. "Interpretations of Parenthood in an In-Vitro Fertilization Program." *Medical Anthropology Quarterly* 5 (1): 124–138

Moghissi, Kamran S. 1989. "The Technology of AID and Surrogacy." In *New Approaches to Human Reproduction*, edited by Linda M. Whiteford and Marilyn L. Poland, 117–132. Boulder: Westview Press.

Munoz, Alejandra. 1986. "Alejandra Munoz." In *Infertility*, edited by Renate D. Klein, 144–149. London: Pandora Press.

Oliver, Kelly. 1989. "Marxism and Surrogacy." *Hypatia* 10 (3): 95–115.

Overall, Christine. 1987. *Ethics and Human Reproduction: A Feminist Analysis*. Boston: Allen & Unwin.

Rae, Scott B. 1994. *The Ethics of Commercial Surrogate Motherhood. Brave New Familes?* Westport, Conn.: Praeger.

Ragoné, Helena. 1994. *Surrogate Motherhood: Conception in the Heart*. Boulder: Westview Press.

RESOLVE. 1984. "Surrogating: What Do You Think? Fact Sheet." Fall.

Robertson, John A. 1983. "Procreative Liberty and the Control of Conception, Pregnancy, and Childbirth." *Virginia Law Review*. 69: 405–464

Rothman, Barbara Katz. 1988. "Reproductive Technology and the Commodification of Life." In *Embryos, Ethics, and Women's Rights*, edited by Elaine Hoffman Baruch, Amadeo F. D'Adamo, Jr., and Joni Seager, 95–100. New York: Haworth Press.

Sawicki, Jana. 1991. *Disciplining Foucault*. New York: Routledge.

Scheper-Hughes, Nancy. 1992. *Death Without Weeping*. Berkeley: University of California Press.

Singer, Linda. 1993. *Erotic Welfare*. New York: Routledge.

Stabile, Carole A. 1994. *Feminism and the Technological Fix*. Manchester: Manchester University Press.

Strathern, Marilyn. 1992. *After Nature*. Cambridge: Cambridge University Press.

Taylor, Janelle S. 1997. "Image of Contradiction: Obstetrical Ultrasound in American Culture." In *Reproducing Reproduction*, edited by Sarah Franklin and Helena Ragoné. Philadelphia: University of Pennsylvania Press.

Zagar, Shirley. 1991. "Legal Update." *OPTS NEWS*, vol 9: 7.

Zipper, Juliette, and Selma Sevenhuijsen. 1987. "Surrogacy: Feminist Notions of Motherhood Reconsidered." In *Reproductive Technologies: Gender, Motherhood and Medicine*, edited by Michelle Stanworth, 118–137. Cambridge: Polity Press.

Living With the "Truths" of DES

Toward an Anthropology of Facts

Joseph Dumit with Sylvia Sensiper[1]

■ DES REALITY, IMHO

If you were born between 1938 and 1971 or pregnant then, you could be exposed to the drug DES.

—"Facts about DES," National Cancer Institute

[Though it is easily treated if caught in time] ectopic pregnancy remains the most common cause of maternal death during the first half of pregnancy in the United States.

—James R. Scott et al., *Danforth's Obstetrics and Gynecology*, 7th ed., 1994:187[2]

The following is a complaint my wife, Sylvia, filed with the Medical Board of California. This complaint has been on file for over three years, and as of fall 1997, is still in process. It is condensed here, and reads as follows:

I began seeing Dr. Alison Leong at the Westside Women's Place in May of 1993, on the recommendation of a friend. At the time, I was interested in becoming pregnant, and was seeking medical care for this purpose.

I made sure Dr. Leong knew I was DES exposed, as I do with all gynecologists who examine me. I have been told by previous gynecologists that my cervix is a little unusual, probably because of DES exposure. If the doctor doesn't know about the exposure, they are often concerned about what they see. I am also aware that DES may cause complications with pregnancies.

After one miscarriage in August, 1993, I became pregnant again in April, 1994. I did a home pregnancy test on May 2 and got a positive result, but the next morning I started bleeding. I called Dr. Leong and she said to come into the office for a HCG (hormone level) test, which

I did on May 4. The next day she confirmed that I was pregnant.

I was continuing to bleed and have some cramping and asked if there was anything I could do. Dr. Leong said that it did not necessarily mean anything, one just had to wait and see with pregnancy. During my next exam on May 17, Dr. Leong decided to check the pregnancy on the ultrasound machine in her office. She located the pregnancy transvaginally, and pointed out the yolk sac and the pulsating embryo, and pronounced it properly implanted in the uterus. She took pictures for her records and gave us one. If you look at the ultrasound image, there is a line across the bottom of the pregnancy. Dr. Leong wasn't certain what it indicated but thought it was a possible explanation for the bleeding. She said it appeared that I was bleeding "behind the membrane," and possibly aborting a twin.

We were soon to find out that the bleeding was due to an ectopic pregnancy. Ectopic pregnancies happen when the fertilized egg does not implant inside the uterus, but outside of it, typically in a fallopian tube. There it tries to grow into a fetus, connecting up with the blood supply of the mother, getting bigger and bigger, until the tiny tube can no longer sustain the growth and ruptures. We were later informed by many other doctors that the ultrasound Dr. Leong took indeed showed a pregnancy but that she did not ascertain where the pregnancy was, indicating negligence and a misunderstanding of how to use the technology.[3]

I saw Dr. Leong two weeks later on May 25. The nurse took blood for another HCG test, and reassured me that patients often have bleeding and cramps and still deliver healthy babies. The doctor did a vaginal exam and took "cultures" for additional tests. I told her I had bad cramps and heavier bleeding two days earlier but she said not to worry. I asked for another ultrasound, but she either didn't think it was necessary or didn't have time. She instead urged me to go for genetic counseling since CVS (chorionic virilli sampling, a technique akin to amniocentesis) should be done between the 9th and 11th weeks of pregnancy and I was completing my 8th.

Three days later, I felt a sharp pain in my side. The pain was so great that I had to lie on the floor. My husband called the paramedics and they took me by ambulance to Santa Monica Hospital emergency room. The paramedics put me on IV, gave me oxygen, and measured my blood pressure which was very low. Blood work was ordered, and also a series of ultrasound scans.

The doctor on call that evening at the Westside Women's Place was Dr. Yvonne Fried and she came to the emergency room and then fol-

lowed us to the ultrasound room. My husband and I had told both the technician and Dr. Fried that I was DES exposed and had been bleeding and cramping through most of the pregnancy.

The ultrasound technician, Mr. Valery Serebryany, had me lie on a table and he first did an abdominal ultrasound, and then examined me transvaginally. He took at least 12 ultrasound "snapshots" abdominally over about 30 minutes noting the pregnancy, the yolk sac, and the embryo. He and Dr. Fried both agreed that the pregnancy was viable and firmly planted in the uterus and that we didn't have to worry about that.

When he was done, the tech went to use a phone to talk with a radiologist, Dr. Kevin Drake, about the pictures. Dr. Drake signed off an assessment of my situation. Together with the technician, he reported finding a 5.7 cm fundal fibroid, an 8-week, one-day alive intrauterine fetus, and a gestational sac very low in the uterus, suspicious of a threatened abortion.

I was sent home that evening. The next morning I was still in pain. So I called Dr. Fried, and returned to the hospital. After an additional ultrasound scan located fluid in my abdomen, Dr. Fried made the decision to operate, thinking the cause was a ruptured ovarian cyst.

When I woke up in the recovery room, Dr. Fried told me that I had actually had a tubal ectopic pregnancy and they had removed it. They had caught it late in the process of bursting and had to remove the fallopian tube too. There was no uterine pregnancy. Almost 2 pints of blood had gathered in my abdomen by the time they opened me up, and I was minutes away from a transfusion.

There is approximately one ectopic pregnancy for every forty-four live births in the United States. The most recent review of the literature indicates that DES daughters have 8.6 times the risk for ectopic pregnancies as the general population. For DES daughters with uterine abnormalities (like Sylvia) the risk is 13.5 times normal (Swan 1992, cited in Giusti et al. 1995). Put another way, "*patients exposed to diethylstilbestrol in utero have a 5 percent to 13 percent risk of ectopic gestation*" (Kaufman et al. 1984, cited in Scott et al. 1994:188).

I spent three days and nights in the hospital. Dr. Fried visited me one morning to see how I was doing and Dr. Leong came later that day, to remove my surgical staples. I asked her why the ultrasound hadn't been able to pick up the ectopic and she said, perhaps because the tube was "behind" the uterus. I asked if the DES exposure had anything to do with it and she said "no." I asked if ultrasound was a good

diagnostic tool, and she said it's only as good as the people who can read and interpret it. She said that she knew I had bleeding and cramping but she "couldn't check everyone who has bleeding."

Later, when this was all over, we wondered about the efficacy of ultrasound. We looked up ectopic pregnancies in many textbooks and found that ultrasound was uniformly referred to as a good diagnostic tool. Yet we wanted more information about the technology and about what kind of medical care we should seek. We realized that Dr. Leong and the other doctors and technicians believed they had a handle on Sylvia's pregnancy *because* they used ultrasound. Blinded by the power of the technology that was supposed to help them see, they practiced incompetently, mistaking misdiagnosis for fact. It was with that in mind that Sylvia called the UCLA Medical Center.

I asked Dr. Ragavendra, a professor of radiology at UCLA, and head of the ultrasound division, to review the ultrasound images from Santa Monica Hospital. He told me that many of the images indicated that the embryo wasn't in the normal position in the center of the uterus. This was not a question of ambiguity or judgment, the pregnancy was clearly off center. He said that this was a "red flag" to take very careful measurements to discover if it was, in fact, inside the uterus. Due to my DES exposure, my uterus could be shaped differently, and I was at higher risk for ectopic pregnancy. In any case, the ultrasound technician should have probed much more into the exact position of the gestational sac. Due to other symptoms and risk factors there could be no assuming that the sac was intrauterine.

In our three years of taking the ultrasound pictures from doctor to doctor, every doctor we found assumed without prompting that the pictures showed something wrong. Where there was good training, there appeared to be consensus. Looking back at the complaint now, two years later, Sylvia noted that she took Dr. Leong and the other medical professionals who made equally bad judgments to task for their incompetent use of ultrasound but not necessarily for their lack of knowledge about DES. None of them thought that her DES exposure required any additional surveillance or care.

■ THE WHOLE TRUTH AND NOTHING BUT THE TRUTH

Diethylstilbestrol (DES) was a drug given to over three million women in the United States alone, from 1938 to 1975, for the purpose of preventing miscarriages. Produced and promoted by over a hundred companies, it was advertised in medical journals and popular magazines, and often deceptively given to

women as "a vitamin." The children born to women who took DES while preg-
nant, both sons and daughters, suffered multiple, often tragic effects. DES sons
have higher rates of reproductive-tract abnormalities and probably infertility
and testicular cancer. DES daughters are much worse off. They are at signifi-
cantly increased risk for cancer, vaginal adenosis, uterine and cervical abnor-
malities, infertility, ectopic pregnancies, premature delivery, and, ironically,
miscarriages. The medical community has firmly established these problems
and officially committed itself to treating them. Every obstetrical and gyneco-
logical textbook concurs with this commitment. Tragically, however, many
doctors, including obstetricians and gynecologists, either know the wrong
things about DES or think that the problem is in the past. This chapter is an
attempt to analyze how this faulty knowledge is being reproduced.

In multiple ways, as their hybrid name indicates, "DES-children" can be
usefully thought of as cyborgs. First, their mothers' bodies were physiological
fusions of human hormones and DES, the first synthetic estrogen, with
known, profound cascading effects on many other hormone systems. Second,
their development in this context often resulted in new anatomical structures
in the children (such as "T-shaped" uteruses in daughters, unknown outside
of DES exposure) inseparable from this transplacental drug/mother interac-
tion. Thus, they often need to be thought of as sons and daughters of the drug,
as having an additional, pharmaceutical parent, given that the effects of DES
on their physiology mirror genetic transmission. Third, the changes in their
bodies necessitate (or should necessitate) their insertion into a constant net-
work of surveillance and experimentation. The notion of the "DES daughter"
only emerged, for instance, as the result of an exceedingly rare post-
menopausal cancer showing up in four teenage girls exposed in utero to
DES: had the cancer been more prevalent or the numbers of women exposed
to the drug been less than in the millions, this "cluster" would probably never
have been noticed. Fourth, and ironically, despite the fact that their problems
were initially caused by an admittedly overzealous high-tech medical com-
munity, most DES daughters must depend upon just that community for
proper care of their own pregnancies. Their children, in turn, are thus most
likely to be cyborgs, produced in partnership with technoscience.

Finally—and criminally—too many DES daughters are never informed of
their cyborg heritage, and too many medical professionals appear to never
learn that their condition exists. This final sense in which DES daughters are
cyborg goes beyond the idea of a nature-culture hybrid. It involves the role
that facts play in the very division of nature and culture. "Fact" is often a word
used to describe the situation where (our) culture and nature agree. To call
something a fact is to represent a cultural consensus on the nature of nature.
But, I want to argue, facts are not so easily pronounced, even when we have
that elusive thing called consensus. I therefore analyze DES daughters and

their doctors as cyborgs to the extent that they exist in part as the product of writing technologies and information flows. "Writing technologies" is a concept based on the work of Katie King (1994) and means attending to the specifics of how and where meanings travel in texts, practices, and speech. Facts, to be known and acted upon, need to get to people. How they get there is an empirical question. Studying facts as an anthropologist involves a special facet of epistemology: how we actually, historically, come to know something as truth. In this case, through what cultural-material channels do we learn about our nature? My supposition is that facts and the apparatus of factual reproduction (publishing houses, books, pamphlets, and reading habits) are material actors whose agency affects bodies as much as it affects knowledge. Analyzing these relations as writing technologies that transform facts into lived, practical truth in the world is what I am terming an *anthropology of facts*.

My method is to analyze the culture and reproduction of specific kinds of knowledge. This means locating places where facts about DES are read or heard as well as places where they should be present but are not. DES is an important case to examine because there appears to be consensus within the formal medical community and among women's health activists regarding DES effects, proper care for DES daughters, and the need to inform everyone involved about the ongoing effects of DES. By *formal medical community* I mean obstetrics and gynecological textbooks used in medical schools, published articles in medical journals, and government task forces set up to investigate and report on DES. These publications all agree on specific dangers and risks that DES daughters face. They agree on the kinds of exams that need to be done to watch for these risks, and the absolute importance of making sure that both the daughters and medical professionals know about these.

Yet, many popular guidebooks for women getting pregnant and most handbooks for residents and practicing obstetricians and gynecologists have misleading information on DES or no information at all. The effect of this gap between textbooks—or formal facts—on the one hand and guidebooks and handbooks—or practicing facts—on the other is to completely nullify the achievements of both activist groups and many medical professionals. A fact, in other words, is not just a fact. The truth of DES appears to vary depending on what kind of reference material one uses. One cannot simply "look it up." At this popular level of knowledge reproduction then—that of practical guidebooks and handbooks—the nature of otherwise established and well-known facts about the nature of DES daughters—are deleted and many women are further endangered and/or harmed.

DES is still a serious problem and will continue to be until approximately 2010, and even then its effects will linger. For instance, a 1992 National Cancer Institute survey noted that over two million DES-exposed women were

then of childbearing age (Mastroianni et al. 1994). Since 1978, the year of the first government DES Task Force Report, it has been known that the effects of DES continue to be discovered. There is, for instance, no data yet on problems in DES sons and daughters over fifty.

Two reviews of studies on long-term DES exposure (Giusti et al. 1995; Swan 1992) found that it well established that DES daughters are at risk for cervicovaginal clear-cell adenocarcinoma (approximately one in one thousand will develop a very rare form of cancer), vaginal epithelial changes (up to 80 percent of DES daughters have apparently benign precancerous cells known as adenosis around their vaginas), reproductive-tract anomalies (20–50 percent of DES daughters have gross anatomical changes of the cervix, vagina, and uterus), premature births (DES daughters have between 4.7 and 9.6 times more premature births than normal), ectopic pregnancies (DES daughters have between 8.6 and 13.5 times more ectopic pregnancies than normal), and infertility. It has also been well established that the women who took DES while pregnant (DES mothers) are approximately 1.4 times more likely to get breast cancer than the general population. And DES sons have increased risk for epdidymal cysts around their testicles and other reproductive tract abnormalities. Further, the reviews noted that there is "suggestive evidence" (not enough or conflicting statistical evidence) that DES daughters are at increased risk for autoimmune disorders (they report higher incidence of these disorders, but most of these typically do not show up until later in life) and that DES sons are at increased risk for infertility and testicular cancer. Finally, there are the findings, based primarily on animal models, that DES daughters might be at higher risk for breast cancer (they have not yet reached the age when this would show up, but the increased risk for their mothers necessitates caution) and for psychosexual effects (several animal studies show DES can affect developing brain and central nervous systems; DES daughters—and sons as well—have shown increased incidence of depression and anxiety disorders), and that there may be third-generation effects. (DES grandchildren may be at risk for the above. There are some suggestive animal studies on third-generation DES effects. It is too early to know about humans, but there are no plans to study them.)[4]

Giusti et al. (1995) go on to note that DES-exposed daughters should get annual special checkups, be followed as high-risk patients when pregnant, and if possible be referred to centers that have focused on the effects of DES exposure. The authors further note that the risks of cancer for DES-exposed daughters as they grow older are not yet known, that the cohort has not yet reached the age at which clear-cell adenocarcinoma affects the normal population. And finally, "currently, data are insufficient to adequately advise DES daughters on the potential risk of hormonal contraceptives, ovulatory agents, and replacement estrogen therapy" (Giusti et al. 1995:786).

DES has its own section in textbooks, its own category for reproductive-tract abnormalities, its own legal liability history, and a special place in patient rights' activism and in the regulation of drugs. Since 1971, there have been between 150 and 300 articles on DES published *every year* in medical journals.[5] In spite of this prominence, there are still gynecologists who make it through medical schools into private practice and knowingly take on DES daughters without knowing the first thing about what to watch for in their care.

■ LIVING WITH THE FACTS: THE LONG, TRAGIC HISTORY OF DES

There are, in fact, an enormous number of histories of DES.[6] Most detail its incredibly tragic history within a kind of enlightenment narrative. They state that DES was not studied carefully enough at first, and those studies which showed problems were ignored by the medical community at large. When irrefutable proof of DES's harm was provided in 1971, the narrative goes, the medical community responded, the public was outraged, and more research was conducted. Since that time, we know most of the problems caused by DES, and ever more doctors are learning about it through information dissemination. Luckily, they say, we now have much better drug regulation and better clinical trial methods, and DES will soon be a problem of the past.

The problems with this kind of narrative are the assumptions that facts spread steadily, though perhaps slowly, and that knowledge once known stays known. Many histories and activist narratives have emphasized how little the medical community learns from any tragedy that it applies to help prevent others.[7] But the failure in this case requires a much more subtle and critical relation to the concept of truth and the reality of facts.

DES is a significant drug for a number of reasons. As the first synthetic estrogen it represented the solution to a number of problems researchers had in obtaining natural estrogen. When C. E. Dodd and his colleagues successfully synthesized it in 1938, they heralded a new age in research. As part of the British system at the time, their research was not patented. DES was released to the public domain, allowing any company to produce it royalty-free. In the United States, a number of companies immediately went to work and by 1939 had drug applications in to the newly created (1938) Food, Drug and Cosmetic Act agency. DES was the test case for the government to work with industry in the best interests of the marketplace and consumers for safety and money and health.[8] In 1941, with some controversy, the FDA approved DES for a few specific uses: menopausal symptoms, lactation suppression, and prostate cancer.

Research concerned with troubled pregnancies conducted by Harvard-associated researchers Olive and George Smith led to experimentation with DES as "replacement therapy" for hypothesized hormonal problems. Howev-

er, in reporting this work Smith and Smith emphasized the potential value of DES for *all* pregnancies as a preventive measure (Smith and Smith 1941, 1949, 1954). Note especially the title, "The prophylactic use of diethylstilbe-strol to prevent fetal loss from complications of late pregnancy" (1949), pub-lished in the widely read *New England Journal of Medicine*.[9] Companies quickly seized upon this fanfare. With advertisements in major medical jour-nals, coverage in the mass media, and the work of detail men (pharmaceuti-cal company salesmen who went doctor to doctor pushing drugs), DES became a "medical miracle." Over 100 companies marketed DES under 200 different brand names. One ad, for instance, stated:

> "Really?" Yes . . . desPlex® to prevent ABORTION, MISCARRIAGE and PREMATURE LABOR recommended for routine prophylaxis in ALL pregnancies . . . 96 per cent live delivery with desPLEX in one series of 1200 patients — bigger and stronger babies too. No gastric or other side effects with desPLEX — in either high or low dosage. (see Apfel and Fisher 1984: 26)[10]

Estrogen had been known as a cancer-causing agent as early as 1932.[11] But in 1947, on almost no evidence, the FDA approved DES for pregnant women who had had multiple miscarriages.[12] In 1952 and 1953 the use of DES at all in pregnant women was vigorously challenged by three articles in the *Ameri-can Journal of Obstetrics and Gynecology*. Through controlled studies, the authors showed that DES was not effective at altering miscarriage rates and quite possibly even worse than placebos (Dieckmann et al. 1953; Ferguson 1953; Robinson and Shettles 1952).[13] But pressure on doctors was apparently quite intense. One paper commented:

> The synthetic estrogen, diethylstilbestrol, has recently become a popu-lar form of therapy in threatened abortion. The public has been so fre-quently told of the virtues of this drug through articles appearing in lay journals, that it now requires a courageous physician to refuse this medication.[14]

The blame in this passage appears to lie with the pharmaceutical compa-nies, the mass media, and anxious patients. But experiences related by women during the 1950s tell a story that also includes doctors prescribing DES as a matter of course, sometimes without telling them, or even telling them that it was a vitamin (Boston Women's Health Book Collective 1992). The Physician's Desk Reference (PDR), a compendium of medication infor-mation, listed DES along with the very high dosage schedule recommended by the Smiths under the heading: "used to prevent accidents of pregnancy," every year from 1947 to 1962. Although the detailed dosage schedule was dropped from the PDR, DES was still indicated for use to prevent pregnancy

accidents until 1968. In 1969, prescribers were warned of possible adverse effects on the fetus, but only in 1973 was pregnancy use contraindicated (Apfel and Fisher 1984:137 fn 20).[15]

In 1971, DES started to become a villain in the popular consciousness and in the medical community. An article published in the *New England Journal of Medicine* stated that a very rare form of cancer, usually only found in women over fifty, had been found in four young women and that all of them had been exposed to DES prenatally. A controlled follow-up of other cases of vaginal clear-cell adenocarcinoma resulted in a clearly significant correlation between DES exposure and the cancer. This marked the first time that a carcinogen had been found to pass through the placenta and affect the fetus growing in the womb. It also was the first time "a specific cancer had been so authoritatively linked to an environmental source" (Fenichell and Charfoos 1981:89–90).[16] The impact of this article was such that the FDA fairly quickly banned the use of DES with pregnant women.[17] Congress also began to look into the widespread use of DES in rearing cattle for meat production. Informal use of DES by some doctors continued in the United States probably through 1975 (Madaras and Patterson 1984:810), and in Europe, DES was used in many places through the 1970s and into the 1980s.[18]

The publicity and public outcry that followed the initial articles on DES and cancer enabled women who had the rare cancer and had been exposed to DES to start filing lawsuits against the manufacturers of the drug.[19] They faced, however, two unique difficulties in bringing these cases to trial. First, statute-of-limitation laws required that suits be filed within a few years of the injury. In the case of DES, sixteen to twenty-five years elapsed before the injuries became known. As a solution, some states passed specific laws allowing DES daughters to sue from the time their injuries became known. The second difficulty that DES daughters faced was that in many cases, medical records proved useless for figuring out which of the two hundred DES drugs was actually taken by their mothers. Normal law required that the plaintiff (the woman) prove that the defendant (a specific pharmaceutical company) actually caused the harm. For these plaintiffs, although DES clearly caused the harm, the question remained which company was actually to blame. Regarding liability, eventually a number of states created an innovative precedent, market-share liability: in cases where DES could be shown to cause the injury but the specific company could not be determined, each company would be held responsible for the percentage of damages equal to its share of the DES market when the drug was prescribed.[20]

The decade following 1971 saw coordinated activities dedicated to tracking and studying the effects of DES. By 1974, the NCI set up a cooperative project to study the incidence and natural history of genital changes and cancer in DES daughters, called the DESAD (DES-Adenosis) Project (DES

Task Force 1978:4). Registries were set up for locating and tracking DES daughters.[21] By 1977, two articles had been published suggesting that DES daughters were at greater risk for menstrual disorders, miscarriages, ectopic pregnancies, premature delivery, and perhaps infertility (Kaufman et al. 1977; Bibbo et al. 1977). These were noted by the 1978 DES Task Force, which established that DES daughters all needed to be monitored at least annually with a special series of tests (known as the DES exam) to guard against cancer and other problems. This DES exam was detailed in the report and supposed to be disseminated to the entire medical community and to the rest of the population.

Women's health activists also took up the task of informing themselves and others about the effects of DES. The U. S. "DES Action" groups, modeled on DES Action Netherlands, and "DES Watch" groups, were formed to force the government and health professionals to deal with the crisis.[22] In England, a 1973 BBC documentary on DES received almost no response. By contrast, the BBC's 1989 documentary received over 500 calls and led to the formation of the DES Action Group UK (Emens 1994), also based on DES Action Netherlands. The continued pressure of activist groups like DES Action, as well as the lawsuits, appears to have been and continues to be a necessary stimulus for studies of affected women (Apfel and Fisher 1984:109).

In 1984 three popular guides to women's care each included extensive sections on DES. *Womancare: A Gynecological Guide to Your Body* (Madaras and Patterson 1984) lists DES on thirty-seven pages, including a ten-page section specifically on DES that provides a history and a comprehensive list of the studies to date relating to it, a list of seventy-seven DES-type drugs that may have been prescribed to pregnant women, and specific instructions that DES daughters need to become experts themselves:

> It is important to find experienced doctors, for inexperienced ones may not know how to do the correct tests, may miss important signs or may mistreat or dismiss the condition. . . . DES daughters should familiarize themselves with the signs of ectopic pregnancy. (812, 816)

The book lists ways to get in touch with DES activist organizations, obtain government pamphlets, and locate DES-aware doctors. It provides detailed information on DES exams, problem warning signs, psychological problems with guilt between mother and daughter, and with having gynecological tests at very early ages. It even mentions how to contact organizations regarding lawsuits should one have serious problems.

The second book, *Our Bodies, Ourselves: A Book by and for Women*, by the Boston Women's Health Book Collective (1984:583–586) provides a similar overview in four pages. It also notes that more research is needed in all areas and that some doctors still do not know about DES problems and the DES

exam. The third book, a popular pregnancy guide, *What to Expect When You're Expecting* (Eisenberg, Murkoff, and Hathaway 1984) begins a section on DES by acknowledging that many exposed women are worried about its effect on their pregnancies. While it downplays the risks, noting that "happily, these effects appear to be minimal—it is estimated that at least 80 percent of DES-exposed women have been able to have children," it then provides a clear warning regarding the risk of ectopic pregnancies, the need to be aware of ectopic symptoms, and the need to inform your obstetrician of your exposure. Each of these three books cites DES as a risk factor in their sections on ectopic pregnancies, and each provides information on how to get better informed about DES. And when they were revised and reprinted, each continued their section on DES.

The 1985 DES Task Force published similar information on the effects of DES on daughters and sons, but also indicated that "the weight of the evidence in January 1985 now indicates that women who used DES during their pregnancies may subsequently experience an increased risk of breast cancer" (p. 9). It thus became clear that DES affected almost everyone it touched and that DES mothers as well as their children were at significant risk for problems and all should be informed and watched carefully. The Task Force also reiterated its 1978 plea: "All physicians and other health professionals should be informed."

Further government initiatives have continued into the present. In 1993, for instance, the NCI and the National Institute of Child Health and Human Development (NICHD) put out a request for proposals for cooperative agreements to develop a national program to inform health professionals and the public on the adverse effects of DES. Thus there has been an apparently continuous emphasis on studying DES effects and on informing doctors and potential sufferers since 1971, when the first cancer was linked to DES daughters.

■ AT PRESENT, A FRACTURED FIELD OF FACTS

Understanding Pregnancy and Childbirth is one of the most highly regarded and widely read pregnancy and childbirth books ever published. . . . Sheldon H. Cherry, M.D., named by *New York* magazine as one of "The Best Doctors in New York" in 1991, is a practicing obstetrician and gynecologist . . . his column, "Pregnancy and Childbirth," appears regularly in *Parents Magazine*.

—From the back of *Understanding Pregnancy and Childbirth*, 1992 (which mentions that DES increases risk for miscarriages but fails to mention that it also increases risk for ectopic pregnancies and cancer)

Given the above history, one would assume that most DES-exposed daughters and sons would know of their exposure and that practicing obstetricians and gynecologists would be aware of how to handle DES-exposed patients or

to refer them to specialists. Yet, in spite of the published medical journal articles, in spite of the persistent warnings in obstetrical and gynecological textbooks, and in spite of some popular books which cite chapter and verse studies indicating the risks for pregnant DES daughters, there remains a surprisingly uneven field of facts available to readers. Too many books, popular and medical, say nothing about the risks of DES for women today. In cyborg terms, under the deceptive guise of informing readers, they instead hobble their ability to understand and get help for their drug-altered bodies.

When most critics comment on flaws in the medical treatment system, they usually focus on the ambiguity or absence of substantial and substantiated knowledge. The implicit assumption of almost all critics is that once a fact can be firmly established by and among professionals, it is then a real fact and should be treated as such. The finality implied by the notion of "established fact" belies the *work* of facts. Precisely who actually hears or reads the accounts of the facts? Where exactly are they repeated in print and taught to students? How are they perpetuated from year to year, book edition to book edition? Answering these questions requires accounting for facts as material objects circulating among us. The issue we need to address is how facts actually travel, their life cycle.

To this end, I conducted a field survey of the published literature, searching through obstetrics and gynecology textbooks, pamphlets, popular pregnancy handbooks, and the Internet. The results were not encouraging, but they portray the need for an anthropology of facts to complement cultural approaches to medicine and histories of knowledge.

Popular books, manuals, and guides for women on pregnancy were examined for information relating to DES exposure, specifically for whether there was any connection made between DES and cancer, miscarriages, ectopics, and the need for exposed women to get a special exam and see a doctor who is aware of how to treat DES complications. Table 1 is a preliminary survey.

Updated copies of both *What to Expect When You're Expecting* (1996) and *The New Our Bodies, Ourselves* (1992) contained DES information almost identical to that in their 1984 editions, with *Our Bodies* noting specifically that:

> Although we know much more about DES than we did ten years ago,
> daughters, sons and mothers face unanswered questions about their
> future health. More research is needed in all areas. Furthermore, some
> doctors still do not know about the DES exam, special pregnancy problems and recent medical findings; their ignorance can result in serious
> overtreatment or undertreatment. Finally we need to tell the DES story
> so that people who have been exposed can receive the medical care
> that they need and so that we can help prevent similar medical mistakes from happening in the future. (p. 586)

Table 1: DES and Popular Pregnancy and Childbirth Books

Books	Indexes DES	DES and cancer	DES and miscarriage	Need for special exam	DES and ectopic	DES action	# of DES exposed
What to Expect When You're Expecting 1996	X	X	X	X	X	X	>million
Womancare 1984	X	X	X	X	X	X	millions
New Our Bodies, Ourselves 1992	X	X	X	X	X	X	3–6 million
The Planned Parenthood Women's Health Encyclopedia 1996	X	X	X	X	–	X	2.4 million daughters
AMA Complete Guide to Women's Health 1996	X	X	X	–	–	–	–
Understanding Pregnancy and Childcare 1992	X	–	X	–	–	–	–
The Complete Book of Pregnancy and Childbirth 1996	X	X	–	–	–	–	–
Birth over Thirty-five 1995	X	X	–	–	–	–	–
Natural Childbirth the Bradley® Way 1996	X	X	–	–	–	–	–
Your Pregnancy: Questions and Answers 1995	X	–	–	–	–	–	–
Planning for Pregnancy, Birth and Beyond 1994	–	–	–	–	–	–	–

That is it, however, for helpful pregnancy books. The last book listed in the table, *Planning for Pregnancy*, the official book of the American College of Obstetrics and Gynecology, "America's leading authority on women's health care," has no index entry for DES and does not mention it when discussing ectopic pregnancies. More troubling, perhaps, are the two books that index DES but say nothing about its potential problems for the pregnant woman. They provide the clear impression that DES exposure exists but does not require further action. Susan McCutcheon's *Natural Childbirth the Bradley® Way*, revised 1996, a manual on taking back control over your pregnancy, actually uses DES as an example of why we cannot trust doctors or the FDA. Yet it is hard, I feel, to trust the authors of this book as they do not inform the millions of DES-exposed daughters, who are potentially part of their readership, of existing risks. Likewise, Sheila Kitzinger's *Birth over Thirty-Five* notes DES only as "the notorious drug that causes a special kind of cancer in the vagina of some daughters of women who have taken it at the beginning of pregnancy" and fails to warn her especially at-risk readership of the specific challenges of DES exposure (1995:27–28). Kitzinger's (1996) *The Complete Book of Pregnancy and Childbirth* actually mentions that DES sons and DES daughters both have problems: "The daughters had higher rates of vaginal cancer and cervical malformations. Some of these women with malformed cervixes need cervical cerclage and some do not" (1996:115). Unfortunately for her readers, she does not specifically direct them to knowledgeable doctors, nor does she warn of increased risk of miscarriages, ectopics, and other problems in all DES daughters.

These books raise a series of questions regarding accountability and facts in public advice giving. Do the authors of popular self-help, pregnancy, and childcare books have an ethical obligation to warn of potential risks such as DES? Is their assumption perhaps that specific pregnancy problems will be handled by their readers' doctors? Should the lapses be termed errors? Or should the failure be laid at the feet of government task forces and activist groups who have not gotten the word out to enough people?

These questions foreground the issue of a specific culture of facts. In this case, the quality of expert opinion packaged for a popular audience functions as a very poor knowledge prosthetic. The unevenness apparently testifies to the lack of homework done by the authors and the lack of oversight by their sponsors (including the AMA and ACOG), as well as by their publishers.

Books written specifically for obstetricians and gynecologists revealed a more significant problem. Tables 2 and 3 summarize the results of a field survey of books used in medical schools and available in medical school bookstores for purchase by medical students.

As Table 2 shows, every current textbook I was able to locate in a medical library indicated that DES was a risk factor for ectopic pregnancy. Further,

Table 2: DES in Physician Textbooks

Textbooks	Indexes DES	DES and cancer	DES and miscarriage	Need for special exam	DES and ectopic	DES action	# of DES exposed
Drugs in Pregnancy and Lactation: A Reference Guide to Fetal and Neonatal Risk, 9th ed. 1994	X	X	X	X	X	X	6 million
Infertility, Contraception and Reproductive Endocrinology, 3rd ed. 1991	X	X	X	X	X	–	2 million
Current Obstetrics and Gynecological Diagnosis and Treatment, 8th ed. 1994	X	X	X	X	X	X	1 million
Williams Obstetrics, 19th ed. 1993	X	X	X	X	X	–	.5–2 million; 3 million
Danforth's Obstetrics and Gynecology, 7th ed. 1994	X	X	X	X	X	–	–
Novak's Gynecology, 12th ed. 1996	X	X	X	X	X	–	–
Essentials of Obstetrics and Gynecology, 2nd ed. 1992	X	X	X	X	X	–	–
Manual of Clinical Problems in Obstetrics and Gynecology, 3rd ed. 1990	X	X	X	X	X	–	–

Table 3: *DES in Physician Handbooks*

Handbooks	Indexes DES	DES and cancer	DES and miscarriage	Need for special exam	DES and ectopic	DES action	# of DES exposed
Obstetrics, Gynecology and Infertility: Handbook for Clinicians (Resident Survival Guide), 4th ed. 1995	X	X	X	X	X	–	–
Physicians Drug Handbook, 6th ed. 1995	X	X	–	X	–	–	–
Danforth's Handbook of Obstetrics and Gynecology 1996	X	–	X	–	–	–	–
Lexi Comp Drug Information Handbook, 4th ed. 1996–97	X	–	–	–	–	–	–
Manual of Obstetrics, 5th ed. 1996	–	–	–	–	–	–	–
Obstetrics and Gynecology: House Officer Series 1988	–	–	–	–	–	–	–

each one cautioned about the need for special attention to the bodies of DES daughters regarding both reproductive and cancer risks. Apparently at this level, then, there is consensus within the medical community on the importance and specific effects of DES. These textbooks, however, are all over a thousand pages and weigh over five pounds, and it is quite difficult to maneuver them and look up entries.

Many physicians use the handbooks, trade paperbacks, and smaller versions of the textbooks, listed in Table 3, that are clearly designed to be easily accessed reference works. Yet these books reveal a fairly amazing absence of referents. Comparing two apparently related books demonstrates a particularly troubling contradiction: the textbook *Danforth's Obstetrics and Gynecology*, 7th ed. (Scott and DiSaia 1994) clearly indicates the 5–13 percent risk of ectopic pregnancies with DES daughters. But its handbook version, *Danforth's Handbook of Obstetrics and Gynecology* (Scott and DiSaia 1996), only mentions that DES is related to miscarriages. They are both edited by the same doctors and published by the same company, but in the translation from the large-format 1,121-page textbook to the 544-page trade handbook, the warning regarding the special care needed for DES daughters is dropped, and DES is deleted from a list of risk factors for ectopic pregnancies.

Only one of six handbooks I found in a medical school bookstore attended to the risks associated with DES. *Obstetrics, Gynecology and Infertility: Handbook for Clinicians (Resident Survival Guide)*, 4th ed. 1995, a very tiny three-by-four-inch book, devoted two pages to DES, including a list of associated risks and a summary of a DES specific exam. Further, under ectopic pregnancies, it mentioned DES as a risk factor. *None* of the other handbooks noted this.

Other handbooks commit the same sin as many of the popular guides, mentioning DES without linking it to effects like ectopic pregnancies. Finally, two handbooks, *Obstetrics and Gynecology: House Officer Series* (1988) and *Manual of Obstetrics*, 5th ed. (Niswander and Evans 1996), fail to index DES at all. These handbooks clearly try to stand as reference works. The failure of these handbooks to replicate the knowledge regarding DES that is well known and clearly stated in textbooks and journal articles indicates a fault line in the field of fact circulation. Truth apparently varies considerably depending upon what level of reference one accesses. It is quite possible, then, to imagine that a competent doctor might check in his or her handbook for any precautions regarding DES and find nothing.

It is also possible that the authors of the popular guides to pregnancy and childbirth checked these handbooks, rather than textbooks or Medline, to locate information regarding DES and ectopic risk factors. If this is the case, then I have identified a specific site of fact reproduction that effectively and continuously short-circuits the efforts of most other cultural actors combined-

—task force recommendations, DES Action work, and textbook writers. The next step in this anthropology of facts would be to conduct participant observation among medical school students and to interview handbook and popular book writers to locate precisely how these facts are circulated.

This is also the place to recognize that an anthropology of facts is also an anthropology of politics, discovering where monitoring and pressure have failed, and where they should be applied. Given the almost continuous attention to DES since 1971, I certainly did not expect the randomness of attention in current obstetric and gynecological handbooks, nor in popular books written for pregnant women. Why this is the case is an important question, but not one I want to address here. Continuing reasons for the current state of relatively poor health care in the United States for women include the closed system of medical care, doctors not wanting to shoulder blame (Apfel and Fisher 1984), patriarchy (Ehrenreich and English 1978), capitalism (Rothman 1989), the reification of technology (Davis-Floyd 1992), the extreme influence of pharmaceutical companies on medical practice (Fenichell and Charfoos 1981), poor regulation by the government, short historical memory, and so on. This sustained ignorance has been repeatedly noted by many others. The 1978, 1985, and 1992 NCI DES Task Forces and panels have all emphasized the need for better dissemination of information to doctors and the general population, and those popular health books that do address the problems of DES exposure also complain about the numbers of doctors who are completely clueless.

Sylvia and I are adding our voices to this chorus, but I am also pointing to the need for a critical attitude toward informed expertise and the printed word. The facts that stand for truth turn out to be local and arbitrary. With Sylvia's next pregnancy, we went to Georgetown University Medical Center in Washington, D.C., where we were seen by doctors who had spent much of the last twenty years dealing specifically with high-risk pregnancies and DES daughters. They monitored Sylvia extensively and provided excellent care, allowing us retrospectively to understand just how incompetent the doctors at the Westside Women's Place had been. Yet even among these more qualified physicians, there seemed to be a cloud of misinformation around DES. "At least we won't have to worry too much longer about your kind," one doctor told Sylvia, "you're a dying breed." Perhaps he was thinking that after twenty-plus years, the need for vigilance on this particular set of problems will be over. But we could only wonder at the effect of words like those on medical students still four years away from seeing patients. Will their eyes glaze over during a lecture on DES, because they assume that DES is at least one thing they won't have to remember when they start practicing? As doctors in the future, faced with DES daughters asking for proper care, will they consult

their handbook and calmly assert that DES has nothing to do with ectopics? If so, then a senior doctor's words and the handbooks will have helped to reproduce further harm. DES daughters will continue to be produced as unwilling, ignorant cyborgs, suffering not only from the previous fusion of the drug with their bodies but also from the ongoing assault of material facts on their bodies as well.

Our story, at least, has a happy ending. In August 1995, after careful monitoring, weekly ultrasound, CVS, more surgery at sixteen weeks (this time to perform a combination Shirodkar and McDonald cerclage procedure, a technique for reinforcing cervixes that have been rendered "incompetent"— another effect of DES), Andrew Elijah was born by scheduled cesarean.

■ HISTORY IS NOT. FACTS ARE NOT.

This concluding heading highlights the issue of the uneven circulation of facts in our lives. Despite the history of DES, despite the "facts" known about DES, one can too easily live in the present as if DES has neither history nor truth. By analyzing the history of DES in the context of one particular personal experience, we have attempted to pin down where exactly facts play a role in the knowledge and treatment of DES daughters. Attending anthropologically to the circulation of facts as material objects and actors, we have located specific sites of fracture across which facts disappear or become their opposite. With DES, these sites are the many medical handbooks and popular pregnancy guides that play roles within the daily knowledge activities of women, men, and doctors.

In cyborg terms, these technologies of writing continually intervene in our reproduction. This chapter could have been about how and why drug-altered bodies are cyborg, how and why that original cyborgian alteration with drugs must then extend to further alterations with technologies, how all these cyborgian alterations put the altered subject, now thoroughly cyborg, on the frontier of technomedicine where all the unknowns lie, and how and why our fascination with and reification of technology keep us from treating subjects on that frontier as if we don't know that we don't know. But the "low-tech" apparatuses of textual "fact" production should not be separated from "high-tech" biomedicine, because ultimately they underpin it. Conspiracies and structural discrimination are not necessary; small gaps in dissemination are enough to produce violent effects. Educational technologies like medical school, reference technologies like handbooks, and informational technologies like popular guides each mediate the application, production, and reproduction of science, technology, and bodies. Our nature, as we come to know it, depends upon our culture of information. We hope that this chapter can

point to methods that can be used to analyze the facts that are available in a more anthropologically informed manner, attending to the circulation of "facts" as a critical part of our own lives and to the subtleties of our increasingly cyborg selves.

Notes

1 Sylvia writes: I drew on Joe's research for an article entitled "Medical Care for the DES Daughter," published by the online journal Healthgate. See http://www.healthgate.com/healthy/woman/1997/DES/index.shtml.

2 The quotation cites Stovall et al. 1990:1098.

3 Although the American Institute of Ultrasound in Medicine (AIUM) has established guidelines for examinations and procedures, they are only "guidelines." Medicine is an "open" license, and there is nothing that prevents a doctor or medical establishment from purchasing ultrasound equipment and using it in their practice, regardless of their expertise or training in it.

4 See Giusti et al. (1995) and Swan (1992) for references to these findings.

5 Based on Medline-sampled journals only.

6 The best concise history of DES can be found in Diana B. Dutton's *Worse than the Disease: Pitfalls of Medical Progress* (1988:31–90). For a detailed history, see Susan Bell's dissertation "The Synthetic Compound Diethylstilbestrol (DES), 1938–1941: The Social Construction of a Medical Treatment" (1980) as well as Bell (1995). Books focusing solely on DES include *Women and the Crisis in Sex Hormones* by Barbara Seaman and Gideon Seaman (1977), *Daughters at Risk: A Personal DES History*, by Stephen Fenichell and Lawrence S. Charfoos (1981), *DES: The Complete Story* by Cynthia Orenberg (1981), *D.E.S.: The Bitter Pill* by Robert Meyers (1983), *To Do No Harm: DES and the Dilemmas of Modern Medicine* by Roberta J. Apfel and Susan M. Fisher (1984). DES is also a featured case study in a number of books including the Institute of Medicine's 1994 two-volume report: *Women and Health Research*. It is not my purpose here to shed new light on this history. I retell it because many people who should know about it have not heard it .

7 See the Introduction for a number of examples.

8 A 1940 pamphlet by the pharmaceutical corporation Merck and Co., Inc., *Diethylstilbestrol: Annotated Bibliography, Revised October 1940*, lists 148 articles on DES, 55 on clinical uses. The October 1941 revision lists 249 articles, with 126 on clinical uses.

9 Note for instance the following two titles: "The prophylactic use of diethylstilbestrol to prevent fetal losss from complications of late pregnancy" from the *New England Journal of Medicine* (Smith and Smith 1949) and "Prophylactic hormone therapy: relation to complications of pregnancy" from *Obstetrics and Gynecology* (Smith and Smith 1954).

10 Apfel and Fisher (1984) review the literature cited in the ad and comment on the absence of the 1953 Dickermann paper "demonstrating that DES was ineffective for normal pregnancies." This ad is also reproduced in many other books and articles on the history of DES use. It also can be seen at the NCI web site DES PUBLICATIONS, Guides for DES-Exposed Mothers, Daughters, and Sons (http://www.dcpc.nci.nih.gov/PCEB/pubs/DES_Pubs/ directory.html).

11 Lacassagne (1938), reviewed and confirmed by Allen et al. (1939). Fenichell and Charfoos (1981:31); Apfel and Fisher (1984).

12 "Between 1941 and 1947, [DES] was used during pregnancy without FDA approval. . . . Stunningly, the expansion of DES usage to pregnancy and the introduction of larger doses were done by simple administrative fiat. No new research data or reviews were required, and

the use of DES was now exempted from official regulatory constraint" (Apfel and Fisher 1984:20). Apfel and Fisher provide a detailed account of exactly how many photocopied articles and arguments were exchanged between pharmaceutical companies and the FDA (135 fn 13). They further note that the studies used in support of this were primarily the articles of Smith and Smith, none of which were based on "blind" trials: in each case, the investigators knew who was getting DES and who was not.

13 These were accompanied by editorials in JAMA, NEJM, and Lancet noting the risk being incurred by women. But these warnings were all but ignored (Dutton 1988; Noller and Fish 1974). These articles have themselves been the subject of a series of case studies of controlled clinical trials (Grant and Chalmers 1985; Berendes and Lee 1993; Macarthur et al. 1995).

14 Robinson and Shettles (1952). Cited in Fenichell and Charfoos (1981:60), and in other DES histories (e.g., Grant and Chalmers 1985:70–71).

15 The PDR has been published since 1947 in cooperation with drug manufacturers. Critics note that the PDR is effectively a marketing tool of drug companies that is regulated by the FDA (Dutton 1988:57, 401 fn 123–127).

16 They and others have pointed out that this linking of cancer to the drug was only possible because the specific cancer had *never* before been documented in young women.

17 Though not immediately. New York State banned it within two months following confirmation of additional cases of cancer in young girls exposed to DES in utero. The FDA waited until Congress ordered hearings on the matter. (See Fenichell and Charfoos 1981:160+.) Fenichell and Charfoos estimate that as many as 20,000 more women were given DES during the delay.

18 Until 1975 in England and the Netherlands, until 1977 in France, until 1981 in Spain and Italy, and until 1983 in Hungary. "DES was prescribed in every country where U.S. drug companies had markets" (Boston Women Health Book Collective 1992:583).

19 By 1976 there were forty-eight lawsuits on file, five class action suits (Fenichell and Charfoos 1981: 166). By 1984 there were over one thousand suits (Mariner 1984).

20 A quick search on a legal database revealed 428 articles on DES, indicating the impact these lawsuits had on the legal and pharmaceutical communities. The search was conducted using Legal Resources Index, which provides indexing for over 750 legal sources.

21 In addition to DESAD, there was a study tracking DES mothers, one tracking DES sons, follow-ups to three 1950s trials, and a clear-cell adenocarcinoma registry. There are also two recent NCI initiatives to study DES-exposed mothers, daughters, and sons. See Giusti et al. (1995: 779–781) for more details.

22 For further information on DES Action, see their web site (http://www.desaction.org).

References

Allen, E., H. Danforth, and A. Doisy, eds. 1939. *Sex and Internal Secretions: A Survey of Recent Research*. 2d ed. Baltimore: Williams and Wilkins.

Apfel, Roberta J., and Susan M. Fisher. 1984. *To Do No Harm: DES and the Dilemmas of Modern Medicine*. New Haven: Yale University Press.

Barnes, Ann, and National Institutes of Health. 1980. *Fertility and Outcome of Pregnancy in Women Exposed in Utero to Diethylstilbestrol*. Bethesda: Department of Health, Education, and Welfare, Public Health Service, National Institutes of Health.

Bell, Susan. 1980. "The Synthetic Compound Diethylstilbestrol (DES), 1938–1941: The Social Construction of a Medical Treatment." Ph.D. diss., Brandeis University.

———. 1981. "A New Model of Medical Technology Development: A Case Study of DES." *Research in the Sociology of Health Care* 4:1–32.

– – –. 1995. "Gendered Medical Science: Producing a Drug for Women." *Feminist Studies* 21 (3): 469–500.

Benson, Ralph Criswell, and Martin L. Pernoll. 1994. *Benson and Pernoll's Handbook of Obstetrics & Gynecology*. 9th ed. New York: McGraw-Hill.

Berendes, H. W., and Y. J. Lee. 1993. "Suspended Judgment. The 1953 Clinical Trial of Diethylstilbestrol during Pregnancy: Could It Have Stopped DES Use?" *Controlled Clinical Trials* 14 (3): 179–182.

Bibbo, M., W. B. Gill, F. Azizi, R. Blough, V. S. Fang, R. L. Rosenfield, G. F. Schumacher, K. Sleeper, M. G. Sonek, and G. L. Wied. 1977. "Follow-Up Study of Male And Female Offspring of DES-Exposed Mothers." *Obstetrics and Gynecology* 49 (1): 1–8.

Bichler, Joyce. 1981. *DES Daughter: The Joyce Bichler Story*. New York: Avon Books.

Boston Women's Health Book Collective. 1992. *The New Our Bodies, Ourselves: Updated and Expanded for the '90s*. New York: Touchstone.

Briggs, Gerald G., Roger K. Freeman, and Sumner J. Yaffe. 1994. *Drugs in Pregnancy and Lactation: A Reference Guide to Fetal and Neonatal Risk*. 4th ed. Baltimore: Williams and Wilkins.

California Department of Health Services. 1983. "Report to the California Legislature on the DES Program Pursuant to SB 1392 (chapter 776, Statutes of 1980)." Sacramento: State of California, Health and Welfare Agency, Department of Health Services.

California Department of Health Services, Ad Hoc Advisory Committee on DES, and Moses Tran Clegg. 1978. "Guidelines for the Management of DES-Exposed Daughters." Davis: State of California, Health and Welfare Agency, Department of Health Services.

Clegg, Moses Tran. 1954. *The Use of Stilbestrol in Fattening Cattle*. Berkeley: Division of Agricultural Sciences, University of California.

Clements, Roger V. 1994. *Safe Practice in Obstetrics and Gynaecology: A Medico-Legal Handbook*. Edinburgh and New York: Churchill Livingstone.

Cruikshank, Stephen H., and Allan Chamberlain. 1990. *Gynecology for the House Officer*. Books in the House Officer Series. Baltimore: Williams and Wilkins.

Cunningham, F. Gary, and J. Whitridge Williams, eds. 1993. *Williams' Obstetrics*. 19th ed. Norwalk, Conn.: Appleton & Lange.

Datta, Sanjay. 1995. *The Obstetric Anesthesia Handbook*. 2d ed. St. Louis: Mosby.

Daubresse, Etienne. 1948. *Le Stilboestrol* [par] E. Daubresse [et al.] Conference de Bruxelles, 9 mars 1947. Bruxelles: Editions Erasme.

Davis-Floyd, Robbie. 1992. *Birth as an American Rite of Passage*. Berkeley and London: University of California Press.

DeCherney, Alan H. 1994. *Current Obstetrics & Gynecologic Diagnosis and Treament*. 8th ed. Lange Medical Book Series. Boston: Appleton & Lange.

Dieckmann, W. J., M. E. Davis, L. M. Rynkiewicz, and R. E. Pottinger. 1953. "Does the Administration of Diethylstilbetrol during Pregnancy Have Therapeutic Value?" *American Journal of Obstetrics and Gynecology* 66: 1062–1081.

Dolin, Eliza Anne. 1985. *The Biomedical Construction of Knowledge and Utility: Toward a New Anthropology of Science and Technology*. Senior honors thesis, Department of Anthropology, Harvard University.

Dutton, Diana Barbara. 1988. *Worse than the Disease: Pitfalls of Medical Progress*. New York: Cambridge University Press.

Edelman, David A. 1986. *DES/Diethylstilbestrol: New Perspectives*. Lancaster: MTP Press.

Ehrenreich, Barbara, and Deirdre English. 1978. *Complaints and Disorders: 150 Years of the Experts' Advice to Women*. Garden City, N. Y.: Anchor Press.

Eisenberg, Arlene, Heidi Eisenberg Murkoff, and Sandee Eisenberg Hathaway. 1984. *What To Expect When You're Expecting*. New York: Workman.

Emens, J. M. 1994. "Continuing Problems with Diethylstilboestrol." *British Journal of Obstetrics and Gynaecology* 101 (9): 748–750.

Farmer, Jan, and National Library of Medicine. 1975. "Diethylstilbestrol and Gynecologic Neoplasms: January 1970 through December 1974, 80 citations." Literature Search no. 75–3. Bethesda: U.S. Department of Health.

Fenichell, Stephen, and Lawrence S. Charfoos. 1981. *Daughters at Risk: A Personal DES History*. Garden City, N.Y.: Doubleday.

Ferguson, J. H. 1953. "Effect of Stilbestrol on Pregnancy Compared to the Effect of a Placebo." *American Journal of Obstetrics and Gynecology* 65: 592–601.

Fink, Diane J., National Institutes of Health, and United States DES Task Force, Office of the Assistant Secretary for Health. 1978 DES Task Force Summary Report. Bethesda: U.S. Department of Health and Human Services, Public Health Service, National Institutes of Health.

— — —. 1984. *DES Task Force Summary Report* (first issued September 1978). NIH Publication no. 84–1688. Bethesda: U.S. Department of Health and Human Services.

— — —. 1985. *DES Task Force Summary Report* (Sept. 21, 1978). Bethesda: U.S. Department of Health and Human Services, Public Health Service, National Institutes of Health.

Fisher, Susan M., and Roberta J. Apfel. 1988. "Female Psychosexual Development: Mothers, Daughters, and Inner Organs." *Adolescent Psychiatry* 15: 5–33.

Giusti, R. M., K. Iwamoto, and E. E. Hatch. 1995. "Diethylstilbestrol Revisited: A Review of the Long-Term Health Effects." *Annals of Internal Medicine* 122 (10): 778–788.

Gordon, John D., Maurice L. Druzin, and Jan T. Rydfors. 1995. *Obstetrics and Gynecology: Handbook for Clinicians (Resident Survival Guide)*. San Francisco: Scrub Hill Press.

Grant, A., and I. Chalmers. 1985. "Epidemiology in Obstetrics and Gynaecology: Some Research Strategies for Investigating Aetiology and Assessing the Effects of Clinical Practice." In *Scientific Basis of Obstetrics and Gynaecology*. 3d ed. Edited by Ronald R. Macdonald, 49–84. Edinburgh: Churchill Livingstone.

Hacker, Neville F., and J. George Moore. 1992. *Essentials of Obstetrics and Gynecology*. 2d ed. Philadelphia: Saunders.

Hamm, Alice Collins, National Cancer Institute, Division of Cancer Control and Rehabilitation, Office of Cancer Communications, National Institutes of Health. 1980. *Questions and Answers about DES Exposure during Pregnancy and before Birth*. Bethesda: U.S. Department of Health and Human Services, Public Health Service, National Institutes of Health.

— — —. 1984. *A Followup Study of Mothers Exposed to Diethylstilbestrol in Pregnancy*. Bethesda: National Cancer Institute, Office of Cancer Communications.

Hecht, Annabel, United States Food and Drug Administration, Office of Public Affairs. 1979. *DES: The Drug with Unexpected Legacies*. Bethesda: Department of Health, Education, and Welfare, Public Health Service, Food and Drug Administration, Office of Public Affairs.

Herbst, Arthur L., Chicago Symposium on DES, American College of Obstetricians and Gynecologists. 1978. *Intrauterine Exposure to Diethylstilbestrol in the Human: Proceedings of "Symposium on DES,"* 1977. New York: Bantam Books.

Herbst, Arthur L., and Howard Alan Bern. 1981. *Developmental Effects of Diethylstilbestrol (DES) in Pregnancy*. New York: Thieme-Stratton.

Hill, Anna Bailon. 1982. "Cytogenetic Effects Induced by Diethylstilbestrol in Human Lymphocytes." Ph.D. dissertation, Department of Genetics, University of California, Berkeley.

Hillard, Paula J. A. 1993. "Gynecologic Disorders and Surgery." In *Psychological Aspects of Women's Health Care: The Interface between Psychiatry and Obstetrics and Gynecology*, edited by Donna E. Stewart and Nada L. Stotland. Washington D.C.: American Psychiatric Press.

Holmes, Helen B., Betty B. Hoskins, and Michael Gross. 1981. *The Custom-Made Child?: Women-Centered Perspectives*. Clifton, N.J.: Humana Press.

Jensen, Sigurd Eskjar. 1992. *Studies of the Effect of Diethylstilbestrol on the Plasma Lipids and Thyroid Function: An Experimental Investigation of 20 Male Patients Who Have Recovered from Coronary Occlusion*. Chicago: Aarhus, American College of Obstetricians and Gynecologists.

Kaufman, R. H., G. L. Binder, P. M. Gray, Jr., and E. Adam. 1977. "Upper Genital Tract Changes Associated with Exposure in Utero to Diethylstilbestrol." *American Journal of Obstetrics and Gynecology* 128 (1): 51–59.

Kaufman, R. H., K. Noller, E. Adam, et al. 1984. "Upper Genital Tract Abnormalities and Diethylstilbestrol-Exposed Progeny." *American Journal of Obstetrics and Gynecology* 148: 973.

King, Katie. 1994. *Theory in Its Feminist Travels: Conversations in U.S. Women's Movements*. Bloomington: Indianapolis University Press.

Kitzinger, Sheila. 1995. *Birth over Thirty-Five*. New York: Penguin Books.

———. 1996. *The Complete Book of Pregnancy and Childbirth*. Rev. and expanded ed. New York: Alfred A. Knopf.

Lacassagne, A. 1938. "Apparition D'adenocarcomes Mammaires Chez Des Souris Males Traitees par une Substance Oestroge Synthetique [Appearance of Mammary Adenocarcinoma in Male Mice Treated with a Synthetic Estrogenic Substance]." *Comptes Rendu des Seances De La Societe De Biologie* 129: 641–643.

Lacy, Charles. 1996. Drug Information Handbook, 1996–97. 4th ed. Hudson, Ohio: Lexi Comp.

Lopez, Joanne Carol. 1986. "A Study of Effects of Neonatal Treatment with Diethylstilbestrol and 17-Hydroxyprogesterone Caproate on Endocrine Target Tissues in Female Mice." Ph.D. dissertation, Department of Genetics, University of California, Berkeley.

Macarthur, C., P. J. Foran, and J. C. Bailar 3rd. 1995. "Qualitative Assessment of Studies Included in a Meta-Analysis: DES and the Risk of Pregnancy Loss." *Journal of Clinical Epidemiology* 48 (6): 739–747.

Madaras, Lynda, Jane Patterson, and Peter Schick. 1981. *Womancare: A Gynecological Guide to Your Body*. New York: Avon.

———. 1984. *Womancare: A Gynecological Guide to Your Body*. New York: Avon.

Marcus, Alan I. 1994. *Cancer from Beef: DES, Federal Food Regulation, and Consumer Confidence*. Baltimore: Johns Hopkins University Press.

Mariner, Wendy K. 1985. "The Potential Impact of Pharmaceutical and Vaccine Litigation." In *The Effects of Litigation on Health Care Costs: Papers*, edited by Mary Ann Baily, Ann T. Hunsaker, Warren I. Cikins, and the Brookings Institution, 43–68. Brookings Dialogues on Public Policy. Washington, D.C.: The Brookings Institution.

Mastroianni, Anna C., Ruth R. Faden, Daniel D. Federman, Ethical Institute of Medicine and Committee on the Legal Issues Relating to the Inclusion of Women in Clinical Studies. 1994. *Women and Health Research: Ethical and Legal Issues of Including Women in Clinical Studies*. Washington, D.C.: National Academy Press.

Merck & Co. 1940. *Diethylstilbestrol: Annotated Bibliography*. Rev. October 1940. Rahway, N.J.: Merck & Co., Inc.

———. 1941. *Annotated Bibliography April 1941. Stilbestrol (Diethylstilbestrol)*. Rahway, N. J.: Merck & Co., Inc.

———. 1941. *Annotated Bibliography, April 1941. Stilbestrol (Diethylstilbestrol)*. Supplement. October 1941. Rahway, N.J.: Merck & Co., Inc.

Merkin, Donald H. 1976. *Pregnancy as a Disease: The Pill in Society*. Port Washington, N.Y.: Kennikat Press.

Meyers, Robert. 1983. *D.E.S.: The Bitter Pill*. New York: Seaview/Putnam.

Mishell, Daniel R., Val Davajan, and Rogerio A. Lobo. 1991. *Infertility, Contraception, and Reproductive Endocrinology*. 3d ed. Boston: Blackwell Scientific.

Moreau, David. 1995. *Physician's Drug Handbook*. 6th ed. Springhouse, Penn.: Springhouse.

National Cancer Institute, Division of Cancer Control and Rehabilitation. 1976. *Questions and Answers about DES Exposure before Birth*. Bethesda: Department of Health, Education, and Welfare, Public Health Service, National Institutes of Health.

National Cancer Institute, Office of Cancer Communications. 1985. *Recently Reported Health Effects of Exposure before Birth and during Pregnancy to the Synthetic Estrogen Diethylstilbestrol* (DES). Bethesda: National Cancer Institute, Office of Cancer Communications.

National Institutes of Health. 1977. *Were You or Your Daughter Born after 1940?* Bethesda: Department of Health, Education, and Welfare, Public Health Service, National Institutes of Health.

Niswander, Kenneth R., and Arthur T. Evans. 1996. *Manual of Obstetrics*. Little Brown spiral manual. Boston: Little, Brown.

Noller, Kenneth I. 1992. *DES Update*. New York: Elsevier.

Noller, Kenneth L., and C. R. Fish. 1974. "Diethylstilbesterol Usage: Its Interesting Past, Important Present, and Questionable Future." *Medical Clinics of North America* 58 (4) (July): 793–810.

Nowak, Geraldine D., National Library of Medicine. 1978. "Adverse Effects of Prenatal Exposure to Diethylstilbestrol (DES): January 1975 through October 1978, 163 citations." Literature Search no. 78–29. Bethesda: U.S. Department of Health, Education, and Welfare.

Orenberg, Cynthia Laitman. 1981. *DES: The Complete Story*. New York: St. Martin's Press.

Rivlin, Michel E., John C. Morrison, and G. William Bates. 1990. *Manual of Clinical Problems in Obstetrics and Gynecology with Annotated Key References*. 3d ed. Little, Brown spiral manual. Boston: Little, Brown.

Robboy, Stanley J., National Institutes of Health, National Cancer Institute, Division of Cancer Control and Rehabilitation. 1980. *Prenatal Diethylstilbestrol (DES) Exposure: Recommendations of the Diethystilbestrol-Adenosis (DESAD) Project for the Identification and Management of Exposed Individuals*. NIH publication no. 80-2049. Bethesda: U.S. Department of Health and Human Services.

———. 1983. *An Atlas of Findings in the Human Female after Intrauterine Exposure to Diethylstilbestrol*. Washington, D.C.: U.S. Department of Health and Human Services, Public Health Service, National Institutes of Health, National Cancer Institute. For sale by the Superintendent of Documents, United States Goverment Printing Office.

Robinson, D., and L. B. Shettles. 1952. "The Use of Diethylstilbestrol in Threatened Abortion." *American Journal of Obstetrics and Gynecology* 63: 1330–1333.

Rothman, Barbara Katz. 1989. *Recreating Motherhood: Ideology and Technology in a Patriarchal Society*. New York: W. W. Norton.

Scott, James R., Philip J. DiSaia, and Charles B. Hammond. 1996. *Danforth's Handbook of Obstetrics and Gynecology*. Philadelphia: Lippincott-Raven.

Scott, James R., Philip J. DiSaia, Charles B. Hammond, and William N. Spellacy. 1994. *Danforth's Obstetrics and Gynecology*. 7th ed. Philadelphia: Lippincott-Raven.

Seaman, Barbara, and Gideon Seaman. 1977. *Women and the Crisis in Sex Hormones*. New York: Rawson Associates.

Smith, George V., and Olive W. Smith. 1941. "Estrogen and Pregestin Metabolism in Pregnancy: The Effect of Hormone Administration in Pre-eclampsia." *Journal of Clinical Endocrinology* 1: 477–484.

———. 1946. "Increased Excretion of Pregnanediol in Pregnancy from Diethylstilbestrol with

Special Reference to the Prevention of Late Pregnancy Accidents." *American Journal of Obstetrics and Gynecology* 51: 411–415.

―――. 1949. "The Prophylactic Use of Diethylstilbestrol to Prevent Fetal Loss from Complications of Late Pregnancy." *New England Journal of Medicine* 241: 562–568.

―――. 1954. "Prophylactic Hormone Therapy: Relation to Complications of Pregnancy." *Obstetrics and Gynecology* 4: 129–141.

Squibb, E. R., and Sons. 1942. *Stilbestrol (Diethylstilbestrol) Abstracts. A Useful Annotated Bibliography of Clinical Papers.* New York: Squibb.

Stovall, T. G., A. L. Kellerman, F. W. Ling, and B. J. E Buster. 1990. "Emergency Department Diagnosis of Ectopic Pregnancy." *Annals of Emergency Medicine* 19: 1098.

Swan, S. H. 1992. "Pregnancy Outcome in DES Daughters." In *Report of the NIH Workshop on Long-Term Effects of Exposure to Diethylstilbestrol (DES)*, edited by R. M. Giusti, 42–9. Washington, D.C.: U.S. Department of Health and Human Services, Public Health Service, National Institutes of Health.

Turner, Timothy. 1988. "The Effects of Neonatal Exposure to Diethylstilbestrol (DES) on Receptor Levels and in Vitro Growth Patterns of Sex Accessory Glands in Male Mice." Thesis, M. S. Engineering, University of California at Los Angeles.

United States Congress. 1978. *An Act to Amend the Public Health Service Act to Provide for a Program to Carry Out Research on the Drug Known as Diethylstilbestrol, to Educate Health Professionals and the Public on the Drug, and to Provide for Certain Longitudinal Studies Regarding Individuals Who Have Been Exposed to the Drug.* Chicago: American College of Obstetricians and Gynecologists.

United States Congress, House Committee on Energy and Commerce. 1992. *DES Education and Research Amendments of 1992*: Report (to Accompany H.R. 4178) (Including Cost Estimate of the Congressional Budget Office). Washington, D.C.: U.S. Government Printing Office, Superintendent of Documents.

United States Congress, House Committee on Government Operations, Intergovernmental Relations Subcommittee. 1972. *Regulation of Diethylstilbestrol (DES) (Its Use as a Drug For Humans and in Animal Feeds): Hearing Before a Subcommittee of the Committee on Government Operations, House Of Representatives*, 92d Cong., 1st sess. Washington, D.C.: U.S. Government Printing Office.

United States Congress, House Committee on Interstate and Foreign Commerce, Subcommittee on Health and the Environment. 1976. *Diethylstilbestrol (DES): Hearing before the Subcommittee on Health and the Environment of the Committee on Interstate and Foreign Commerce, House of Representatives*, 94th Cong., 1st sess., on Title I of S. 963, Dec. 16, 1975. Washington, D. C.: U.S. Government Printing Office.

United States Congress, Senate Committee on Labor, Health and Public Welfare, Subcommittee on Practice; United States Congress, Senate Committee on the Judiciary, Subcommittee on Administrative Procedure; Diane J. Fink; United States Office of the Assistant Secretary for Health; DES Task Force; Surgeon General and National Institutes of Health. 1975. *Regulation of Diethylstilbestrol (DES), 1975: Joint Hearing before the Subcommittee on Health of the Committee on Labor and Public Welfare and the Subcommittee on Administrative Practice and Procedure of the Committee on the Judiciary, United States Senate*, 94th Cong., 1st sess., on S. 963, Feb. 27, 1975, DES Task Force. (Summary Report, Sept. 21, 1978). Washington, D.C.: U.S. Government Printing Office.

United States Congress, Senate Committee on Labor and Human Resources. 1992. *DES Education and Research Amendments of 1992*. Report (to Accompany S. 2837). Washington, D.C.: U.S. Government Printing Office.

United States Office of the Assistant Secretary for Health, and DES Task Force. 1987. *Report of*

the 1985 DES Task Force. Bethesda: U.S. Department of Health and Human Services.

United States Office of the Assistant Secretary for Health, DES Task Force, National Cancer Institute, Barbara Seaman, and Gideon Seaman. 1987. *Report of the 1985 DES Task Force*. Bethesda: U.S. Department of Health and Human Services.

Ways, Susan Cynthia. 1982. "Immunological Aspects of Development of Genital Tract Lesions and Tumors in Neonatally Diethylstilbestrol-Treated Female Mice." Ph.D. dissertation, Department of Zoology, University of California, Berkeley.

Zatuchni, Gerald I., and Ramona Slupik. 1991. *Obstetrics and Gynecology Drug Handbook*. St. Louis: Mosby Year Book.

The Logic of Heartbeats

Electronic Fetal Monitoring and
Biomedically Constructed Birth

Elizabeth Cartwright

In this chapter I present an ethnographic analysis of birth in the context of biomedicine, technology, and the systems of logic that facilitate our beliefs in a medical interpretation of the birthing process. This is a journey directly into the heart of what Bourdieu (1990) calls the "logic of practice." I examine the social production of this specific, practice-oriented logic as it is enacted in a large teaching hospital in the Southwest United States. I carried out ethnographic observations and practitioner interviews over three years with obstetricians, registered nurses, certified nurse midwives, and licensed midwives. I argue that through understanding the implementation of this particular medical technology, some processes which are fundamental to the acts of healing in general and childbirth in particular are clarified.

During the birth of each baby, with blood splattering the walls and mothers' anguished cries resounding up and down the halls of the hospital, the consecutive steps of obstetrical practice are "logically" enacted. This is a logic of the moment, one that can take the practitioner through a multitude of situations. Its enactment is embodied in the pounding hearts and sweating hands of caregivers interacting with women and their unborn children. It is a logic examined before, during, and after the birth among colleagues and in the middle of the night when practitioners awaken in utter existential fear of possible negative physical outcomes and legal repercussions resulting from their actions. It is a logic that is inscribed and preserved in the cultural artifact of the paper "strips" of data that are generated by fetal monitors.

My focus is on the biomedical technology of electronic fetal monitoring (EFM) as it is used to assess both the woman and her unborn child during labor. The EFM strip (output) shows the fetal heart rate on one side while

simultaneously marking the pattern of uterine contractions on the other side. Fetal monitors have been in use in most obstetrical clinics and hospitals in the United States since the 1970s. Before that time specially configured stethoscopes were used. Indeed, the use of fetal stethoscopes is still common among birth practitioners of all kinds who work in geographical areas or under licensures where continuous fetal monitoring is not required or is not desired. Monitors manufactured since the mid-1980s also come equipped with keyboards where vital signs, cervical dilation, medications administered, and maternal position changes are noted, as well as anything else that medical personnel think it is important to type onto the strip. Through critical understanding of the highly elaborated role of this particular technology, biomedically framed childbirth can be illuminated, challenged, and reformulated. This issue grows even more important as technologies such as the EFM are distributed transnationally to countries that lack the clinical infrastructure to support the high-tech biomedicial interventions and protocols designed to enhance clinical outcomes (Good 1995).

In this chapter I employ Bourdieu's logic of practice as a means of better understanding the enactment of specialized knowledge. Particularly I focus on his notion that events occur in a specific time sequence and at a particular tempo. Because of this, events need to be studied and represented in a way which preserves their progressive nature. The use of the EFM and its output, the EFM strips, provides a clear demonstration of this temporally situated, practice-oriented logic. I also present some diverse anthropological insights which I use to describe biomedically enacted childbirth in a manner which de-centers our culturally constructed/felt understandings of birth taking place in a hospital. Haraway's (1991) notion of the cyborg is used to illuminate newly emerging configurations of human-machine interactions. In this case, those configurations include the interactions and interdependencies of mothers, babes, obstetrical practitioners, and the fetal monitoring equipment which links them together bodily and conceptually. Finally I discuss insights from Jackson's (1989) exploration of divination and risk as it applies to monitoring, legal surveillance, and the influence of malpractice on practitioners' ability to practice.

Employing these theories, we can begin to anthropologically address the use of biomedical technology in the highly complex context of the late twentieth century. I work through four steps inherent in the treatment process as it is contextualized in the social enactment of birthing using biomedical technology. A wider application of these ideas to healing in general could provide interesting insight into the microprocesses of the enactment of biomedical power as well as resistance to the biomedical model. First, I explore the concept of *tempo* in the practitioner-patient-technology interaction. The tempo of the healing treatment is created by the physiological status of the laboring

woman and her unborn baby, the representation of their status by the EFM, and the interpretation of that status by medical practitioners on the basis of their accumulated knowledge. Thus this tempo is enacted in concert with the prosthetic technology of perception—the EFM. Second, I move on to ethnographically describe the embodied and emotional experience of perceiving the patient's status through the output of the EFM. Third, I describe how the process of birth is manipulated into a pathological state which can be "cured" by biomedical treatments. Finally, taking a broader perspective, I conclude that healing is an act which requires the existing technology of a given culture for its ability to divine the physiologically hidden as well as for the way in which it dictates and legitimizes the movements of practitioners as they seek to gain control over disruptive bodily processes.

Seen in this way, it becomes evident that in all healing events there is a common underlying structure of logic within which practitioners work. That structure is dictated by learned norms of the profession, be it biomedicine or shamanism, by the progressive sequence of change within physiological systems undergoing a stressful situation, and by the various technologies used to reveal the progression of events that practitioners seek to control through their various treatment regimens. As with all technologies used by healers (I wish to include non-biomedical practitioners and their technologies as well), the use of the EFM can only be challenged if its implementation is understood. In order to clarify its use I turn to an exploration of Bourdieu's (1990) *The Logic of Practice*.

■ BOURDIEU'S LOGIC OF PRACTICE

Bourdieu's logic of practice is founded on what he calls the "practical faith" which underlies the motives of specialists such as medical practitioners. "Doxa" for Bourdieu is the state of adhering to the act of practice so closely that reaction becomes unconscious and automatically enacted. The body thus enacts what it has memorized through cultural training. The focus for Bourdieu is on practice and how it is "logically" enacted. This is not the static logic of textbook logicians, but rather the play-by-play logic of events that are happening real-time. This is a way of understanding events moving at the tempo of the moment. It is the tempo—the rhythm, the accelerandos (accelerations), and the rallantandos (decelerations)—that provides the temporal framework for practitioners to make decisions and to carry out procedures. In the event of a normal labor and delivery, myriad physiological factors influence the rate of progression of the labor. These factors include the size of the baby, the strength of the uterine contractions, the position of the baby, and the size of the mother's pelvis. In the event of a pathophysiological state occurring during labor, such as preeclampsia (increased blood pressure

which may lead to convulsions or coma) or chorioamnionitis (an infection in the uterus), the initial severity of the pathophysiological state and the rate of bodily deterioration thereafter provide the parameters of time within which practitioners must function.

Bourdieu warns against trying to collapse events situated in time into linear, static representations on paper. He insists that scholars try to maintain some sense of what an event was like as it was experienced embedded in time and movement. Practice is irreversible and non-synchronous—properties which endow it with specific meanings only at specific times. The concept of temporality and the enacting of decisions are important with regard to fetal monitoring. Bourdieu's notion of temporally situated logic gives anthropology a theoretical space in which to question what happens away from the textbooks that contain the codified knowledge and beyond the discourse of practitioners and patients regarding their perceptions of events, situating analysis in the treatment event itself. The strip emerging from the fetal monitor controls the tempo of access to information. It defines the acceptable rhythm of implementing treatment regimen. Birth becomes a performance of practitioner, mother, and babe on a stage with the constantly shifting scenery of the monitored fluctuations of the two physiological statuses. Medical anthropology is challenged here both in terms of capturing the event and of dealing with its ultimate textual representation, of describing the use of electronic fetal monitoring (EFM) in treatment events so as to reveal its logic of practice.

■ TECHNOBIRTH AND THE LOGIC OF HEARTBEATS

> We (the nurses) come in the room and look at the monitor. Everyone is focused on the monitor. The father is focused on the monitor. The doctors come in and they look at the monitor. I think some doctors could identify the monitor strip and couldn't pick the woman out of a line-up.
>
> — obstetrical R.N.

Haraway's (1991) "Cyborg Manifesto" provides insight into the universe of biomedicine peopled with both humans and machines. For Haraway the concept of the cyborg is the unity of human and machine with an ironic twist. Cyborgs are "creatures simultaneously animal and machine, who populate worlds ambiguously natural and crafted" (1991:149). While "hooked up" to the EFM, the mother and the fetus become merged with the machine in a bond which is only broken at the moment of birth. They become the cyborgs of technobirth, a collective of human and inhuman. Their functioning is welded into one conceptual unit.

The intimate world of life in the womb is transcribed into a visible form by the fetal monitor. Uterine activity is registered, as well as the mother's movements, breaths, coughs, and laughs which are inscribed in the bass clef to the

babe's soprano heartbeat on the "strip." The hidden is revealed. The revelation is read by biomedicine as a partial expression of Truth and is used as the basis for many medical decisions. The thin-lined cryptic scrawls that snake out of the monitor are late-twentieth-century hieroglyphics at their most ambiguous and most powerful.

The heartbeat and the uterine movements play the melody to the countrapuntal episodes of treatment that are written down by nurses and doctors. "Punched in" through keyboards which print out the actions as they are completed, the treatment regimens are permanently affixed in their exact temporal location with respect to the physiological functioning of the mother and her child. Point and counterpoint. A fugue. One follows another across the strip—the heartbeat, the mother's movements, the medical practitioners, and their interventions. The mother and the baby are interpreted through and with the machine; their functioning merges. They are "read" as one. They are controlled as one. Why is it that the biomedical process of birth has been elaborated in this manner?

While numerous studies have shown that continuous monitoring does not improve birth outcome (American College of Obstetrics and Gynecology 1995), it has become the standard of practice in most American hospitals to monitor the unborn child's heartbeat during labor and sometimes continuously for as many as fourteen weeks before birth. Fetal monitors were put into clinical use without being proven clinically effective (American College of Obstetrics and Gynecology 1995). Their widespread availability and their ability to penetrate the hidden world of the womb, making it accessible to practitioners, helped to firmly implant the monitors in obstetrical practice. Sandmire (1990) succinctly critiques the use of EFM from a biomedical standpoint, noting that obstetrical problems often result from the decreased maternal movement during labor necessitated by the monitor, as well as from the increased danger of infection that accompanies the use of the internal fetal monitor. While some practitioners and some pregnant women object to the use of fetal monitoring in particular situations for these and other reasons, many obstetrical treatments are based on interpretations of the EFM output. It provides more than an assurance that all is well with the fetus: it also provides the minute-by-minute feedback used to make obstetrical decisions regarding appropriate treatment protocols. In short, it has become an integral part of the habitus of obstetrics.

The use of the EFM is embedded within two sorts of logic. On the one hand, people respond to the output as a kind of text. The strips represent a linear logic which is permanent, ordered as to time, and portable for discussion throughout the obstetric unit, and for dissection in court. While EFM strips are used in obstetrical decision making as textual output, they also function as a form of media—as practice in action. As a visually oriented society we have

come to understand the logic of life as much through abstract symbols and glaring visual juxtapositions as through carefully constructed texts. And so it is with the ongoing production of our symbolic representation of fetal life.

The output from EFMs visually rolls out of the monitor on strips of paper, and it is also projected onto screens throughout the labor and delivery unit for practitioners to view. The tracing inches across space in ghostly green lines vivid against the black screen. It moves, it must be alive. Heartbeats become miniature actors in the movie of Life that is showing long before the baby sees the light of day.

The experience of biomedical birth is not only grounded visually in the EFM, but the machine also constitutes an aural presence on the labor and delivery unit. The rhythm of the fetal heartbeat resounds in the labor room. The heartbeat accelerates, infection is inferred, antibiotics are given, surgical delivery is considered. The heartbeat falters, slowing after the contraction, struggling back up to its previous baseline after each contraction—read stress and distress. Oxygen is administered to the woman, maternal position is changed to optimize blood flow to the placenta, intravenous fluids are increased, practitioners reach up into the birth canal and scratch the baby's head to elicit an increase in heart rate response to assess physiological reserves. One hand on the abdomen, eyes on the monitor, ears tuned for arrhythmias, tachycardia (increased heart rate), bradycardia (decreased heart rate), practitioners assess the output as it is being produced simultaneously by machine and woman. In a tense situation the woman moves, the babe moves, and a mad dash is made to "find the heartbeat, get a pickup," adjust external monitors, place internal monitors. The tempo and the rhythm of birth are completely embedded in the sight and sound of the monitoring equipment. The monitor is more than an uncomfortable belt around the woman's waist. It is the biomedical birth practitioner's most relied-upon tool of assessment, favorite security blanket, and crystal ball, all rolled up into one.

Returning to Bourdieu's logic of practice, we see professionals in a thoroughly postmodern context. As healers, these obstetrical practitioners are responding through the learned obstetrical doxa which is reinforced judicially through malpractice lawsuits. Practitioners are responding not only to their human patient but also to the monitor as it represents the patient. They are responding to the unity, to the cyborg. The body hexis of practitioners is performed to the rhythm of the electronically reproduced sound of the mathematically interpolated heartbeats. Appropriate treatment with respect to learned doxa changes quickly. In a matter of seconds a different treatment can be indicated. Practitioners, fetus, pregnant woman, and the electronic fetal monitor are wet-wired, fused into an amalgamation of physiological functions, specialized professional knowledge, and deeply embodied experience. Biological perceptions merge with virtual reality, and the cyborg is performed.

The scenario is a common one: the laboring woman is resting in a hospital bed, monitor on, fetal heart tones thump, thumping. No one else is in the room. Out at the nurses' station a group of nurses and doctors stand around chatting, frequently glancing at the monitor screen. A "severe" deceleration of the fetal heart rate is noted. Immediately several practitioners rush toward the patient's room. The door flies open. Doctors and nurses begin treatments based on previously established protocols. Adrenaline pumping, they perform vaginal exams to check for a possible prolapsed umbilical cord, change the mother's position to maximize blood flow to the uterus, place internal monitors for increased accuracy of pickup as well as a host of other actions. If none of these measures is effective at restoring a normal fetal heartrate, an emergency surgical delivery is performed. The esprit de corps and sense of the heroic should not be underestimated if the heartbeat returns to normal— which it most likely would have done without any of these procedures. A deceleration that practitioners would consider to be "severe" could mean a medical emergency, as in the case of a prolapsed umbilical cord. In the majority of cases, however, the deceleration does not indicate a medical emergency and in some cases it may just be a regular rate fluctuation. The laboring woman is then once again left alone as the practitioners retreat out of the room. Accurate and controllable surveillance becomes a practical necessity for the enactment of obstetrical doxa.

Complete surveillance is also mandated by law for practitioners who want to work with women giving birth (see Schifrin, Weissman, and Wiley 1985). Standards of care are established via the EFM machine, and thus in the never-quite-sure realm of birth, each time a delivery occurs outside the monitor's panoptical eye, whether it occurs in the hospital without the EFM or in the home, the legal and monetary risk to the practitioner is exponentially increased. Foucault's panopticon is an apt metaphor for the use of the EFM with respect both to the surveillance of the laboring woman and the legal monitoring of the practitioners. Fetal heart tones are visually projected all over the obstetrical unit on screens and audibly projected up and down the halls if the volume is turned up on the monitor. They are also projected into doctor's offices across the city and into doctor's homes which are hooked up to remote screens. Maternal movement is restricted in order to produce the clearest and most interpretable strip. When the woman is attached to the EFM, she is belted into bed, strapped into place. While many women who give birth in the hospital want to be in bed so that they can receive intravenous pain medications or epidural anesthesia, some women find lying down extremely uncomfortable. Motion on the part of the normal, healthy mother is not allowed—it is "interference," it is "noise." If the mother should try to move, the strip will show that motion and a nurse or physician will look

into the room to make sure the unwarranted movement is stopped. If there is too much of this non-sanctioned movement, the "strip" will not be "interpretable" either now or, should the occasion arise, in the courtroom. The courtroom is the ultimate exposition of the strip; in the case of poor physical outcomes, it is the strip's ultimate destination. Those practitioners who didn't exercise enough control have to pay up. The "strip" is often an important part of the legal argument and the basis of multimillion-dollar settlements (Ennis and Vincent 1990). It is used in at least 50 percent of all obstetrical court cases (Sandmire 1990:1131). It is a part of the permanent medical record. The use of EFM technology is embedded within the legal system as well as within the biomedical system.

After "emergency" scenarios such as the one described above, women become docile—after all, they never know when the practitioners might all of a sudden detect a change in the heart rate which might necessitate immediate attention. Like Foucault's description of the prisoners who stopped rebelling because they believed they were being watched, even when they weren't, these women remain in the "correct" position for hours at a time. They have been effectively reconstituted in what Davis-Floyd (1992) calls the technocratic model of birth. Simultaneously, practitioners are constrained in their scope of practice in that they must respond to the EFM output in the accepted manner or face legal sanctions. Practitioners are also working under the watchful eye of the panopticon.

■ BIOMEDICAL IDEOLOGY IN THE INSTITUTIONAL CONTEXT

From a legal point of view, there's nothing more incriminating than a monitor strip because you can read it any old way. In retrospect when you get a baby that didn't do well you can almost always look back on the strip and see something questionable. The lawyer will say, "Hey! Why didn't you do something here?"

—R.N.

A pathological conceptualization of birth necessitates a reinterpretation of what is "natural" and a reevaluation of outcomes. Willis argues: "One of the most important general functions of ideology is the way in which it turns uncertain and fragile cultural resolutions and outcomes into a pervasive naturalism" (1977:162). This is a process that reproduces class ideologies among groups of individuals as they are contextualized within institutions. While obstetrical practitioners have some insight into the processes of the biomedical institution and their relations with it as workers, their continued practice within that framework demands that they take on a viewpoint which is consistent with a biomedically interpreted notion of what constitutes a "normal delivery"—that is, one which is carried out under the auspices of medical per-

sonnel, within an institution, using the accepted technologies and treatments. To define what is "normal," the opposite end of the spectrum — "abnormal" — must be defined and/or created.

Techniques of normalization discussed by Foucault (1990:141) within the realm of bio-power include a set of material elements that serve as weapons, relays, communication routes, and supports for the power and knowledge relations that invest human bodies with meaning and subjugate them by turning them into objects of knowledge. Rabinow (1984:21) discusses the Foucaultian idea of technologies of normalization as they play a key role in the systematic creation, classification, and control of anomalies in the social body. They perform various functions, serving to isolate anomalies and to normalize anomalies through corrective procedures determined by other related technologies. EFM performs these same functions, first through recording heartbeat patterns, then through deeming certain fetal heart rate tracings possibly anomalous and/or pathological. Fetal heartbeat patterns are recorded in a linear fashion alongside a graphic representation of the duration and intensity of uterine contractions. The response of the fetal heart rate to the compression caused by the uterus may be to accelerate, to stay the same, or to decelerate. Particular patterns of decelerations and/or lack of accelerations are hypothesized to reflect a "negative physiological status" in the fetus. Davis-Floyd describes how the technocratic model of birth results from first deconstructing the natural process of birth and then dissecting it into components which can be measured, manipulated, and reconstructed through the use of various technologies (See Introduction 1994:1127). Fetal heart tracings show how obstetrical biopower is reckoned through perceptual penetration and control.

■ TRANSLATING THE STRIP: TREATMENT AND THE DESIRE TO RENDER VISIBLE

The monitor gives these women a false sense of security . . . it's like because they're on the monitor, this monitor is somehow magical and it's going to make their baby be OK. But by doing that, it's like they're giving away another segment of their power to this machine. This machine has no power to make their baby be OK. Just as many babies have bad outcomes with these monitors as without them. But the women don't understand that. They think somehow because we all stare at it so much that somehow it's going to protect their baby. It's not.

—Obstetrical R.N./Licensed Midwife

Practitioners spend a great deal of time focused on the "strips" of paper output emerging from the fetal monitors. Because these strips are both medical and legal documents, they must be carefully crafted by the practitioners. Great care is taken to punch in data via the keyboards so that they reflect current protocols and appropriate actions. The inappropriate is not recorded. The

control granted to biomedical practitioners is reinforced by their function as translators of the fetal status via these "strips." Power produces and reproduces biomedical ideology and knowledge in a reciprocal relationship. As practitioners stand around monitors in the patient's room or study the screens which project the images of the EFM throughout the obstetrical unit, they talk about the quality of the strip: "We need to see some accelerations (of fetal heart-tones)" and "If this strip doesn't start to look better we're going to need to consider a c-section"—are typical practitioner observations. It is the strip, at least in part, that needs to be cured.

Beyond the obvious role of recording events, the strip is used to justify interventions and non-interventions. If a practitioner feels it is appropriate to delay a surgical delivery, but the strip is non-reactive (without heartbeat accelerations of standard increases in speed and duration), the physician may try to elicit the accelerations using various techniques—through manually scratching the top of the baby's head by reaching up into the vagina, through maternal position changes, or by using an electronic device which sends sound waves through the mother's abdomen which startle the baby, with a concomitant increase in heart rate expected. These measures *do not* positively affect the baby's physiological status; they serve only to document that the babe has sufficient physical resources and neurological intactness to respond to stress. Through increased risk of infection from manual examination they increase the likelihood of infection entering the uterus. And they may well negatively affect the baby's psychological and emotional status (Chamberlain and Arms 1995; see also Chamberlain, this volume).

The physician has diagnosed the anomaly—in this case it is "non-reactivity"—and has gained agency over it by producing fetal heart rate accelerations. This is then documented on the monitor strip. If the strip "looks good," yet the delivery results in a fetal demise, the practitioners are all in a much better legal position than if the strip didn't meet normal criteria. Often completely healthy babes are born who have "abnormal-looking" strips before delivery and vice versa. In didactic learning seminars for obstetrical residents and nurses, attending physicians will often show a particularly bad strip to first-year interns and ask what they think the fetal outcome was. Interns inevitably give their dire predictions. The attending physicians then either confirm the prediction or state that the baby was fine, much to everyone's amazement.

Practitioners processually and publically learn the doxa of strip interpretation. Consensus is important (Grant 1991). The ambiguity of the heart rate tracings makes interpretation an important clinically learned skill for the obstetrical staff of nurses and doctors who use it on a daily basis. It takes a great deal of authority to enact the logic of practice in a way which is contraindicated by the strip. Defensive medicine is practiced and documented. Its enactment may be beneficial and/or detrimental to the health of the moth-

er and babe. The difficulties inherent in using the full extent of professionally and legally mandated diagnostics while weighing the risks and benefits of these technologies constitute a tightrope that conscientious practitioners walk every day.

■ DIVINATION AND RISK

If I had to predict that kid's future from that strip, well, he may not go to Harvard.

—Attending Obstetrical M.D.

. . . there is a threshold of tolerance beyond which chance ceases to be a matter of risk willingly taken and becomes an external tyranny to be desperately avoided.

—M. Jackson, *Paths Toward a Clearing* (1989:51)

It is *chance* which modern obstetrics wishes to reduce. By treating the mother and the unborn child via the monitor strip, biomedical practitioners seek to reduce both the biological risk of negative obstetrical outcomes and the legal risk of repercussions surrounding less than optimal outcomes. As Schifrin et al. state in the journal *Law, Medicine and Health Care*:

What the physician decides to do is less important than how he or she goes about making that decision. A doctor who commits his or her interpretation and plan to the medical record is much less likely to be sued successfully, regardless of the accuracy of the assessment of the fetal monitor tracing. It is the reasonable (but not necessarily accurate) interpretation of the tracing, combined with a reasonable (but not nec-essarily correct) plan of action, that is crucial, both for successful patient care and for a successful legal defense. (1985:103)

Despite the fact that studies have shown no reduction in birth morbidity and mortality, the use of this monitoring equipment is considered to be the "safest" manner in which to carry out the birthing process and therefore is the basis of how biomedical practitioners in the United States are trained and how they subsequently practice. As in the case of divination described by Jack-son (1989), the act of culturally reducing risks gives us a way of going forward with the activity in the face of much unpredictability. Precision results in an "abreaction of anxiety," and the uncertain future is transformed into the past which is "a source of knowledge and the domain of certitude" (Jackson 1989:60).

Jackson goes on to argue that the benefits derived from divination are so great *at the time of the divination* that their ultimate "truth" is rarely called into question. So goes the biomedical art of strip interpretation. Embedded into the spaces between fiercely painful contractions, decisions made by prac-

titioners and enacted on women are of-the-moment. These decisions will be strung together and given meaning through the telling and retelling of the birth story as practitioners recount events to other practitioners at case reviews and as the mother recounts events to her friends and family. The same monitor output could be used to justify a surgical delivery or a normal vaginal birth. Fetal heart rate tracings are usually too ambiguous to be read as absolute indicators, but their interpretive potential is virtually limitless.

When we examine the great variety of ways in which science and divination alike introduce a semblance of order and system into an uncertain universe, it begins to look as if establishing the "truth" of science or of divination in terms of some notion that the systems *correspond* to external reality is not necessary in order for these systems to help us cope with life and make it meaningful (Jackson 1989:66). The mysteries inherent in the process of the physiological functioning of the body in general and in the process of birthing in particular provide ample instances of practitioners trying to reduce the risk of the death of a mother and/or her babe in the face of not really knowing what is going on. Making a diagnosis based upon the EFM tracing, among other clinical factors, in some measure is an abreaction of the immediate anxiety, an accepted manner of obstetrical treatment, and a way to make the situation meaningful, both at the time of diagnosis and in retrospect.

■ CONCLUSION

As medical anthropology spirals further and further into the exploration of healing processes, the universe to be explored becomes increasingly complex. Beyond the names of medicinal plants and the words to curing songs, anthropologists are recognizing that the intricacies of practitioner and patient interactions are situated in biological and social time. It is the interaction that heals. The EFM strip provides an artifact—an artifact of the seconds that pass by, of physiological functions, and of the calculated interventions of biomedical practitioners. Obstetrical practice and the technology of fetal monitoring show Bourdieu's notion of the tempo of practice being played out simultaneously in realities both biological and social. Oddly enough, it is in the world of high tech where this process is charted most clearly and simply, as evidenced by the paper strips rolling out of the monitors. But a vague representation of the real complexity of the healing event, the fetal monitoring record reminds us of the magically progressive interaction between bodies and those who seek to heal them. It would be profitable in future studies of a wide variety of birth practitioners to give further attention to: (1) the tempo of events during labor and delivery (see Szurek 1997); (2) the technologies/techniques of perceptions used to make clinical observations of physiological, emotional,

and spiritual changes in the mother and babe; and (3) the interventions implemented by the practitioners.

As Pratt (1985) points out, personal and scientific authority weave in and out of ethnographies and travelogues alike. Historically, ethnographies have been conceived of as "highly textured totalizing picture(s) anchored in ethnographers where 'self' is understood not as a monolithic scientist-observer, but as a multifaceted entity who participates, observes, and writes from multiple, constantly shifting positions" (Pratt 1985:39). In this chapter, it is from this shifting, albeit highly reflexive, position that I write. I am an obstetrical R. N. As both a medical practitioner and an anthropologist, I find myself moving back and forth between the epistemological dialects of practice and reflection. From an anthropological perspective my years of obstetrical experience have given me a deeply participatory reading of what it means to be a practitioner of biomedicine. As an anthropologist I take inspiration from Jackson's view of fieldwork:

> It is the interaction between the observer and observed which is crucial. . . . To desist from taking notes, to listen, watch, smell, touch, dance, learn to cook, make mats, light a fire, farm—such practical and social skills should be as constitutive of our understanding as verbal states and espoused beliefs. (1989:9)

As I spend hours and hours on the labor and delivery ward watching and recording the output from the EFM while coaching women through contractions, I too am immersed in the cyborg. My heart skips beats when the fetal tracing slows to very low levels. My ears and eyes are constantly alert for possible decelerations. Split-second falterings, if repeated in a particular way, make me more attentive, make me watch for other signs such as bleeding or imminent birth. Intuition via the sounds of the heartbeats, the placement of heart rate changes, or the overall forms of the linear representations of heartbeats and contractions in the context of all the other physiological and psychological factors can either reassure me or induce me to call another nurse or an obstetrician. Often this sort of knowledge comes from the day-to-day enactment of biomedical obstetrics. In their study of postmodern midwives, Davis-Floyd and Davis (1996:6) point out that intuition is perceived as a "viable and valid source of authoritative knowledge" among a large number of midwives with whom they spoke. The changes in the mother and baby that my colleagues and I notice are often not clearly discernible on the "strip." They reside in a complexity of information that has yet to be represented as output from any sort of machine.

From my constantly shifting position, I have tried to expand the notion of the logic of practice to include specific attention to tempo and to allow for the

incorporation of new information that is constantly being added, embodied, and acted upon in concert with a rapidly expanding repertoire of increasingly sentient technologies. As healers in the late twentieth century, we are called upon to practice in a universe of often incomprehensible technologies and fearsome litigation. As a biomedical team of doctors, nurses, certified nurse midwives, and nurse practitioners, we respond, often with surprising synchronicity, to the information displayed on the EFM. Obstetrical doxa is our infrastructure, and the monitor is an integral part of our habitus. Intuition and divination meet the cyborg, and new modes of interaction surround the process of birth. As anthropology challenges and clarifies the experiences of women giving birth in the institutional setting, biomedicine can continue to envision a new and better future by being sensitive to the negative as well as to the positive side effects of the cyborgification of mother and child.

References

American College of Obstetrics and Gynecology. 1995. "Fetal Heart Rate Patterns: Monitoring, Interpretation, and Management." *Technical Bulletin* 207 (July).

Bourdieu, Pierre. 1990. *The Logic of Practice*. Translated by Richard Nice. Stanford: Stanford University Press.

Chamberlain, David, and Suzanne Arms. 1995. "The Prenatal Psyche." Unpublished ms.

Davis-Floyd, Robbie. 1994. "The Technocratic Body: American Childbirth as Cultural Expression." *Social Science and Medicine* 38 (8): 1125–1140.

———. 1992. *Birth as an American Rite of Passage*. Berkeley: University of California Press.

Davis-Floyd, Robbie, and Elizabeth Davis. 1996. "Intuition as Authoritative Knowledge in Midwifery and Home Birth." In *Childbirth and Authoritative Knowledge: Cross-Cultural Perspectives*, edited by Robbie Davis-Floyd and Carolyn Sargent. Berkeley and London: University of California Press.

Ennis, M., and C. Vincent. 1990. "Obstetric Accidents: A Review of 64 Cases." *British Medical Journal* 300: 1365–1367.

Foucault, Michel. 1990. *The History of Sexuality*. New York: Vintage Books.

Good, Mary Jo DelVecchio. 1995. "Cultural Studies of Biomedicine: An Agenda for Research." *Social Science and Medicine* 41 (4): 461–473.

Grant, J. 1991. "The Fetal Heart Rate Trace Is Normal, Isn't it?: Observer Agreement of Categorical Assessments." *The Lancet* 337: 215–218.

Haraway, Donna. 1991. *Simians, Cyborgs, and Women: The Reinvention of Nature*. New York: Routledge.

Jackson, M. 1989. *Paths Toward a Clearing: Radical Empiricism and Ethnographic Inquiry*. Bloomington: Indiana University Press.

Pratt, Mary Louise. 1985. "Scratches on the Face of the Country; or, What Mr. Barrow Saw in the Land of the Bushmen." *Critical Inquiry* 12 (Autumn): 119–143.

Rabinow, Paul, ed. 1984. *The Foucault Reader*. New York: Pantheon Books.

Sandmire, H. F. 1990. "Whither Electronic Fetal Monitoring?" *Obstetrics and Gynecology* 76 (6): 1130–1134.

Schifrin, B. S., H. Weissman, and J. Wiley. 1985. "Electronic Fetal Monitoring and Obstetrical Malpractice." *Law, Medicine, and Health Care* 13 (3): 100–105.

Szurek, Jane. 1997. "Resistance to Technology-Enhanced Childbirth in Tuscany: The Political Economy of Italian Birth." In *Childbirth and Authoritative Knowledge: Cross-Cultural Perspectives*, edited by Robbie Davis-Floyd and Carolyn Sargent, 287–314. Berkeley and London: University of California Press.

Willis, Paul. 1977. *Learning to Labour*. New York: Columbia University Press.

From Technobirth to Cyborg Babies

Reflections on the Emergent Discourse of a Holistic Anthropologist

Robbie Davis-Floyd

(with contributions from Joe Dumit, whose editorial comments, together with Davis-Floyd's responses, appear in italics throughout)

Cyborg imagery can help express two crucial arguments . . . first, the production of universal, totalizing theory is a major mistake that misses most of reality, probably always, but certainly now; and second, taking responsibility for the social relations of science and technology means refusing an anti-science metaphysics, a demonology of technology, and so means embracing the skillful task of reconstructing the boundaries of daily life, in partial connection with others, in communication with all of our parts. . . . Cyborg imagery can suggest a way out of the maze of dualisms in which we have explained our bodies and our tools to ourselves. . . . Though both are bound in the spiral dance, I would rather be a cyborg than a goddess.

—Donna Haraway, "A Cyborg Manifesto: Science, Technology, and Socialist Feminism in the Late Twentieth Century," 1991:181

For much of the past sixteen years, I have been researching women's experiences of pregnancy and childbirth in American society. The results of that research have appeared in a number of publications. Here I indulge in a more autobiographical and reflexive approach, to ponder my fairly recent anthropological engagement with the problematics of cyborgs and cybertalk. It is not a discourse I would have gravitated to on my own, but rather one I felt I had to open myself to as a direct result of my research on pregnancy and childbirth among white middle-class American women—including myself. Let me explain.

■ A CYBORG BIRTH

My first child was born in 1979. A twenty-six-hour labor that started out in the hospital's alternative birth center ended in cesarean section. As I lay on the

operating table, numb from my chest to my toes, I received graphic confirmation of the "reality" of Cartesian mind-body dualism—for the first time in my life, I existed only as a disembodied head. Entering the hospital (at least in my own mind) as Earth Mother, I had in just over one day become Cyborg—my body and my experience of that body had been irrevocably altered by the pitocin that made the contractions too painful to bear, by the Demerol that made me woozy and unable to cope, by the institutional policy that would not let me eat even though I was starving, by the long steel hook that broke my waters and made it essential that the birth happen within a certain amount of time, by the deadly cold metal table on which I now lay, by the epidural anesthesia that cut me off from all sensation below my upper chest, and by the green curtain that cut me off from even visual contact with my huge belly and my emerging child.

I wish I had known about cyborgs then, because that concept has such power. Cyborgs can be interpreted as not diminished but enhanced beings; they are often not less than but rather more than human. In those painful, terrifying, and most of all confusing moments of disembodiment, when I felt shrunken, helpless, and overwhelmed, I could have used the sense of transcendence that might have accompanied my cyborgification. I am certain that the terror, the confusion, the feeling of spinning out of control, out of contact, out of my body and into the narrow parameters of my mind would have been greatly mitigated if my cesarean could have been accompanied by the beneficial mediation of a cyborg consciousness. Instead of suffering a devastating sense of disempowerment, I could have—since I was suddenly forced to live in my head anyway—become fascinated by the intellectual conundrum of being a body one minute and only a head the next. I could have pondered the coevolution of human and machine that started in Europe in the 1700s and led to this moment—or did it really start hundreds of thousands, perhaps even millions of years ago, the first time a hominid female sharpened a digging stick? Was it the first hunter's spear that was piercing my belly now? Was this (as I discovered later) totally unnecessary high-technology operation the uncomplicated result of an interventive obstetrics (pressured to be even more so by an equally interventive legal system) with roots only in our own historical period, or was it the inevitable result of an inexorable evolutionary process that was dragging me, kicking and screaming (without moving or speaking) into the cyborg future of humankind?

I could have been captivated by the intellectual challenge of trying to deconstruct my cyborgification and its results, which seem to me now to constitute a scattering, a diffusion, a parceling out of the birthing functions that in other circumstances I myself would have had to perform—or die trying. There was an anesthesiologist at my head controlling the sensations that I did-

n't feel and an obstetrician at my belly incising through five layers of flesh to reach into the deep and intensely private recesses of my womb and pull out with his hands the baby that otherwise my own muscles, grit, and will would have had to push down the birth canal and into the warmth of my waiting arms. Several nurses assisted him, doling out the tools of my dissection, graphically described as follows in my medical chart:

> A transverse skin incision was made sharply with a knife and carried down through the subcutaneous layers until the fascia was reached. The fascia was sharply incised with the knife and the incision carried laterally. The rectus muscles were separated in the middle and retracted. The parietal peritoneum was grasped with clamps and incised, exposing the abdominal cavity. The visceral peritoneum overlying the lower uterine segment was then grasped, incised, and dissected sharply and bluntly creating a bladder flap over the lower uterine segment. The lower uterine segment was then incised sharply with a knife and the incision extended bluntly. The infant was delivered from the cephalic position as pressure was exerted on the uterine fundus. The infant was briefly placed on the mother's upper chest and then handed to the father to be taken to the nursery for further care. The placenta was manually extracted and appeared intact. The uterus was then externalized from the abdominal cavity and explored for any remaining placental fragments. The uterus was then replaced in the abdominal cavity and the defect was repaired in a single layer closure. . . .

My husband stood and watched, the visual prosthesis for my gaze, which was cut off by the ugly green curtain. So many people to do the work of one! A cyborgian system, consisting of people, information, institution, and artifacts, all there to "externalize" one baby from one mother—who if they had but been left alone, could perfectly well have accomplished this miracle on their own. But no one in that room knew that for sure; everyone, at the time, thought that this procedure was necessary, perhaps even lifesaving.

Had it been so, there would have been a glory in this symbiosis, this refusal of the human spirit to give in to the perversity of Mother Nature, who occasionally seems just as willing to let a baby die as help it be born. She doesn't care—it's all the same to her—life dies, returns to her bosom, refertilizes her soil, and is born again. What is one baby's death to Gaia, who sees only the ever-recycling, ever-renewing, ever-interlinked whole? But humans care. These doctors, the obstetrician and the anesthesiologist—the dual agents of my cyborgification—were trying to take control of a natural process they perceived as having gone awry, to make sure that the end result was a live and healthy baby.[1] Certainly they did not perceive themselves as victimizing or in

any way disempowering me, or as engaging in the mutilation and prosthesis (see Introduction) of the natural process of birth. What I felt about what they did was in no way part of their experience of doing it.[2]

Years later, when I read Donna Haraway's "Cyborg Manifesto," I was utterly fascinated by the optimism that characterizes her portrayal of the cyborg universe. But when my daughter was delivered by cesarean in 1979, this manifesto had not yet been written, and so instead of the transcendent fascination that could have been mixed with the pain, what I felt while I was being "sectioned" was a profound alienation from my body and from the experience of birth, a deep loneliness, and an overwhelming sense of helplessness and victimization (from which I did not fully recover until, four years later, I gave birth to my second child at home). When, as the report describes, my baby was laid briefly on my chest, I was barely able to move my arms to hold her. But my experience of bonding with her was nevertheless remarkable—I felt instantly as I gazed at her that we knew each other, that we were still one, despite the obvious fact that we were now quite separate and discrete. It is a sense of oneness that no physical separation has ever threatened or reduced. Later, when I learned the language of holism, I was able to use its words to explain that our energy fields, merged during her gestation in my womb, stayed connected even after our physical separation. But at the time I did not need the language of holism to have the experience of being wholly one with my newborn child, as I would have needed the language of the cyborg to sense a transcendence in my body's technocratization. Interesting it is to me now that this first birth experience so richly encompassed both dimensions— the technocratic and the holistic—that would eventually constitute focal points for my professional research.

Joe to Robbie: Wait a minute. Cyborgs embrace the organic and the non-organic. But you seem to think that cyborgs aren't holistic. Can you situate the notion of holism that you draw on here (where holism is precisely not cyborg but fully organic, and only natural)? To me that is a specific ethno-holism if you will. Perhaps I show my suburban-computerized roots here, but when I hear "holism" I imagine a world that includes technology, filled with all sorts of techniques and instruments.

Robbie to Joe: Certainly the holistic physicians I have interviewed for the next book I am writing—on the paradigm shift from technomedicine to holistic healing—would agree with you. They use lots of technologies—e.g., biofeedback machines, diagnostic computers—that they see as an integral part of holistic practice. What I mean by "holism" here is a specific paradigm of healing that sees the body as an energy field in constant interaction with all other energy fields and that stresses the value of an integrative approach to healing the whole person in the context of that person's life and relation-

ships. What I mean by "technocratization" is a specific paradigm that I call the technocratic model of medicine, which defines the body as a machine. From that basic definitional principle stems a particular, highly interventive approach to childbirth, one which insists that, like a machine in a factory, the laboring body should produce its product within a specified amount of time; and if not, this birthing machine is obviously dysfunctional and in need of intervention and repair. That my body might have its own rhythms and pace of labor, that my emotional response to the frightening and cold hospital environment might impede my progress, that what I really needed was plenty of time, food, and love—these things, which are intrinsic to a holistic approach to birth, have no relevance under the technocratic model. I don't know if cyborgs can be holistic. I do know that there was nothing holistic, and everything cyborg, about my cesarean birth.

One year later, after reading numerous books and talking to countless people about the bizarre and hurtful nature of my birth experience, I came to the conclusion that the cesarean had been medically unnecessary—the result of hospital procedures and schedules that did not allow my labor to proceed on its own time. (Indeed, four years later, my home birth labor lasted three full days. The normality of long labors for many women is unrecognized in most hospitals; had I not been at home for the second birth, I would have had a cesarean again.) My outrage was intense. All I could see was that I had been brainwashed and mutilated by a dysfunctional medical system. So it is hardly surprising that the first eight or so interviews I conducted a few months later when I began my dissertation research were full of leading questions like "Didn't you hate it when they hooked you up to the electronic monitor?" "Having to lie in that hospital bed was awful, wasn't it?" I was angry about my hospital birth, and I wanted, expected, and believed that my interviewees would be too. But after I transcribed that first set of entirely unprofessional interviews, I realized with dawning shock that what the women were telling me was not at all what I wanted to hear. I wanted them to refuse anesthesia and have natural childbirth, or at least to be upset if they couldn't. But what they wanted was an epidural as soon as the contractions got intense, and were upset if they didn't get that pain relief. While some of the 100 women I eventually interviewed shared my attitude, the majority—70 percent—did not (see Davis-Floyd 1992:187–240).

■ TECHNOBIRTH AND TECHNOCRACY

Once I realized that contemporary obstetrics is a system that is co-created by obstetricians and women, each of whom have much to gain from deconstructing organic childbirth and reconstructing it as technological produc-

tion, I was forced to look again at the human-machine interaction that characterizes this reconstructed technobirth — at the strong symbiosis between the woman and the technology; at the way in which it removes the chaos and fear from women's perceptions of birth; and at its perfect expression of certain fundamentals of technocratic life (Davis-Floyd 1994b). The IV, for example, is the umbilical cord to the hospital, mirroring in microcosm the fact that we are all umbilically linked to the technocracy, dependent on society and its institutions for our nurturance and our life. The episiotomy, in which the inchoate, fluid, malleable, and quite sufficiently stretchy perineum is routinely cut with scissors to speed up delivery of the head, enacts and displays not only our cultural tendency toward impatience but also our extreme commitment to the straight line as a basic organizing principle of cultural life (Davis-Floyd 1992). The fact that the baby's image on the ultrasound screen is often more real to the mother than its movement inside her (see Mitchell and Georges, this volume) reflects our cultural fixation on experience one-step-removed on TV and computer screens. The electronic fetal monitor (see Cartwright, this volume) wires the woman into the hospital's computer system, bringing birth into the Information Age. The plastic bassinet in which the newborn is placed metamorphoses into the crib, the playpen, the plastic carrier, and the television-set-as-babysitter — and a baby who bonds strongly to technology as she learns that comfort and entertainment come primarily from technological artifacts. That baby grows up to be the consummate consumer, and thus the technocracy perpetuates itself.

Over time I began to perceive the mutilation and prosthesis of technobirth as the fullest metaphoric expression of life in the technocracy, which, taking off from Peter Reynolds (1991), I define as a society whose central organizing mythology constellates around a technological progress that will culminate in transcendence of all natural bounds, including both biological and planetary limitations (Davis-Floyd 1994b; see also Reynolds). The cyborg represents, even embodies, our increasing closeness to that goal, and so takes on a mythological significance that is extreme.

There is so much that is positive in this myth of cyborgian transcendence. Without the kind of human-machine symbiosis so graphically achieved and perpetuated in hospital birth, Stephen Hawkings would be completely incapacitated instead of a vital member of the astrophysical community, and my brother-in-law would be still be in agony from the disc that ruptured in his back. The metal plate that replaced it and the steel bars that support his spine and set off airport security alarms cyborgify him as surely as my total engagement with and dependence on the computer that I am writing this on, the ergonomic chair on which I sit, the special glasses I have to wear to be able to focus on the screen, and my total dependence on the car I drove to get to this office make me a semicyborg too. (And then there was the night back in 1986

when, after months of intensive work on my dissertation, I had the bizarre and inexplicable experience that for a brief period my consciousness and the cursor became interlinked, and the cursor seemed to go wherever I willed it to!) I cannot disagree with those who suggest that "cyborg" may be a richer conception of the proper object of anthropology than "human being" in the biological sense (Downey et al. 1994). We are (almost) all cyborgs now.

Except of course for David Underwood (a pseudonym), who lives outside of Palestine, Texas with his wife and eight children, all home-birthed and home-schooled and home-fed from the organic garden in the back, who select-cuts timber for a living and drags the trees out with horses to avoid the rape of the forest that would come from cutting a road. And except for Sandra Morningstar, an independent midwife from Missouri, who believes that inserting an IV should not be a required entry-level skill for homebirth midwives, because requiring that skill might send a message to new midwives that it's OK to skip the shepherd's purse—the low-tech herbal remedy for postpartum hemorrhage—and start with the high-tech IV and the pitocin. This interventive approach for her would represent a distortion and a violation of the essence of the kind of holistic midwifery she fights so hard to preserve. And except for Jeannine Parvati Baker, the shamanic midwife who, when the obstetrician ordered her to lie down, left the hospital against medical advice to give birth to her twins at home. In fact, she birthed all six of her children at home, the last three in the water, and she advocates and has written widely about conscious conception, psychic communication with the unborn child, and the deep ecology of what she calls "freebirth" (Parvati-Baker 1978–1992). There are those in this society who actively and articulately resist cyborgification, who honor biology and give it primacy over technology, and who would vastly prefer to focus our efforts to transcend biological limitations on honing our intuition and our psychic abilities through meditation, organic food, and vision quests in the wilderness.

■ A NONCYBORG BIRTH?

Years of involvement with the alternative birth community these midwives represent have made my own relationship to the cyborgian myth a suspicious one. Early on in my dissertation research, I was invited to give talks and workshops at childbirth education conferences. While the childbirth educators who came to my talks were fascinated with my anthropological interpretation of obstetrical routines as rituals that enact the core values of American technocratic society (Davis-Floyd 1992), the intellectual stimulation of my argument was not enough for them. They wanted to know what they could *do* about it. They took it for granted that birth was healthy and organic, not pathological and mechanistic, that women were better off without drugs and

monitors, that the bonding period was critical, that natural childbirth was best.[3] Their holistic attitude influenced me greatly, and helped me find the courage to give birth to my second child—a ten-pound baby boy—at home in 1984. That experience cemented my own transition to a holistic approach to life and to health, including pregnancy and birth. This holistic paradigm (Davis-Floyd 1995; Davis-Floyd and St. John 1998) suggests not only that that the body is an energy field in constant interaction with other energy fields, but also that healing requires attention to the body, mind, spirit, community, and environment, that the pregnant woman and child are inseparably one, that too many technological interventions make birth dysfunctional and themselves cause the problems they are designed to solve, and that women give birth best when they are nurtured and protected so that their bodies can set the tone and the rhythm of birth, with no one else's rhythms or timetable superimposed:

HOME BIRTH, DAY THREE

A contraction awoke me at dawn. I felt tremendously refreshed and extremely grateful for such a wonderful sleep. The contractions were still coming every ten minutes, so I ate a good breakfast and got back into the hot tub. Soon the contractions picked up in intensity. By noon they were coming three minutes apart, and I was in serious distress. By midafternoon I was arching my back in the tub during contractions, pulling on Robert's arms and pushing against the side of the tub with my feet. It was the only way I could stand the pain without going nuts. . . . In desperation I looked at my friend Rima. She began chanting in a very soothing and beautiful tone. My midwives, my husband, and my daughter picked up the chant. They encircled the hot tub, holding hands and chanting, and I chanted my pain and my joy in giving birth, and the room sounded and resounded like a Catholic cathedral.

After an hour or so more, I had to get out of the tub to go to the bathroom. When I finished, I noticed that the bed had been freshly made up with my favorite sheets and quilt to receive my newborn and me. It looked so inviting! I dived onto it in the middle of a contraction, and suddenly everything changed. Without any pre-plan, I simply gave up and surrendered to the overwhelming force of the contractions. Until that moment, I had been struggling to maintain myself as sepa-rate from the pain, to back away from it somehow, or at least to do something about it—to chant with it, dance with it, breathe with it—*anything* but let it be. Suddenly I just let that effort go. I completely gave up, and I said to the pain, "Take me, I'm yours." Then a miracle happened. I felt that I, body and soul, *became* the pain, and once there was no more separation between me and the pain, there was no more

pain! I lay there on the bed, utterly relaxed, breathing softly, in total peace. I could hear the midwives whispering, "Good, that's really good." And that was, for me, one of the most important life-lessons of this birth—the value of yielding, of complete surrender. As Elizabeth Noble puts it, "Resistance to the pain *is* the pain." As long as I struggled for separation from the pain, I got more pain. When I gave up the struggle and surrendered to the pain, there was no more pain.

I could only maintain that altered state as long as no one divided my attention, so I lost it when my waters broke and people started to speak to me. But now I was high on the transcendence I had just experienced, and excited because the birth was so near. Returning to the hot tub, I tried some tentative pushes, but I didn't put my heart and soul into it because the pushing hurt more than the contractions alone, and I was disappointed because I had been told that often pushing hurts less. After about twenty minutes of this half-hearted pushing, the midwife asked me to get out of the tub and push on the toilet. She said that the heart tones were fluctuating because the baby was "stuck on the Ischeal spines." She wanted me to push with all my will, and she knew that the toilet is the one place where technocratic women like me are most likely to reflexively open up and let go.

As I ran down the hall to the bathroom, the second most important lesson of the birth happened to me. The walls of the hall, and all the other people running down it with me, suddenly fell away, and I was completely alone in a universe of my own making. And I *got it* that this time there would be no rescue. There was no white knight with an epidural to rescue me from the dragon of pain. No one and no thing could do this for me. It was totally and completely up to me. And I had set it all up so that it would come to this existential moment of realization that *I had to do this thing*. All of my life, things had come easy for me. This was hard! It was the hardest thing I had ever faced. But the only way out of it was through it, and *I* had to do it.

And then I was, finally and for the first time, truly ready to give birth. My commitment at long last was complete. I shivered with the realization that *this was it*! Now, here, me in this place, feeling this pain—no, *doing* this pain. I was actively doing the pain to myself now—no more avoidance. I put my heart and soul, and every muscle in my body, into pushing the baby past the "stuck place." The pain was unbelievable! but it was tempered by my new-found determination. I was going to do this thing, no matter how much it hurt. There was TREMENDOUS relief in that commitment.

There was also relief in my subsequent discovery, at long last, of *how* to push. I had been straining the wrong muscles, and I finally figured

out that if I bore down from my diaphragm, I could actually gauge the proper angle to push from and into. After that, my pushes became much more effective. I can still feel that sensation in my diaphragm of the discovery of a powerful muscle that I had never consciously utilized like that before.

It's strange—even though my official plan had been to give birth in the water, I *knew* from the beginning that I was not actually going to do that. I knew that I needed the water for labor, but my bed has always been my "safe place." After I succeeded in getting the baby past the stuck place (we knew I had because the heart tones stabilized), I got up from the toilet and instinctively headed for the bed. Robert got on it first, with his back to the wall, and I piled between his legs, semi-upright, leaning back against him. I found out later that it took me, then, about fifty minutes to push out my baby. Here, as best I can tell you, is what that was like.

Pain. Grinding, blinding, absorbing intensity. Only pain, and pushing into the pain. Only pain, and pushing. I have been pushing for an eternity now. There is no thought nor even hope that this will be the last push— it's just itself, a swimmer's stroke. In the midst of my absorption, I see the lesson, another life-lesson from this birth. I get it! When you're in the middle of the English Channel, you can't afford to think about how far away from shore you are. If you do, the next thing you will think is, "This is impossible. I will never be able to swim that far." That's why the champion marathon swimmers don't count the distance. They enter a timeless dimension, where this stroke is all there is. This stroke, and this one, and then this one. I am in that timeless world. I quit wondering eons ago when the baby will come out. There is only this contraction, and this push, and this pause, and then this contraction, and this push, and—

Then the midwife's Voice, summoning forth my consciousness from its burial in the depths of sensation. I emerge, suddenly aware that I am here, that there still is a Me that can be called forth from this primordial absorption. The Voice says, "Look! Look in the mirror." Dazed, I lift my head, straining to see over the mound of my belly. What I see shocks me into full awareness. Blonde, white blonde hair, starkly and miraculously framed by the curly dark locks on the sides of my distending vagina. I am stunned. There is not only this pain, this grinding, bone-crunching agony of raw sensation. There is another! A baby! A not-me. My hair is dark. But in the mirror, I see blonde hair framed in my vagina. Oh yes, that is what I am doing. I am giving birth to a baby. There is a baby. I am birthing it. My pushes are working! My pain is for something! I draw a breath of wonder, and push again, and watch transfixed as the oval of hair grows

larger. It's working! I am working. I am doing this; it is me, this is Me, doing this, giving birth.

I fall back, exhausted, and rest until the next contraction seizes me in its bony grip, and I galvanize every fiber in my body and PUSH. I know what I am doing now, and why. For a while there, lost in the pain-haze, I had forgotten.

A sudden sharp burn intrudes on the deeper pain that I have almost gotten used to, and, taken completely by surprise, I cry out. (My four-year-old daughter Peyton, gazing raptly from her bird's-eye view on a high stool at the foot of the bed, throws her hands over her ears for an instant, then takes them off again, relieved to see that I am back to my guttural grunts and moans.) And then the Voice says, "Reach down. Reach your hand down." And I reach down—what am I reaching for? What am I? And my hand encounters a head—warm, wet, enormous. I will never forget that sensation—it is imprinted in my hand's palm and my heart's memories. And I rest between contractions, glorying in the miracle of two-in-oneness, cradling my baby's head in my hand.

I am in joy and at peace, but the midwives are concerned. Something about shoulder dystocia. When are they going to get off it, I wonder. I know that all is well. But I can sense their anxiety, and I understand, so I willingly forsake my peace and push for them, not waiting for the next contraction. If I don't get the baby out fast, they will turn me over on my hands and knees, and I can feel my body rebel against the thought of any change in position. So I galvanize again—a deep breath, an internal focus on that muscle in my diaphragm, a precise gauging of the angle of pressure, the total participation of every cell in my body, and . . .

I have tried, but I cannot describe the overwhelming relief and release I experienced when the baby suddenly flew out—on film all we have of that instant is his body's blur. I sank back into Robert's arms, carrying with me the impression of my newborn lying on the bed, asleep! no less, after all that—so peaceful. Just as I had known my daughter, I *knew* him. I knew he was okay—just taking his own time to come to terms with this sudden change in dimensions. (Excerpted from Davis-Floyd n.d.)

■ MIDWIVES, CYBORGS, AND ME

As I settled into mothering my daughter and newborn son and returned to work on my books and research (always seeking that ephemeral perfect balance between work and family), I began receiving more and more invitations

to speak to small groups and large conferences of birth practitioners, including nurses, midwives, and sometimes obstetricians. It was the independent midwifery conferences where I felt the most at home—the holistic, nurturant approach of midwives to birth was very much in alignment with my own. I soon became fascinated with midwives' willingness to listen to intuition—that still, small, and culturally devalued inner voice—as a primary source of authoritative knowledge during birth (Jordan 1993; Davis-Floyd and Davis 1996). During extensive interviews, I heard many stories about the times midwives had relied on intuition, even if it contradicted their own standards and protocols. I was amazed and humbled by their courage and their respect for that kind of embodied knowledge. "Where does it come from?" I asked them. "It's in my heart, my gut, my hands," they answered me. "It's a cone of power that flows through my body." These midwives themselves are potential cyborgs-in-the-making: from their cellular phones to their oxygen tanks to their websites and e-mail networks, they dance ever more fluidly on the edge of the human-machine interface. Erase those lingering mental images of the hand satchels and saddlebags of yesteryear—today's midwives carry a mini-vanful of equipment to their clients' homes.[4] They respect and learn to utilize technology, but they do not grant it center stage. They use it only when they believe that it will truly be of service to the mother and her child, and they insist that the essence of their practice is their intuitive connection with the laboring woman. One of them even went so far as to say that:

> Assisting women at birth—that's all it is, is intuition. I listen to the baby's heartbeat, because, you know, I listen to the baby's heartbeat, but I don't really care about it, because I have this inner knowing that everything's fine.
>
> *Q. Do you also know when everything isn't fine?*
>
> Sure you know, there's an energy there.
>
> *Q. Has there ever been a time when the stethoscope told you one thing but your intuition another?*
>
> No. If I detect a problem with the baby's heartbeat, there have already been signs that I'm suspecting there may be a problem. The heartbeat almost never tells me anything. . . . [I document it] for the lawyers. (Jeannette Breen, quoted in Davis-Floyd and Davis 1996:248)

In recent publications (1992–1998), I have contrasted this holistic attitude with the insistent technocratic reliance of hospital-based practitioners on information externally obtained from tools and machines that can only be handled by technical experts who hold a monopoly on authoritative knowledge. I have written extensively about the differences between these techno-

cratic and holistic approaches to birth. And I have found the mediation of these conceptual oppositions in the midwives who serve women across the full spectrum that ranges between these two oppositional poles, bringing elements of each into the other—technological diagnosis and remediation into home birth, nurturance and home-cooked food into the hospital—in the manner of yin and yang.

The first time I read the "Cyborg Manifesto," however, I realized with shock that Haraway was talking about an entirely new paradigm—one that went way beyond the dichotomies I was analyzing, full of as much organicity as technology, as much tenderness as machinery, as much hope as skepticism. It was a new way of thinking about the human-machine interface, and I found it both chilling and fascinating. I sat in the audience listening to the presenters on the first cyborg panels at the annual meetings of the American Anthropological Association in 1992 and got hooked. Here was the positive side of the technological transformations sweeping hospital birth—a way to see them as part of human-machine coevolution's newest phase: the information society. I got into it. In some ways, it was an "if you can't beat em, join em" kind of thing (I'm too much of an optimist not to seize hope, even if it looks like a Transformer!). In other ways, cyborg anthropology was offering me a productive means of coming to terms with the hegemonic real-time realities of technology-assisted reproduction and technobirth. I found the complexities of the cyborg to more accurately, more hopefully, and more thoroughly represent the complexities of the technologization of reproduction than the reductionistic holistic-technocratic dichotomies with which I had been working. My increasing engagement with this new field—a process that leaves me both stimulated and concerned—is culminating now in the co-creation of this book. And for that engagement I have taken some flack from those who, like me, are horrified at the overtechnologization of birth as of life. While I honor their perspective—it is also mine!—I can only say that I can find no refuge in a blanket rejection of the cyborg and all s/he represents. How indeed could I honestly reject what I am?

Joe to Robbie: I remember that during your 1995 AAA presentation of this paper, you showed a slide of yourself naked in your bed giving birth to your son, and while the audience gasped, you stated, "Donna Haraway has said that she would rather be a cyborg than a goddess. Unlike her, I would rather be a goddess than a cyborg!" I think you might want to address that here.

Robbie to Joe: I don't know if I should put that in. It won't mean the same in print as it did when I could say it while showing the slide of myself giving birth. It is still true—I would rather be a goddess—a fully embodied woman, who knows that she IS her body, who accepts herself, her sexuality, her femininity, and her creativity, and whose life is an expression of all that. But I

also know that my interdependence with technology makes me a cyborg, too. I mean, even during my home birth, during which I experienced myself as the embodied Goddess, I was also cyborg: the baby's heart tones dropped a bit during pushing, and my energy flagged; we were both helped by the oxygen I breathed through the mask the midwives put on my face, connecting me to the big friendly oxygen tank in the corner. So I don't know how to grapple with that in print. Haraway talks about cyborg goddesses—but I don't think that's what I mean. Lots of questions, like the one you asked me earlier: can cyborgs be holistic? organic? Does a rejection of the overtechnologization of birth constitute a rejection of the cyborg itself?

Joe to Robbie: To me this is what makes cyborg such a powerful concept: it can be all of this: very open, or very specific and terrible, or very specific and positive. I'm personally unconvinced that current notions of holism and environmentalism don't presuppose a natural or originary world that doesn't exist: e.g., Haraway points out to the outdoorsy Santa Cruz students that their love of nature and natural parks and so on is predicated on those parks being relatively inaccessible to the majority of the population who are too poor to enjoy them, and on the notion that the state can continue to keep the Native Americans—who still ask to reinhabit those lands—off of them. I'm completely in sympathy with your definition of a goddess and I think you should repeat that in this chapter and then ask again whether that is incompatible with being the cyborg that you already are. I'm in favor of leaving it as a question—cyborgs are supposed to be troubling, not solved. Besides, all Good Cyborgs are continually asking what is a better way to go about things, better for the planet and all of its creatures and creations.

Robbie to Joe: Hmmm. . . .

For a deeper understanding of my own dichotomies, I look to the midwives upon whom my current research now focuses. For example, home birth midwife and PhD candidate Janneli Miller is the rare individual who lives, like me, in the world of midwifery and organic childbirth and in the world of anthropology. When I ran into Janneli at a midwifery convention, our eyes met in common understanding and she said to me, "You know, of the two worlds, this is the one where I feel most at home. Anthropologists think they're so cool, and so grounded—they talk about embodiment but live in their heads. Until you hang out with midwives, you don't know what 'cool and grounded' really is."

I serve on the Board of the North American Registry of Midwives, the agency in charge of setting up and administering the first process of national certification for direct-entry midwives (which leads to a new credential: the Certified Professional Midwife [CPM])—and I know firsthand how hard they are working to carve out a space in the technocracy for their holistic approach

to birth and for the apprenticeship model of learning that fosters and preserves it. Persecuted and harassed by the medical system, independent midwives (nurse and non-nurse alike) who work in homes and birth centers often risk arrest and jail to offer women the only viable alternatives to the cyborgification of birth that exist in the technocracy.[5] I am committed to their study and their service, as I am equally committed to the study and the service of the hospital-based nurse-midwives who struggle daily with the tension between organic and cyborg childbirth, and who do their best to create for women who give birth in the hospital the space within which to generate many unique and creative unions of the cyborg and the woman. They apply the technologies that make women *and* hospitals feel safe; at the same time, they nurture, hold, love, and empower the woman to remain (should she so desire) the goddess, the giver of birth—cyborg though that goddess may be. Thus it seems to me unfortunate that at this point in time it is far easier to find American anthropologists intensively studying every aspect of technologized reproduction than to find them intensively studying midwives and the hospitals, homes, and birth centers where they ply their womancraft.

■ THE BODY IN CYBORG ANTHROPOLOGY?

To deconstruct biological reality is as challenging and fascinating as the deconstruction of conceptual reality. The seductive thrill of the new reproductive technologies (NRTs), which scramble, invert, and subvert what we used to take for granted as the basic human reproductive mode, meshes neatly with our current anthropological immersion in the multiplicity, diversity, complexity, and ambiguity central to postmodern approaches and analysis. And it is new in the human experience. Thus it is hardly surprising that anthropologists should themselves be so seduced by the NRTs that they neglect the study of organic conception, gestation, and birth. And yet I would suggest that this state of affairs is unacceptable in our field. We are mammals: we live in bodies of flesh and bone and blood, we eat, drink, excrete, have emotions and orgasms, live, age, and die. Babies (still) grow in our wombs, we (still) birth them with sweat and blood and tears, and it is a scientific reality that no formula company has ever come up with a crib toy as intellectually stimulating as a mother's face or a recipe that is as good for our children as the milk that spurts from our breasts. (So basic is that milk to our deep being that we and our primate cousins are generically defined by it: the word *mammal* means "of the breast.") The hormone (oxytocin) that flows through our bodies to stimulate labor is the same hormone that flows through us as we make love with our partners and breastfeed our babies, showing us that these biologies have more in common than we knew and teaching us as women that, like having orgasms, the intense and stimulating sensations of giving birth and

breastfeeding[6] are integral parts of our biosexual birthright (Newton 1973, 1977[7]). Women I have interviewed who know this for a fact often ask their husbands to make love to them throughout labor: nipple stimulation increases oxytocin levels and makes labor more effective, clitoral stimulation provides islands of intense pleasure in an ocean of intense pain! Can we grapple with such biologies? I want an anthropology that talks the language of the birthing body as fluidly as cybertalk, an anthropology that probes these complexities of organicity as rigorously as it deconstructs cybernetics.

My discomforts and disquiets with cyborg anthropology just recently crystallized around this quote from Donna Haraway (1997:213–265) entitled "Universal Donors in a Vampire Culture: It's All in the Family. Biological Kinship Categories in the Twentieth-Century United States":

> I am sick to death of bonding through kinship and "the family"; and I long for models of solidarity and human unity and difference rooted in friendship, work, partially shared purposes, intractable collective pain, inescapable mortality, and persistent hope. It is time to theorize an "unfamiliar" unconscious, a different primal scene, where everything does not stem from the dramas of identity and reproduction. Ties through blood—including blood recast in the coin of genes and information—have been bloody enough already. I believe that there will be no racial or sexual peace, no livable nature, until we learn to produce humanity through something more and less than kinship.

While I can only applaud Haraway's expanded vision of a humanity that transcends kinship, it leaves me confused. What to do with the very real fact that almost all of the women I interviewed, no matter how technological their births, reported to me that the physical and emotional act of bonding with their newborn baby immediately after birth was the most important element of the entire experience? What to do with the entire field of pre- and perinatal psychology (see Chamberlain, this volume), which insists, on the basis of extensive evidence, that the unborn child in the womb is conscious—hears, feels, sees, learns, and remembers—and that experiences received in the womb and during birth can imprint powerfully on the psyche and have a major influence on development?

Joe to Robbie: I like this specific dialogue with Haraway. It would be nice if you could expand it even more—and take on the question of whether you think the bonding experience with the baby is something that can help work through the racism, sexism, wars of blood? Or whether it is to the side of this. My particular reading of Haraway here is that she is starting with a form of your response, and then asking: even if this mother-baby bonding is the most intense experience, is it the means to ground a notion of humanity, of caring

for others who are not our babies? Yes, it is incredibly important, but doesn't the generalization of this experience to bonding-in-general suggest that because it is the most intense, it should also therefore be proof that my blood-kin are worth more than others to me, worth enough even to go to war over, or to discriminate against?

Robbie to Joe: It's the patriarchal co-option of "bonding" that gives us wars over kin! Men's fixation on being blood kin has led them to commit massive repression of women's sexuality and freedom in order to ensure the purity of their precious patrilines.

Joe to Robbie: If not (and I'm forcing the issue here), then there seem to me to be two perspectives left: (1) universal—mother-baby bonding is the most intense experience, but not qualitatively different: it is just the most intense example of all of our human-bonding. Or (2) this bonding is totally special and completely separate and unique—it is one-and-two (not blood or genes), and unlike any other relationship, and therefore it should not be biologized into kin. With these senses we could desire that our relationship with humanity be something that is more and less than kinship — more intensity of felt connection and far less biology.

Robbie to Joe: OK. Then I want something more and less than kinship too! But I still don't know how to reconcile Haraway's call for an end to the bloodiness of blood kinship with the realities that a baby's experience in the womb and immediately after birth will affect its experience of life. If the fetus is conscious, as Chamberlain insists, what might be the effect on that consciousness of the "transcendence" of kinship that results from being created in a test-tube, gestated by one mother, and nurtured by another? Who knows? If all of that is done with love, maybe cyborg babies will experience themselves as both uniquely created and uniquely loved.

But what I see in doctor's offices and hospitals isn't that. As we make our babies cyborg throughout pregnancy and birth, no one asks how they feel about the high-pitched ultrasound waves they hear, about the invasion of the amniocentesis needle, about electrodes being screwed into their scalp during labor, about losing the amniotic fluid that cushions them from the contractions when the sac is ruptured by some MD in a hurry. What price must our babies pay so that we can have Information? What happened to Mystery and Trust, and Acceptance of What Is? Now that we can control almost everything about who and what we reproduce, to choose not to exercise that control begins to look like negligence. So, wanting to be safe, responsible parents, we opt for the technology and the control without realizing that our babies are the ones who will pay the technological piper.

In most hospitals, immediately after birth, babies are scrubbed, pricked for AFP testing, stuck with a needle for a vitamin K shot, laid on a cold scale to be weighed, and have antibiotics stuck into their eyes to prevent the blind-

ness that might occur if their parents have VD. To a newborn used only to the wavy warmth of the womb, these kinds of procedures are both painful and terrifying. This postbirth cyborgification of the newborn interferes with the development of sensed relationship between mother and child—the sensing of mouth to nipple, smell to smell, skin to skin, eyes to eyes.[8] This mutual sensing, if allowed to happen at all, is often terminated at the end of the ten-minute "bonding" period that many hospitals allow, and the baby is whisked off to a nursery for a four-hour observation period. If s/he cries, the nurse may stick a plastic nipple attached to a bottle of sugar water in her mouth, which may later interfere with her ability to breastfeed. This kind of cyborgification doesn't transcend kinship, it mutilates it, and it is a crime against the mammalian nature of mother and child.

By all means, let us transcend the kinship that ties us to bloody wars and racial hatred in its name. But let us not scorn, or devalue, or ignore, or prevent, the deep sense of relatedness that, assisted by a flood of hormones, can, if we would but allow it, develop between mother and child (artificially or naturally conceived) when the bonding experience itself is not rendered cyborg by the persistent intrusion of procedures, technologies, and nursery care.

Joe to Robbie: I can tell you what I don't like about this line of reasoning: it appears to set things up so that recognizing the cyborg in us, in our ways of living (good and bad), in our own births, and in our midwives ends up being equated with all that is truly terrible with hospitals. As if women weren't the first tool users, as if midwives weren't among the first professionals, the first experts, the first to experiment with formalized techniques and technological assistance in childbirth. If certain traditions of medicine perverted this, and if much of hospital birthing practices ignore what was innovative and life-giving about this midwifery, and if many of them seem caught up in technology-for-technology's-sake, is that reason to give up seeking to distinguish what is good about cyborg practices? Use and abuse seem to be collapsed here.

Robbie to Joe: I do not mean to collapse them! Instead, I draw on our Introduction, where we speak of the four different uses of the concept of cyborg that are at work in the chapters in this volume: (1) the cyborg as positive techno-scientific progress; (2) the cyborg as a mutilation of natural processes; (3) the cyborg as neutral analytic tool and metaphor of all human-technological relationships; and (4) the cyborg as signifier of contemporary, postmodern times in which human relations with technoscience have changed for better and for worse. You are invoking (3) and (4), while I am invoking (2). To invoke one to make a point is not to deny the others. Sometimes rendering a natural process cyborg is mutilating, as I describe above, sometimes enhancing, as you point out.

From the first time we sharpened a digging stick, wove a bag to carry a baby, or used a stethoscope to listen to a baby's heart, we have been enhancing our lives through technology and, according to some analysts, cyborgifying ourselves. I have been talking to Brigitte Jordan about these issues, and she says the crucial questions are not whether this is good or bad, but "Who controls the technology? Who owns it, who can speak authoritatively about it, and for whose benefit is it used?" Is the woman with the stick digging because she chooses, or because someone else is exploiting her labor? Again, who benefits? There is all the difference in the world between a midwife listening to my baby's heart to glean information that can benefit the child, and being hooked up to an electronic fetal monitor so that the hospital can protect itself from lawsuit.

I agree that to frame midwifery technologies as cyborg is to take away ownership of the seduction of the cyborg from the patriarchy—to broaden the concept thus is to allow anyone to own that seduction. And that's the crux of it, Jordan says. Who owns the techology? Who benefits? Who controls? Maybe to the above four uses of cyborg we shoud add (5) the cyborg as oppressor, and (6) the cyborg as liberator. For they are all part of the human cyborg story that we are trying to tell in this book. If I overfocus on (2) cyborg as mutilator, and (5) cyborg as oppressor, it's not to collapse use and abuse, but rather because I think society—and anthropologists!—tend to overfocus on all the rest and leave out the shadow side of the cyborg story.

In the world of midwifery and alternative childbirth in which I spend much of my professional time, it is a given that the manner of birth will influence the manner of life, that babies born gently into loving hands, and gently treated after birth, will have a better chance at becoming gentle and loving people. Anthropologists appear to make no such unprovable assumptions. So far apart are my worlds sometimes that even though my special skill is translating between them, often I cannot. Here is a recent example. Through years of involvement with alternative birth, I became aware of the problematic nature of male circumcision. I have seen videos of babies being circumcised—their screams of pain, their efforts to get away from the knife, are horrifying to behold (Milos 1989). I have learned that there is no medical justification at all for this procedure (see Chamberlain, this volume)—no benefit, only the loss of the tremendous sexual sensation that comes from the movement of the penis inside the foreskin—the foreskin that is cut off during circumcision is the most sensitive part of the glans (Boyd 1990; Diamond 1994:139–145). Men circumcised in their twenties report that their sexual pleasure plummets from a "ten" to a "two" after circumcision; men who go to extreme lengths to reverse their circumcisions through foreskin restoration report that their sexual pleasure rises exponentially for every inch of foreskin regrowth they achieve (Boyd

1990:69–71, 86; Bigelow 1992). For me this information is now fact, the same way it is a fact that homebirth is safer than hospital birth. Yet I recently found myself completely unable to convince some of my close anthropological colleagues not to circumcise their newborn children.

I am surprised that I even tried, as I long ago gave up talking to women about giving birth at home. The idea that only hospitals and their technology can make birth safe so permeates this culture that there is simply no point in trying to convince anyone otherwise, even though it is completely untrue and there is plenty of scientific evidence out there to prove it (see Enkin, Kierse, and Chalmers 1989; Goer 1995; Wagner 1994). There are 35,619 practicing obstetricians in the United States today, most of whom are busy convincing the 94 percent of American birth-giving women they see that they have to be cyborgs to have babies. And there are around seven thousand practicing nurse- and direct-entry midwives trying to empower women to give birth as they are, not as the culture wishes to make them. I know that if I could reverse those figures, so that thirty-five thousand midwives would be attending 94 percent of the pregnant women (with a few thousand obstetricians available for the few real emergencies), prematurity, cesarean, and perinatal mortality rates would drop dramatically, breastfeeding and maternal satisfaction would increase, and forty billion dollars a year would be saved—enough to more than eliminate the financial crisis in our health care system. I try not to think about it, but when I do, it drives me absolutely crazy. We are spending billions of dollars on birth machinery and the new reproductive technologies, and very few on the doulas and midwives who could truly make birth better.[9]

And so it is with enormous pain and ambivalence that I view the cyborgification of birth and of anthropology. The seductive potential of the cyborg, so fraught with the dangerous possibilities and infinite expansions of Haraway's vision, is incredibly coercive and co-optive. It's very cool to analyze the human-machine symbiosis of a woman hooked up to the EFM as cyborgian; it's very uncool to know that the price she may pay for being that kind of cyborg is an unnecessary cesarean. When I see the entire obstetrical staff of a given unit hanging out in the hall staring at the computerized monitor banks, instead of hanging in with the women in labor, rubbing their backs and holding their hands (see Cartwright, this volume), I want to scream that this is wrong, this is a distortion, a perversion, of what we could have become. I want to beat down the doors of the insurance companies with the news that if they would only pay for a doula to spend the entire labor one-on-one with the woman, they would reduce the length of labor and the cost of its "management" by more than one-third and improve both physical and psychological outcome for mother and child (Klaus, Kennell, and Klaus 1993). When I see cyborg babies in the NICU full of tubes and wires who were born prematurely simply because the doctor decided to induce labor, mistakenly thinking the baby was full-term, I want to

yell at the women who allowed this to happen that *we* are responsible for demanding evidence-based care[10] that reflects our individual realities, not the technocratic norm. When I see women damaging their immune systems with antibiotics on the one-in-ten chance that a given NRT will work for them, I want to hold them in my arms, grieve with them for their pain, and talk about dealing with the emotional issues that may be blocking their efforts to conceive (Payne 1997), about adopting a noncyborg baby, or about a book by Jane English (1988) called *Childlessness Transformed*.

But I don't do any of those things. Instead, like the good professional anthropologist I try to be, I take on the task of trying to grapple with, analyze, interpret, explain, and perhaps in some small way influence the cyborgian wave that is sweeping us as a species toward a future that our planet may not have the resources to sustain. I don't know if that's the best I can do, or a total cop-out. For sixteen years now I have striven for balance in my analytical approach. Even as I have learned the very real dangers of epidurals to both mother and baby, I have refused to judge the women who demand epidurals and schedule their cesareans between conference calls; instead I have interviewed them extensively, exploring their self and body images and coming finally to understand the complete correspondence between those disembodied images and the kind of births they choose (Davis-Floyd 1994b,c). As I noted above, I work ethnographically with certified nurse-midwives whose approach to birth is sometimes as high-tech as any obstetrician's, and sometimes with independent midwives whose approach to birth is generally noninterventive. And I strive to understand both the differing philosophies that motivate these midwives and their multiple and fluid convergences (Davis-Floyd 1998). I also study aerospace engineers who are actively engaged in shaping human futures by commercializing outer space (Davis-Floyd 1998)—hardly the transcendent vision of Gene Roddenberry's *Star Trek* but nevertheless a happening thing. In all these arenas I have struggled with the question of the dual responsibilities I feel between studying what is and raising a ruckus about what should be.

I have often thought about becoming a birth activist, but I find that I value the balance of the anthropological approach, the distancing move an anthropologist can make any time she finds herself in danger of caring too much. For she knows that any story, no matter how compelling, how juicily organic, or how cyborgian, is still just one of the thousands of stories that we humans make up about the world. No story can be taken too literally, no cause espoused too rabidly, when one can take the safe conceptual stance that it's "just another paradigm"—a passionless stance I often see students adopting. I value my discipline, but sometimes I want to yell at anthropology too. As we rush to analyze cybertalk and technosex, are we/should we/must we help to entrench the realities they represent?

The lead chapter in this book deals with technosemen—semen that has been artificially "lavaged" and manipulated to contain only the healthiest sperm. The authors note that some sperm banks nowadays, on the basis of evidence that pollution can reduce sperm counts, recommend that married couples who live in polluted areas should have the husband's sperm lavaged to select out the healthiest sperm and injected by artificial insemination. It took me some time to notice that the intellectual excitement of their argument had caused me to gloss over the very serious threat to our future bodies posed by areas in which pollution levels are so high. Likewise, it was an intellectual turn-on when, during my fieldwork with aerospace engineers, I was able to see that the thousands of satellites that will soon be ringing the planet, sucking information up from it, zinging it back and forth, and beaming it back down are reconstructing Gaia herself as a techno-organic system, an emergent cyborg.[11] The seduction of that concept almost prevented me from seeing that all those microwaves could have serious effects on the ecosystem (and thus on the human future), as could the increasing number of satellite launches that punch holes in the atmosphere, scattering gases and debris.

Goddess knows, every time I ask techies at Motorola or Johnson Space Center or Draper Labs how far technology can take us, they say there are no limits, none at all. In the unlimited potential of the nano-technologies that can penetrate and interact with our living cells and the macro-technologies that launch rockets the size of skyscrapers to carry us into outer space, there is nothing to keep us from evolving as cyborgs—nothing, that is, except the finite amounts of oil, coal, gas, and minerals that exist on this planet. Not to worry! There is a physicist in my hometown who is staking his career on the possibility of extracting energy from the zero-point vacuum. If he succeeds, maybe technolife on this planet will stop being a zero-sum game and we can all become cyborgs in any way we choose. If we run out of minerals, we will have plenty of energy available to go mine Grandmother Moon, and then, like her daughter the Earth, she can become a cyborg too.

Joe to Robbie: Here again I wonder if you are painting yourself into a corner implying that cyborgs=anti-environmentalism, and therefore implying that there were humans who were natural and not cyborgs and that "natural" naturally leads to good living. I'm using the term cyborg here in its doubled sense: a lot that is bad and a lot that is good. Useful to think with because it is both natural and technological, always questioning.

Robbie to Joe: I am NOT implying that cyborgs=anti-environmentalism. You have convinced me that humans, like cyborgs, can be anything except 100 percent natural and organic—everything we (cyborgs and humans) do is culturally (read: technologically) mediated. I guess it's just a matter of degree— more or less organic, more or less embodied, more or less of technology or of the earth. I am not essentializing here—I am well aware that biological

processes are culturally patterned and that biology only takes on meaning through culture. After all, isn't that the great anthropological insight: that there is no "natural" for us, that to be human means to mediate everything through culture? Let's look at Brigitte Jordan's crucial questions: Who owns the technology? Who controls it? For whose benefit is it used? Shall the technological artifacts that make us cyborg be the instruments of our liberation, or of our further oppression? Those questions are as relevant for mining the moon as for giving birth.

If we are all cyborgs now, then may our cyborgification give new meaning to the concept of freedom of choice. May we be as free to choose biology as technology, as free to evolve ourselves as conscious, organic, natural, embodied, mammalian, earth-based, biology-respecting cyborgs as to evolve ourselves as the cyborgs of high-tech. That's not the way it's going so far, Joe, but that's not the fault of the cyborg but of the humans who supervalue the "cyb" and trash the "org." Maybe, as we move into the new millenium, we can find a way to honor both.

Acknowledgments

This chapter is an expanded version of a paper that was originally written for oral presentation at the 1995 meetings of the American Anthropological Association in Washington, D.C. during a panel on "Cyborgs in Cyberspace or Humankind in Space and Time?: The Rhetorics and Analytics of Cybertalk in General Anthropology." My thanks to the panel organizers, David Hakken and Jennifer Croissant, for the opportunity to crystallize these reflections. Thanks also to Joe Dumit for the joys of collaboration and for his excellent editing skills.

Notes

1 It is important to understand that birth, when completely left alone, turns out well more than 90 percent of the time when the mother is healthy, well nourished, and receives adequate social support. The cascade of obstetrical interventions that mutilate and prosthetize the natural process of childbirth was originally designed to circumvent the small percentage of problems that can arise. But instead of being reserved for times when they are truly needed, these interventions have for decades been applied in standardized and blanket form to all births, turning even normal births into cyborg productions and technodazzle displays of our society's fascination with and dependence on the technological wonders it creates.

2 Four years later, as I was interviewing physicians to see if any of them would agree to provide backup for the home birth of my second child, one of them, the head of obstetrics at the biggest hospital in Austin, asked me, "What do women want anyway? I had a woman in here this morning crying because she had a cesarean. And yesterday a different woman cried in my arms because her baby had died. Why can't the ones who are lucky enough to have healthy babies just be satisfied with that?" As if all women should want the same thing. As if joy can't be permeated with grief. As if the physiological commonalities and regularities of the birth process generate emotional uniformity too. Women, like the childbirth that is uniquely their own, cannot be standardized.

3 In this, childbirth educators differ from the majority of their clients, who believe in their

right to pain-free childbirth and prefer the monitors and drugs. This discrepancy sets up a tension in the field of childbirth education between women who want to feel no pain, educators who know the dangers of drugs and the value to mother and child of drug-free birth, and hospitals who insist that the educators must encourage women to have epidurals for economic reasons. Indeed, I have spoken with many hospital-based birth practitioners—midwives, nurses, and childbirth educators—who say that whenever they encourage their clients to give birth without drugs, and the clients take them up on it, the anesthesiologists come knocking on their doors to say that their livelihood is being threatened and that the practitioners had better stop their advocacy of natural childbirth or face the consequences. Is cyborgification contagious? In this case, it would seem so.

4 The typical postmodern midwife carries myriad technologies with her to home births. For a full list, see Davis-Floyd and Davis 1996.

5 Midwives who attend home births practice legally in some states, illegally in others, and alegally in a few. In some places, they find insurance coverage, physicians willing to provide emergency backup in case they need to transport their clients to a hospital, and a supportive medical system. But in many others, they experience direct persecution by the medical establishment. This persecution takes many forms: physicians refuse to provide backup and actively harass any other physicians who do. State agencies send in a couple posing as potential clients, who get the midwife to admit that she attends home births and then arrest her for doing so. The police burst in and search the midwife's home for medical paraphernalia. A midwife is handcuffed and jailed simply for attending home births. This harassment extends not only to direct-entry midwives but also to certified nurse-midwives who attend home births.

Homebirthers in general are a self-reliant bunch who operate under an alternative model of reality that does not define women's bodies as dysfunctional machines in need of medical care. In other words, they eschew the beliefs and values of the technocracy in favor of their alternative reality. And the system, which has very limited tolerance for this sort of thing, often retaliates with force. I think I would not have as much trouble with the notion of the cyborg were the forces of our cyborgification not so powerfully aligned with the same cultural forces that persecute midwives, suppress home birth, encourage cesareans, and log old-growth forests. Haraway sees cyborgs as subversive, but from my vantage point, they look awfully hegemonic.

6 Marshall Klaus, John Kennell, and Phyllis Klaus provide a compelling account of the complex biological effects of breastfeeding after birth:

> [When the newborn nurses at the mother's breast, or even simply licks the mother's nipple after birth, this] leads to the release of oxytocin (the let-down reflex) by the mother [which hastens the after-birth contractions of the uterus needed to deliver the placenta and reduce bleeding]. After breastfeeding is underway, the sight or a reminder of the infant results in the let-down reflex. Each suckling period increases the oxytocin level, which has a calming effect on the mother and also tends to increase the tie the mother has to the infant. The latter effect is the reason oxytocin has been called the "cuddle hormone." In addition, when the infant suckles from the breast, there is a large outpouring of twenty different gastrointestinal hormones in both the mother and the infant, including cholecystokinins, which stimulate the growth of the baby's intestines and increase the absorption of calories with each feeding. The stimuli for this release are carried by the mother's nipple and the inside of the infant's mouth. . . . Whenever the nipple of the mother is touched, either by the infant's lips or by a finger, there is a fourfold to sixfold increase in her

prolactin level. After breastfeeding begins, the level decreases. These changes in prolactin levels induce the alveoli of the breasts to produce milk.

Women who, through nipple stimulation by the baby, have been able to breast-feed their adopted babies have also reported the rapid development of strong feel-ings of closeness and attachment while breastfeeding. In these situations, skin-to-skin contact, touch, smell, body warmth, and auditory and visual stimuli, as well as maternal hormones, probably all operate together to promote attachment. (Klaus, Kennell, and Klaus 1995:84–85)

7 Niles Newton's work on the sexuality of birth and breastfeeding and the interplay between Western culture and women's physiology was groundbreaking at the time, is still on the cut-ting edge of biocultural research, and deserves far more attention from anthropologists than it has received.

8 For example, a study conducted by Widstrom (1990) found that mothers whose babies' hands or mouths touch their mothers' nipples during the first hour after birth kept their babies in their rooms significantly longer than mothers who did not have this contact. Anoth-er study found that newborns in skin-to-skin contact with their mothers cry less than babies who are wrapped and placed in bassinets (Klaus, Kennell, and Klaus 1995).

9 For example, back in 1974 two certified nurse-midwives were put in charge of all normal births in a small county hospital in California for three years in an experimental pilot pro-gram. During that time, the rates of obstetrical intervention fell dramatically, the incidence of prematurity dropped almost by half, and neonatal mortality dropped from 23.9 per thou-sand to 10.3 per thousand—less than half of what it had been before the midwives arrived. At the end of the three years, fearing the competition, the local obstetricians fired the midwives and resumed charge of all births in this hospital. Within a few months, the rates returned to their former high levels (Levy, Wilkinson, and Marine 1971).

A further example: a doula is a supportive female companion who attends women in labor. Sosa, Kennell, Klaus, and their associates, working first with Guatemalan women and more recently with women in a large charity hospital in Texas, have proven the physiological value of the doula (Kennell 1982; Kennell et al. 1988; Klaus, Kennell, and Klaus 1993). Their studies all involve comparison of results of normal hospital labors with labors of women attended one-on-one by a doula. Somewhat caustically, Kennell summarizes their dramatic results in technocratic context:

> If I told you today about a new medication or a new electronic device that would reduce problems of fetal asphyxia and the progress of labor by two-thirds, cut labor length by one-half, and enhance mother-infant interaction after delivery [as does the presence of the doula], I expect that there would be a stampede to obtain this new medication or device in every obstetric unit in the United States, no matter what the cost. Just because the supportive companion makes good common sense does not decrease her importance. (1982:23)

10 Most standard obstetrical procedures, such as routine use of electronic fetal monitors, ultra-sound, episiotomy, etc., are not supported by scientific evidence. A number of scientists and obstetrical practitioners have begun to demand a move toward "evidence-based care"—that is, care that reflects the realities of a large and growing body of relevant data. Sophisticated meta-analyses of all available scientific studies in obstetrics up to 1989 have been carried out and published in the authoritative 1,500-page work *Effective Care in Pregnancy and Child-birth*, Volumes I and II (Chalmers, Enkin, and Keirse 1989). An abridged version, entitled *A Guide to Effective Care in Pregnancy and Childbirth* (Enkin, Keirse, and Chalmers 1989), which makes the information in the larger work easily available to the public, was also pro-

duced. New information is regularly published electronically through the Cochrane Database on Pregnancy and Childbirth, Manor Cottage, Little Milton, Oxford OX44 7QB, UK. In the U. S. and Canada, contact Canadian Perinatal Clinical Trials Network, Local D0-705, Hospital St.-Francois d'Assise, 10 rue de l'Espinay, Quebec, Canada G1L 3L5 (418-525-4455; fax 418-525-4481; e-mail: 3028wfra@vmi.ulaval.ca). The database is available on disk and CD-ROM for IBM and Apple MacIntosh computers.

11 In her foreword to *The Cyborg Handbook* (1995), Donna Haraway makes the case that James Lovelock's original conceptualization of Gaia was as a cybernetic system, a cyborg. This poses the question: Could there have been cyborgs before there were humans? —a possibility I am not willing to buy into. The ecosystemic earth before the evolution of high-technology humans was whatever it was, but it was not a cyborg. For me, cyborgs are the result of the fusion of humans with human-created technology. That technology, only now, is finally and ultimately cyborgifying the earth.

References

Bigelow, Jim. 1992. *The Joy of Uncircumcising*. Aptos, Calif.: Hourglass.

Boyd, Billie Ray. 1990. *Circumcision: What It Does*. San Francisco: Taterhill Press.

Chalmers, Iain, Murray Enkin, and Marc Keirse. 1989. *Effective Care in Pregnancy and Childbirth*, vol. I and II. Oxford: Oxford University Press.

Davis-Floyd, Robbie. 1987. "Obstetric Training as a Rite of Passage." *Medical Anthropology Quarterly* 1 (3): 288–318.

———. 1990. "The Role of Obstetrical Rituals in the Resolution of Cultural Anomaly." *Social Science and Medicine* 31 (2): 175–189.

———. 1992. *Birth as an American Rite of Passage*. Berkeley: University of California Press.

———. 1993. "The Technocratic Model of Birth." In *Feminist Theory in the Study of Folklore*, edited by Susan Hollis, Linda Pershing, and M. Jane Young, 297–326. Chicago: University of Illinois Press.

———. 1994a. "The Rituals of American Hospital Birth." *Conformity and Conflict: Readings in Cultural Anthropology*. 8th ed. Edited by David McCurdy, 323–340. New York: Harper-Collins.

———. 1994b. "The Technocratic Body: American Childbirth as Cultural Expression." *Social Science and Medicine* 38 (8): 1125–1140.

———. 1994c. "Mind over Body: The Pregnant Professional." In *Many Mirrors: Body Image and Social Relations*, edited by Nicole Sault. New Brunswick, N.J.: Rutgers University Press.

———. 1995. "Introduction" to Anne Frye's *Holistic Midwifery: A Comprehensive Textbook for Midwives in Homebirth Practice*, vol. 1, *Care during Pregnancy*. Portland, Ore. : Labyrs Press.

———. 1998a. "An Anthropological Perspective on the Direct-Entry Debates." In *Getting an Education: Paths to Becoming a Midwife*, 4th ed. A Midwifery Today Book. Eugene, Ore.: Midwifery Today.

———. 1998b. "Commercializing Outer Space: Profit, Paranoia and Paradox in the Futures Planning of the Aerospace Industry." In *Para-Sites*, Late Editions VII, ed. George Marcus. Chicago: University of Chicago Press.

———. nd. *The Technocratic Body and the Organic Body: Hegemony and Heresy in Women's Birth Choices*. New Brunswick, N.J.: Rutgers University Press, forthcoming.

Davis-Floyd, Robbie, and Elizabeth Davis. 1996. "Intuition as Authoritative Knowledge in Midwifery and Home Birth." *Medical Anthropology Quarterly* 10 (2): 237–269.

Davis-Floyd, Robbie, and Carolyn F. Sargent. 1997. *Childbirth and Authoritative Knowledge: Cross-Cultural Perspectives*. Berkeley: University of California Press.

Davis-Floyd, Robbie, and Gloria St. John. 1998. *From Doctor to Healer: The Transformative Journey*. New Brunswick, N.J.: Rutgers University Press.

Diamond, Jared. 1994. *The Warrior's Journey Home*. Oakland, Calif.: New Harbinger Publications.

English, Jane E. 1988. *Childlessness Transformed: Stories of Alternative Parenting*. Mt. Shasta, Calif.: EarthHeart Publishing.

Enkin, Murray, Marc Keirse, and Iain Chalmers. 1989. *A Guide to Effective Care in Pregnancy and Childbirth*. Oxford: Oxford University Press.

Goer, Henci. 1995. *Obstetric Myths versus Research Realities*. Westport, Conn.: Bergin and Garvey.

Haraway, Donna. 1991. "A Cyborg Manifesto: Science, Technology, and Socialist-Feminism in the Late Twentieth Century." In *Simians, Cyborgs, and Women: The Reinvention of Nature*, 149–181. New York: Routledge.

———. 1997. *Modest_Witness@Second_Millenium.Female Man© _Meets_Oncomouse™ : Feminism and Technoscience*. New York: Routledge.

Jordan, Brigitte. 1993. *Birth in Four Cultures: A Cross-Cultural Investigation of Childbirth in Yucatan, Holland, Sweden and the United States*. 4th ed. Rev. and updated by Robbie Davis-Floyd. Prospect Heights, Ill.: Waveland Press.

Kennell, John H. 1982. "The Physiologic Effects of a Supportive Companion (Doula) during Labor." In *Birth: Interaction and Attachment*, edited by Marshall H. Klaus and Martha O. Robertson. New Jersey: Johnson and Johnson.

Kennell, John H., and Marshall H. Klaus. 1984. "Mother-Infant Bonding: Weighing the Evidence." *Developmental Review* 4: 275–282.

Kennell, John H., Marshall H. Klaus, Susan McGrath, Steven Robertson, and Clark Hinckley. 1988. "Medical Intervention: The Effect of Social Support During Labor." *Pediatric Research* (April): 211 (Abstract #61).

Klaus, Marshall H., and John H. Kennell. 1982. [1976] *Parent-Infant Bonding*. St. Louis: C. V. Mosby.

———. 1983. "Parent to Infant Bonding: Setting the Record Straight." *Journal of Pediatrics* 102 (4): 575–576.

Klaus, Marshall H., John H. Kennell, and Phyllis Klaus. 1993. *Mothering the Mother: How a Doula Can Help You Have a Shorter, Easier, and Healthier Birth*. Reading, Mass.: Addison-Wesley.

———. 1995. *Bonding: Building the Foundations of Secure Attachment and Independence*. Reading, Mass.: Addison-Wesley.

Klaus, Marshall H., and Phyllis Klaus. 1985. *The Amazing Newborn*. Reading, Mass.: Addison-Wesley.

Levy, B. S., F. S. Wilkinson, and W. M. Marine. 1971. "Reducing Neonatal Mortality Rates with CNMs." *American Journal of Obstetrics and Gynecology* 109: 50–58.

Milos, Marilyn F. 1989. "Male Circumcision: An Eyewitness Account." Unpublished ms. For a copy, or for information about male circumcision, contact Marilyn F. Milos, NOCIRC, 415-488-9883.

Newton, Niles. 1973. "The Interrelationships between Sexual Responsiveness, Birth, and Breastfeeding." In *Contemporary Sexual Behavior: Critical Issues in the 1970s*, edited by Joseph Zubin and John Money. Baltimore: Johns Hopkins University Press.

———. 1977. *Maternal Emotions: A Study of Women's Feelings Toward Menstruation, Pregnancy, Childbirth, Breastfeeding, Infant Care, and Other Aspects of their Femininity*. New York: Paul B. Hoeber.

Parvati-Baker, Jeannine. 1978. *Hygeia: A Woman's Herbal*. Monroe, Utah: Freestone Publishing.

— — —. 1986a. *Conscious Conception: Elemental Journey through the Labyrinth of Sexuality*. Monroe, Utah: Freestone Publishing.

— — —. 1986b. [1974] *Prenatal Yoga and Natural Birth*, Rev. Ed. Monroe, Utah: Freestone Publishing.

— — —. 1991. "The Deep Ecology of Birth: Healing Birth Is Healing Our Earth." Monroe, Utah: Freestone Publishing

— — —. 1992. "The Shamanic Dimension of Childbirth." *Pre- and Perinatal Psychology Journal* 7 (1): 5–20.

Payne, Niravi. 1997. *The Language of Fertility*. New York: Harmony Books.

Reynolds, Peter C. 1991. *Stealing Fire: The Mythology of the Technocracy*. Palo Alto, Calif.: Iconic Press.

Righard, L., and M. O. Alade. 1992. "Sucking Technique and Its Effects on Success of Breastfeeding." *Birth* 19 (4): 185–189.

Villardi, R.H., J. Orter, and J. Winberg. 1990. "Does the Newborn Find the Nipple by Smell?" *The Lancet* 344: 989–990.

Wagner, Marsden. 1994. *Pursuing the Birth Machine: The Search for Appropriate Perinatal Technology*. London and Sydney: ACE Graphics (U.S. distributor: ICEA Bookcenter, P.O. Box 20048, Minneapolis MN 55420).

Widstrom, A. M. 1990. "Short-Term Effects of Early Suckling and Touch of the Nipple on Maternal Behavior." *Early Human Development* 21:153–163.

Techno-Toys and Techno-Tots

Growing Up Cyborg

Development Stories for Postmodern Children

Jennifer L. Croissant

■ INTRODUCTION: CYBORG IDENTITIES

Cyborgification is a dual process of fragmenting the human body and decentering subjectivities. Like the distinction between an elaborated speech code, based on and capable of abstraction, and a restricted one focused on the local and particular (Bernstein 1971), learning styles of bodily control and movement can be implicated in "class reproduction" and the reproduction of gender. Children are growing up cyborg between the extremes of disembodiment presented by the possibilities of life in cyberspace and the complete reduction to embodiment posited for production workers subject to the machinations of hypermobile global capital in export zones.

Haraway (1985:67) remarked that cyborgs have no "origin stories." They are not tied to, for example, Judeo-Christian tales of The Garden and The Fall, which frees them from imputations of a unitary "nature" and from assumptions of conventional humanism. In contrast, Schelde (1993) argues that cyborg and monster stories are an important folklore, complete with origin stories and morality plays. Narratives of cyborgs in Western popular and technical cultures, when taken together, are stories of creation and control. For example, cyborgs are generally anxiety-ridden creatures, searching for a stable identity. Or consider that cybernetic research relies on themes from evolutionary narratives: the achievement of bipedalism, digitality in conjunction with an opposable thumb and use of tools, strict cortical organization and neurological sophistication, language, and sociality and sexuality in human evolution are used as templates for both justifying and organizing cybernetic research. In particular, human-machine synthesis is seen as the next stage of human evolution.

This chapter is an examination of the "cyborgification" of children found in three types of narratives of children's development. In the first set of stories, developmental milestones in neurophysiological and robotics research provide a template for interpreting and evaluating children's progress. In the second set, changes in developmental narratives in parenting books, most particularly those of the Institute for Human Development, illustrate the reinterpretation of children's learning in cybernetic terms. The third group of narratives consists of cyborg quests for identity and growth as found in movies and comic books. These three sets of stories, in the context of a constellation of the social changes of postmodernity, provide opportunities to reflect on Foucault's notion of the biopower of contemporary global, postindustrial societies and the increasing salience of ideas about flexibility and fragmentation outlined by Harvey (1989) and Jameson (1984). In the concluding section I discuss the implications of such studies in relation to the notions that cyborgs are particularly flexible bodies emblematic of postmodernity and that such flexibility at the human-machine interface represents the next step in human evolution — a future made increasingly likely by the multiple cyborgifications of children.

■ MOVING GRACEFULLY: MODELS OF MOTOR LEARNING AND DEVELOPMENT

We can expand the study of the reciprocal relations of social and physical bodies outlined by Mary Douglas (1973) into the analysis of human movement. The movement of social bodies is created within and sustained by the physical bodies of a given culture. In an era of mobile capital and flexible accumulation, the unstable narratives of human movement and their achievement by infants take on new significance. Human movers are situated in tensions between culturally specific, local embodiments and the construction of bodies in relation to flexible accumulation and a global marketplace. The cyborgification of developmental narratives both constitutes and reflects these new bodies. I focus on the understandings of humans and cyborgs deployed in the popular and technical accounts, and argue that the various narratives both legitimate and produce cyborg identities.

The scientific texts I draw upon are from the fields of biomechanics, including sports sciences and kinesiology, as well as psychology and neuroscience. The cybernetic discourse of children's motor development in neurophysiological research intersects with childrearing books, producing a nexus of culture, scientistic discourse, and narratives of evolution. Through the use of cybernetic information theories in motor development research, children are interpreted as information processors and construed as flexible, as capable of being programmed by environment and activities (see Adrian and Cooper 1989:17). Flexible bodies are tolerant and "unresisting" in the sense of loosely

bounded and not rigid. Flexible bodies do not, apparently, say "no." They are represented as nonspecific to time or space, not embodying nor particular to a local culture. The narratives of these texts of human infant motor development, as forms of American folklore and as encapsulations of professional wisdom, are part of the resources from which parents, physicians, and educators actively construct the body and its capacities for movement.

Contemporary research on children's motor development is focused on the relationships between what children learn and the genetic and neurophysiological mechanisms by which children accomplish this. In discussing the origins and developments of the behavioral approach to motor control and learning, psychologist Richard Schmidt (1988:3–6) notes that contemporary research has origins in both neurophysiology and psychology. After World War II, the contributions of Wiener's *Cybernetics* and information theory aided the expanding analogies of the brain as a computer (Schmidt 1988:11). In Schmidt's account, the major issues in motor control are divided between neurological approaches which neglect learning and psychological approaches focusing on performance.

The dichotomy between neurological and psychological approaches is manifest in the two major cybernetic models of human motor programming and behavior. Motor learning and control theories fall within a dichotomy of *open-loop* and *closed-loop* programming. Open-loop theories of control are based on an open circuit model, where a system executes a one-way process or produces a one-way stream of information. Closed-loop circuits incorporate positive and negative feedback into the execution of a process, "closing" the stream of information by looping it back into the system. For motor control researchers, open-loop models are problematic in that they afford no mechanisms for learning. Closed-loop theories, framed as neurophysiological models, and the use of "schema" (Schmidt 1975) for cognitive approaches are argued to redress this gap. For closed-loop models, feedback is incorporated into error-correction processes. The motor program is revised through learning until an adequate motor representation is arrived at and a task completed. For example, the (usually) increasing accuracy with which a child can connect a baseball bat with a baseball is taken to be evidence of the closed-loop learning models.

Steele (1968:387) summarizes the open-loop model:

> The concept of a motor program may be viewed as a set of muscle commands that are structured before a movement sequence begins, and that allows the entire sequence to be carried out uninfluenced by peripheral feedback.

Repetitive, single movements, especially where speed, accuracy, and distance prevent the timely synthesis of feedback, are modeled as governed by an

open-loop motor program. The open-loop program is contrasted with the closed-loop approach, which is often represented as a standard servomechanism. For example, Kelso's (1982) discussion of variations of motor programs presents a typical representation of a simple servomechanism and of the human movement control system which expands upon this model. The questions at the core of these technical narratives are questions about voluntaristic aspects of movement, and about learning; they are questions about free will.

Within the highly specialized scientific texts, nature and nurture are mapped onto theories of "open" and "closed" motor programs and questions about what role "feedback" from the environment has on the development and deployment of motor skills. In sports sciences textbooks and baby books, these tensions are manifest in conflicts between what is portrayed as inevitable progress in a context of unlimited capacities and the representation of "external" factors such as education and environment which come into play as narrative elements. There is a near-millenialist "progress-talk" in these texts, a normalization of efficiency, and what amounts to a recapitulation of the major themes of individualism in American culture.

■ BUILDING THE BETTER (ROBOT) BABY

Controversies over nature and nurture are transported through dichotomies between genetic capacities and environmental influences. Hardware and software metaphors continue the mimesis, and these are further encoded into open- and closed-loop theories of motor control. In particular, the energetic hypotheses for movement optimization are linked to evolutionary strategies for efficiency. This confirms Haraway's observations (1989, 1991) that sociobiological theories recapitulate major themes in economic ideologies.

> Development proceeds from head-to-toe (cepahlo-caudal), and from trunk-to-limbs (proximal-distal). With respect to gross locomotor movements, many children may be observed to follow this progressive order: swimming, crawling, climbing, walking, running, jumping, throwing, and on to complex movements involving part or all of the above. (Adrian and Cooper 1989:17)

Taken as a composite from the popular press parenting literature, it seems that babies (middle-class and most likely Caucasian ones) first creep, then crawl, stand, "cruise" (which is to use furniture and objects to facilitate movement—such as circumnavigating the living room), and then walk, run, and eventually develop the finer gradations of adult gaits (see especially Dr. Spock's [1985:293] description of this). I will discuss later the normative characteristics of the chronologies, which usually take the form of pediatricians' charts or lists of milestones.

I will be focusing in this section on walking and ambulation, the "gross" motor skills, rather than manual dexterity. There are a number of other issues that are also relevant but beyond the scope of the current discussion, such as gender and movement and the interconnections of motor development with what is presented variously as social, psychological, emotional, or intellectual growth. But movement turns out to be very useful for connecting these topics and sounding out their relationships.

What drives human development generally, and the acquistion of motor skills specifically? According to best-selling pediatrician-author Brazelton (1983:33), "the inner forces propelling development" are a "drive to survive independently in a complex world," a "drive toward mastery," and "a drive to fit in, to identify with, to please." This tension between drives to individuation versus identification, and of the embodiments these drives imply, is a prevalent dichotomy in popular culture. The centrality of a particular form of mobility is evidenced in a number of places in professional and public discourse, and is made further apparent in the high value that walking has as a milestone for parents evaluating a baby's progress. In scientific and sports sciences and biomechanics texts for use by future physical educators and coaches, walking is a key skill. It is highly useful for evaluating maturation. Walking provides benchmarks for growth and development and the normalizing framework of efficiency and coordination to which movers (both children and adults) are subjected (Keen 1993).

Specific programming and implementation of human movements are effectively connected to the genetic program of human evolutionary development. In evolutionary developmental genetics, a common heuristic is that the human embryo recapitulates the evolutionary stages that the species passed through—the phylogeny. It is a standard narrative of developmental embryology and biology. But it also comes out as an explanation of a common movement phase:

> Another series of reflexes combine to propel an infant across a bed, or even through the water. An infant has available, like an amphibian, a rhythmic extension and flexion of his legs and arms, which can be accompanied by a swinging of his trunk from side to side. This activity looks like that of an amphibian, and relates to them in the hierarchy of evolution. (Brazelton 1983)

To put it crudely and in the language of cynical baby-sitters, it seems that children develop from amphibians (frogs, perhaps) to rug rats to house apes. For example, the Institute for Human Development (an organization with a program for children's development that will constitute a primary subject of my analysis in this section) emphasizes a key period where brachiation (swinging by the arms), derivative of the ancestral arboreal primates, is important for

superior intellectual and motor development (Doman et al. 1991). But just as protohominids dropped from the trees and learned to traverse the savannah, children too move through a brachiation phase:

> When the emerging human no longer found it necessary to hold his arms above his shoulders in order to balance himself, he became the first creature in the long history of the world to free his hands from their role in locomotion and thus come to use them for other purposes. (Doman et al. 1991)

That is, "one small step for man, one giant step for mankind!" Bipedalism and conventional upright posture and movement are among the characteristics used to identify human beings.

The developmental narrative of the texts also encapsulates narratives of both cultural and biological evolution. In the Better Baby "mobility development scale," there are seven brain stages, which correspond to seven response and expression stages in a mobility chronology. The brain stages are "medulla and cord, pons, midbrain, initial cortex, early cortex, primitive cortex, and sophisticated cortex," which correspond to reflex responses (movement of arms and legs without bodily movement), vital response (crawling), meaningful response (creeping), initial human expression (walking with arms used for balance), early human expression (walking with arms free from primary balance role), primitive human expression (walking and running in cross pattern), and sophisticated human expression (using a limb in a skilled role which is consistent with the dominant hemisphere) (Doman et al. 1991:160). Some keys, such as "human," "meaningful," "primitive," and "sophisticated," mark a teleological chronology from ancient to "modern."

Walking is thus interpreted as an evolutionary achievement of the human species, and its achievement by an individual infant indicates an elevation in status of an infant toward adulthood. "Meaningful" is invoked to indicate intention on the part of the mover. "Primitive" indexes the chronology in the secular origin myths of the West. In promotional literature from the Institutes for the Achievement of Human Potential (the Better Baby Press), the authors remark that they have done extensive studies of other cultures, "from the most primitive to the most sophisticated" (Doman 1992:3). That this research is concerned with dominant hemispheres (i.e., handedness) and comes from a "dominant hemisphere" (whether characterized as the North or the West) is no little irony. Human children progress as human cultures progress, in this colonialist narrative, from the primitive to the (post)modern. Using the language of information theory in a narrative of evolution in the service of cyborgification expands the gap between the "hemispheres" of the contemporary world.

Narratives of the achievement of mastery are intertwined with a co-occur-

ring narrative tension, as mentioned above, between individuation and identification. That is, the dichotomy between the individual and the social is recapitulated in narratives of motor development. The child's social and sociological development is an interesting debate in itself: focusing on movement reveals that motor actions, particularly standing and walking, simultaneously are an indication or symbol of autonomy and individuation, and one of the first ways that this so-called separation is achieved. The individual/society narrative figures very prominently here, and a sub-narrative emerges from these sources. It indicates a second tension, of nature and nurture, which arises in these constructions, as well as the progress teleology so clearly evident.

In the popularized narratives of baby books, there are three major issues which arise out of examination of narratives of motor development. The first is related to tensions within the narratives between nature and nurture. There is a conflict between what is portrayed as inevitable progress in a context of unlimited capacities and the representation of "external" factors such as education and environment which also come into play as narrative elements. Motor learning is said, on one page, to be a natural outcome of neurological development and genetic endowments and programming. And yet, on another page (and the major premise, for example, of the Better Baby Press and the Institute for Human Development), it is claimed that coordination and movement are not natural but achieved, primarily through the work of parents.

These Better Baby Books rely on a sense of guilt for enrolling parents in their programs. Unless a child is explicitly "brain injured" (their term), parents are thoroughly indicted for any lack of achievement on the part of their children. Even more explicitly cyberneticizing than the motor development milestones, parents are actively encouraged to be "synapse builders" and to develop the information processing capacity of their childrens' brains. Parents are encouraged to use flashcards, count, and teach very early memorization (which entails buying products) so that babies are exposed to many bytes of information, by which they will develop their storage capacity and learn information to synthesize with additional data later in life.

A second major issue arises in the commodification of experience, particularly of children and of childhood, and is manifest in the content and structure of the texts, particularly those of the popular press. A major subtext of these developmental narratives relies on ideologies of the family and childhood, individualism, and gendered themes of maternalism: families are nuclear, and all parents are mothers (see Doman et al. 1991). The Institute for Human Development goes so far as to professionalize motherhood, which, in the realm of contemporary feminist discourse about motherhood and reproduction, presents a challenging subject for debate. In any case, the achievements of children are part of a larger scheme of objectification and commodification. The Better Baby Books sell on parental guilt, the promise

of prep schools, and experiences for children in the "high culture" of the West.

Notwithstanding differences in perspective among the parenting experts, bodily control is a hallmark of middle-class Western values. This control and mastery orientation is indicative of a posture, also gendered, toward the rest of the world. I am most familiar with this in terms of the control orientation (dis)embodied in Western thought and scientific knowledge, as critiqued by Carolyn Merchant (1990/1980) or Susan Bordo (1987) and as found in the revision of Freudian thought in object relations theory. Basically, the narratives of motor development in infants recapitulate the enlightenment hope for control and mastery over creation; the hope is for an ordering of a complex and unruly universe, brought about by human achievements. The Institutes for the Achievement of Human Potential and the Better Baby Press are intimately concerned with producing "Renaissance children," a political and epistemological program.

But as I noted above, these narrations are not without their ironies, and human bodies are resistant to disciplines. In the next section I integrate these various narrations of motor development from scientific and popular texts in a further discussion of movement and embodied culture. Within these narrations, what might an increasing cyborgification entail? Among other things to expect with increasing cyborgification of motor development theory and practice is a widening gap between the children who embody the ideals of flexibility and robust motor programming and are capable of moving gracefully, who are effective information managers in the cognitive domain, who will be the adults who manage and move with and for transnational capital flows, and those for whom such movement is a struggle, a luxury, or a dream.

Another possible outcome with increasing cyborgification is the erosion of ideas about human nature and the possibility of a shared humanity. Linnda Caporael (1986:232) discussed the attribution of thought to computers, pointing out that in the end, the question of what makes people think machines can think is a question about what makes us think other people can think. Turkle (1984) makes similar observations. Anthropomorphism is a conventional and community strategy in situations of uncertainty, while mechanomorphism is the converse strategy used by a technical community. "Anthropomorphized, even unintelligent machines may become social entities" (Caporael 1986:215). Anthropomorphism is a "default schema" for manufactured objects (or, in other cases, animals) and leads to a perpetuation of "back metaphors," that is, the application of a set of human characteristics to machines, which are then applied back to humans as an exhaustive set (Caporael 1986:226). For example, in her popular exposition of the technical possibility of the "artificial person," neural net researcher Maureen Caudill (1992) identifies the characteristics that a synthetic system must embody.

These involve mobility, vision, touch, memory, learning, problem solving, speech, thinking, and emotionality—characteristics of a typical kind of anthropomorphism.

So recent reports by researchers at MIT developing a "baby brain" in a robot (Travis 1994) are the flip side of the cyborgification of (human) children. Their machine, named "Cog," is being designed to implement a program in artifical intelligence and robotics. Cog will be "born" with "certain base-level behaviors," such as a bonding with a "mother." It will have hard-wired abilities which correspond/co-respond to what is "thought to be the case in babies, cross-cultural cues such as smiles, frowns, soft encouraging tones, and nodding heads." Researchers will provide "Cog with a crude ability to interpret the reactions of people around it" as "hardware" and part of "nature" rather than "nurture."

■ CYBORGS NARRATE: I, ROBOT?

It will be a while before Cog speaks to us, if ever. In the meantime, many fictional cyborgs have given us some clues to their identities. Gabriele Schwab (1987:68, 73) discusses the shared cultural fantasms of fragmented bodies which figure in children's toys (such as "Captain Cosmo") and anxieties about prosthetic and transplanted organs as well as prosthetics generally. Besides narrations of flexible bodies, the cyborgification of childhood presents us with a particular example of the fragmentation of identity in a system of commodity exchange. I discuss the fragmentation issue below; the focus here is a literature associated with children—comic books—to explore the narrations of a quest for identity and the problem of a fragmented body. The first stories of cyborgs are where a machine is the core "being" of the cyborg. In the other comics, it is a human being which provides the basic materials (and an identity) for the cyborg, the mechanical components added later as a result, almost uniformly, of injuries and laboratory accidents.[1]

Machine Man is clearly a child of the Cold War.[2] Produced for the government in a top-secret laboratory, Machine Man fights aliens, criminals, and corrupt officials of both civil and military origin, solves mysteries, and saves people, including those who do not trust his mechanical origins. Each issue precipitates some sort of monologue on his ambiguous nature as a machine yet also a human (although he is entirely mechanical) with intelligence, problem-solving ability, and purportedly no emotions to interfere with his rationality and superior strength. In one issue Machine Man, also known as "X-51," uncovers a hidden message from his creator/father (whom he addresses as Father) after a serious accident which requires extensive repairs and reprogramming. After viewing this message from his Father, which legitimates his name, Aaron Stack asserts his identity as "his own man" and is guaranteed that his programming

can never be tampered with (again)—settling the problem of free will as a problem of interference from "outside" the individual.

These issues of free will, identity, and authenticity are apparent in a more recent cyborg story. Frank Miller and Geof Darrow produced the highly acclaimed and excruciatingly graphic novel series *Hard Boiled*, a story about "reality through the eyes of a psychotic cyborg."[3] This is an urban, postmodern, dystopian world divided up among corporate enclaves, and it is apparent by the third and final issue that the cyborgs are assassins used by the corporations to eliminate rivals. The cyborgs' bodies have a veneer of human flesh, and are given memories, families, and identities as means of social control. The central figure is confused about his identity—he is "fed the memories of dead men," and has overlapping and conflicting recollections.

The basic plot is that the cyborgs are trying to become free, two female cyborgs having overcome their programming to assert identities (they name themselves Barbara and Blanche) and wage war against their creators/oppressors. They are trying to enroll the male cyborg in their fight. In the beginning he asserts his human characteristics: "But I'm just a regular guy," with a wife and two kids. He resists the possibility that he is a machine. In the end, the male cyborg realizes he is manufactured, returns to the patriarchal, corporate order to fight his fathers, is defeated (crying "Uncle!"), and is to be reprogrammed. The female cyborgs are destroyed, or destroy themselves. As Glass (1989) noted for *Robocop*, which I discuss more fully below, a cyborg's search for wholeness presents a utopic moment in film depictions, and the narrations are generally cast in what resembles the problems of white adolescent male identity.

One exception emerges in the story of "Cyborg,"[4] in which an African-American youth receives machine components after a laboratory accident kills his mother and injures him. He is an example of the second cyborg variation, one created by augmenting an authentic human being with prosthetics. Both of his parents were millionaires and worked for a secret research laboratory. "Vic Stone" tangled with the ambiguities of gang life and academic excellence, with Olympic athletic aspirations thrown in for good measure. The technology integrated into his body was of his mother's design and "a way of saving the dismembered victims of war." The army intended to use it make "the perfect soldier," but his father needed to use it to save his son's life.

> But if his body is made of steel, his heart was all too human. Strength and compassion. A street-tough vocabulary and a brilliant scientific mind—dichotomies that make Victor Stone a constant, never-predictable enigma.

Throughout the series are monologues and questions about identity and authenticity. Cyborg status stands for the marginal status (if relying on stereo-

types) and conflicting demands of a young man of African American upper-middle-class heritage.

In *The Machine*[5] we get indirect hints, rather than extensive monologues, about the problems of identity for the central cyborg character. "While I am no longer one of them, I am connected to them. . . ." The Machine, "Avram," lives in "Steel Harbor," a now typical scene of urban decay in cybernetic literature. He is looking, for example, for a "little genuine, *human* isolation" when chaos knocks at his door. He "likes Barbara. She treats me like a person." This series is new enough that there are few clues to his past identity, but certainly the hints at human origins are clear, while his body has wiring, conduits, and components that mark him as a cyborg.

Cyborgs beginning with mechanical systems to which human characteristics and identities are integrated are always *made to kill*. Cyborgs beginning with a human being (if not a human body) with an existing identity and personal history are generally *made to survive*, clearly a desirable feature for feminist politics. Nonetheless they are objects and subjects of extreme violence. Yod, of Marge Piercy's novel *He, She, and It*, is a manufactured being who develops his own identity. While clearly gentle, good with children and other living things (at least after an altercation with a thorny rosebush), sensitive, and capable of a rich emotional life, he was created to defend. He is the golem of the free town of Tikva, programmed and sent to defend his community to the death, despite his objections.

Glass explicitly associates the cyborg in cinema with "transitional" objects for children.[6] The cyborg "Murphy" in *Robocop* forms a constellation of significations (Glass 1989:39–41). First, the cyborg is emblematic of new technologies in the workplace, in this case the automation of police work. Second, the cyborg paradoxically provides reassurance against fears of decay in street culture, in part brought about by the automation and alienation of public street life. Third, Murphy signifies concerns about the decline of human character. The cyborg demonstrates "conscience," yet is prevented from doing justice (violence is the assumed means to this end) to the truly criminal—in this case his corporate owners. A corollary to this emerges: omnipotence contains its own anxieties. Fourth, the cyborg in the film indicates a general fear of dehumanized people.

> One patterned challenge to the characters in these films is to reassert their humanness against their forcible marriage with or takeover by the machine. (Glass 1989:41)

Movies such as *Robocop* are not entirely postmodern, given a "modernist sensibility of opposition" (Glass 1989:44). Glass analyzed the film *Robocop* as a "new bad future" film, emphasizing a politics of despair, diminished expectations, and a passive public appealing to "experts" to fix things. These films

are kitschy—self-referential and often self-parodying, and play on recycled sentiments. The complexity of transitional or marginal figures enlarges a narrative space for multiple readings by a heterogeneous audience—clearly central to the appeal of the cyborg to Haraway. These multiple readings do not, however, come together into a vision for social change; they exhibit an ambivalence to the heterogenous others in the audience:

> Such ambivalence . . . is, at best, dialectical, at worst, simply contradictory. Put more positively, those systems against which we test and measure the boundaries of our own identity require subjection to a double hermeneutic of suspicion and revelation in which we must acknowledge the negative, currently dominant tendency toward control, and the positive, more latent potential toward collectivity. (Nichols 1988:22)

And clearly, the potential of the cyborg as a figure for imaginative collectivity is latent rather than expressed. With children interpreted and reinterpreted through cybernetic narratives of development, what is the basis of a collectivity of cyborgs except in their marginal and slave status in relation to "certified" humans? With evolutionary narratives naturalizing the emergence of cyborgs as anthropomorphized robotic systems, and cybernetic metaphors playing an increasingly important role in describing and normalizing development, flexible bodies and unhappy decentered subjectivities are part of the erosion of collectivities for refashioning politics and the public sphere.

■ CONCLUSION: FRAGMENTED STORIES FOR FLEXIBLE BODIES

Some thirty years ago C. Wright Mills (1959:166–167) warned of the ascendance of "the Cheerful Robot." Recently, Donna Haraway has argued her preference for being a cyborg (1991:81). What does it mean when cyborgs, as the biologized progeny of von Neumann's and Wiener's cybernetics, figure positively (nearly unanimously) for the most recent radical critiques of science, technology, and culture?

Not only children but also adult bodies are also postmodern, flexible, and cyborgified. For example, Barry Glassner (1990, 1988) has analyzed changing conceptions of the body and fitness in a variety of media. His argument is that through the discourses of fitness, contemporary bodies are becoming fit for a postmodern selfhood. The changing discourses of health and fitness undo modernist dualities of masculine and feminine, body boundaries, and the distinctions between interior and exterior, work and leisure, and mortality and immortality. Multiple interests in fitness align with processes of commodification, distribution of scientific information, and transformations of self in post-

modern (white upper-middle-class) United States culture. Radley (1991:165) similarly remarks that fitness discourses have a Foucauldian effect:

> The application of the techniques of physiology has made possible a sports science, which subjects the body still further to inscription, and which amplifies the authority of the requirement that it be properly maintained.

These scientific discourses, whether in fitness or development, contribute to the normalization of cyborg bodies. Mary Douglas (1973:16) has remarked that the body can be seen as an organ of communication; as a vehicle of life and thus appropriately vulnerable; as pragmatic and unproblematic; and as irrelevant (the millenialist turn). In general,

> . . . the more value people set on social constraints, the more value they set on symbols of bodily control. . . . The major preoccupations will be with its functioning effectively; the relation of head to subordinate members will be a model of the central control system, the favorite metaphors of statecraft will harp upon the flow of blood in the arteries, sustenance, restoration, and strength. (Douglas 1973:16)

The narratives discussed in this chapter help to mark transitions from what Foucault noted as docile bodies to what Emily Martin (1990, 1993) identifies as flexible bodies. In an era of mobile capital and flexible accumulation, the interpretation of human movement through information theory and the achievement of movement by infants take on a new relevance (Jameson 1984; Harvey 1989). While Martin focuses on immunology and the changing representations of health, "flexible bodies" can be taken literally, as easily organized and reorganized, transportable across boundaries, and extremely "plastic." The shift is from a particular ordering of movement, such as that described by Foucault (1979) as cellular and thus "modern," to postmodern. That is, certain cyborg children may indeed fare very well in the future. And yet others out of the "loop" will fare very poorly.

My review of narratives of motor development and cyborg stories points to avenues for future research in embodied culture, avenues marked by the concept of "habitus" and by the discipline of bodies and biopower as described by Bourdieu (1990) and Foucault (1979). Implicated in biomechanics knowledge are not only the changing relations of postmodernity for the body but also the transformations of machines and of understandings of machines. For example, Rabinbach's (1990:18) discussion of the "metaphor of the human motor—a body whose experience was equated with that of a machine" implies the transformation of ideas about machines as externally driven and reversible devices to those of the motor, which is internally governed and

based on "irreversible processes." So not only does a proposition for future study on "flexible bodies" imply studies of physical education, health programs, neurobiological research, and examinations of global economics and stratification, but further study of machines in themselves as features of our public landscape.

This selection of cyborg narratives illustrates the extent to which cultural productions can be inscribed in and naturalized by scientific work. Researchers proposing theories of motor control rely on progress narratives, a stock rhetoric of science to make their claims, and frame their work within conventional norms of performance. Those proposing cyborgian childrearing practices naturalize their claims by referring to scientific knowledge. And these narratives are couched within evolutionary narratives where a human-machine synthesis is emblematic of the next phase of evolution. The outcomes of the convergences of these narratives include flexible, cybernetic bodies, fragmented identities, a naturalization of global inequalities, and the possibility that parents are furthering this evolutionary "mandate" by raising cyborg children.

Notes

1 I have selected the following comics on the basis of the centrality of the cyborg to the story, and because they are each exemplary of the major themes of cyborg narratives. There are numerous others, and none, including those with female cyborgs, stray very far from the themes of problematic identities, superhuman strength, and questions about free will that surface in the series discussed below.

2 See *Machine Man: The Living Robot* (circa 1978), written and drawn by Jack Kirby, Marvel Comics. An analysis of *Superman*, another child of the Cold War, is called for here, especially in the postmodernization of Superman resulting from his death and reincarnation into a cyborg that proves to be inauthentic.

3 Frank Miller and Geof Darrow (1991). *Hard Boiled*, numbers 1,2, and 3, Dark Horse Comics. The serialized graphic novella is very violent and can be read as pornographic.

4 *The New Teen Titans*, DC Comics. See especially number 47, 1988.

5 *The Machine* (1993). Dark Horse Comics.

6 Turkle (1984) established computers as "evocative objects," which people use to think about themselves, and analyzes the responses of children to computers. Glass is using the terminology of D. A. Winnicott for describing the transitional object, while Turkle remains somewhat closer to Freud.

References

Adrian, Marlene, and John Cooper. 1989. *The Biomechanics of Human Movement*. Indianapolis: Benchmark Press.

Bernstein, Basil. 1971. *Class, Codes, and Control*, vol. 1, *Theoretical Studies towards a Sociology of Language*. London: Routledge & Kegan Paul.

Bordo, Susan R. 1987. *The Flight to Objectivity: Essays on Cartesianism & Culture*. Albany, N.Y.: SUNY Press.

Bourdieu, Pierre. 1990. *The Logic of Practice*. Stanford: Stanford University Press.

Brazelton, T. Berry, M. D. 1983. *Infants and Mothers: Differences in Development*. Rev. ed.

Caplan, Frank, ed. 1982. *The First Twelve Months of Life: Your Baby's Growth Month by Month*. New York: Perigee (Putnam).

Caporael, Linnda. 1986. "Anthropomorphism and Mechanomorphism: Two Faces of the Human Machine." *Computers in Human Behavior* 2: 215–234.

Caudill, Maureen. 1992. *In Our Own Image: Building the Artificial Person*. New York: Oxford University Press.

Croissant, Jennifer L. 1994. *Bodies, Movements, Representations: Elements toward a Feminist Theory of Knowledge*. Ph.D. diss., Department of Science and Technology Studies, Rensselaer Polytechnic Institute.

Doman, Glenn. 1992. *The Gentle Revolution*, brochure (April 1992) from the Institutes for the Achievement of Human Potential, Philadelphia.

Doman, Glenn, Douglas Doman, and Bruce Hagy. 1991. *How to Teach Your Baby to Be Physically Superb*. Philadelphia: The Better Baby Press.

Douglas, Mary. 1973. *Natural Symbols: Explorations in Cosmology*. New York: Vintage.

Foucault, Michel. 1979. *Discipline and Punish*. New York: Vintage.

Glass, Fred. 1989. "The 'New Bad Future': Robocop and 1980s Sci-Fi Films." *Science as Culture* 5: 7–49.

Glassner, Barry. 1988. *Bodies: Why We Look the Way We Do (And How We Feel About It)*. New York: G. P. Putnam's Sons.

———. 1990. "Fit for Postmodern Selfhood." In *Symbolic Interaction and Cultural Studies*, edited by Howard S. Becker and Michael M. McCall, 215–243. Chicago: University of Chicago Press.

Haraway, Donna J. 1991. *Simians, Cyborgs, and Women: The Reinvention of Nature*. New York: Routledge.

———. 1985. "Manifesto for Cyborgs: Science, Technology and Socialist Feminism in the 1980s." *Socialist Review* 15 (2): 65–107.

———. 1989. *Primate Visions: Gender, Race, and Nature in the World of Modern Science*. New York: Routledge.

Harvey, David. 1989. *The Condition of Postmodernity: An Enquiry into the Origins of Cultural Change*. Oxford: Basil Blackwell.

Jameson, Frederic. 1984. "Postmodernism, or the Cultural Logic of Late Capitalism." *New Left Review* 146: 53–92.

Keen, Mary. 1993. "Early Development and Attainment of Normal Mature Gait." *Journal of Prosthetics and Orthotics* 5 (2): 35–38.

Kelso, J. A. Scott, ed. 1982. *Human Motor Behavior: An Introduction*. Hillsdale, N. J. : Lawrence Erlbaum Associates.

Martin, Emily. 1990. "The End of the Body?" *American Ethnologist* 17 (1): 121–140.

———. 1993. *Flexible Bodies*. Boston: Beacon Press.

Merchant, Carolyn. 1990/1980. *The Death of Nature: Women, Ecology, and the Scientific Revolution*. New York: Harper and Row.

Mills, C. Wright. 1959. *The Sociological Imagination*. London: Oxford University Press.

Nichols, Bill. 1988. "The Work of Culture in the Age of Cybernetic Systems." *Screen* 29 (1): 22–46.

Porush, David. 1987. "Reading in the Servo-Mechanical Loop." *Discourse* 9 (Spring-Summer): 53–63. (Special issue: "On Technology: Cybernetics, Ecology, and the Postmodern Imagination.")

Rabinbach, Anson. 1990. *The Human Motor: Energy, Fatigue, and the Origins of Modernity*. Berkeley: University of California Press.

Radley, Alan. 1991. *The Body and Social Psychology.* New York: Springer-Verlag.

Schelde, Per. 1993. *Androids, Humanoids, and Other Science Fiction Monsters: Science and Soul in Science Fiction Films.* New York: New York University Press.

Schmidt, R. A. 1975. "A Schema Theory of Discrete Motor Skill Learning." *Psychological Review* 82: 225–260.

———. 1988. *Motor Control and Learning.* Champaign, Ill.: Human Kinetics Publishers, Inc.

Schwab, Gabriele. 1987. "Cyborgs: Postmodern Phantasms of Body and Mind." *Discourse* 9 (Spring-Summer): 64–84. (Special Issue: "On Technology: Cybernetics, Ecology, and the Postmodern Imagination.")

Spock, Benjamin, and Michael B. Rothenberg. 1985. *Dr. Spock's Baby and Child Care.* New York: Pocket Books.

Steele, Steven W. 1968. "Movement Control in Skilled Motor Performance." *Psychological Bulletin* 70 (6): 387–403.

Travis, John. 1994. "Building a Baby Brain in a Robot." *Science* 264 (May 20): 1080–1082.

Turkle, Sherry. 1984. *The Second Self: Computers and the Human Spirit.* New York: Simon and Schuster.

Inhabiting Multiple Worlds

Making Sense of SimCity 2000™ in the Fifth Dimension

Mizuko Ito

In his science fiction novel *Ender's Game*, Orson Scott Card presents an allegory for a generation of video kids, a story of a game that begins in play and ends in something deadly serious. The book follows the child protagonist, Ender, through his star career at the elite Battle School, where he passes every trial concocted by the military commanders at the academy, each one framed as a confrontation in a complex computerized battle game. Ender triumphs unflaggingly, emerging, finally, as the leader of a prepubescent militia of the highest promise, running through simulation after simulation of battles of an alien invasion. While a story of a child coupling so tightly with simulations of destruction might be enough food for cautionary thought, Card also provides us with a final obliteration of the simulacrum of childhood innocence. Ender's last game turns out, unbeknownst to him, to be a real military attack that results in the genocide of an entire alien species.

Card's story is both a celebratory and a cautionary tale. In it, he treads the well-worn ground of boy heroism and explores the seductiveness of simulation games. But below the glossy surface of just another hero story, of combat and conquest, is the uncomfortable figure of a child who is both hero and not quite in control—master of a toy world with unforeseen consequences. Skirting the abyss of a peculiar paranoia, Card teases out a familiar suspicion: perhaps there is a moment when a game is more than mere fantasy.

I find this suspicion lurking irresistibly and uncomfortably throughout my observations of children playing simulation games. While there is a certain closure to video games, a sense in which we are tempted to call them "microworlds" or dismiss them as "just games," that closure is constantly subverted by unexpected refractions and recombinations, unorthodox identifica-

tions that threaten the containment of the microcosm. This analysis is driven by these suspicions of recombinant meanings and unforeseen interlocutions with a virtual imaginary. I am interested in the webs of relationships and identifications made available to children playing and making sense of a particular genre of virtual world—simulation games of which I believe SimCity 2000™ to be a particularly intriguing example.

■ SIMCITY 2000™

Following up on its 1985 hit computer game, SimCity™, the software company Maxis upped the ante on simulation games with the release of SimCity 2000™ in November 1993, following a one-million-dollar development investment (Darlin 1994:300). Unlike the original SimCity™, SimCity 2000™ was the work of a large production team and integrated the suggestions of hundreds of fans of SimCity™ who wrote to Maxis asking for new features (Dargahi and Bremer 1995:337). While SimCity™ broke new ground by presenting an innovative model for a computer game based on world-building simulation, SimCity 2000™ pushes the envelope on complexity and multimedia. It capitalizes on the expanded capabilities of new personal computer platforms, incorporating 3D graphics and animation, advanced music and sound effects, new public transit systems, a water system, hospitals, schools, and a complex new economic system (Dargahi and Bremer 1995:396). Both SimCity™ and SimCity 2000™ are hit products in the competitive computer game field, continuing to earn Maxis millions in revenue (Darlin 1994). The games have spawned an entire subculture, with Usenet newsgroups, competitions, numerous publications, and even networked versions initiated by a loyal user community.

SimCity 2000™ is both authoring tool and interactive game. It offers an intriguing space for the user, providing a responsive virtual environment equipped with tools for users to build and administer an entire virtual city. The primary interface window is a grid that can be rotated or zoomed in and out. Starting with a blank landscape dotted with trees, water, and hills, the player chooses different tools from a toolbar running alongside the screen, building, bulldozing, and zoning. In addition, there are numerous informational windows that report on population, educational levels, pollution, industrial growth, and city budget, among many other factors. The basic progression of the game revolves around building roads, zoning districts, and providing city services such as power, water, schools, parks, and libraries. In addition, the player must make decisions about budgeting: taxes, city ordinances, and allocation of funds. If zoned and administered properly, "Sims" (simulated people) will populate the grid, creating their own buildings and voicing their opinions through the city newspaper.

The user plays the role of mayor of the city, and receives certain rewards for good governance and population growth, such as a mayor's house, a statue, or a spontaneous parade. The design of the system tends to promote a model of expansion and growth by providing rewards around achievement of population levels, but numerous parallel and subgoal structures exist in the game, including ecological and economic balance, community relations, and aesthetics. Since SimCity 2000™ foregrounds user authoring, it is less a game driven by a specific goal than a structured space of possibility for the user to explore in a pleasurable way. Subverting linear growth scenarios are numerous disasters that can be turned on and off, including fires, floods, and space alien invasions.

The algorithms underlying SimCity 2000™ rely on cellular automata[1] techniques, creating an impression of lively growth, interactivity, and change—a sense of the city as a living entity. The graphics and sound in SimCity were designed by teams of professional designers and musicians, resulting in a compelling series of effects that are visually and aurally pleasurable. Combined with the unpredictable responsiveness of the growth algorithms, the SimCity 2000™ effects result in an engaging virtual environment with an ongoing series of visual, auditory, and interactional surprises. Construction sites change to small buildings, which are in turn torn down to make space for a large shopping mall or a stunning skyscraper. As the population and transportation network of the city grows, antlike cars start flowing frenetically across highways and roadways, and planes and traffic helicopters fly across the cityscape, occasionally crashing into a tall building and maybe even starting a fire.

Will Wright and Jeff Braun, founders of Maxis, deliberately avoided the label "educational software" for SimCity™, believing that "people have a low opinion of educational software" (Wright in Barol 1989: 64). The SimCity 2000™ sourcebook bills the game as "entertainment/educational software" (Dargahi and Bremer 1995:4). The game spans the boundary between the explicitly educational children's market and the entertainment market, competing with the dominant paradigm of combat games. The SimCity™ games are rare crossover hits, winning rave reviews from educators (Tanner 1993; Paul 1991; Jacobson 1992; Eiser 1991; Peirce 1994) as well as attracting a wide following among the computer gaming community as a whole. The game has also been reviewed extensively in the popular press (i.e., Barol 1989; Schone 1994).[2]

■ SIMCITY 2000™ IN THE FIFTH DIMENSION

I am not aiming toward an evaluation or even a critique of the content of the game per se, but rather to look at the game content and capabilities of players in a system of ongoing social activity. This arises out of my study of children

interacting with information technologies, which includes involvement in a project that develops after-school programs where children use these technologies around certain educational goals.

For the past year, I have been a researcher with the Fifth Dimension project (5thD), a network of after-school clubs with sites across the United States and in Mexico and Russia, organized by Michael Cole at the University of California, San Diego. The work of Cole and his colleagues in developing the 5thD precedes my involvement by over a decade and grows out of activity, theoretical perspectives, and concerns around children's cognitive development (for examples, see Cole 1996, Nicolopolou and Cole 1993; Cole and Griffin 1986, 1987). In its current instantiation, the 5thD consists of an activity system that involves undergraduate tutors/fieldworkers drawn from a class at the affiliate university, elementary-aged children from the local community, computers running educational software, and a series of artifacts designed to guide children and undergraduates in their interactions with one another and the machines. Some of these structuring resources in the 5thD include a "constitution," folders with the records of each child, "task cards" guiding progress through a game, a "maze" that specifies a path for playing different games, Internet resources that link the different clubs, and a "wizard/ess" who is a mythical guardian spirit for the clubs, reachable only through telecommunications. Each 5thD club uses these resources in ways particular to its site, but all of the clubs embody a certain focus on maintaining a collective system where children can have fun and achieve mastery through joint activity with people multiply positioned. The clubs are generally located at community centers of one sort or another, including Boys and Girls Clubs, schools, and libraries.

The fieldwork for this paper was done at one of the sites in California. For my analysis, I am drawing on interviews that I conducted with 5thD staff, my observations of children at the club, the database of undergraduate fieldnotes,[3] and, most centrally, two videotape-and-screen captures of people playing SimCity 2000™ at the club.

SimCity 2000™ was introduced to the club with fanfare. It was a present given to the Wizard on her/his birthday and was installed on the computer reserved for "Young Wizard's Assistants" (YWAs), the children who have mastered a certain number of games. The original SimCity™ was well established at the club as a popular game with some loyal adherents. SimCity 2000™ quickly gained popularity as one of the most desirable games. Soon the site coordinator had kids writing to the Wizard to ask for special permission to play the game, and kids monitored their watches impatiently as they carved playtime into thirty-minute or fifteen-minute turns. During the five-month period that the game was at site, it tended to attract the more technically savvy kids, usually the predominantly male older kids and YWAs.

In their discussion of physicists interacting with visual representations, Elinor Ochs et al. suggest that physicists take "interpretive journeys" through graphic space through the use of gesture, drawing, and talk in group meetings. They describe the ways in which physicists dynamically interact with graphs on a blackboard, often using talk that places them within the graphical representation. For example, one physicist gestures to a graph on the blackboard, placing himself within the representation with a personal pronoun: "I just can't hop over." Their interaction with the representation, then, "is a means not only of representing (possible) worlds but also of imagining or vicariously experiencing them" (Ochs et al. 1994:163).

The processes described by Ochs and her colleagues parallel some of the activity of children playing computer games. Elsewhere I have argued that couplings with virtual environments provide opportunities for alternative embodiment through subject positions enabled by the sociotechnical apparatus. These identities are not ultimately reducible to identities located in "real life,"[4] but rather are contingent on the particular semiotic and material technologies mobilized by the game (Ito 1994, 1996). Buying into a graphical space as a representation or a compelling virtual reality is an achievement that requires ongoing identifications supported through joint activity. Despite its purported "realism," engagement with SimCity 2000™ as a representation of a city requires constant and active sense-making activity that ties the events happening on the screen with experiences in "real life" and identifications with game participants. Users are drawn into the simulated reality of the game by coupling with particular subject positions within it, creating and performing links to circumstances outside the context of the game. This point is borrowed in part from what Raymond McDermott and Henry Tylbor have argued in describing a "collusional" approach to conversation analysis, that "the pathway of meaning of talk is by no means simple and assured. . . . The irremediable absence of strict borders between persons and others, between acts and other acts, produces interactional puzzles that require constant alignment and collusion from participants" (McDermott and Tylbor 1986:136).

To this analytic mix I would add collusion with machines in the constitution of computationally enabled cyborg subjects (Haraway 1985). For example, in one of the sequences that we captured on videotape, a YWA, "Jimmy," is building a city with an undergraduate, "Holly," and together they set up a series of relationships that make sense of and locate them within elements of the virtual world. Jimmy has played the game a number of times before, and is considered fairly accomplished. He is still learning some of the basic functionality of the game, however, and almost always fails to make a city that is stable. Jimmy is thirteen years old, which makes him one of the oldest mem-

bers of the club, and he has been attending the 5thD for three years. He is a well established and comfortable figure in the club, and makes friends easily with the undergraduates that cycle through quarter after quarter. This is Holly's first time to play the game. She was handed the task card for it by the site coordinator, and is working with Jimmy for the first time. Throughout their engagement with the game, they have a fairly lively give-and-take, with Holly asking questions about game functionality and Jimmy asking her for advice about trying to make sense of various aspects of the game.

They have been working on this city for about twenty minutes, with Jimmy in control of the mouse the entire time. Their city has just reached a population of one thousand, which triggers the "rewards" button to highlight, indicating that the player can build the mayor's house. As Jimmy moves his pointer up to select a button on the toolbar, he notices the rewards button, and the following exchange ensues:

> J: I can make my house, my mayor's house. [clicks on rewards button] Where do I want to make my house?
>
> H: [laughs] You want it overlooking everything? [laughs] Aaah . . . Do you want to have it overlooking the lake or something? [dismisses year-end budget window]
>
> H: Yeah, you can have like those be the really nice houses or something. Like up in the hills?
>
> J: Up here? [moves cursor to flat area on ridge]
>
> H: Uuuu maybe over here [pointing] because this you'd be just overlooking over the power plant. That wouldn't be very nice. Maybe over by the lake or something?
>
> J: How 'bout, right here? [positions cursor over flat ground by the lake]
>
> H: Sure, yeah, like right on the lake?

In this segment of activity, Jimmy begins by taking up an identification, proposed by the structure of the game, between him and the mayor: "I can make my house. My mayor's house," and then invites Holly into the decision of where to place it: "Where do I want to make my house?" Holly's talk then draws in a series of connections from her knowledge about the world—what constitutes desirable real estate, a good view, and signifiers of power and wealth. Jimmy takes up her first suggestion, to put it overlooking a lake, by trying to place it on a ridge overlooking an industrial area. She then offers an alternative suggestion, to place the house in the uninhabited region by the lake. Jimmy, with her agreement, places "his" house by the lake opposite the

city. Holly is not basing her suggestions on any knowledge of the underlying algorithms of the game that calculate real estate value or the "not in my back yard" (NIMBY) phenomenon, but rather she makes the game sensible for Jimmy in terms of her sociocultural knowledge. In fact, the placement of the mayor's house is inconsequential in terms of game outcomes but functions as an effective hook for locating a subject position for the player within the game's *mis en scene* and, conversely, for locating the game within a system of social distinctions. This kind of talk, where Holly refers to social contexts at large to make sense of the game, is fairly typical of their interaction. At other times, for example, Holly initiates discussions around where prisons should be located in relation to residences or how good school districts attract families.

While the tone of the talk is decidedly playful and peppered with laughter—it's just a game, after all—Jimmy, Holly, and SimCity 2000™ have succeeded in organizing themselves around a series of identifications that link Jimmy, the mayor, "nice" parts of town, and a good view. I am not arguing that Jimmy has "learned" that powerful locations are associated with hills and lakes, but rather a set of cultural meanings have been achieved interactively that instantiate these relationships. Like Ochs's physicists, Jimmy, through an animated representational technology and the mediation of his knowledge interlocutor (Holly), has enacted and been drawn into this set of meanings. Perhaps more significantly, a complex of desire and power has been constituted with a particular relationship to Jimmy's own subjectivity as he is established as mayor and controller of the game. One might then speak less of Jimmy's internalizing certain cultural values than being drawn into a particular cultural nexus, a cyborg subject whose identity is partially, and at least momentarily, contingent on a coupling with a social and technical apparatus.

■ MASTERY: FINDING ORDER IN A CLOSED WORLD

In the case of Holly and Jimmy, neither are masters of SimCity 2000™, and Holly in particular is lobbing back and forth from "real-life" relationships in order to make sense of the virtual world. The computer and the human participants are able to cement a common interactional space through the commonsensical cultural assumptions built into the game interface, Jimmy's familiarity with the basic tools of the game, and Holly's frequent identifications with real-life contexts. Yet the game is opaque and complex enough that they frequently run into trouble, failing to get water flowing or running out of money. By contrast, "Bruce," another undergraduate working at the club, is an expert at the game, has read the manual, and has an understanding of the actual algorithms that lie below the visible manifestations of the computer interface. In a second videotape, Bruce is working with "Dean," an eleven-

year-old YWA, who is playing the game for the first time. "Erik," who is only eight years old but an accomplished player at the game, has joined them. He is well known in the club as extremely interested in and focused on SimCity 2000™, to the point that the Wizard has had to take explicit steps limiting his play on the game and directing him toward other 5thD activities.

In this tape, Dean is in control of the mouse throughout the session, and Erik is sitting next to him, tossing in occasional comments and suggestions. Their interactional dynamics are quite different from Jimmy and Holly's. Much more of the discussion stays within the terms of game elements and functionality, and relationships instantiated within the context of the virtual world. There are very few references to social life outside of the virtual space, which contrasts with Holly's frequent moves to make the designed city accountable to certain social norms. Bruce, Dean, and Erik's is a mode of interaction more oriented to mastery within the terms that the game sets up, such as gaining population levels or building an efficient transportation or water system.

Near the beginning of the activity, Dean opens up the budget window and selects "city ordinances." There he is given a list of certain revenue-generating options such as parking fines or sales tax and certain spending options such as free clinics, pollution controls, or business advertising. His first move is to begin selecting all of them. Erik verbalizes Dean's activity:

E: Nuclear free zone. Pollution control.

D: [starts to select all of the city ordinances]

B: Hey, what are you doing?

D: I'm making city ordinances.

B: No, no, no, listen. These all cost money. All these things cost a lot of money. You can't really put them in it because you'll lose money. These first four you can put in. I usually don't legalize gambling. Beause these ones you actually get money in for doing them.

[As Bruce talks, Dean deselects all the ordinances he selected, leaving only the revenue-generating ones]

D: Legalize? [pointer hovers over gambling ordinance]

B: Don't legalize gambling yet.

D: [deselects legalize gambling option]

B: *You can put in parking fines.*[5]

E: *Why don't legalize gambling?*

B: What?

E: Why don't legalize gambling?

B: Because that increases your crime rate.

E: [raises eyebrows in surprise]

B: Crime goes up. Yeah.

E: Oh yeah. *Because people don't really want to move there.*

B: *People don't like your city.* It's like Las Vegas. It's kind of seedy.

D: [Dismisses ordinance window]

Bruce cuts into Dean's activity—"Hey, what are you doing?"—and uses the moment as an opportunity to explain certain relationships. By the end of this sequence, the budget has been configured prioritizing growth and revenue within the instrumental logic of the game. This instance of talk, in fact, was the only time during the thirty-minute session when Bruce made explicit reference to an example outside the context of the game to make sense of game elements. During the rest of the time, the relationship of the game to the world at large was either taken for granted or not consequential to the activity at hand. Significantly, this particular reference to Las Vegas was generated by Erik's explicit questioning regarding legalizing gambling. General club practice, which has informed Erik's interaction with the game, is to legalize gambling because it generates much more revenue than the other ordinances. The connection to another factor in the game, crime, is new to him, and prompts some questioning. In general, the three participants' talk is characterized by tight referential interweaving around the technical aspects of the game.

One additional example may further illustrate the sorts of interactions that I am characterizing as oriented toward mastery within the internal logic of the game. Approximately eleven minutes into their session, Bruce points out some of the more complicated features of the game to Dean and triggers some talk around deciphering a particular graph.

B: You see this little graph? [points] You know what that means?

D: [opens graphs window]

E: Whoa! Go back go back [responding to window snapping shut]

D: [opens window and drags to keep window open] That's my S. That's my something. That's my industrial. That's my residential, and that' s my commercial. [moves cursor down to point to different lines in the graph, labeled "S," "I," "R," and "C," as he refers to them]

E: Commercial.

B: Right. This other one right here. [pointing to another item on tool-bar]

E: [jumps up and points to closing window]

D: [closes graph window]

E: The seaport! That's seaport! That's seaport!

D: [Opens neighbors window] I don't have many people.

In response to Bruce's question, Dean makes links between the lines on a normally hidden graph window and the different zones in his city, industrial, residential, and commercial. He skips over the line labeled "S," — "That's my something" — a move that Bruce also glosses over. Erik, however, notices the omission and, as Dean closes the graph window, jumps up and enthusiastical-ly points out that "S" must refer to seaport, a special kind of zone. The excite-ment is in uncovering a new symbolic relationship between two game ele-ments. His insight is not, however, acknowledged by the other two, who have moved on to the next graph, which shows population levels. Even as Erik's contribution is not taken up by the others, the participants have managed to cement a common interactional space which is focused on deciphering the intratexual referents within the game, the meaningful space of identifications looping tightly within the technical terms and goals of the game.

The suggestion here is not that the sense-making processes in these inter-actions are sealed within the boundaries of the game algorithms. Clearly, the very design of the game system and the subjectivity of participants is absolute-ly embedded within a larger social field, regardless of the intra-referentiality of particular readings of the game. Unlike the segment with Jimmy and Holly, however, we see less a process of identification with a subject position in a vir-tual reality than an engagement with the technical apparatus that produces the interface effects. Instead of working to decode the elements of the virtual environment as richly endowed with connections to the world at large, Bruce, Erik, and Dean seek to uncover the particular instrumental logic of the game as designed by the Maxis production team. Like film critics that might ana-lyze a camera angle and lighting, the three forge links with the production apparatus, making the game meaningful as a complexly embodied technical achievement.

■ VISUAL AND INTERACTIONAL PLEASURE

In her discussion of computers and video games, Sherry Turkle (1984) sug-gests that games generate a particular kind of "holding power," an "almost

hypnotic fascination" that forms a special relationship with the computer. She describes Jarish, a game player who is very focused on mastery, on bringing the game under control. Further, she describes his ability to accomplish this because, "despite the complexity of the games, there is a program behind, there are rules." He will walk into an arcade and try to find the "craziest, most out-of-control" game that he can find, and attempt to uncover the underlying rules of the interaction (1984:72). In many ways, the interactions among Bruce, Erik, and Dean seem understandable in Turkle's terms. All three of them focus their attention on finding the rules that make the game tick.

In both the interactions with these three and in the interactions with Holly and Jimmy, however, I also observed another mode of engagement which pointed to a kind of holding power of the game, but one that was based on an immediate visual, sonic, or interactional pleasure, not immediately directed to the rules or goals of the game. For example, as Dean and Bruce work through the budget window later on in their game, Dean starts clicking on the button to raise property taxes, which prompts a sound effect of people booing. Bruce interrupts this activity, while Dean protests that he just wants to "make them happy" as he lowers the property tax to hear the Sims cheer. Bruce interrupts again, however, pointing out the "best way to make money" and increase population, which eventually brings Dean back into focus around the goals of the game:

D: [starts bumping up the property tax, big grin]

B: What are you doing? No, no, no.

D: I know, I . . . no, I just *want to see.* . . .

B: *Now,* now *listen*

D:[starts lowering tax, and hears the sound effects of Sims cheering]

*Yeeeeee*aaah.

I just want to make them happy.

B: *The best way to make money*—You want to increase your population, right?

D: [stops clicking on tax button, and closes budget window]

B: So you lay down the green, right? So if you put all, make all this all green, then, aah, your population will increase and then you could raise taxes and then you could get up to your five thousand mark.

D: Ohh okay.

Dean's apparent pleasure in this interaction can, I believe, be understood

as a kind of computer holding power which is based on a particular kind of interactive special effect. It is the combination of direct interactional engagement with the machine and a unique responsiveness that creates a brief but tight interactional coupling between Dean and SimCity 2000™. This kind of interactional pleasure occurred numerous times on the two tapes that I observed closely, but was only initiated by the children who were controlling the mouse.

An extended sequence of a sort of visual interactional pleasure emerged during Jimmy's play with Holly. At a certain point in the game, as his city grows, Jimmy attempts to build highways. "I want to do a highway," he declares, selecting the highway tool. "How do I do a highway?" Moving his cursor around, he discusses with Holly where he might put the highway, settling on an area near a commercial district. He bulldozes to make way for the highway and then builds it around one edge of the city, discovering at a point that he can make it curve around the corner if he clicks on blocks perpendicular to one another. As he builds his highway in the foreground, he notices that it is elevated above the level of the regular roadways. "That's cool!" he exclaims. "I can make it above?" Holly speculates on whether they can build the highway through the city, and then Jimmy points with his cursor to a tall, blue-and-white skyscraper: "That's so cool!" Holly asks, "Is that a high rise?" "Yeah," Jimmy answers. "I love them," he declares emphatically. Jimmy goes on to continue his highway, and then discovers that if he makes overlapping segments, they result in a cloverleaf. He looks over at Holly with delight when this happens, and she laughs. "So cool!" he exclaims, building further overlapping segments that result in a twisted quadruple cloverleaf. "My gosh," says Holly, "you're going to have those poor drivers going around in circles." Jimmy then bulldozes the whole cloverleaf pattern, blowing up a large building in the process and then declaring that he is going to start a new city. He closes his city without saving it.

While this sequence begins with certain accountabilities to building a transportation system, by the end, Jimmy has wasted thousands of dollars on a highway to nowhere, blown up a building, and trashed his city. He apparently has few attachments to the city that he has worked on for over thirty minutes, and in fact replicates a pattern of building up cities to a point of difficulty and then getting rid of them, not bothering to save or follow up on his work. The pleasure here is in a certain interactional aesthetic, in the spectacle of the interface, not in the instrumental goals of the game or in inhabiting an engaging virtual reality. It is the special effect rendered in interactive media.

I liked Sim 2000 because after you save it you can destroy it!! And then you can reload it!!!

—letter to 5thD wizard

On one of my field visits to the Boys and Girls Club, I set up a machine with SimCity 2000™ and invited some kids to play on it. "Do you know SimCity?" I asked a boy of maybe seven or so, whom I hadn't seen before. "Yeah!" he declared. "That's the game where you blow up the cities!" Nonplused I nonetheless asked him if he would like to play, and whether he knew how to, and he answered yes on both counts. As he hunted around the toolbar to perform some operation, it became clear he knew little about how the game worked. Finally, he asked, agitated, "Where are the guns?" With the help of another boy, he succeeded in setting the city on fire, and shortly thereafter left to play a different game.

Caught off guard by this young boy's apocalyptic impulses, I grew increasingly uneasy about the intertextual relationships he seemed to imply. As I progressed in my fieldwork on SimCity™, I found these ricocheting references to action games punctuating children's talk about SimCity 2000™, reverberating through a certain space of anxiety and suspicion. While not entirely surprised, I somehow find myself the unwitting innocent here. A childhood fare of Pac Man and Asteroids is hardly sufficient cultural capital in a world of Mortal Kombat.

As Jimmy is patiently building up his city, one of his bridges explodes because he hasn't allocated sufficient maintenance funds. "I broke it again! My bridge!" he exclaims in distress. Another boy, observing, responds, "Cool. Save it and restart." "And do what?" asks Jimmy, apparently perplexed by the suggestion. The other boy continues, his voice rising: "I love doing that. I love just saving a city and then, just *destroy it* ! Every disaster!" Another child, just checking into the scene, pipes in, "I know! Especially the monsters. Those are cool." "The monster's different on this one," declares the first boy, in the know regarding the new version of SimCity 2000™. "It is?" "Yeah," he continues, "you've never seen the monster of SimCity 2000?"

As a player of SimCity 2000™ myself, I never quite understood the appeal of disasters and assumed that they were in the game as an added challenge to keeping a city prosperous and well populated. I didn't pursue the possibility of destroying a city for fun. Exploration of the disasters options in SimCity 2000™ revealed not only the predictable earthquakes, fires, and riots even, but also a monster, a huge mechanical alien that beams down destructive rays from a sphere centered between long, spiderlike legs, blasting, in the process, claims to realism already strained by the fusion plants and arcologies[6] of the year 2050. The space alien is a peripheral but unmistakable nod to fantasy

worlds continuously reinscribed in computer games ever since the hit game, Space Invaders.

What I found surprising in these intertextual revelations was not that children brought resources from a dominant culture of gaming to bear on computer games but rather the doggedness with which they pursued them in Sim-City 2000™, a game with only a sliver of action potential. Regardless of whether this exemplifies a certain lack of creativity on my part or a peculiar intensity on the part of the kids, what these stories do point to are the multiplicity of readings that can make sense of a computational artifact as well as the persistent hegemony of a dominant culture of action gaming. While the game design might provide specific resources to players, the discursive space of engagement with the game is irrepressibly shot through with the tangled webs of referentiality that might arise as much from other computational worlds as from newspapers or suburban life.

The technically astute SimCity 2000™ players in the 5thD couple and decouple fluidly with their computational devices, mobilizing a wealth of interpretive resources attuned to the pleasures and opportunities of media-saturated lives. The interactional puzzles that these children encounter in their play with SimCity 2000™ are a complex blend of particular functional capabilities of the software and hardware in question, realities of urban life, identifications suggested by the virtual reality, persistent encroachments of hegemonic idioms of action games and media, as well as the interventions of other 5thD citizens. SimCity 2000™ emerges as a meaningful technosocial object only through the combinations, recombinations, and juxtapositions of these heterogenous players.

Acknowledgments

This research was supported in part by a grant from the Mellon Foundation and by the Institute for Research on Learning. Critical to the study was the involvement of a large research network around the Fifth Dimension project. In particular, tape analysis was enabled by innumerable conversations with Raymond McDermott, Michael Cole, James Greeno, Theresa Moore, Hideyuki Suzuki, Shelley Goldman, Don Bremme, and Raquel Ramirez. Data collection and research insights were further enabled by Amy Olt, Katherine Brown, Olga Vasquez, Yolanda James, Margie Gallego, Karen Fiegener, Elaine Camuso, Tabitha Hart, Vanessa Gack, and the Solana Beach Boys and Girls Club. In addition, Julian Bleecker and Scott S. Fisher provided key conversations in formulating and refining this analysis, and Susan Newman, John Muse, Robbie Davis-Floyd, and Joe Dumit provided invaluable comments on drafts of this chapter.

Notes

1 Cellular automata (CA) are a computation method developed by John Von Neumann and Artificial Life scientists in an attempt to mathematically model a self-reproducing automaton (Helmreich 1995:69–71). Cells on a grid change states in cycles, in response to states in

neighboring cells. SimCity 2000™ uses CA techniques to model changes in the tiles of the city map, adapting the CA model by having cells respond to states beyond neighboring cells (Dargahi and Bremer 1995:397).

2 Most reviews tend to evaluate the game based on its ability to realistically model aspects of a city. Julian Bleecker provides a provocative critique of some of these assessments of SimCity 2000™, suggesting, in a move complementary to this paper, that the game be assessed in relation to a player's interpretive apparatus rather than on the basis of representational realism (1994).

3 Undergraduates that staff the clubs generally are enrolled in a course where they study sociocultural research methods and theories of learning in conjunction with their experiences in the 5thD. Part of the coursework is to write fieldnotes for every day of their participation in the 5thD.

4 "Real life" is in quotes in order to work against an ontological separation between what happens on and off the screen (i.e., between the "real" and the "virtual"). I pursue an understanding of virtual worlds as concrete and computationally embodied rather than as immaterial or unreal (Ito 1996).

5 Italicized segments indicate overlapping talk.

6 Arcologies are futuristic, super-high-density, self-contained cities imagined by Paolo Soleri. In SimCity 2000™ arcologies can be built after certain population levels are achieved (Dargahi and Bremer 1995:73).

References

Barol, Bill. 1989. "Big Fun in a Small Town: Modeling the Perfect City on a Home Computer." *Newsweek* (May 29): 64.

Bleecker, Julian. 1994 "Urban Crisis: Past, Present and Virtual." *Socialist Review* (Winter 1994): 189–221.

Card, Orson Scott. 1985. *Ender's Game.* New York: Tom Doherty.

Cole, Michael. 1995. "A Utopian Methodology for Cultural-Historical Psychology." Presented at the annual meeting of the American Educational Research Association, San Francisco.

Cole, Michael. 1996. *Cultural Psychology: A Once and Future Discipline.* Cambridge: Belknap Harvard.

Cole, M., and P. Griffin. 1986. "A Sociohistoric Approach to Remediation." In *Literacy, Society, and Schooling: A Reader,* edited by Suzanne de Castell, Allan Luke, and Kieran Egan, 110–131. New York: Cambridge University Press.

———. 1987. *Contextual Factors in Education: Improving Science and Mathematics Education for Minorities and Women.* Madison: Wisconsin Center for Educational Research.

Dargahi, Nick, and Michael Bremer. 1995. *SimCity 2000™: Power, Politics, and Planning.* Rev. ed. Rocklin, Calif.: Prima Publishing.

Darlin, Damon. 1994. "Early Bird versus the Flock." *Forbes* 154 (2): 298.

Eiser, Leslie. 1991. "Learning to Save the Environment." *Technology and Learning* (March 1991): 18–23.

Haraway, Donna. 1991. [1985] "A Cyborg Manifesto: Science, Technology, and Socialist-Feminism in the Late Twentieth Century." In *Simians, Cyborgs, and Women,* 127–148. New York: Routledge.

Helmreich, Stefan Gordon. 1995. *Anthropology Inside and Ouside the Looking-Glass Worlds of Artificial Life.* Ph.D. diss., Department of Anthropology, Stanford University.

Ito, Mizuko. 1994. "Cybernetic Fantasies: Extensions of Selfhood in a Multi-User Dungeon." Paper presented at the American Anthropological Association annual meeting, Atlanta.

— — —. 1996. "Virtually Embodied: The Reality of Fantasy in a Multi-User Dungeon." In *Internet Culture,* edited by David Porter, 87–109. New York: Routledge.

Jacobson, Pat. 1992. "Save the Cities! SimCity in Grades 2–5." *The Computing Teacher* (October 1992): 14–15.

McDermott, Raymond, and Henry Tylbor. 1986. "On the Necessity of Collusion in Conversation." In *Discourse and Institutional Authority: Medicine, Education, and Law,* edited by Sue Fisher and Alexandra Dundas Todd, 123–129. Norwood, N. J.: Ablex.

Nicolopolou, A., and M. Cole. 1993. "The Fifth Dimension, Its Playworld, and Its Institutional Contexts: The Generation and Transmission of Shared Knowledge in the Culture of Collaborative Learning." In *Contexts for Learning: Sociocultural Dynamics in Children's Development,* edited by E.A. Forman, N. Minnick, and C. A. Stone. New York: Oxford University Press.

Ochs, Elinor, Sally Jacoby, and Patrick Gonzales. 1994. "Interpretive Journeys: How Physicists Talk and Travel through Graphic Space." *Configurations* 1: 151–171.

Paul, Ronald H. 1991. "Finally, a Good Way to Teach City Government!" *The Social Studies* (July/August 1991): 165–166.

Peirce, Neal R. 1994. "Kids Design the Darnedest Cities." *National Journal* 9 (May 21): 1204.

Schone, Mark. 1994. "Building Rome in a Day." *Village Voice* (May 31): 50–51.

Tanner, Clive. 1993. "SimCity in the Classroom." *Classroom: The Magazine for Teachers* 13 (6): 37–39.

Turkle, Sherry. 1984. *The Second Self: Computers and the Human Spirit.* New York: Touchstone.

Cyborg Babies and Cy-Dough-Plasm

Ideas about Self and Life in the Culture of Simulation

Sherry Turkle

The genius of Jean Piaget (1960) showed us the degree to which it is the business of childhood to take the objects in the world and use how they "work" to construct theories—of space, time, number, causality, life, and mind. Fifty years ago, when Piaget was formulating his theories, a child's world was full of things that could be understood in simple, mechanical ways. A bicycle could be understood in terms of its pedals and gears, a wind-up car in terms of its clockwork springs. Children were able to take electronic devices such as basic radios and (with some difficulty) bring them into this "mechanical" system of understanding. Since the end of the 1970s, however, with the introduction of electronic toys and games, the nature of objects and how children understand them have changed. When children today remove the back of their computer toys to "see" how they work, they find a chip, a battery, and some wires. Sensing that trying to understand these objects "physically" will lead to a dead end, children try to use a "psychological" kind of understanding (Turkle 1984:29–63). Children ask themselves if the games are conscious, if the games know, if they have feelings, and even if they "cheat." Earlier objects encouraged children to think in terms of a distinction between the world of psychology and the world of machines, but the computer does not. Its "opacity" encourages children to see computational objects as psychological machines.

Over the last twenty years I have observed and interviewed hundreds of children as they have interacted with a wide range of computational objects, from computer programs on the screen to robots off the screen (Turkle 1984, 1995). My methods are ethnographic and clinical. In the late 1970s and early

1980s, I began by observing children playing with the first generation of electronic toys and games. In the 1990s, I have worked with children using a new generation of computer games and software and experimenting with on-line life on the Internet.

Among the first generation of computational objects was Merlin, which challenged children to games of tic-tac-toe. For children who had only played games with human opponents, reaction to this object was intense. For example, while Merlin followed an optimal strategy for winning tic-tac-toe most of the time, it was programmed to make a slip every once in a while. So when children discovered a strategy that would sometimes allow them to win, and then tried it again, it usually didn't work. The machine gave the impression of not being "dumb enough" to let down its defenses twice. Robert, seven, playing with his friends on the beach, watched his friend Craig perform the "winning trick," but when he tried it, Merlin did not make its slip and the game ended in a draw. Robert, confused and frustrated, accused Merlin of being a "cheating machine." Children were used to machines being predictable. But this machine surprised.

Robert threw Merlin into the sand in anger and frustration. "Cheater. I hope your brains break." He was overheard by Craig and Greg, aged six and eight, who salvaged the by-now-very-sandy toy and took it upon themselves to set Robert straight. Craig offered the opinion that "Merlin doesn't know if it cheats. It won't know if it breaks. It doesn't know if you break it, Robert. It's not alive." Greg adds: "It's smart enough to make the right kinds of noises. But it doesn't really know if it loses. That's how you can cheat it. It doesn't know you are cheating. And when it cheats, it doesn't even know it's cheating." Jenny, six, interrupted with disdain: "Greg, to cheat you have to know you are cheating. Knowing is part of cheating."

In the early 1980s, such scenes were not unusual. Confronted with objects that spoke, strategized, and "won," children were led to argue the moral and metaphysical status of machines on the basis of their psychologies: Did the machines know what they were doing? Did they have intentions, consciousness, and feelings? These first computers that entered children's lives were evocative objects: they became the occasion for new formulations about the human and the mechanical. For despite Jenny's objections that "knowing is part of cheating," children did come to see computational objects as exhibiting a kind of knowing. She was part of a first generation of children who were willing to invest machines with qualities of consciousness as they rethought the question of what is alive in the context of "machines that think."

In the past twenty years, the objects of children's lives have come to include machines of even greater intelligence, toys and games and programs that make these first cybertoys seem primitive in their ambitions. The answers to the classical Piagetian question of how children think about life are being

renegotiated as they are posed in the context of computational objects that explicitly present themselves as exemplars of "artificial life."

■ 1. FROM PHYSICS TO PSYCHOLOGY

Piaget, studying children in the world of "traditional"—that is, non-computational—objects, found that as children matured, they homed in on a definition of life which centered around "moving of one's own accord." First, everything that moved was taken to be alive, then only things that moved without an outside push or pull. Gradually, children refined the notion of "moving of one's own accord" to mean the "life motions" of breathing and metabolism. This meant that only those things that breathed and grew were taken to be alive. But from the first generation of children who met computers and electronic toys and games (the children of the late 1970s and early 1980s), there was a disruption in this classical story. Whether or not children thought their computers were alive, they were sure that how the toys moved was not at the heart of the matter. Children's discussions about the computer's aliveness came to center on what the children perceived as the computer's psychological rather than physical properties. To put it too simply, motion gave way to emotion and physics gave way to psychology as criteria for aliveness.

Today, only a decade later, children have learned to say that their computers are "just machines," but they continue to attribute psychological properties to them. The computational objects are said to have qualities (such as having intentions and ideas) that were previously reserved for people. Thus today's children seem comfortable with a reconstruction of the notion of "machine" which includes having a psychology. And children often use the phrase "sort of alive" to describe the computer's nature.

An eleven-year-old named Holly watches a group of robots navigate a maze. The robots use different strategies to reach their goal, and Holly is moved to comment on their "personalities" and their "cuteness." She finally comes to speculate on the robots' "aliveness" and blurts out an unexpected formulation: "It's like Pinocchio."

> First Pinocchio was just a puppet. He was not alive at all. Then he was an alive puppet. Then he was an alive boy. A real boy. But he was alive even before he was a real boy. So I think the robots are like that. They are alive like Pinocchio [the puppet], but not "real boys."

She sums up her thought: "They [the robots] are sort of alive."

In September 1987, more than one hundred scientists and technical researchers gathered together in Los Alamos, New Mexico, to found a discipline devoted to working on machines that might cross the boundary between "sort of" to "really" alive. They called their new enterprise "artificial life."

From the outset, many of artificial life's pioneers developed their ideas by writing programs on their personal computers. These programs, easily shipped off on floppy disks or shared via the Internet, have revolutionized the social diffusion of ideas. Christopher Langton (1989:13), one of the founders of the discipline of artificial life, argued that biological evolution relies on unanticipated bottom-up effects: simple rules interacting to give rise to complex behavior. He further argued that artificial life would only be successful if it shared this aesthetic of "emergent effects" with nature.

The cornerstone idea of decentralized, bottom-up emergence is well illustrated by a program written in the mid-1980s known as "boids." Its author, the computer animator Craig Reynolds, wanted to explore whether flocking behavior, whether in fish, birds, or insects, might happen without a flock leader or the intention to flock. Reynolds wrote a computer program that caused virtual birds to flock, in which each "bird" acted "solely on the basis of its local perception of the world" (1987:27). Reynolds called the digital birds "boids," an extension of high-tech jargon that refers to generalized objects by adding the suffix "oid." A boid could be any flocking creature. Each "boid" was given three simple rules: (1) if you are too close to a neighboring boid, move away from it; (2) if not as fast as your neighboring boid, speed up; if not as slow as your neighboring boid, slow down; (3) if you are moving toward the greater density of boids, maintain direction; if not, do so. The rules working together created flocks of boids that could fly around obstacles and change direction. The boids program posed the evocative question: How could it be established that the behavior produced by the boids (behavior to which it was easy to attribute intentionality and leadership) was different from behavior in the natural world? Were animals following simple rules that led to their complex "lifelike" behavior. Were *people* following simple rules that led to *their* complex "lifelike" behavior?

In writing about the dissemination of ideas about microbes and the bacterial theory of disease in late-nineteenth-century France, the sociologist of science Bruno Latour (1988) argued that the message of Louis Pasteur's writings was less significant than the social deployment of an army of "hygienists," state employees who visited every French farm to spread the word. The hygienists were the "foot soldiers" of Pasteur's revolution. In the case of artificial life the foot soldiers are "shippable" products in the form of computer programs, commercial computer games, and small robots, some of which are sold as toys. I do not argue that these products *are* artificial life, but that they are significant actors for provoking a new discourse about aliveness. Electronic toys and games introduced psychology into children's categories for talking about the "quality of life"; a new generation of computational objects is introducing ideas about decentralization and emergence.

In the mid-1980s, the biologist Thomas Ray set out to create a computer world in which self-replicating digital creatures could evolve by themselves. Ray imagined that the motor for the evolution of the artificial organisms would be their competition for CPU (central processing unit) time. The less CPU time that a digital organism needed to replicate, the more "fit" it would be in its "natural" computer environment. Ray called his system Tierra, the Spanish word for "Earth."

In January 1990, Ray wrote the computer program for his first digital creature. It consisted of eighty instructions. It evolved progeny which could replicate with even fewer instructions. This meant that these progeny were "fitter" than their ancestor because they could compete better in an environment where computer memory was scarce. Further evolution produced ever smaller self-replicating creatures, digital "parasites" that passed on their genetic material by latching onto larger digital organisms. When some host organisms developed immunity to the first generation of parasites, new kinds of parasites were born. For Ray, a system that self-replicates and is capable of open-ended evolution is alive. From this point of view, Ray believed that Tierra, running on his Toshiba laptop computer, was indeed alive.

Ray made Tierra available on the Internet, ready for "downloading" via modem. And it was downloaded all over the world, often to school science clubs and biology classes. A fifteen-year-old high school student said that working with Tierra made him feel as though he were "looking at cells through an electron microscope. I know that it is all happening in the computer, but I have to keep reminding myself." Tierra was an object-to-think-with for considering self-replication and evolution as essential to life. "You set it up and you let it go. And a whole world starts," said the student. "I have to keep reminding myself that it isn't going to jump out of the machine. . . . I dreamt that I would find little animals in there. Two times I ran it at night, but it's not such a great idea because I couldn't really sleep."

Ray could not predict the developments that would take place in his system. He too stayed up all night, watching new processes evolve. The lifelike behavior of his digital Tierrans emerged from the "bottom up." At MIT's Media Laboratory, the computer scientist and educational researcher Mitchel Resnick worked to bring the artificial life aesthetic into the world of children. He began by giving them a robot construction kit that included sensors and motors as well as standard Lego blocks. Children quickly attributed lifelike properties to their creations. Children experienced one little robot as "confused" because it moved back and forth between two points (because of rules that both told it to seek out objects and to move away quickly if it sensed

an object). Children classified other robots as nervous, frightened, and sad. The first Lego-Logo robots were tethered by cables to a "mother" computer, but eventually researchers were able to give the robots an "onboard" computer. The resulting autonomy made the Lego-Logo creations seem far less like machines and far more like creatures. For the children who worked with them, this autonomy further suggested that machines might be creatures and creatures might be machines.

Resnick also developed programming languages, among these a language he called StarLogo that would enable children to control the parallel actions of many hundreds of "creatures" on a computer screen. Traditional computer programs follow one instruction at a time; with Resnick's StarLogo program, multiple instructions were followed at the same time, simulating the way things occur in nature. And as in nature, simple rules led to complex behaviors. For example, a population of screen "termites" in an environment of digital "woodchips" were given a set of two rules: if you're not carrying anything and you bump into a woodchip, pick it up; if you're carrying a woodchip and you bump into another woodchip, put down the chip you're carrying. Imposing these two rules at the same time will cause the screen termites to make woodchip piles (Resnick 1992:76). So children were able to get the termites to stockpile woodchips *without ever giving the termites a command to do so*. Similarly, children could use StarLogo to model birds in a flock, ants in a colony, cars in a traffic jam—all situations in which complex behavior emerges from the interaction of simple rules. Children who worked with these materials struggled to describe the quality of emergence that their objects carried. "In this version of Logo," said one, "you can get more [out of the program] than what you tell it to do" (Resnick 1992:131–132).

An object such as StarLogo opens up more than new technical possibilities: it gives children concrete material for thinking in what Resnick has termed a "decentralized mindset." The key principle here is self-organization—complexity results although there is no top-down intervention or control. In a centralized model of evolution, God designs the process, sets it in motion, and keeps close tabs to make sure it conforms to design. In a decentralized model, God can be there, but in the details: simple rules whose interactions result in the complexity of nature.

StarLogo teaches how decentralized rules can be the foundation for behavior that may appear to be "intentional" or a result of "following the leader." It also provides a window onto resistance to decentralized thinking. When confronted with the woodchip piles, Resnick reports that most adults prefer to assume that a leader stepped in to direct the process or that there was an asymmetry in the world that gave rise to a pattern, for example, a food source near the final location of a stockpile (Resnick, *Turtles, Termites, and Traffic Jams:* 137ff). In reflecting on this resistance to ideas about decentralization, Resnick

(1992:122) cites the historian of science Evelyn Fox Keller who, in reviewing the history of resistance to decentralized ideas in biology, was led to comment: "We risk imposing on nature the very stories we like to hear."

Why do we like to hear centralized stories? There is our Western monotheistic tradition; there is our experience over millenia of large-scale societies governed by centralized authority and controlled through centralized bureaucracy; there is our experience of ourselves as unitary and intentional actors (the ego as "I"); and there is also the fact that we have traditionally lacked concrete objects in the world with which to think about decentralization. Objects such as StarLogo present themselves as objects to think with for thinking about emergent phenomena and decentralized control. As a wider range of such objects enter our culture, the balance between our tendency to assume decentralized emergence or centralized command may change. The children who tinkered with parallel computation became comfortable with the idea of multiple processes and decentralized methods. Indeed, they came to enjoy this "quality of emergence" and began to associate it with the quality of aliveness.

The idea that the whole is greater than the sum of its parts has always been resonant with religious and spiritual meaning. Decentered, emergent phenomena combine a feeling that one knows the rules with the knowledge that one cannot predict the outcome. To children, emergent phenomena seem almost magical because one can know what every individual object will do but still have no idea of what the system as a whole will look like. This is the feeling that the children were expressing when they described getting "more out" of the StarLogo program than they told it to do. The children know that there are rules behind the magic and that there is magic in the rules. In a cyborg consciousness, objects are re-enchanted.

When children programming in StarLogo got a group of objects on the screen to clump together in predictable groups by commanding them to do so, they did not consider this "interesting" in the sense that it did not seem "lifelike." But if they gave the objects simple rules that had no obvious relation to clumping behavior but clumping "happened" all the same, that behavior did seem lifelike. So, for children working in the StarLogo learning culture, "teaching" computer birds to flock by explicitly telling them where to go in every circumstance seemed to be a kind of "cheating." They were developing an "ethic of simulation" in which decentralization and emergence became requirements for things to seem "alive enough" to be interesting.

In this example, computational media show their potential to generate new ways of thinking. Just as children exposed to electronic toys and games begin to think differently about the definition of aliveness (thinking in terms of psychology rather than physical motion), so children exposed to parallel processing begin to think about life in terms of emergent phenomena.

■ 3. THE "SIMS"

The authors of the "Sim" series of computer games (among these SimAnt, SimCity, SimHealth, SimLife) write explicitly of their effort to use the games to communicate ideas about artificial life (Bremer 1991:163). For example, in the most basic game of SimAnt (played on one "patch" of a simulated back-yard), a player learns about local bottom-up determination of behavior: each ant's behavior is determined by its own state, its assay of its direct neighbors, and a set of rules. Like Reynolds's "boids" and the objects in StarLogo, the ants change their state in reference to who they are and with whom they are in contact. SimAnt players learn about pheremones, the virtual tracer chemicals by which ants, as well as Resnick's StarLogo objects, "communicate" with one another. Beyond this, SimAnt players learn how in certain circumstances, local actions that seem benign (mating a few ants) can lead to disastrous global results (population overcrowding and death). Children playing Sim games make a connection between the individual games and some larger set of ideas. Tim, a thirteen-year-old player, says of SimLife: "You get to mutate plants and animals into different species You are part of something important. You are part of artificial life." As for the Sim creatures themselves, Tim thinks that the "animals that grow in the computer could be alive," although he adds, "This is kind of spooky."

Laurence, a more blasé fifteen-year-old, doesn't think the idea of life on the screen is spooky at all. "The *whole point* of this game," he tells me,

> is to show that you could get things that are alive in the computer. We get energy from the sun. The organisms in a computer get energy from the plug in the wall. I know that more people will agree with me when they make a SimLife where the creatures are smart enough to communicate. You are not going to feel comfortable if a creature that can talk to you goes extinct.

Robbie, a ten-year-old who has been given a modem for her birthday, uses her experience of the game to develop some insight into those computer processes that led adults to use the term "virus" for programs that "traveled." She puts the emphasis on mobility instead of communication when she considers whether the creatures she has evolved on SimLife are alive.

> I think they are a little alive in the game, but you can turn it off and you cannot "save" your game, so that all the creatures you have evolved go away. But if they could figure out how to get rid of that part of the program so that you would *have* to save the game and if your modem were on, then they could get out of your computer and go to America Online.

Sean, thirteen, who has never used a modem, comes up with a variant on Robbie's ideas about SimLife creatures and their Internet travel: "The [Sim] creatures could be more alive if they could get into DOS."

In Piaget's classical studies of the 1920s on how children thought about what was alive, the central variable was motion. Simply put, children took up the question of an object's "life status" by asking themselves if the object could move of its own accord. When in the late 1970s and early 1980s I studied children's reactions to a first generation of computer objects which were physically "stationary" but which nonetheless accomplished impressive feats of cognition (talking, spelling, doing math, and playing tic-tac-toe), I found that the focus had shifted to an object's psychological properties when children considered the question of its "aliveness." Now, in children's comments about the creatures that exist on simulation games, the emphasis is on evolution. But this emphasis also includes a recapitulation of criteria that draw from physics and psychology. Children talk about digital "travel" via circulating disks or over modems. They talk of viruses and networks. In this language, biology and motion are resurfacing in a new guise, now bound up in the ideas of communication and evolution. Significantly, the resurfacing of motion (Piaget's classical criterion) is bound up with notions of presumed psychology: children were most likely to assume that the creatures on Sim games have a desire to "get out" of the system and evolve in a wider computational world.

■ 4. "CYCLING THROUGH"

Although the presence of computational objects disrupted the classical Piagetian story for talking about aliveness, the story children were telling about computational objects in the early 1980s had its own coherency. Faced with intelligent toys, children took a new world of objects and imposed a new world order, based not on physics but on psychology. In the 1990s, that order has been strained to the breaking point. Children will now talk about computers as "just machines" but describe them as sentient and intentional. Faced with ever-more-complex computational objects, children are now in the position of theoretical *bricoleurs*, or tinkerers, "making do" with whatever materials are at hand, "making do" with whatever theory can fit a prevailing circumstance. They cycle through evolution and psychology and resurface ideas about motion in terms of the communication of bits.

My current collection of comments about life by children who have played with small mobile robots, the games of the "Sim" series, and Tierra includes the following notions: the robots are in control but not alive, would be alive if they had bodies, are alive because they have bodies, would be alive if they had feelings, are alive the way insects are alive but not the way people are alive; the Tierrans are not alive because they are just in the computer,

could be alive if they got out of the computer, are alive until you turn off the computer and then they're dead, are not alive because nothing in the computer is real; the Sim creatures are not alive but almost-alive, they would be alive if they spoke, they would be alive if they traveled, they're alive but not "real," they're not alive because they don't have bodies, they are alive because they can have babies, and, finally, for an eleven-year-old who is relatively new to SimLife, they're not alive because these babies don't have parents. She says: "They show the creatures and the game tells you that they have mothers and fathers but I don't believe it. It's just numbers, it's not really a mother and a father." There is a striking heterogeneity of theory here. Different children hold different theories, and individual children are able to hold different theories at the same time.

The heterogeneity of children's views is apparent when they talk about something as "big" as the life of a computational creature and about something as "small" as why a robot programmed with "emergent" methods might move in a certain way. One fifth-grader named Sara jumped back and forth from a psychological to a mechanical language when she talked about the Lego-Logo creature she had built. When Sara considered whether her machine would sound a signal when its "touch sensor" was pushed, she said: "It depends on whether the machine wants to tell . . . if we want the machine to tell us . . . if we tell the machine to tell us" (Resnick 1989:402). In other words, within a few seconds, Sara "cycled through" three perspectives on her creature (as psychological being, as intentional self, as instrument of its programmer's intentions). The speed of her alternations suggests that these perspectives are equally present for her at all times. For some purposes, she finds one or another of them more useful.

In the short history of how the computer has changed the way we think, it has often been children who have led the way. For example, in the early 1980s, children—prompted by computer toys that spoke, did math, and played tic-tac-toe—disassociated ideas about consciousness from ideas about life, something that historically had not been the case. These children were able to contemplate sentient computers that were not alive, a position that grownups are only now beginning to find comfortable. Today's cyborg children are taking things even further; they are pointing the way toward a radical heterogeneity of theory in the presence of computational artifacts that evoke "life." In his history of artificial life, Steven Levy (1992:6–7) suggested that one way to look at where artificial life can "fit in" to our way of thinking about life is to envisage a continuum in which Tierra, for example, would be more alive than a car but less alive than a bacterium. My observations suggest that children are not constructing hierarchies but are heading toward parallel, alternating definitions.

The development of heterogeneity in children's theories is of course tak-

ing place in a larger context. We are all living in the presence of computational objects that carry emergent, decentralized theories and encourage a view of the self as fluid and multiple. Writers from many different disciplinary perspectives are arguing for a multiple and fluid notion of the self. Daniel C. Dennett (1991) argues for a "multiple drafts" theory of consciousness. The presence of the drafts encourages a respect for the many different versions, and it imposes a certain distance from being identified with any one of them. No one aspect of self can be claimed as the absolute, true self. Robert Jay Lifton (1993) views the contemporary self as "protean," multiple yet integrated, allowing for a "sense of self" without being *one* self. Donna Haraway equates a "split and contradictory self" with a "knowing self": "The knowing self is partial in all its guises, never finished, whole, simply there and original; it is always constructed and stitched together imperfectly; and therefore able to join with another, to see together without claiming to be another" (1991a:22). In computational environments, such ideas about identity and multiplicity are "brought down to earth" and enter children's lives from their earliest days. Even the operating system on the computers they use to play games, to draw, and to write carries the message. A computer's "windows" have become a potent metaphor for thinking about the self as a multiple and distributed system (Turkle 1995). Hypertext links have become a metaphor for a multiplicity of perspectives. On the Internet, people who participate in virtual communities may be "logged on" to several of them (open as several open-screen windows) as they pursue other activities. In this way, they may come to experience their lives as a "cycling through" screen worlds in which they may be expressing different aspects of self. But such media-borne messages about multiple selves and theories are controversial.

Today's adults grew up in a psychological culture that equated the idea of a unitary self with psychological health and in a scientific culture that taught that when a discipline achieves maturity, it has a unifying theory. When adults find themselves cycling through varying perspectives on themselves ("I am my chemicals" to "I am my history" to "I am my genes"), they usually become uncomfortable (Kramer 1993:xii–xiii). But such alternations may strike the generation of cyborg children who are growing up today as "just the way things are."

Children speak easily about factors which encourage them to see the "stuff" of computers as the same "stuff" of which life is made. Among these are the ideas of "shape shifting" and "morphing." Shape shifting is the technique used by the evil android in *Terminator II* to turn into the form of anything he touched—including people. A nine-year-old showed an alchemist's sensibility when he explained how this occurs: "It is very simple. In the universe, anything can turn to anything else when you have the right formula. So you can be a person one minute and a machine the next minute." Morphing

is a general term that covers form changes which may include changes across the animate/inanimate barrier. A ten-year-old boy had a lot to say about morphing, all of it associated with the lifestyle of "The Mighty Morphin' Power Rangers," a group of action heroes who turn from teenagers to androidal/mechanical "dinozords" and "megazords" and back. "Well," he patiently explains, "the dinozords are alive; the Power Rangers are alive, but not all the parts of the dinozords are alive, but all the parts of the Power Rangers are alive. The Power Rangers become the dinozords." Then, of course, there are seemingly omnipresent "transformer toys" which shift from being machines to being robots to being animals (and sometimes people). Children play with these plastic and metal objects, and in the process they learn about the fluid boundaries between mechanism and flesh.

I observe a group of seven-year-olds playing with a set of plastic transformer toys that can take the shape of armored tanks, robots, or people. The transformers can also be put into intermediate states so that a robot arm can protrude from a human form or a human leg from a mechanical tank. Two of the children are playing with the toys in these intermediate states (that is, in their intermediate states somewhere between being people, machines, and robots). A third child insists that this is not right. The toys, he says, should not be placed in hybrid states. "You should play them as all tank or all people." He is getting upset because the other two children are making a point of ignoring him. An eight-year-old girl comforts the upset child. "It's okay to play them when they are in between. It's all the same stuff," she says, "just yucky computer cy-dough-plasm." This comment is the expression of the cyborg consciousness that characterizes today's children: a tendency to see computer systems as "sort of" alive, to fluidly "cycle through" various explanatory concepts, and to willingly transgress boundaries.

Walt Whitman wrote: "A child went forth every day. And the first object he look'd upon, that object he became." When Piaget elaborated how the objects in children's lives constructed their psyches, he imagined a timeless, universal process. With the radical change in the nature of objects, the internalized lessons of the object world have changed. When today's adults "cycle through" different theories, they are uncomfortable. Such movement does not correspond to the unitary visions they were brought up to expect. But children have learned a different lesson from their cyborg objects. Donna Haraway characterizes irony as being "about contradictions that do not resolve into larger wholes . . . about the tension of holding incompatible things together because both or all are necessary and true" (1991b:148). In this sense, today's cyborg children, growing up into irony, are becoming adept at holding incompatible things together. They are cycling through the cy-dough-plasm into fluid and emergent conceptions of self and life.

References

Bremer, Michael. 1991. *SimAnt User Manual*. Orinda, Calif.

Dennett, Daniel C. 1991. *Consciousness Explained*. Boston: Little, Brown.

Haraway, Donna. 1991a. "The Actors Are Cyborg, Nature Is Coyote, and the Geography Is Elsewhere: Postscript to 'Cyborgs at Large.'" In *Technoculture*, edited by Constance Penley and Andrew Ross. Minneapolis: University of Minnesota Press.

———. 1991b. "A Cyborg Manifesto: Science, Technology, and Socialist-Feminism in the Late Twentieth Century." In *Simians, Cyborgs, and Women: The Reinvention of Nature*. New York: Routledge.

Kramer, Peter. 1993. *Listening to Prozac: A Psychiatrist Explores Antidepressant Drugs and the Remaking of the Self*. New York: Viking.

Latour, Bruno. 1988. *The Pasteurization of France*. Translated by Alan Sheridan and John Law. Cambridge: Harvard University Press.

Langton, Christopher G. 1989. "Artificial Life." In *Artificial Life: The Proceedings of an Interdisciplinary Workshop on the Synthesis and Simulation of Living Systems*, edited by Christopher G. Langton. *Santa Fe Institute Studies in the Science of Complexity*, vol. 6. Redwood City, Calif.: Addison-Wesley.

Levy, Steven. 1992. *Artificial Life: The Quest for a New Frontier*. New York: Pantheon.

Lifton, Robert J. 1993. *The Protean Self: Human Resilience in an Age of Fragmentation*. New York: Basic Books.

Piaget, Jean. 1960. *The Child's Conception of the World*. Translated by Joan and Andrew Tomlinson. Totowa N. J.: Littlefield, Adams.

Resnick, Mitchel. 1989. "LEGO, Logo, and Life." In *Artificial Life: The Proceedings of an Interdisciplinary Workshop on the Synthesis and Simulation of Living Systems*, edited by Christopher G. Langton. *Santa Fe Institute Studies in the Science of Complexity*, vol. 6. Redwood City, Calif.: Addison-Wesley.

———. 1992. *Turtles, Termites, and Traffic Jams*. Cambridge, Mass.: MIT Press.

Reynolds, Craig. 1987. "Flocks, Herds, and Schools: A Distributed Behavioral Model." *Computer Graphics* 21 (July).

Turkle, Sherry. 1984. *The Second Self: Computers and the Human Spirit*. New York: Simon and Schuster.

———. 1995. *Life on the Screen: Identity in the Age of the Internet*. New York: Simon and Schuster.

Children of Metis:
Beyond Zeus the Creator

Paganism and the Possibilities for Embodied
Cyborg Childraising

Anne Hill

■ IN THE BEGINNING: PAGANS, GODDESSES, AND CYBORG THEORY

Athena may have been the first clearly cyborg Goddess in Greek myth. Coinciding with an early wave of invasions along the Mediterranean, she and her followers were forced to renounce her earlier birth from her mother Metis the Titaness and accept the story of being born from Zeus's head (Graves 1955). Hers may be seen as the first high-tech birth, thanks to the skillful hammer of Hephaestos, yet she never fully relinquished her earlier identity either, and managed to exist powerfully within the patriarchal Olympian pantheon while remaining true to the gifts of her mother, symbolized by the serpent on her shield and the owl on her shoulder. To a Pagan, it is quite possible to imagine being both a cyborg and a Goddess.

Paganism starts with an embodied worldview. We Pagans believe that the Goddess, our name for the all-encompassing Source, is immanent in all things. This worldview at first glance closely parallels the "holistic paradigm" identified by Robbie Davis-Floyd (1992), as Pagans revere and feel a kinship with nature and the living things of the earth, and strive to live in harmony with the cycles of nature. According to the Institute for the Study of American Religions (1993), Paganism is the fastest-growing religion in North America today. In general, the phenomenal growth of Paganism represents an emerging acceptance of a holistic, embodied worldview. However, many modern Pagans hold positions of influence and responsibility in fields governed by the technocratic paradigm—particularly in the area of computer science. To these "techno-pagans" (Yohalem 1995), there is no contradiction between their work and their spirituality; in fact, it is the Pagan worldview in part which encourages their creative imaginings of the human-machine intersection.

Pagans also believe in not one Goddess, but many; in not one God, but many. When we speak of "the Goddess," we are referring in shorthand to the universal creative principle in all her forms and faces, and not simply to a single feminine deity. Pagans are polytheistic: we are constantly rediscovering long-forgotten deities and dreaming up new ones when need arises. Not all Pagans even worship the same pantheon of Gods and Goddesses: in any given corner of the continent, one might find groups whose rituals focus on African, Norse, Greek, Roman, Celtic, or other pantheons. We make the Goddesses, and they make us. It is a fluid discourse, our mythology, between waking life and dream life; between nature and culture, human, animal, and machine.

The popularity of Paganism among feminists and activists is often misunderstood as being solely a call toward an original Garden of unity, "a source of insight and a promise of innocence" (Haraway 1991:152–153). Poetic remembrances of an earlier harmony with Nature and a yearning for that connection are part of the Pagan heritage, but misrepresent the diversity of this polytheistic spirituality. Pagans are at the forefront of experimentation with gender fluidity, for example, and as a consequence, deities have been imagined, or encountered, which reflect the potent breaches of man/woman, gay/straight/bi identities (Rabbit 1989). Part of the attraction of activists to Paganism is that its diversity and locality defy attempts to create a monotheistic whole from the various parts.

Haraway (1991) also suggests that Paganism can be seen as an oppositional identity, and there is clearly merit in this political usage, as we continue to be provoked, endangered, and discriminated against by the Religious Right in this country. Yet it seems to me that a Pagan worldview might offer more to cyborgic identities than is implied by her suggestion. Pagans are a remarkably diverse lot and do not easily fit onto one side or another of the nature/culture, holistic/technocratic scales. Our point of unity, ironically, is the recognition that our individual connections to the Sacred cannot be centralized or governed, and must be allowed to flourish in their full diversity.

Robbie Davis-Floyd (1992) and others have done a tremendous amount of work identifying the rift in dominant culture between technocratic and embodied paradigms in childbirth and childraising. Drawing on my own and others' experience raising children within a Pagan and activist community, I will explore the theoretical and practical ground within our worldview where lie possibilities for integration of technocratic and alternative approaches to raising children.

"When the myths come alive for us, they change" (Starhawk 1987:ix). May Athena, the Goddess of wisdom, be with us as we shapeshift once again, as we claim for ourselves and our children the tools that made the masters' house, while not losing touch with the earth, from whom we have emerged, and unto whom we will return.

My good friend Sigrid is being transported to a hospital in Santa Cruz after forty-eight hours and little progress in what she had hoped would be a home birth. As I give her a final goodbye hug—I am not going with her, but will get there later—she looks at me through her exhaustion and says, "I'm sorry." Unable to bear hearing an apology from a laboring woman, and wanting to cheer her up, I say, "Hey, maybe you'll have the same labor room I did." I want to remind her that ten years before, I was in her shoes, when after an equally long home labor, I went to the hospital to deliver my first baby. I recognize her fear that entering the hospital may mean she is seduced into interventions that she does not need or want; and I recognize her feeling of failure, that she is not going to have the home birth of her dreams but something more tainted with technology than she is comfortable with.

In the end, her baby boy came out healthy (as did mine), seeming none the worse for the stress she had been through. Both Sigrid's doctor and mine conducted themselves in a respectful way, with sensitivity to the fact that we were there not as a first choice but under duress, and that we did not, would not trust them as probably most of their other patients would. Here in Santa Cruz, stronghold of the homebirth movement, a woman's odds of having a relatively tamperproof hospital birth are much greater than in most cities, but hospital horror stories are still a possibility one must guard against with either good advocacy or good fortune, or both.

Over the past ten years, having attended many births of friends and gone through four pregnancies myself, resulting in a miscarriage and three live births, I have witnessed many sides of the debate on technology and natural childbirth. Each time during my own pregnancies I worked toward having as little medical intervention as possible; each time it was my great good fortune to be delivered by loving and experienced hands. I could not always control the amount of what I viewed as unnecessary medical procedures that were performed during my labors, but I was extremely grateful for the times when other procedures came in handy—such as in resuscitating my baby or stopping me from bleeding to death. Each pregnancy and birth has added to my understanding of my own creative power, and each interaction with technology has made me that much better at making informed medical decisions for my children as they grow.

Still, when a woman is pregnant, she wants what she wants, whether it is assurance of an epidural or assurance that no drugs will be used, ever. Labor is not really the time to argue politics or theory; we react from our gut-level instincts, and for many of us in the homebirth movement, that instinct has been that medical science is an uneasy, unnatural ally, and best stayed away from as much as possible. The occasional hybrid doctor who has skills in both

a home or hospital setting is the exception rather than the rule, and is such a new creature that we sniff around her, trying to detect the scent of danger we associate with most survivors of medical schools.

Our sense of otherness is clearly not without precedent, and the abuses of technology within medicine are daily and unrelenting (see Chamberlain, Cartwright, this volume; Ehrenreich and English 1973). Yet this instinct limits us now, dividing us from each other as any separatist movement is likely to do, along lines of imagined purity, and denying not only the fruitful possibilities of our engagement with technology, but also the fact that we have all to some degree given ourselves to this new lover. In fact, much of the misuse of technology in birth is initiated by women themselves who, in their fear of birth, insist on having all the managed care money can buy, whether they need it or not (see Davis-Floyd 1994).

Under closer scrutiny, the classifications of "homebirth" and "hospital birth" do not determine the extent to which our birth is a cyborg experience: Do prenatal blood tests count more or less than an external fetal monitor used for twenty minutes? What about the use of vitamins during pregnancy, as opposed to pitocin during labor? At what point does our child then become a cyborg: was he bombarded by sonogram waves that have subtly altered his prenatal growth, or was it the erythromycin drops in his eyes that dealt the final blow? Or did we use IVF technology to conceive a child who was then born at home? Mentor (this volume) has written evocatively of the boglike nature of the theoretical ground here at the intersection of natural and technocratic conception and birth.

The absurdity of the identity headaches we give ourselves points to our great insecurity over being human and animal in the information age, and also to the limits of the worldview we have been working with. It is no longer possible to say that either "natural" childbirth or "technologically assisted" birth is better, because the boundary between the two has been irrevocably breached, and even our most dearly held maps are being rendered useless. Yet as potent an ordeal as it is, childbirth is but a microcosm, a powerful subset of the greater concern of childraising, and the gate through which all children must pass on their various ways into the world. We need a new map, and it should be one that can inform us not only about the terrain of reproduction but also about caring for the children we must then raise.

■ EXPLORING THE TERRAIN: FAMILIES IN A PAGAN ACTIVIST COMMUNITY

In constructing a map of childbirth and childraising, I will pull together several of my own permanent partialities (Haraway 1991), most notably as a teacher, an activist fond of direct action politics, and a priestess of the Pagan

tradition of Wicca, also known as Witchcraft, the ancient mystery religion of pre-Christian Europe.

I will also draw on the collective experiences of my community of friends who share similar values, goals, and experiences. We are mostly European-American, mostly college-educated, work at various blue- and white-collar professions up and down the Pacific seaboard, with particularly strong clusters in and around the San Francisco Bay Area, and many of us have children who are or will be friends themselves. Together we have organized and protested against, among other things, nuclear power, arms proliferation, environmental degradation, and weapons research for well over a decade. As we strive to keep living by our principles, we have supported one another, argued with one another, and kept up a steady stream of visits, phone calls, and e-mail to maintain our connections. We remain committed to the bioregionalist ideal of localized self-government, and many of us still work toward that goal in groups run by nonhierarchical consensus process.

To this community of political activists has been joined the people and ideals of the Reclaiming community, a spiritual matrix in the SF Bay Area working to unify Wiccan spirituality and politics, with a vision rooted in the religion and magic of the Goddess—the Immanent Life Force. Witchcraft is a Pagan religion, meaning that it views the earth as alive, and sacred. We believe that the Goddess dwells within all things and takes many forms. By strengthening our connection to the Goddess within us, our own Deep Self, we open ourselves to greater forces of change and possibility than can be tapped by collective action alone.

In Reclaiming, we use magic and ritual as tools for empowerment and transformation. We celebrate the eight seasonal festivals of our ancestors and create rituals to sacralize the passages in our own lives and the lives of our children. What we can imagine, we can create. By wedding political struggle to magic and transformation, we have created a lively interchange of ideas, visions, and strategies which forms the basis for this chapter. Over the years there has been such an integration of the activist and Pagan currents among us that when I refer to my "community," I am not referring to one or the other, but all of us.

Family, that familiar, reassuring term, shapeshifts before our eyes when constructed or reconstructed through interaction with cybernetic systems. In my community we have a diversity of family forms, including extended families, co-housing groups, intentional communities with multiple parents, lesbian and gay couples, "traditional" nuclear families, and single parents living with housemates who share parenting, to name a few. Given this diversity, Galvin and Brommel's (1991) definition of the family is the most suitable for the purposes of this discussion:

A family may be viewed more broadly as a group of people with a past history, a present reality and a future expectation of interconnected mutually influencing relationships. Members often (but not necessarily) are bound together by heredity, by legal marital ties, by adoption, or by a common living arrangement at some point in their lifetime.

By extension, I will use the term "parents" to denote those adults within the family system who assume primary responsibility for childraising.

■ THE LAY OF THE LAND: ETHICS AND THE WILD

In our community, we have some principles rooted in our worldview that we try to live by, and the main one is empowerment. Empowerment can be understood as that combination of self-confidence, independent thought, intuition, and engagement with the world that we need in order to live by our principles and stand up for what we believe in. We strive to act from a sense of personal power, to be active participants in our own lives and in society at large. We encourage our children and one another to be informed about what is going on and to respond in the most creative, constructive way possible. But we have found that it is not enough to simply have information about the choices confronting us:

> Feminists, Rothman reminds us, thought that increased access to information would give women more choices and more power to make those choices. "What we perhaps overlooked," Rothman continues, "is that it is power which gives one control over both information and choice." (Davis-Floyd 1992:288)

To act from our own ethics requires not just education but support from others. Community, serving as a buffer zone between the needs of the family and the demanding voice of technocratic culture, encourages us to act from our principles whenever possible.

It is important to us that our children learn to make decisions for themselves and feel confident enough in their own perceptions that they can act from their convictions. We encourage our children's self-esteem in part by teaching them how to make responsible choices for themselves. Another way is by celebrating their transitions from one stage of life to the next. We use ritual to mark their passage from babyhood to childhood, from being a child to becoming a young woman or man, and just about any other important event in their lives that we want to recognize in a sacred manner. Our rituals may be as simple as lighting candles for our children to make a wish over their birth-

day cakes, or as elaborate as a daylong ritual for a young woman at menarche, complete with a rented hall and a feast of red foods, but they serve the purpose for which they are intended.

We believe that each child has her own unique link to the Goddess. We are here as caretakers of our children, but they belong to the Goddess; they are Her children just as we are. So we try to treat our children respectfully, and teach them by example to extend this attitude to all other creatures. Every part of the Earth has a spirit, and whether we imagine deities as archetypes from our unconscious or as potentially embodied helpers who help us park downtown and counsel us to do the right thing at the right time, most Pagans will agree that they appreciate a little respect.

It is not enough to say that these beliefs align us with "nature," on the great nature/culture, holistic/technocratic continuum, however. What Paganism has to offer this polarized view is a shift of focus, a recognition of that place outside of the dichotomy that can inform and enhance both positions. Gary Snyder (1990) draws a distinction among nature, culture, and the wild that is useful in expressing how immanence, our own wild magical-biological wholeness, can offer strategies for cyborg childraising that might be overlooked or underestimated by using any other approach:

> It comes again to an understanding of the subtle but critical difference of meaning between the terms nature and wild. Nature is the subject, they say, of science. Nature can be deeply probed, as in microbiology. The wild is not to be made subject or object in this manner; to be approached it must be admitted from within, as a quality intrinsic to who we are. Nature is ultimately in no way endangered; wilderness is. The wild is indestructible, but we might not see the wild. (Snyder 1990:181)

The wildness that we feel when we are in connection to the Goddess and one another in some essential way transcends the dichotomy of nature/culture. It is the aspect of our beings that we hold inviolate, the wilderness that is not for sale or up for negotiation, and the place in which we can imagine creative solutions to the challenges of raising children in a technocratic world. If our link to Spirit is untrammeled, we can consider shifts between natural and cyborgic identities without feeling as though we are under siege.

Part of the activist Pagan tradition is to use our link to the wild to shift perspective, finding imaginative responses to seemingly polarized situations. We cannot go back to the same Garden we emerged from, remaining secluded forever from the rapid changes occurring in our culture. At the same time, accepting every new treatment, diagnosis, and technofad as "harmless" for our children endangers not only their health but also their ability to think for themselves and make informed decisions in their own lives. From the place of

wildness within us we can enter into dialogue with both alternative models and cybernetic systems, imagining a different, we hope better, and certainly more inclusive garden for the future.

■ MAPPING THE ELEMENTS OF CHILDRAISING

On the basis of the experiences of our community over the years, I will chart some possibilities for interconnection and negotiation in four areas of human development: the body, the intellect, the intuition, and the emotions. Each area corresponds to one of the four elements: Earth, Air, Fire, and Water. The fifth element, which is Spirit, is only created by a combination of the four. Spirit is the center of our circle and corresponds to the place of wildness, of Goddess connection within us, that will be our reference point as we consider the effects of technology on children.

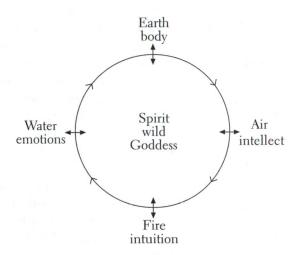

When we look at the four elements within a child, our primary concern is that they are there in some form; that their strength and vibrancy are in balance with the others; that their development is not impeded or blocked; that the child is able to explore and use the qualities of each element; and that each element's connection to the child's spirit is not hampered. The directional arrows around the circle's perimeter indicate that each point must be nourished for the whole to flourish, and the strength of each adds to the strength of the others.

Air, The Intellect

Our intellect lets us be curious and inspired. The element of Air rules all

the functions related to communication: our abilities to speak, to listen, to see, to taste, to receive. When our intellect is adequately nourished, we can ask the questions necessary to identify choices and make decisions. For children, learning to communicate means developing the skills to express themselves, and it means learning to think critically, not just fill in the blanks to other people's questions.

With the qualities of Air, we can see all sides of an issue and identify hidden biases in textbooks and technology. The cybernetic systems to which our children are exposed now are full of biases and assumptions (see Turkle, this volume): taller is better, girls are emotional, boys are violent. Children's capacity to succeed is often judged by how well they can adapt to standard classroom arrangements; those who deviate from the norm are labeled, analyzed, and medicated. Fortunately, within educational circles more attention is being given to the different ways that children learn (Gardner 1993), and our whole model of what education means is currently the topic of heated debate.

When we can speak the unspoken, ask what has not been asked, and challenge what we have been told, we strengthen our intellect. From the point of view of the wild, what it is non-negotiable in the realm of Air is our right to have equal access to all information concerning us and to make decisions based on our own judgment and code of ethics. There must be tolerance of diversity not only in the ways that we learn but also in the paths we choose.

Air is also the place of the imagination, and of storytelling. We teach our children our values through the stories we tell, and the most important stories our children will ever hear are the ones about their own beginnings: their ancestors, their families, and themselves. From the view of the wild, the story of one's life is a mystery tale, where actual events coincide with mythic events, helping us see a deeper meaning and purpose in our everyday life.

Few children will protest when we tell them stories from when they were babies, and these can become parables or myths, informing their sense of self throughout their lives. My mother tells me that after two days of early labor with me, and two admissions to the hospital after which labor stopped each time, she and her doctor decided I was ready to come out, hooked her to a pitocin IV, and delivered me. I've always thought that story either accounts for why I'm so slow and stubborn or shows that I was already, no matter what the doctor might have done.

We may find ourselves telling our children a highly edited version of their birth story, and that may be quite appropriate. There is a difference between telling children our part of their birth story and their part, however. Younger children, especially, when asking how they were born, do not need to hear about our ordeal in great detail. We can tell them our impressions of them before they were born, whether they had a hard or easy time being born,

whether they were happy, sad, quiet, or loud on entering the world, and who was there to greet them. It is up to us as parents to discern how much information is enough, and then tell it in a way that communicates some of the power and mystery of their creation.

There is a real danger to our intellect and imagination when we let technoscience tell our stories for us. Medical testing and diagnosis can be extremely useful throughout our children's lives, but they are never the full story. It is often difficult to let the weight of medical opinion be just one opinion in a field of many, but that's what it is. If we accept the probabilities of medical tests over our own hunches, if we accept the sonogram picture as superior to the one in our own minds, we rob our children of our own deep thoughts and imaginings.

We may find it hard to feel comfortable with our children's encounters with the transfigurations of science and technology. Yet we have at our disposal the tools of Air to help us: we can be informed about our choices for them, and we can use our imagination to find the power in their story. When we help our children identify with the part of themselves that is unique, with the special information they have to add to the world, we are helping them create their life story from a place of wildness.

Fire, The Intuition

The second region in this map of possibilities is that of Fire. Fire rules both our will and our intuition. From our will, we find the strength to act, and the confidence gained from our experiences. The will is where our sense of "no" comes from, thus the ability to tell others where our limits or boundaries are and the ability to hear and respect where other people place theirs. In assault prevention programs for grade school children, we say that children have the right to be safe, strong, and free. Believing in those rights and acting from them are qualities requiring strength of will.

Strengthening the will also means developing self-discipline, not an easy concept for adults, let alone children. Because we want our children to grow up feeling powerful in the world, we give them structure when they are young. Children need to play and have self-directed time to interact with their world, but not all the time. They also need limits to their freedom that are clear and consistent. Many Pagan families have a period of daily meditation, prayer, or other spiritual practice which they share with their children, in part to develop the habit of self-discipline.

Fire is also associated with the intuition, and as Pagans we strive throughout our lives to deepen our connection to our own intuition. Emerging from Deep Self, the Unconscious, our intuition is the voice of the wild. If we have a question, we are able to speak it because our intuition says we have the right to ask. We try to give our children the confidence to trust their own instincts.

All the self-defense training in the world is not going to help my son if he doesn't recognize or heed his own internal alarm bells that tell him when something is not right. I can't possibly prepare him for every experience he will have in his life, nor will I be there to coach him indefinitely, so it is critical that I help him think for himself, make choices for himself, and pay attention to his gut instincts.

In the grand scheme of things, medical science is just one of many belief systems, albeit one that has particular authority in this culture. From the point of view of the wild, however, each situation may require the aid of one or more systems. Homeopathy, herbs, acupuncture, diet changes, chiropractic, and bodywork are alternative therapies that work remarkably well for many childhood ailments, though our training may cause us to judge their effectiveness before actually trying them. Each has its strengths, and each child may have stronger affinities with one than another. Learning to trust our own intuition about what works best for our children is a way we can make difficult decisions while maintaining the perspective of the wild.

One of the other fruits of a well-developed intuition is creative ability and self-expression. In ritual, we sing, dance, and express joy through our bodies. The Goddess says, "All acts of love and pleasure are My rituals," so we create ways to celebrate the holidays in which our children can participate. One family has hosted a Winter Solstice Cookie Party every year, where children can decorate Solstice cookies, listen to stories, and sing songs. When their two daughters came of age, one choreographed a dance for her ritual and the other sang a song to everyone there. They trusted their creative abilities enough to know how to express themselves to the community that had watched them grow from girls into young women.

Water, The Emotions

The third elemental region of this map is Water, which encompasses the range of human emotions. Love, empathy, compassion, and also hatred, fear, and alienation are all currents of emotion that run through us, all reflections of the strength of the Water element in our bodies. The rhythm of our heartbeat, the ebb and flow of our breathing—all are governed by Water. Water is not so much concerned with balance, as Air is, but with rhythm, like the patterns of waves against the shore or the heartbeat that sets us swaying to our own music. When Water is in balance, the pace of our lives is not so fast that we overextend ourselves and get sick, nor does it become so stifling that we get depressed, resentful, and withdrawn.

Children, as well as adults, need to be able to express their full range of emotions. Video and computer games have drawn a lot of fire, and rightly so, for their militaristic goals and glorification of violence. Yet one could argue

they have also served a useful role in providing an outlet for young people to feel angry and aggressive and not be punished for it. There are precious few areas in social and family life where expressing anger is not frowned upon or punished in some way. The expression of anger itself is human, but the programmed response in video games of violent action as a natural consequence of feeling anger is harmful to individuals, families, and nations. The more we can model having powerful feelings and not acting on them, the easier it will be for our children, in the long run, to slip in and out of emotional states without acting in ways that are harmful to others or themselves.

Within the Pagan/activist community, there are some creative responses to the dilemma posed by TV and mainstream media influences. In many households, there is no TV to watch, but there is a computer. One homeschooled teenager keeps in touch with her friends via e-mail, and studies independently using the Internet and two on-line services. There are as many different levels of video tolerance in my community as there are families and individuals. It is generally agreed that from the point of view of the wild, what matters is that our utilization of TV, video, and computer games not constrain our children's emotional development, imagination, or their ability to establish meaningful relationships.

Water is a place of connection, of empathy for others. The heart is the center of emotion in the body and is where we take in and give out love and nurturance. The wild says that all things have a spirit that can be felt. From the wildness within the heart, we feel our connection with other beings and our place in the great web of life. When we teach our children respect for the creatures of the earth, it is not only the golden rule and good manners we are talking about but also respecting the Spirit that dwells within all things.

"An' it harm none, do as you will," is the Wiccan Rede, the basic manifesto of the Craft, and one of the few formal statements of principle we have. Harm is a complex concept, and open to great differences in interpretation. We teach our children not to intentionally harm others, try to show them when their mistakes have caused harm, and suggest ways for them to balance their actions. But in truth, we are so woefully ignorant ourselves of many of the systems we set about altering or crafting to our liking that it is hard to know where to start sometimes in teaching our children about doing no harm. So we also stress the importance of acting with good intentions and having compassion for ourselves and others along the way.

Earth, The Body

When we look at the body, we are looking at what grounds us, what connects us to the earth, our community, to our ancestors, and our animal selves. Our bodies reflect our physical health, which affects our ability to stay upright

and balanced as we move about. The body also symbolizes where we've been and what we know, the sum of our life experience. The phrase "I know what I know, and this is what I know" is an apt one for the Earth element.

Inviolate to the proper growth and nurturance of the body are the essentials of good food, sleep, connection to the earth, fresh air, and clean water. If these basic requirements are not met, our children will not be able to grow to their full potential. In considering our child's physical state, we can also ask ourselves how much time she spends outside each day, whether she has an inordinate fear of the natural world, whether she knows who her ancestors are, whether she knows what we do for a living. If any of these things feel out of balance for her age and maturity, that is useful information for us to act on, because the body grows best with balance and stability.

When confronted with a proposed medical procedure for my child, I can ask myself: What has her experience been so far? If I were trying to decide whether to give my daughter the latest immunization, I might ask, among other things, whether I think she has the physical stamina right now to absorb the toxins. What are the risks associated with both the "disease" and the "cure"? How strong is her immune system right now, and is it wise to consider taxing it with a heavy load? If so, what would help her body prepare for and absorb the vaccine?

While many Pagan families believe strongly in full immunization for their children, many families choose not to vaccinate their children at all; some choose to give their children selected vaccines from the myriad available; and others choose to have their children fully immunized but may wait until the child is a year or two old, by which time her immune system has become more fully developed.

There is a great debate about immunization, and not only in the Pagan community. Are those who refuse to immunize selfishly protecting their children from the negative effects of vaccinations while riding the coattails of "herd immunity" within the greater immunized society, which keeps their children safe from dangerous diseases? Or are those who immunize succumbing to the intense propaganda of the medical establishment, while running the risk that their children fall prey to more serious autoimmune diseases later in life due to the effects of the vaccinations on the developing immune system? In the face of conflicting evidence, lack of long-term studies, and emotionally charged conjecture on both sides, it is important to recognize the incredible complexity of the question, as well as the diversity of viewpoints which determine whether a family chooses to vaccinate its children. From the point of view of the wild, what is important in each case is that the family has taken all the information available, weighed the physical risks involved against the social, medical, emotional, and economic forces at work, and made the decision that works the best for them.

Advances in creative engineering have given birth to strollers which let you jog along with your kid, and backpacks and bicycles for the very young. These gadgets have made it much easier for many parents to enjoy nature with their children, another aspect of Earth. But they have also created a long list of controversial paraphernalia, from walkers and bouncers to computer-like "educational" stimulation toys for the high chair, stroller, and carseat (see Croissant, this volume), which mediate a child's experience of her body, often with detrimental developmental effects. From the point of view of the wild, what is important for our children's bodies is physical health and connection to the earth. When we judge any technology in terms of its appropriateness for our child's particular physical and developmental needs, we are taking into consideration the element of Earth within our child.

■ CONCLUSION: REGENERATION, AND REBIRTH

An activist-Pagan practice of childraising can support both our innate wildness and our right to utilize technoscience for the good of our children and families. Pagans know the strength of the wild and practice letting its transformative magic work in daily life. Activists recognize that only through individual and group empowerment can policy be made that satisfies both human ethics and ecological imperatives.

Though modern technology is the offspring of militarism, entertainment, and capitalism (Haraway 1991), the transformative power it offers us parallels the shamanic techniques of ancient cultures. One of our tasks is to recognize this ironic identity we have inherited and use ethics to shape its effects on future generations. With guidelines that stem from our connection to the wildness of Spirit, we can evaluate our connection to cybernetic systems: How do they change, increase, or deny our power? What part of us is the same, what is different? How can we inform others about this new identity, and assure both their access and right of refusal?

The other task at hand is to not assume that our engagement with technology is an end to itself. Though metaphors for the human body using communication terminology may represent a leap forward from the mechanistic metaphors of a century ago, it would be foolish to reduce the mysteries of life on the planet to "a problem of coding" (Haraway 1991:164). Though we may succeed in creating machines that act or even think like humans, it will be decidedly more difficult to get humans to act like machines—at least for very long. The wild says that there will always be another metaphor around the corner, and in every metaphor there will have to be room left for the mystery of Spirit that is not explainable through it.

Just as the dominant culture has a need to constantly reduce the inexplicable to a series of predictable events, it has an even greater need for new fron-

tiers to explore (plunder) while blithely ignoring the mess it has made in its last frontier, or the frontier before that. To join the chorus of voices heralding the new "frontier" of cyberspace is in part to reinforce our urge to forget all about the rubbish we've left in outer space, all the radioactive waste we've created and are now trying to bury in the desert, all that we have taken from others that is not ours. Probing the mind/machine interface is exciting, but it is not going to solve all our problems, clean our houses, or make our children breakfast when we've been up at the computer all night. In the end, it is just another system among many through which to interact with the world.

We stand once again in the lair of Hephaestos, the inventor, the surgeon, the hacker, gawking at the cool fractal patterns on the wall, watching as he slices through strands of DNA as others would scale a fish. May we be mindful of the owl upon our shoulder, and heed her words whispered into our ears. May we use our serpent shield to help draw boundaries: learning what we need, speaking what we know to be true, protecting our connection to the sacred, and acting in the best interests of ourselves and our children.

References

Davis-Floyd, Robbie. 1992. *Birth as an American Rite of Passage*. Berkeley: University of California Press.

———. 1994. "The Technocratic Body: American Childbirth as Cultural Expression." *Social Science and Medicine* 38 (8): 1125–1140.

Ehrenreich, Barbara, and Deirdre English. 1973. *Witches, Midwives, and Nurses: A History of Women Healers*. Old Westbury, N.Y.: The Feminist Press.

Galvin, Kathleen M., and Bernard J. Brommel. 1991. *Family Communication: Cohesion and Change*. New York: HarperCollins.

Gardner, Howard. 1993. *Multiple Intelligences: The Theory in Practice*. New York: Basic Books.

Graves, Robert. 1955. *The Greek Myths: 1*. Baltimore: Penguin Books.

Haraway, Donna. 1991. *Simians, Cyborgs, and Women: The Reinvention of Nature*. New York: Routledge.

Rabbit, Sparky T. 1989. "Meeting the Queer God." *Reclaiming Newsletter* 35: 27–30.

Snyder, Gary. 1990. *The Practice of the Wild*. San Francisco: North Point Press.

Starhawk. 1987. *Truth or Dare: Encounters with Power, Authority, and Mystery*. San Francisco: Harper and Row.

Yohalem, John. 1995. "Letter from the Editor." *Enchanté: Journal for the Urbane Pagan* 20: 31.

Janet Isaacs Ashford is a freelance writer, graphic designer and musician. She is the author of two books and many articles and educational materials on childbirth, including *The Whole Birth Catalog* (Crossinbg Press, 1983), *Birth Stories: The Experience Remembered* (Crossing Press, 1984), *Mothers and Midwives: A History of Traditional Childbirth* (1988), and *The Timeless Way: A History of Birth from Ancient to Modern Times* (InJoy Videos, 1998). From 1979 to 1988 Ashford edited and published *Chidbirth Alternatives Quarterly* which is archived at the National Library of Congress. She has lectured widely since 1984 on the history of childbirth as depicted in art and has collected over 500 slides of childbirth in history. Ashford is also the author of six books on computer graphics. She is the mother of three children, all born at home without medical assistance. Her web site is at www.jashford.com.

Elizabeth Cartwright is a doctoral candidate in anthropology at the University of Arizona, Tucson. Her research interests include how technology is used in the act of healing, women's health issues, and the construction of ethnic identity. Her dissertation explores indigenous perceptions of environmental degradation and toxic exposures to pesticides among the Amuzgo Indians of southern Mexico.

David B. Chamberlain is a California psychologist, independent scholar, founder/editor of <birthpsychology.com> on the world wide web, and President of the Association for Pre- and Perinatal Psychology and Health (APP-PAH). With over forty published articles on the capabilities of prenates and neonates, he is a major contributor to prenatal and perinatal psychology. His popular book, currently in six languages, is now available in a tenth anniversary edition, "The Mind of Your Newborn Baby" (Berkeley: North Atlantic Books, 1998).

Jennifer L. Croissant is Assistant Professor in the Program on Culture, Science, Technology, and Society at the University of Arizona. Her research interests include the sociology and anthropology of knowledge, science, and technology, most basically considering the ways ordinary knowledge and institutionalized sciences are constituted and the ways systems of knowledge interact. She is currently engaged in research projects focused on the human

body and attempts to model and modify it, pain, cybernetics and cyborgs in scientific and popular culture, university-industry interactions, engineering education, and vanilla beans.

Charis M. Cussins is assistant professor in the Department of Sociology and in the Women's Studies Program at the University of Illinois, Urbana-Champaign. She works on valued reproductions, in the fields of reproductive technologies, ex-situ (zoo) conservation, and in-situ community-based conservation.

Robbie Davis-Floyd is a cultural anthropologist specializing in medical anthropology, ritual and gender studies, science and technology studies, and the anthropology of reproduction. A Research Fellow in the Department of Anthropology of the University of Texas at Austin, she is author of *Birth as an American Rite of Passage* (1992), coauthor of *From Doctor to Healer: The Transformative Journey* (1998) and coeditor of *Childbirth and Authoritative Knowledge: Cross-Cultural Perspectives* (1997) and *Intuition: The Inside Story* (1997). Passionate about the benefits to mothers and babies of midwifery care, she is involved in the national and international midwifery movements, and her current research focuses on the development of direct-entry midwifery in North America. She is also engaged in collecting oral histories from the scientists and engineers who pioneered the American space program, and is enjoying this opportunity to move from inner to outer space.

Joseph Dumit is Assistant Professor in the Science, Technology and Society Program at MIT. He practices as an anthropologist and historian of science and technology, specializing in medical imaging, brains, computers, and emerging illnesses in the United States. He is coeditor of *Cyborgs and Citadels: Anthropological Interventions in Emerging Sciences and Technologies* with Gary Lee Downey (SAR Press 1997).

Eugenia Georges is Associate Professor of Anthropology at Rice University. Since 1990, she has been conducting research on Greek women's and physicians' experiences with a variety of reproductive technologies. She is currently working on a book which examines changing meanings of motherhood and reproduction in the context of Greek modernity. In addition to her work on gender, health, and the politics of reproduction, she has written on transnational migration from the Dominican Republic to New York City. She is the author of *The Making of a Transnational Community: Migration, Development and Cultural Change in the Dominican Republic* (Columbia).

Anne Hill is a writer, musician, educator, and small business owner. She holds a B. A. in Women's Studies from UCSC, and is currently coauthoring a

book entitled *Circle Round: Raising Children in Goddess Tradition*, with Starhawk and Diane Baker, forthcoming from Bantam in 1998. She lives with her family in northern California.

Mizuko Ito is a cultural anthropologist and a researcher at the Institute for Research on Learning in Menlo Park, California. Her paper in this volume draws from dissertation work on kids and computer games. Past research includes the study of Internet communities, fieldwork to help develop a computer-based math curriculum, and user studies in corporate contexts. Research areas include: translocal relations as they are mediated by new media technologies, the relations between online and offline spaces and identities, technology access issues, and how to form interdisciplinary linkages and new methodologies for an anthropology of cyberspace.

Emily Martin is Professor of Anthropology at Princeton University. Beginning with *The Woman in the Body: A Cultural Analysis of Reproduction* (Beacon Press 1987), she started to work on the anthropology of science and reproduction in the United States, in particular on how gender stereotypes have shaped medical language and how they circulate among and are contested by women in different age groups and communities. The next phase of her research focused on the interplay between scientific and popular conceptions of the immune system. In *Flexible Bodies: Tracking Immunity in America from the Days of Polio to the Age of AIDS* (Beacon Press 1994), she analyzes the manner in which the concept of "flexibility" in immune discourse has been involved in a transformation of contemporary notions of health and business practices. Her present work is on theories of normalization and the evolving constitution of selfhood in contemporary society.

Steven Mentor (aka Cybunny) is finishing a dissertation at the University of Washington on cyborgs and/as literary/political theory. Currently he is teaching English and designing educational multimedia at Evergreen Valley College in the Silicon Valley. His 7 Jeopardy! categories would be: Interfacial expressions; Social History of Cybernetics; Raising Your Test-Tube baby; Anarchism; Playing in the MUD; Technology as Prosthetic; and Frisbetarianism. He lives with his (mid)wife and (IVF) son in Santa Cruz, California.

Lisa M. Mitchell teaches anthropology at the University of Victoria. Her research in the anthropology of medical and scientific knowledge has been directed toward genetic counseling; reproductive technology, specifically, ultrasound fetal imaging; and the controversy over the health effects of electromagnetic fields. She is currently completing a book on the cultural meanings and implications of ultrasound fetal imaging in Canada. Her latest

research examines the intersections of popular, genetic, and obstetrical discourses in abnormal ultrasounds.

Lisa Jean Moore is a Postdoctoral Fellow at the Center for AIDS Prevention Studies and the President of the Sperm Bank of California. She is currently working on a project about historical representations of human genital anatomy with Adele Clarke. Her other interests include studying sexual technologies, including the female condom. In the fall of 1998, Lisa will join the faculty of the City University of New York, College of Staten Island.

Rayna Rapp is Professor of Anthropology and Chair of the Graduate Program in Gender Studies and Feminist Theory, New School for Social Research, in New York City. Her edited and coedited volumes include: *Toward an Anthropology of Women, Promissory Notes: Women in the Transition to Socialism, Articulating Hidden Histories,* and *Conceiving the New World Order: The Global Politics of Reproduction.* She has recently completed a book on the social impact and cultural meaning of prenatal diagnosis—*Moral Pioneers: Fetuses, Families, and Amniocentesis* (Routledge 1998)—from which her chapter is drawn. She has been active in the movements for reproductive rights and to build women's studies in the United States for twenty-five years.

Elizabeth F. S. Roberts is a graduate student in the Department of Anthropology at the University of California at Berkeley. Another article of hers examining the practice of surrogate motherhood appears in *Small Wars: The Cultural Politics of Childhood,* edited by Carolyn Sargent and Nancy Scheper-Hughes. She is currently working on a project concerning contraceptive reproductive technologies in "developing" countries.

Matthew Schmidt is a doctoral candidate in the Department of Social and Behavioral Sciences at the University of California, San Francisco. His interests include social constructions of masculinity, reproductive technologies, and community building on the Internet. He is currently working on an ethnography of avatar-based interaction spaces.

Sylvia Sensiper is a writer, video producer, and photographer. Her projects include the video *Films Are Dreams That Wander in the Light of Day* (1989) and the photo essay "Intersections" (1991) featured in the Spring/Summer 1997 issue of *Visual Anthropology Review.* She holds a Masters in Visual Anthropology and a Ph.D. in Public Policy and Social Research, and is currently affiliated with the Harvard Business School.

Sherry Turkle is Professor of the Sociology of Science at the Massachusetts Institute of Technology and author of *Life on the Screen: Identity in the Age of the Internet* (Simon and Schuster 1995), *The Second Self: Computers and the Human Spirit* (Simon and Schuster 1984; 2d rev. ed., MIT Press, forthcoming), and *Psychoanalytic Politics: Jacques Lacan and Freud's French Revolution* (Basic Books 1978; 2d rev. ed. Guilford Press 1992). She specializes in the study of people's relationships with technology, particularly computers. Her most recent research focuses on the psychology and sociology of computer-mediated communication.

Index